POPULAR AMERICAN HOUSING

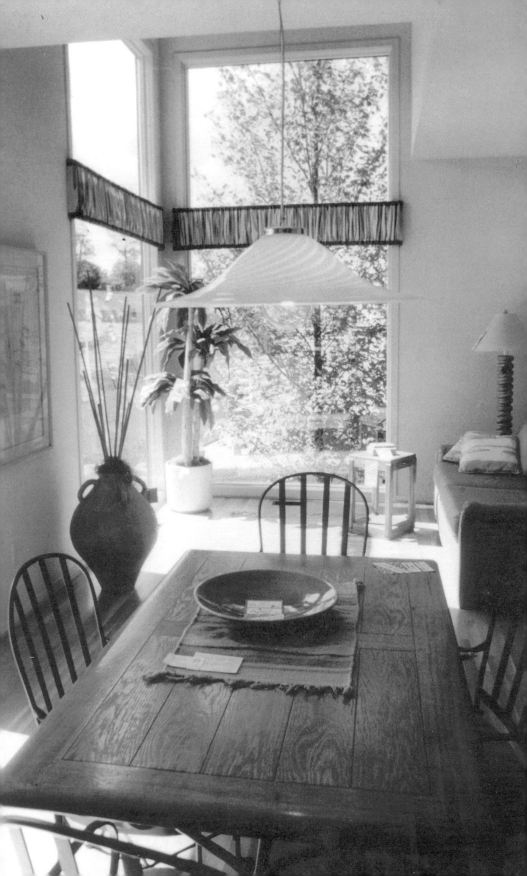

POPULAR AMERICAN HOUSING

A Reference Guide

Edited by Ruth Brent
and Benyamin Schwarz

American Popular Culture
M. Thomas Inge, Series Editor

GREENWOOD PRESS
Westport, Connecticut • London

Library of Congress Cataloging-in-Publication Data

Popular American housing : a reference guide / edited by Ruth Brent
 and Benyamin Schwarz.
 p. cm.—(American popular culture, ISSN 0193–6859)
 Includes bibliographical references and index.
 ISBN 0–313–28032–0 (alk. paper)
 1. Housing—United States. I. Brent, Ruth S. II. Schwarz,
 Benyamin. III. Series.
 HD7293.A3P66 1995
 363.5'0973—dc20 94–47420

British Library Cataloguing in Publication Data is available.

Library of Congress Catalog Card Number: 94–47420
ISBN: 0–313–28032–0
ISSN: 0193–6859

First published in 1995

Greenwood Press, 88 Post Road West, Westport, CT 06881
An imprint of Greenwood Publishing Group, Inc.

Printed in the United States of America

The paper used in this book complies with the
Permanent Paper Standard issued by the National
Information Standards Organization (Z39.48–1984).

10 9 8 7 6 5 4 3 2 1

To the angels and the mortal creatures who dwell with us.

If we think of the verb *to dwell* in a wide and essential sense, then it denotes the way in which humans fulfill their wandering from birth to death on earth under the sky. Everywhere the wandering remains the essence of dwelling, as the staying between earth and sky, between birth and death, between joy and pain, between work and world. If we call this multifarious between the *world*, then the world is the house, which is inhabited by the mortals. The single houses, however, the villages, the cities, are works of architecture, which in and around themselves gather the multifarious between. The buildings bring the earth as the inhabited landscape close to man and at the same time place the nearness of neighborly dwelling under the expanse of the sky.

—Martin Heidegger (1957)

Contents

Preface

We said there wasn't no home like a raft, after all. Other places do seem so cramped up and smothering, but a raft don't. You feel mighty free and easy and comfortable on a raft.

—Mark Twain, *The Adventures of Huckleberry Finn*

What matters in housing is what it does for people as well as what it is. We attribute to housing various meanings. Rapoport (1980) suggested that housing has been approached as a product, as a commodity, as a process, as a place, as territory, as private domain, as a "behavior setting," and as a locus of activities. *Popular American Housing: A Reference Guide* is intended to capture the multidisciplinary essence of housing as a complex system that seeks to meet the goals of a variety of users. Researchers are aware of the mammoth complexity of this topic and its broad range of perspectives. Because housing may be approached as a system of interacting or interdependent disciplines, this book presents a collection of chapters for scholars who span the arts and humanities, social sciences, and related design professions and who wish to pursue the richness of this topic. The format of the reference guide emerged as a way to help students and researchers grasp the comprehensive nature of housing within the tapestry of American popular culture. It is a useful tool to gain entrance to basic knowledge and awareness of seminal work. Our purpose is to stimulate and advance scholarly inquiry by providing perspectives, concepts, and insights that address the issue of housing.

While this book strives to be a comprehensive introduction to housing studies, naturally there are some omissions and overlaps. Authors were given the freedom

to link theory, research, and practice by identifying references essential to their topics. They were encouraged to highlight the most important issues related to their discipline area with no systematic structure. Consequently, the reader may find differences in style and approach to the topics in each chapter.

We are indebted to M. Thomas Inge, who served as series editor for this book and provided constant encouragement. It was Tom who enthusiastically recognized the critical role of housing in American popular culture and was unwavering in his mission to transcend barriers between disciplines and to promote scholarship that would in turn improve our world. We wish to acknowledge our mentors for their significant influence in helping us grasp the value of American housing—Gertrude Esteros, Evelyn Franklin, and Lee Pastalan; our resourceful librarian, Janice Dysart, who was always courteous and imaginative during the laborious quest for citations; Melanie Himmelberg, who cheerfully assisted with compiling references; Bea Smith, who supported us in spirit and patience; and our families, who were steadfast in helping us through the struggles, during the time devoted to this project and now in its celebration of completion.

REFERENCE

Rapoport, A. (1980). *Towards a Cross-Cultural Valid Definition of Housing*. Paper presented at the 11th Environmental Design Research Association Conference.

Introduction

Ruth Brent and Benyamin Schwarz

Human beings have been concerned about shelter since Adam and Eve were expelled from Eden. Unlike other creatures that build as a result of their genetic programming, humans *think* as they build. Humans build to satisfy a need in a conscious act that embodies countless decisions and choices and gives expression to feelings and values. According to the German philosopher Martin Heidegger, "We do not dwell because we have built, but we build and have built because we dwell, that is because we are *dwellers*." To dwell signifies the way "we human beings *are* on the earth." If Heidegger is right, this trait is central to our existence, hence the essence of housing may be lodged in its humanness—connecting people and places. In this sense, the study of housing is an attempt to answer the basic questions of a humanist—"What does it all mean?" "Where should we go?" "Where have we come from?" "Who are we?"

Every environment embodies meanings and at the same time affords certain actions to take place. Although the experience of housing and its meaning is essentially individual, the understanding of the relationships between the people and their residential environment is in the locus of housing research. This book brings into focus different aspects of housing from various disciplines in the context of American culture. The lore of American housing can be told within multiple contexts and various disciplines. The approach taken here is that of a humanist, searching to enhance and expand housing knowledge in the broadest sense. More succinctly, this book seeks to improve the understanding of the nature of American housing through a reference guide that can stimulate scholarly research. The following chapters reflect several professional paradigms and illustrate the broad multidisciplinary nature of the field of housing.

NEED, PURPOSE, AND PHILOSOPHY

Housing is more than shelter. Housing can be examined as a dynamic process of transactions involving several actors. It reflects the ever-changing demand and its provision mirrored by policies and interventions. Housing may be a financial asset or a component in the urban or the rural environment. On another level, housing may be perceived through its sociopsychological meaning and use. The study of housing is a multifaceted line of inquiry that encompasses elements of history, sociology, psychology, planning, architecture, political science, economics, geography, art, and anthropology. The broad and fragmentary nature of the field constrains any academic researcher or student of this multidisciplinary domain.

In order to overcome these problems, this reference guide provides chapters on particular topics of American housing. Each chapter covers issues and concepts that may be important to scholars, policy makers, environmental psychologists, architects, designers, planners, housing specialists, developers, or other practitioners. This book strives to inform the reader about the current body of literature and the seminal work in each of the sub-fields that were selected for this volume. While the chapters do not cover all the aspects of housing, they allow the reader to make intelligent comparisons between various housing contexts and disciplinary perspectives. Additionally, each chapter includes an extensive bibliography and a guide to periodicals.

ORGANIZATION

The contributions in this book are organized in eight chapters. Chapter 1 begins with the discussion of vernacular housing and American culture. Howard Wight Marshall refers to those dwellings built by people of different regions, according to certain patterns that often employ materials, techniques, and design that can be traced back to older traditions. The chapter reviews the vernacular architecture versus the high-style architecture of American housing. This chapter leads to the historical perspective of housing in Chapter 2. Josette H. Rabun and Betty McKee Treanor present an intricate but succinct introduction to guides on American housing history. Chapter 3 focuses on the environmental and social science perspective of housing. Benyamin Schwarz, Roberta Mauksch, and Sandra Rawls look at residential environments in their broad sense of home and housing, neighborhood and community with a special focus on three interdependent components—people, behavior, and physical setting. Then, Chapter 4 provides an overview of housing in the arts and popular media. Jackie Donath's chapter is an examination of American popular housing as image and icon, focusing on the arts and popular media as "channels" of visual and symbolic information and communication. Chapter 5 approaches housing from the public administration standpoint. Andrew D. Seidel discusses how our governments have developed policies and programs to provide housing. The role of public administration and policy for

housing is divided into the direct and indirect programs wherein books, articles, and periodicals are identified. Next, Chapter 6 reviews the areas of housing finance, marketing, economics, and management. Raedene Combs discusses the central role of the housing industry in the American economy, the complex systems of financing, and the prevalence of mechanisms for matching buyers with sellers. Chapter 7 is an overview of the environmental design, construction processes, and technology aspects of housing. Barbara Flannery and Benyamin Schwarz review the professional disciplines and their perspective on housing, special populations and accessibility needs, descriptions of building trades, terms, materials, construction processes, and past industrial housing experiments, as well as issues of energy management, computer technology, futuristic housing, air quality, and household hazards. Finally, Chapter 8 considers how electronic resources can be used in housing research. Edward Brent, Ruth Brent, and Benyamin Schwarz introduce the reader to electronic communication and information that are currently available for researchers and practitioners.

Through this volume's organization our purpose is to allow flexibility for the reader to pursue her or his needs and interests. We hope that *Popular American Housing: A Reference Guide* will assist the reader in linking theory, research, and practice. We trust that the interested researchers and practitioners from various disciplines and fields will find this book a valuable contribution to the study and the improvement of housing for the benefit of all dwellers.

POPULAR AMERICAN HOUSING

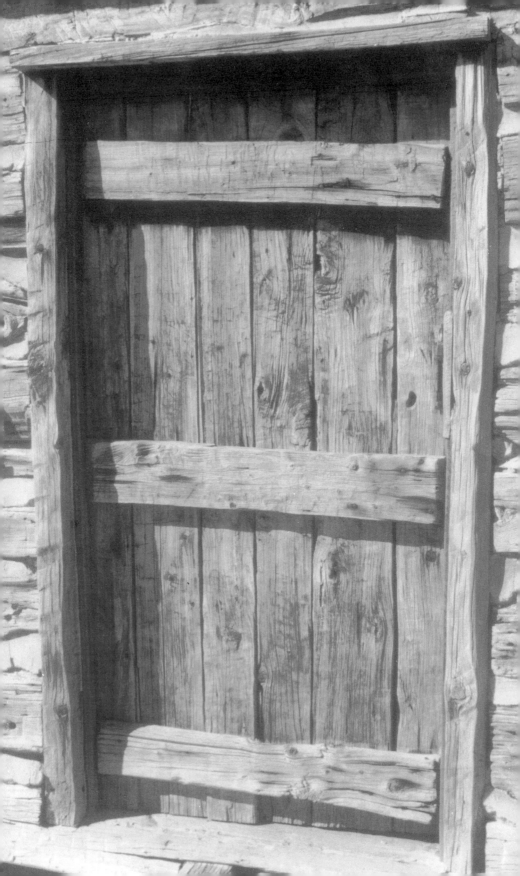

1

Vernacular Housing and American Culture

Howard Wight Marshall

The problem . . . then, lies less in identifying specific forms and technics than
it does in identifying the characteristics of the traditional aesthetic philosophy
that governs the selection, production, treatment, and use of forms.

—Henry Glassie (1972)

INTRODUCTION: THE STUDY OF VERNACULAR
ARCHITECTURE AND POPULAR HOUSING

In the constellation of houses old and new, the majority are not the result of
academic or high-style design; rather, they are classified as *vernacular houses*.
While some scholars regard this register of design as anonymous or collective,
others are pressing for appreciation of the anonymous designer or builder as one
we simply have not discovered yet. The sense of the word *anonymous* is, thus,
like the terms *primitive* or *naive*, pejorative and counterproductive as we continue
to search for historical truth and nearby history.

While the study of architectural history is of venerable age, until the past gen-
eration the bulk of historical explanation focused on the houses designed in high
style, built by a great architect, or dwelt in by a famous historical figure. Today
we are seeing interest in multidisciplinary approaches to architecture in its history
and design aspects, and especially vernacular building, issues of ethnicity and
cultural versatility, cultural landscape, and environmental conditions. All these
things are the product of time and of people's interaction with the land.

The study of vernacular architecture has been part and parcel of several dis-

ciplines for many years. Researchers and teachers in such disparate fields as art history, sociology, folklore and folklife, geography, anthropology, archaeology, American studies, social history, economics, and linguistics study historic buildings and vernacular houses. Architecture falls within the realm of the broader term *material culture*. Led by innovative scholars such as folklorist Simon Bronner at Pennsylvania State University, architectural historian Cary Carson at Colonial Williamsburg, and American studies scholar Thomas Schlereth at Notre Dame, there is a modest movement to establish material culture as a distinctive and separate field of inquiry, and there is some logic to this.

In *Material Culture and Technology* (1973), Robert F. G. Spier offers an overview of material culture from the standpoint of an anthropologist, and Norman Pounds provides a survey of the subject in *Hearth and Home* (1989). However, vernacular architecture will continue to be most firmly situated within the long-established fields of folklore/folklife studies, art history, historical archaeology, and geography, those departments where most researchers and scholars hold teaching positions. Museums are naturally another significant location where vernacular architecture and material culture hold prominence.

DEFINITION

We take for a basic definition of vernacular houses the following: those dwellings built by people in a community, region, or ethnic group according to older, inherited, agreed-upon, yet flexible patterns and aesthetic ideals carried in people's memories, patterns that often employ locally available materials and customary techniques of design and construction that may be traced back to commonplace building in "the old country," whether Europe, Africa, the Middle East, or Asia.

The terms *popular architecture* and *vernacular architecture* may be used interchangeably if what is meant is the architecture of the populace and not high-style, academic, or high-design architecture that most values creativity and modernity, seems to start from scratch (as the Bauhaus designers pretended), and seeks to be fashionable and even elitist. Vernacular architecture operates in a system related to academic design but separate from many of the pressures and goals of high-style or academic design. It continually changes, even if subtly and slowly, and we can chart the subtleties of social and cultural history in the varieties of buildings and their revealing details. Change occurs within the flexible boundaries of custom and in keeping with the expectations of the community.

Virtually all of the compendia and anthologies issued recently contain introductory essays or editorial remarks about the difficulties and challenges of trying to define vernacular architecture. Collectively read, one can get a very good sense of trends in the study of vernacular housing as well as statements from leading scholars in Camille Wells, "Old Claims and New Demands: Vernacular Architecture Studies Today" (1986), Thomas Carter and Bernard L. Herman's introductions to their *Perspectives in Vernacular Architecture III* (1989) and *Perspectives in*

Vernacular Architecture IV (1991), and Robert St. George's excellent introduction to his *Material Life in America, 1600–1860* (1988), exploring the intriguing relevance of social historian Fernand Braudel and anthropologist Claude Lèvi-Strauss (both French scholars influenced by the writings of Karl Marx).

VERNACULAR VERSUS HIGH-STYLE

One way to think of popular housing is simply to say that popular housing is all those countless millions of domestic spaces and dwellings that are *not* designed by futuristic or scholastically trained high-style architects but are instead chosen purposely from the local repertoire of vernacular houses in a community or region. These houses may be based on folk ideas of "good fit" in architecture but may more often in the late twentieth century be "designs" selected from a catalog or local display of prefabricated/manufactured housing (the kit house, the mobile home), from magazine stories about "hot" styles of new suburban housing going under the enticing label "custom homes," or built by a contractor to jibe with the general look of an emerging suburban community. So the range of domestic shelter we study runs from the archaeological remains of one-room half-timbered houses in colonial America to the connected adobe rooms of a Native American pueblo in Arizona to a grand Gothic mansion of white wood along a big-city boulevard to the small-frame shotgun house of the sharecropper to the mobile home and the suburban tract house; from Monticello to Lincoln's log cabin to Graceland.

Architecture itself is of course a crucial element in our lives. When we have choices, we select in a dwelling forms and styles that reflect a number of forces in us as people, whether these forces are obvious (to impress our neighbors, mark our success, meet our limited budget) or obscure (psychological comfort, order, balance, predictability, tradition). Spaces may be public or private—in a modern suburban house, the front lawn and the living room versus the basement and bedroom. Symbols are important, from Greek columns, the Victorian porch, or the mailbox that looks like a miniature barn.

THE IMPORTANCE OF FIELD RESEARCH

Field research is the sine qua non of the contemporary student of vernacular housing. This is preservation through documentation, and it is extremely important in capturing information and evidence about the object itself that will be invaluable to future generations of students long after the commonplace vernacular house has fallen to the wrecking ball. First comes the field research and documentation, then analysis and interpretation, and finally conservation. Among the best current guides on the proper documentation of historic structures, and particularly useful because its authors are members of the National Park Service's Historic American Buildings Survey, is John Burns, et al., *Recording Historic Structures* (1989). Burns's book continues the tradition established by Harley McKee

in his 1970 guide called *Recording Historic Buildings*. Researchers will need a compact basic dictionary such as John Scott's *A Dictionary of Building* (1974), Henry Saylor's *Dictionary of Architecture* (1952), or Martin Briggs's *Everyman's Concise Encyclopaedia of Architecture* (1959).

Furthermore, the researcher at any level will find it valuable to peruse early builders' guides, pattern books, carpenters' catalogs, and other late-eighteenth- and nineteenth-century advisories. Among those available in rare book collections and as modern reprints are Owen Biddle, *The Young Carpenter's Assistant* (1805), Calvert Vaux, *Villas and Cottages* (1864), Henry Cleaveland, et al., *Village and Farm Cottages* (1856), Lewis Allen, *Rural Architecture* (1860), as well as widely known and reprinted classics such as Asher Benjamin's *The Country Builder's Assistant* (1797, reprint 1972) and *The Practical House Carpenter* (1830, reprint 1972), and Andrew Jackson Downing's *Cottage Residences* (1842, reprint 1967) and *The Architecture of Country Houses* (1850, reprint 1969). These historic manuals and guides are splendid sources of information, shedding light on many research topics. Builders' guides including Gustav Stickley's influential *Craftsman Homes*, (1909, reprint 1979), continue to be important, as do numerous contemporary popular magazines and promotional brochures available from corporate and small-business producers of prefabricated and manufactured housing— surely an important feature in the dynamic late-twentieth-century housing market. Helpful studies in this light are Thomas Harvey, "Mail-Order Architecture in the Twenties" (1981), Tom Wolfe and Leonard Garfield, " 'A New Standard for Living': The Lustron House, 1946–1950" (1989), and Herbert Gilbert, *The Dream of the Factory-Made House* (1984).

ARCHITECTURE AND CULTURE

What is the culture that defines an American community? First, it is useful to remind ourselves that America is not a melting pot. We need to look at architecture and landscape as visible, tangible manifestations of culture and of heritage, both high-style and vernacular. For vernacular design and popular architecture, one of the best ways to study culture and design is by direct examination and analysis of tangible elements in the built environment, because material things are stable and expressive vessels for communication of ideas. For example, look at landmarks that embody the citizens' sense of place and history in both conscious ways (statues in the cemetery, public school design, church steeples) and unconscious ways (farmstead layout, vernacular houses' symmetry).

In the study of vernacular architecture we look at the traditional structures and landscapes of regional and ethnic personality. Though traditions are manifest in every sort of human experience, from the habits of the Ozark farmer to those of the Wall Street banker, it is the conservative, community-based traditions accrued over time and trial that are the rootstock for vernacular architecture.

LOCALITY AND VERNACULAR ARCHITECTURE

Vernacular architecture is regional architecture. Moreover, many scholars, particularly those working in the tradition of geographers such as Fred Kniffen and folklorists such as Henry Glassie and Warren Roberts, use form as the basis for typological categories and investigations of cultural diffusion—all based on the character of buildings in given regions or communities. Form or pattern (floor plan, layout) is important in traditional building because form is relatively stable over time and space. Vernacular architecture often employs local building materials and has localized and regional patterns based on familiar traditions in design, construction, decoration, and use that have evolved over generations of execution and variation.

People live in environments and not merely in buildings. Our environments and their relationships with other environments are important. Vernacular buildings often reflect an intention to conform to accepted values in the community, resulting from traditions in design rather than from fashionable or futuristic academic architects. Traditional craftsmen-builders naturally and often reuse parts of old structures or entire structures as they expand and tinker with their landscapes and as people take advantage of local climate and terrain.

THE ROLE OF APPRENTICESHIP

Traditional builders acquire competence through apprenticeship and imitation of admired models and artisans, rather than through institutionalized classes or schools of design. Design values are imbedded in the community's traditions and worldview. Rather than being called an architect, the maker of a Pennsylvania farmhouse, a California bungalow, a row of New York City townhouses, or a college dorm was called a builder, contractor, craftsman, bricklayer, or carpenter. One of the features of vernacular design that differentiates it from high-style design is the degree to which the client and other members of the community participate in the architectural process. Forms are often familiar. Neighbors understand what is being built and why. The contractor knows similar buildings and his work is attuned to the needs of the client. This sometimes means there is less room for creativity in the job than in high-style design, but that is expected in the processes of traditional building. People apply decorative details and variations to give the building special character.

HOUSE TYPES

Traditions in housing often evolve over centuries of trial and error yet still retain a special element that expresses the ethnicity of the old builders. As students of vernacular and popular architecture, we can easily write a long list of questions to ask about our subject. One of the perennial questions we like to ask of cultural things is simply: Why do things survive? Why do they last after their supposed

function ends? Because they continue to hold symbolic or psychological values if not indeed physically vital values for people. One reference that gave force to the creating of categories or typologies is Fred Kniffen's "Louisiana House Types" (1936).

Vernacular houses across much of nineteenth- and even twentieth-century America clung to traditional forms and house types. Their surface decoration and "styles" changed in keeping with national changes in taste, from the early Georgian (c. 1810–1840) and Federal (c. 1810–1840) periods through the Greek Revival (c. 1840–1870) and into modern periods and revivals. For vernacular housing researchers, type differs from style. The important element of a building's type— based on its floor plan, placement of chimney or stove, roof form, height—is stable over time. Distinct patterns of vernacular buildings can be charted and mapped through time and space, and we are sometimes able to detect the probable origin for types of buildings we had previously thought to be simply "American."

In our context of vernacular architecture, style pertains to visual elements of decoration and ornament that buildings exhibit. One can place buildings in a category of style by studying these surface qualities. In vernacular architecture, style has little to do with a building's functions or its use of interior space. Stylistic periods change through time as fashions change in the context of popular design and taste, often as influenced by a small number of designers, artists, or architects whose ideas are widely disseminated in the media.

One of the problems with classifications of styles and periods is that the categories are fuzzy and easily abused. For example, "Classical" applies equally to an eighteenth-century brick house in the Virginia tidewater region, a New England church facade, and a suburban shopping mall in Denver, Colorado. One of the areas where folklorists, anthropologists, and geographers have difficulty sharing ideas with art historians is this area of typology; while the first three groups speak of types, the last speaks of styles, and this is only one of the places where terminology can be difficult and confusing. Scholars across the spectrum, including Kniffen, Glassie, Ronald Brunskill, Alan Gowans, Warren Roberts, Howard Marshall, William Pierson, Jan Jennings and Herbert Gottfried, Virginia and Lee McAlester, Thomas Hubka, Dell Upton, and Allen Noble, have wrestled with definitions, the importance of typology, and the various differences between high-style and vernacular building. For just several sources, see Brunskill, *Illustrated Handbook of Vernacular Architecture* (1971, 1978), Gowans, *Images of American Living* (1964), Glassie, *Pattern in the Material Folk Culture of the Eastern United States* (1968), and Hubka, "Just Folks Designing" (1979).

While the works of Kniffen, Glassie, and others offer examples of how to approach house types, it should be remembered that a house type may also be classed as a house "style" by standard architectural historical methods. Thus, the researcher will need basic references with which to analyze the decoration or stylistic details that often serve as an overlay to a traditional folk house. Charles Eastlake's *A History of the Greek Revival* (1872, reprinted 1979) is still very serviceable. For two recent sources of information on style, see John Blumenson,

Identifying American Architecture (1977), and Marcus Whiffen, *American Architecture Since 1780* (1968, revised 1992).

ANTHROPOLOGICAL AND ETHNOLOGICAL APPROACHES

Among the first scholarly studies in the New World were works that focused on Native American shelter. Among these are Lewis Henry Morgan, *Houses and House-Life of the American Aborigines* (1881), and the nineteenth- and early twentieth-century series from the Smithsonian Institution's Bureau of American Ethnology. More recent research in the environmentally spare Great Basin region includes Margaret Wheat's *Survival Arts of the Primitive Paiutes* (1967) and Catherine Fowler's *Tule Technology* (1990). More recently, William N. Morgan's *Prehistoric Architecture in the Eastern United States* (1980) and Peter Nabokov and Robert Easton's *Native American Architecture* (1989) provide solid treatments in describing large regions and themes.

Numerous excellent studies of Native American building traditions can be found, albeit with some difficulty, in the handsome technical reports developed mainly by archaeologists and issued by museums and federal agencies, such as those produced by the Lowie Museum at the University of California at Berkeley, the Nevada State Museum, the American Museum of Natural History in New York, and the Bureau of American Ethnology and other units at the Smithsonian. Some of these reports are old, such as Samuel Barrett's "Pomo Buildings" ([1916] 1977), but still of value today. Many of the nineteenth-century studies and reports give important eyewitness accounts of Native American culture that are missing from archaeological reports. Many studies of Native American material culture, such as Thomas Vennum's outstanding film *The Drummaker* (1974) and monograph *The Ojibwa Dance Drum* (1982) include documentation of housing and dwellings. Among recent archaeological studies of Native American housing are Kenneth Ames et al., "Household Archaeology of a Southern Northwest Coast Plank House" (1992), and Lynne Richards, "Dwelling Places" (1993).

One crucial development of the field of anthropology and its twin, archaeology, is the investigation of the "historic" cultural landscape through different kinds of studies. An influential application of the archaeologist's methods to the nearby mundane artifacts that abound across the United States—those that may be called "post-contact" or "historic"—is Bernard Fontana, et al., "Johnny Ward's Ranch" (1962). More recently, Michael O'Brien, et al., have offered an important survey of survivals of early European-American vernacular houses in northeast Missouri as part of a broad archaeological resources study in *The Cannon Reservoir Human Ecology Project* (1982); and Anne Yentsch and Mary Baudry (eds.), *The Art and Mystery of Historical Archaeology* (1992) and John Cotter, et al., *The Buried Past* (1993) contain important chapters.

Among other studies that shed new light on the processes and dynamics of vernacular housing are Amos Rapoport, *House Form and Culture* (1969), Paul Oliver, "Vernacular Know-How" (1986) and *Dwellings* (1987), David Saile (ed.),

Architecture in Cultural Change (1984), and Paul Groth (ed.), *Vision, Culture, and Landscape* (1990). For another approach grounded in anthropology, the influence of structuralism, semiotics, and linguistic theory has been felt among vernacular housing scholars. Pulling provocative, appealing ideas from scholars such as Claude Lèvi-Strauss, Noam Chomsky, Dell Hymes, and Fernand Braudel, writers such as Henry Glassie have sought understandings of architectural forms and the origins of patterns through structural analysis and seeing houses in terms of generative grammars; for examples of this approach see Glassie, *Folk Housing in Middle Virginia* (1975). Such innovative writers as Reyner Banham in *Los Angeles* (1971) and Robert Venturi, et al., in *Learning from Las Vegas* (1977) are bringing to our attention interpretations of the roles buildings play as signs and symbols of deep meanings. The "hidden" dimensions of how people use and shape space and cultural traditions in body movement have been explored by Edward T. Hall in *The Silent Language* (1959) and *The Hidden Dimension* (1966), and Ray Birdwhistell in *Kinesics and Context* (1970). Other useful work in anthropology includes Robert Plant Armstrong's studies, such as *The Affecting Presence* (1971).

THE STUDY OF SURVIVALS IN VERNACULAR ARCHITECTURE

One thread that unites many works from the nineteenth century on is the theme of survivals. This idea was developed by the anthropological theorist Edward B. Tylor and incorporated into various positions that see culture as evolutionary. The concept may at first seem antiquated, but it remains valid. Certainly, countless features of housing are holdovers from earlier times and places, and these holdovers may or may not retain significance for people today. While changes occur, today's houses can be described and analyzed in terms of elements (forms, decoration, functional uses, linguistic elements, etc.) that may exhibit survivals through generations of use, experiment, and change.

Cultural survivals—the particular layout of a house, the conduct of a wedding ceremony, or the singing of traditional ballads—are most likely to be found in older, insular communities that have remained relatively intact. If vernacular architecture researchers often prefer studies of remote communities, it must be understood that very few, if any, American communities today can be proven to exist in isolation from American culture and media. For example, the stereotyped and misunderstood Native American family living many miles from a paved road or the nearest town is very likely to receive a half-dozen AM and FM radio stations if not dozens of television stations by virtue of a satellite dish receiver.

Why do things survive? Why do they last after their supposed original function changes or ends? Are they curiosities or souvenirs from earlier periods or other places? Consider the fireplace in the suburban house. Its original functions (cooking and heating) gone, the fireplace survives because a hearth has symbolic values for millions of people.

THE STUDY OF FUNCTION IN VERNACULAR ARCHITECTURE

At least as evocative as tracking surviving elements of old cultures is the study of function in art and architecture—how houses and their diverse elements function for the people who use them. Anthropologists have contributed much to this line of inquiry, including Franz Boas and William Bascom. No element of a cultural scene, such as housing, is completely without function or purpose for someone. If a historic house is later reconstructed at an outdoor museum and made into a stop on educational tours for contemporary visitors, its original function has changed. No longer the shelter for its family, the house now serves as an illustration of family life in the past and helps educate people as well as conserving the physical fabric of historic architectural forms and details, however well rebuilt.

No American architecture has a more pungent and mythological personality than the restored log cabin at museums and historic sites across the nation. Its functions may include its demonstration of historic architecture or of techniques in architectural conservation. But perhaps at least as important are the "restored" log cabin's psychological and social functions as a visible metaphor full of conflicting yet largely romantic messages for what we imagine to be historical truth. Study of function in architecture is rewarding and helps us connect the relic of the old building with the aesthetics and mental attitudes of contemporary people.

THE HISTORIC GEOGRAPHIC APPROACH

Also important and closely related to ideas of survivals and functions in the development of the study of vernacular housing is an approach called the historic-geographic method. Developed by mainly folklorists and linguists in the mid-nineteenth century, this approach is comparative and helps reconstruct the origins and diffusion of such things as house types. It stresses the dynamic ways in which cultural traits are transmitted and undergo transformations and innovations through time and across distances by being carried in people's minds and imaginations.

There are many other approaches to the study of vernacular housing, and many are demanding and disputed (as is every good method.) For example, some scholars look for psychoanalytical meanings in architecture and draw on works of Sigmund Freud and Carl Jung among others. We have seen the emergence of a number of innovative approaches to vernacular design in the past decade, yet the time-honored historic-geographic method remains an essential foundation for many of these more adventurous if not radical approaches.

VIEWS FROM HISTORY AND ART HISTORY

Many valuable studies have come from the perspective of art history. Some of the best works were produced in the early twentieth century by interested architects, some of whom sought legitimate examples of historic houses in the com-

munity from which to base reconstructions, restorations, and revivals; for example, Norman Isham and Albert Brown, *Early Connecticut Houses* (1900), Joseph Chandler, *An Architectural Monograph on Colonial Cottages* (1915) and Lemuel Hoadley Fowler's *Some Forgotten Farmhouses on Manhattan Island* (1923) (both in the legendary White Pine Series of Architectural Monographs), Fiske Kimball, *Domestic Architecture of the American Colonies and of the Early Republic* (1922), Frederick Kelly, *The Early Domestic Architecture of Connecticut* (1924), Rexford Newcomb, *Spanish Colonial Architecture in the United States* (1937), Thomas Waterman, *The Mansions of Virginia, 1706–1776* (1945), and Henry-Russell Hitchcock, *American Architectural Books* (1946). Many of these early studies center on high-style houses that are at the same time vernacular spaces. As the field of architectural history developed, there was a rather natural bias toward explication of the classic early communities of New England, the South, and the Hispanic Southwest.

Seminal early studies, often powerfully detailed in their description and historical frames, have been followed by recent studies paying attention to more specific scenes and topics in those regions, as well as basic studies of other regions of the nation. One of the most thorough treatments of a New England topic in recent years is Abbott Cummings's beautiful *The Framed Houses of Massachusetts Bay, 1625 to 1725* (1979).

Also notable among the more recent are some highly theoretical and some essentially ethnographic works, such as William Murtagh's "The Philadelphia Row House" (1957), George Kubler's *The Shape of Time* (1964), Christian Norberg-Schulz's *Intentions in Architecture* (1965), John Maas's *The Victorian Home in America* (1976), Bainbridge Bunting's *Houses of Boston's Back Bay* (1967) and *Early Architecture in New Mexico* (1972). Also see Boston University professor Richard Candee's "The Architecture of Maine's Settlement" (1976) and *Building Portsmouth* (1991), Paul Sprague's "The Origin of Balloon Framing" (1981), Gwendolyn Wright's *Building the Dream* (1981), and Beverly Spears, *American Adobes* (1986), Chris Wilson, "Pitched Roofs Over Flat" (1991), Fred Peterson, *Homes in the Heartland* (1992), and Pamela Scott and Antoinette Lee's *Buildings of the District of Columbia* (1993). Architect and architectural historian Thomas Hubka's *Big House, Little House, Back House, Barn* (1984), following his vigorous theoretical piece called "Just Folks Designing" (1979), is an outstanding analysis of the legendary connected farm buildings in New England communities.

It is unfortunate that most art historians, architects, and architectural historians tend to focus attention on high-style or academic design, because doing this they leave out vernacular houses. Delightful exceptions to this tendency are of course evident. For instance, working within a traditional department of the history of art at Yale, Jules Prown has written multidisciplinary and innovative essays, such as "Style as Evidence" (1980) and "Mind in Matter" (1988).

In the general frame of art historical scholarship are critical essays such as Lewis Mumford's classics, including his *Sticks and Stones* (1924, reprint 1955), Russell Lynes, *The Tastemakers* (1955), and architect Charles Moore's contributions to

Home Sweet Home (1983). Other works influenced by art history that usefully run against the grain include such piquant essays as Tom Wolfe's *From Bauhaus to Our House* (1981), a well-argued tirade against the excesses and mistakes of modern and contemporary high-style architecture and the severe, austere boxes of steel and glass of the International Style, developed in part by German designers such as Walter Gropius and Ludwig Mies van der Rohe. These modernist (and post-modernist) designers seemed to convince us that one could start from scratch, ignoring tradition and community-based aesthetic ideals. For a statement about the New Architecture from Gropius himself, see *The New Architecture and the Bauhaus* (1965) Chapter 7 of David Handlin's *American Architecture* (1985). California architect and builder Cliff May's reflections on the development of the suburban ranch-style house offers one of the scarce looks into the workings of modern housing in *Sunset Western Ranch Houses* (1950); for this general subject also see Robert Winter, *The California Bungalow* (1980), and Charles Moore, et al., *Home Sweet Home* (1983).

In the same category with Tom Wolfe is a study by a professional architect and his colleagues: Robert Venturi, et al., *Learning from Las Vegas* (1977) is one of the most interesting essays on commercial urban design and what is right and wrong with contemporary high-style architecture. Also helpful in sorting out the urban scene is Grady Clay's *Close-Up* (1980) and Kevin Lynch's fine *What Time Is This Place?* (1972). Another outstanding essay that holds the mirror up to architecture and shows it its flaws is Jane Jacobs's *The Death and Life of Great American Cities* (1969), a book useful in historic preservation discussions which criticizes the tax-supported "urban renewal" projects that damaged more than helped our inner cities through a series of projects of demolition and construction.

Several university art and architectural history programs have faculty who concentrate on vernacular design, including the University of California–Berkeley, the University of Utah, Iowa State University, the University of Wisconsin–Madison, the University of Missouri–Columbia, Indiana University, George Washington University, and Boston University. Among the few studies that helpfully address vernacular housing are the Ohio studies by Donald Hutslar and the Missouri studies by James Denny, such as his "A Transition of Style in Missouri's Antebellum Domestic Southern Architecture" (1984) and "The Georgian Cottage in Missouri" (1989).

Some historians and architectural historians focus on the many elements of the technology, much of it European-American, that undergirds the actual construction of American houses. Among the several excellent basic studies are Carl Bridenbaugh, *The Colonial Craftsman* (1950), Charles E. Peterson, "The Technology of Early American Building" (1969), Henry Chapman Mercer, *Ancient Carpenter's Tools* (1960), William Goodman, *The History of Woodworking Tools* (1966), Brooke Hindle, *Technology in Early America* (1966) and *America's Wooden Age* (1975), Charles Peterson (ed.), *Building Early America* (1976), John Fitchen, *Building Construction Before Mechanization* (1988), as well as the intricate, suggestive works of Siegfried Giedion. Leo Marx's *The Machine in the Garden* (1964) remains a classic

study of the relationship between technology and nature and is a basic work on the broad subject.

There are many excellent studies of discrete topics in the history of technology vis-à-vis vernacular housing. Sometimes they are discovered in difficult-to-find magazines or periodicals, but the search is worth the effort. A short list of studies of discrete topics includes Charles Peterson's "Early House-Warming by Coal-Fires" (1950), William Murtagh's "Half-Timbering in American Architecture" (1957–58), Peter Preiss's "Wire Nails in North America" (1973), and in a more broadly theoretical vein, Robert Thayer's essay, "Pragmatism in Paradise" (1990).

Attention is being paid to the role of women in vernacular housing. Toni Prawl's "The W. L. Cornett House, Linn County, Missouri" (1986) demonstrated the way two sisters shaped the final character of an important pioneer dwelling, and Sally McMurry's *Families and Farmhouses in Nineteenth Century America* (1988) is an important new study that includes examination of women's roles in housing and design. Also highly suggestive is Rebecca Bernstein and Carolyn Torma, "Exploring the Role of Women in the Creation of Vernacular Architecture" (1991), Katherine Jellison, *Entitled to Power* (1993), and Ellen Lupton, *Mechanical Brides* (1993).

Rarely studied subjects—such as big-city apartments and urban housing—are beginning to draw more attention. Following the excellent early article by William Murtagh, "The Philadelphia Row House" (1957), recent studies with suggestive interpretive thinking bring to our attention the overlooked themes of multifamily housing, domestic space, townhouses, and apartment living in urban areas. Among these are, for New York, Elizabeth Cromley, *Alone Together* (1990) and "A History of American Beds and Bedrooms" (1991), Judith Capen, "Vernacular Houses—The Washington Row House" (1993), and Elizabeth Hawes, *New York, New York* (1993); for San Francisco, Eric Sandweiss, "Building for Downtown Living" (1986); and for St. Louis, Eric Sandweiss, "Construction and Community in South St. Louis, 1850–1910" (1991), George McCue, et al., "Street Front Heritage" (1976), Richard Rosen, "Rethinking the Row House" (1992), and Shirley Maxwell and James Massey, "Rows and Rows of Row Houses" (1993).

Moreover, the suburb is beginning to be taken seriously as an ingredient in the cultural landscape. One helpful study is Catherine Bishir and Lawrence Earley (eds.), *Early Twentieth-Century Suburbs in North Carolina* (1985).

CULTURAL GEOGRAPHIC APPROACHES

Geographers have contributed much to the evolution of scholarly study of vernacular housing, and many contemporary scholars owe much of their work to the groundbreaking American studies of Fred Kniffen. His articles "Louisiana House Types" (1936) and "Folk Housing" (1965) brought forward the crucial importance of developing typologies for houses and tracing patterns (forms, via the floor plan of a house) across time and space, thereby seeking to understand origins, often in the Old World, of familiar or rare forms of housing across Amer-

ica. There is a great deal of fine work on domestic space in the writings of cultural geographers and environmentalists, such as David Lowenthal's insightful "The American Scene" (1968), Richard Francaviglia's "Mormon Central-Hall Houses in the American West" (1971), Pierce Lewis's "Common Houses, Cultural Spoor" (1975), John Fraser Hart's *The Look of the Land* (1975), Wilbur Zelinsky's survey of human dimensions of landscape, *The Cultural Geography of the United States* (1973), May Watts's *Reading the Landscape* (1975), James Shortridge's "Traditional Rural Houses Along the Missouri–Kansas Border" (1980), John Stilgoe's handsome *The Common Landscape of America, 1580–1845* (1982), and virtually everything one can find by the inspiring J. B. Jackson

Recent studies of huge scope, such as Terry Jordan and Matti Kaups, *The American Backwoods Frontier* (1989), are invigorating and valuable. Equally useful for their documentary detail are close studies of regional sets of houses and localized questions, such as John Morgan's *The Log House in East Tennessee* (1990) and Anne Mosher and D. W. Holdsworth, "The Making of Alley Housing in Industrial Towns" (1992). One article that, though dated, summarizes much of the geographer's modus operandi is E. Estyn Evans's "The Cultural Geographer and Folklife Research" (1972).

THE TEAM: DEETZ AND GLASSIE

Perhaps the most influential scholars and writers on the subject of American vernacular and folk housing are an archaeologist and a folklorist who concentrate on material culture—James Deetz and Henry Glassie. Deetz is a professor of anthropology at the University of California–Berkeley and has written immensely useful and popular essays explaining how to study and think of the material culture we discover as remnants (accidents of survival) from past times. Deetz's *Invitation to Archaeology* (1967) and *In Small Things Forgotten* (1977) are lovely if brief books that continue to inspire researchers as well as students. Henry Glassie is a folklorist and a professor at Indiana University's Folklore Institute. He has studied traditional housing in classic early works such as "The Types of the Southern Mountain Cabin" (1968) to theoretically challenging essays such as *Folk Housing in Middle Virginia* (1975b) to his poetically wrought *Passing the Time in Ballymenone* (1982) and his current studies in Turkey. While Deetz and Glassie are situated in departments of anthropology and folklore, respectively, a hallmark of their approaches is their appreciation of multidisciplinary thinking and their willingness to employ exciting theories and complex arguments from many different disciplinary angles. Glassie is indeed adroit at this important multidisciplinary turn, drawing inspiration as he does from such wide-ranging intellectuals who preceded him in thinking deeply about culture, art, and tradition as William Butler Yeats, Paul Klee, D. H. Lawrence, Franz Boas, Herbert Read, Geoffrey Chaucer, E. Estyn Evans, and William Morris.

Glassie's treatises are among the most stimulating works. To be sure, not all readers agree with Glassie's formulations and pronouncements. In *All Silver and*

No Brass (1975a), Glassie summarized the importance of Ruskin's and Morris's approach to art and design, calling it "the Romantic Argument":

The High Renaissance unleashed the slumbering violence of individualism which, as manifested in the rationalism of the eighteenth century and the materialism of the nineteenth, has separated . . . art from life, and sundered the arts into hidebound categories. The hope for mankind is to search for unity, harmony. Since the contemporary world has become so fragmented, harmony cannot be found on the surface of things but must be sought in the deep unseen where art and life are guided by the same laws. These timeless first principles of life and art can be located in the self by contemplation of the works bequeathed to us from a more integrated, pre-Renaissance period or by experiencing the life of people whose traditions put them in touch—if only in a disturbed, melancholy way— with that earlier, more perfect time.

Glassie's essays have set in place the principal themes for discussion of vernacular design across all disciplinary borders. Abandoning or putting in perspective the classic art history methods of analysis that force houses into high-style chronological periods and misleading categories such as "primitive," Glassie revolutionized the study of everyday houses by making us see that their vital essences are best studied through field research in specific community settings and then placing the forms (patterns) into broad frameworks based on geographic distribution and cultural/ethnic/religious context in time and space.

For Glassie, no theoretical approach can be ignored, and his studies often incorporate anthropological and linguistic analyses of building traditions. Like Morris, Glassie looks backward with respect to the great and almost entirely undocumented artisans of the medieval village, whether the builder of a thatched cottage or a high cathedral. Glassie believes that the Renaissance essentially broke design apart from everyday living and commonplace relevance, and, like Morris and Ruskin's circle, Glassie and his circle attempt to see culture and tradition from the inside out as richly inventive systems operating within otherwise strict conventions. Glassie's approaches are critical in bringing commonplace houses into the stream of academic research and classroom studies.

Glassie encourages us to see that the most significant elements in terms of the inner human meanings of, say, a log cabin is not that it is decorated on the surface with Carpenter Gothic or Greek Revival details, but in discovering through field research and comparative analysis that the typical American log cabin is an amalgam of essentially British Isles forms (floor plans) with German-speaking European technology (the use of the broad axe and horizontal hewn log walls). Such an approach humanizes and makes relevant to our lives everyday vernacular houses and landscapes—that is, the folk art—that represent the majority of American dwellings past and present. Among the best treatments of the nuances of the log cabin are Fred Kniffen and Henry Glassie, "Building in Wood in the Eastern United States" (1966), C. A. Weslager, *The Log Cabin in America* (1969), Alex Bealer, *The Log Cabin* (1978), Warren Roberts, *Log Buildings in Southern Indiana*

(1984) and "The Tools Used in Building Log Houses in Indiana" (1986), and Terry Jordan, *American Log Building* (1985).

Three of Henry Glassie's articles should be included among the basic works on American traditional housing: "Folk Art" (1972b), "Eighteenth-Century Cultural Process in Delaware Valley Folk Building" (1972a), and "Vernacular Architecture and Society" (1984). For completeness and authority, all studies of housing should include an awareness of Glassie's many writings; practically no issue in the study of American housing is not at least touched upon in this impressive corpus of work.

FOLKLORE AND FOLKLIFE STUDIES APPROACHES: THE GROWING EMPHASIS ON ETHNICITY

Among the recent studies by academics with training or substantial expertise in the techniques of folklore and folklife, or training in related fields such as American studies, are Charles Martin's excellent study of how people in an Appalachian regional culture conceive and construct traditional houses, *Hollybush* (1984), Thomas Carter's "Traditional Design in an Industrial Age" (1991), Bernard Herman's *Architecture and Rural Life in Central Delaware, 1700–1900* (1987), Robert St. George's "Artifacts of Regional Consciousness in the Connecticut River Valley, 1700–1780" (1985), Howard Marshall's *Folk Architecture in Little Dixie* (1981b) and *Paradise Valley, Nevada* (1995), Jessica Foy and Thomas Schlereth (eds.), *American Home Life 1880–1930* (1992) and the many prominent publications of John Michael Vlach and Dell Upton. All of these works owe debts to Henry Glassie's challenging writings if not directly to his teaching while at the University of Pennsylvania or Indiana University.

The most important work in terms of African-American traditional housing is that by folklorist John Michael Vlach of George Washington University whose article on the so-called shotgun house electrified scholars in this field and provided the basis for re-examination of the architectural heritage and ongoing influence of this important ethnic group. Preliminarily, one should see Vlach's "The Shotgun House" in Dell Upton and John Vlach (eds.), *Common Places* (1986), "Afro-American Housing in Virginia's Landscape of Slavery" (1991), and *Back of the Big House* (1993). Ellen Weiss offers a solid resource in *An Annotated Bibliography of African American Architects and Builders* (1993).

Also very useful are Peter Wood, "Whetting, Setting and Laying Timbers" (1980), George McDaniel, *Hearth and Home* (1982), Catherine Bishir, "Black Builders in Antebellum North Carolina" (1984), and Dell Upton, "White and Black Landscapes of Eighteenth-Century Virginia" (1985). Recent studies to explicate the dense topic of African-American vernacular architecture take a significant look at locality through field research, and some of these studies include Gregg Kimball, "African-Virginians and the Vernacular Building Tradition in Richmond City, 1790–1860" (1991), and Richard Mattson, "The Landscape of a Southern Black Community" (1992).

Beyond attention to Americans of African and Caribbean backgrounds, new attention is being drawn to the contributions of specific ethnic groups in the vastly complex and versatile material culture of the United States. While a great deal has been done over many decades in terms of British America and German-speaking America, such as Charles van Ravenswaay's monumental *The Arts and Architecture of German Settlements of Missouri* (1977) and Howard Marshall's close look at a rare bird, "The Pelster Housebarn" (1986), we have seen a growing interest in examining the vernacular architecture of other groups. One recent anthology is Allen Noble (ed.), *To Build in a New Land* (1992). Excellent works on Asians, particularly the Chinese, are Christopher Yip, "A Time for Bitter Strength" (1978), Christopher Salter, *San Francisco's Chinatown* (1978), and David Lai, "Cityscape of Old Chinatowns in North America" (1990). University of Missouri professor of rural sociology J. Sanford Rikoon's "The Reusser House" (1979) is a valuable study of Scandinavian influence, as is Kenneth Breisch and David Moore's "The Norwegian Rock Houses of Bosque County, Texas" (1986).

Other examples of scholarship on vernacular architecture among groups whose houses have infrequently been studied include a recent attempt to account for the role of immigrant Italian stone masons in the American West, Howard Marshall's *Paradise Valley, Nevada* (1995). New work is being done to document and explain the traditions of French-speaking Americans, and among the best studies are Jay Edwards, "Cultural Syncretism in the Louisiana Creole Cottage" (1980), Osmund Overby, "Architectural Treasures of Sainte Genevieve" (1985), and the ongoing work of C. Ray Brassieur, such as "The Duclos-Pashia House" (1990). Overall, Dell Upton (ed.), *America's Architectural Roots* (1987), is still the best single treatment of the difficult matter of the specific contributions of different ethnic groups. Furthermore, Upton, a professor in the Department of Architecture at the University of California–Berkeley, provides a succinctly useful overview of vernacular architecture research and approaches in "The Power of Things" (1985).

THE FIELD IS WIDE, THE TEXTBOOKS FEW

There is still no actual textbook for classes engaged in the study of vernacular housing. Two recent texts aimed at university classes in architectural history writ large offer good revised views of the subject. They are Dora Crouch, *History of Architecture: Stonehenge to Skyscrapers* (1985), and Spiro Kostof, *A History of Architecture: Settings and Rituals* (1985). Among the very good recent publications that provide us with a broad outline are William Pierson, *American Buildings and Their Architects* (1976), Virginia and Lee McAlester, *A Field Guide to American Houses* (1984), Clifford Clark, *The American Family Home 1800–1960* (1986), and, more geographically limited and scholarly, John Jakle, et al., *Common Houses in America's Small Towns* (1989). Perhaps the best and most compact treatments of American architecture are, together with Hugh Morrison's still important *Early American Architecture from the First Colonial Settlements to the National Period* (1952), are Marcus Whiffen, *American Architecture Since 1780* (1968, revised

1992), Carl Condit, *American Building* (1968), Leland Roth, *A Concise History of American Architecture* (1979), and David Handlin, *American Architecture* (1985).

Closest to being textbooks in vernacular housing courses are two that have been used by this writer in university classes, folklorist Henry Glassie's groundbreaking *Pattern in the Material Folk Culture of the Eastern United States* (1968, 1975) and Ronald Brunskill's *Illustrated Handbook of Vernacular Architecture* (1971, 1978). Also in this select group of books worthy of being texts, even if they are restricted in the geographic or human boundaries, are Alan Gowans's rather old but still very fine *Images of American Living* (1964), as well as W. G. Hoskins, *The Making of the English Landscape* (1970), James Deetz, *In Small Things Forgotten* (1977), and the many writings of landscape student J. B. Jackson. Chapter 5 in Deetz's 1977 book is an outstanding and succinct look at New England. Also an excellent introduction, although from the standpoint of looking at styles and interior features rather than pattern and distribution in the Glassie manner, is Jan Jennings and Herbert Gottfried, *American Vernacular Interior Architecture 1870– 1940* (1988).

One sensible approach to textbooks for vernacular housing classes is to use one or two of the excellent, diverse anthologies that have appeared in the past decade. These include all the anthologies produced by the Vernacular Architecture Forum, such as Camille Wells (ed.), *Perspectives in Vernacular Architecture* (1982), Dell Upton and John Michael Vlach (eds.), *Common Places* (1986), and a compact collection of clear topical essays that is used for this writer's undergraduate survey course, Dell Upton, *America's Architectural Roots* (1986). To this date, the handiest bibliographic sources remain Frank Roos, Jr., *Bibliography of Early American Architecture* (1968), Howard Marshall, *American Folk Architecture* (1981a), and Dell Upton, "Ordinary Buildings" (1981). For Great Britain, from whence came a good many of the ingredients in American vernacular housing, see Sir Robert DeZouche Hall (ed.), *A Bibliography on Vernacular Architecture* (1972). In addition, the American researcher may profit greatly from the outstanding and pacesetting works produced in Great Britain, such as Iorwerth Peate's pioneering study *The Welsh House* (1944), as well as everything written by Eurwyn Wiliam, Peter Smith, Ronald Brunskill, Maurice Barley, W. G. Hoskins, Raymond Wood-Jones, J. T. Smith, Eric Mercer, Richard Harris (for England and Wales), and, for Scotland and Ireland, Alexander Fenton, John Shaw, Alan Gailey, Philip Robinson, and the late E. Estyn Evans of Ulster.

Another good approach in teaching about vernacular design is the casebook method, which employs studies of specific communities or subjects as illustrations of theory and lecture material. Among good examples of case studies that offer precise description of local or regional scenes, with or without theoretical explorations, include various works by Henry Glassie, Warren Roberts, Ray Brassieur's "The Duclos-Pashia House" (1990), Edward Chappell's "Acculturation in the Shenandoah Valley" (1980), Michael Ann Williams's "Pride and Prejudice" (1990), well-turned graduate theses such as Toni Prawl's "The W. L. Cornett House, Linn County, Missouri" (1986), and Carol Grove's delineation of an im-

portant and little-studied Midwestern dwelling form, "The Foursquare House Type in American Vernacular Architecture" (1992). Also valuable as locality-based studies are art history studies such as Ernest Connally's *The Cape Cod House* (1960), Don Blair's *Harmonist Construction* (1964), about the town of New Harmony, Indiana, and Pamela Simpson and Royster Lyle, Jr.'s *The Architecture of Historic Lexington* (1977).

SURVEY OF SOURCES

The range of publications large and small, familiar and fugitive, that have useful articles and documentation of American housing is vast. The number of popular and academic writings appearing annually, from magazines to great footnoted tomes, cannot be counted.

Many publishers seek to cash in on the "roots" and family history fashion or on the historic preservation movement by putting out books that have nice pictures but poor if not damaging attempts at interpretation and analysis. Perhaps the best of these popularized books are those which simply present the houses with descriptions and avoid attempts to say something significant. One of these helpful books content with attractive presentation of the facts is Chicago newspaperman John Drury's *Historic Midwest Houses* (1967). Similarly, books that offer important glimpses of historic photographs are frequently very helpful, such as Sherry Kontner (comp.), *Vanishing Georgia* (1982).

Each state in the union has an official unit to attend to historic buildings and policy issues affecting historic buildings and sites. These are the state historic preservation offices, and most are located in the state capital as a section of the department of natural resources or the state's historical society. These agencies are supported in the main by tax dollars. This is where survey and inventory work is done and where buildings of historic, cultural, or architectural significance as well as archaeological significance are selected for the National Register of Historic Places. Though these are administrative offices, many states encourage the involvement of citizens in their work and will open their archives to interested researchers.

Likewise, state historical societies may be a good source of information on vernacular housing via their deep collections of archival materials, historic photographs, and ephemera as well as their publications. Some of these publications are printed in limited editions and go out of print far too soon; for example, see Eugene Wilson, *A Guide to Rural Houses in Alabama* (1975). Other historical society studies pay attention to vernacular housing, too; see, for example, Austin Fife, "Stone Houses of Northern Utah" (1972). Citizens groups produce excellent work as well, usually without major funding or notice of the big institutions. Phyllis Strawn's *King's Row Revisited* (1980) is a worthy if small booklet concerning a town's legacy, and Janet Bruce's *The John Wornall House, 1858* (c. 1982) is a full account of the life history and conservation of an important vernacular house in what is now urban Kansas City, Missouri. While these publications are difficult

to locate and may seem to the researcher to be of modest, even fleeting importance, they are a rich source of highly localized and therefore exceptionally important material. An organization seeking to assist local agencies with preservation and conservation, the American Association for State and Local History, routinely publishes valuable studies, such as Barbara Howe, et al., *Houses and Homes* (1987).

Popular magazines and daily newspapers often feature vernacular housing, usually in a desultory fashion. Most periodicals aimed at general audiences in the grocery store or mall are too glitzy and lack theoretical discussion or any inkling of scholarship. However, in the drugstore magazine rack one can find gems in magazines that try harder and do provide helpful essays; for example, Roy Bongartz, "Sainte Genevieve, Missouri" (1984), Gerald Ward, "Furnished Houses [Strawberry Banke Museum, NH]" (1992), and Wendell Garrett, "History in Houses—Dumbarton House in Georgetown, District of Columbia" (1993). Other magazines that routinely include helpful essays are some of the more serious of the popular titles such as *Scientific American*, *Natural History*, and *Smithsonian*.

Work through the lists of unpublished theses and dissertations in your local university library. Many excellent studies in this category do not for one reason or another reach formal published form, but they are richly rewarding sources of material and ideas. They are available on microfilm and can be acquired by interlibrary loan. One such example is a masters thesis in anthropology at the University of Texas in Austin, Paula Jane Johnson's "T Houses in Texas" (1981). The Society of Architectural Historians recently published *Bibliography of Doctoral Dissertations Relating to American Architectural History, 1897–1991*, compiled by James M. Goode.

One should also watch the newsstand for relevant articles in magazines and newspapers that normally would not feature architecture pieces. One such example is Philip Langdon's "The American House" (1984). Various encyclopedias and handbooks are sometimes a good source also. Among those appearing in recent years that contain essays on vernacular housing are Charles Wilson and William Ferris (eds.), *Encyclopedia of Southern Culture* (1989; see, for example, Edward Chappell's excellent essay, "Architects of Colonial Williamsburg").

Among the relevant sources and collections accessible to the general public are the following:

- American Association for Living Historical Farms and Agricultural Museums, c/o Dr. Terry Sharrar, Extractive Industries, National Museum of American History, Smithsonian Institution, Washington, DC 20560.
- American Association for State and Local History, Nashville, TN 37219.
- The American Institute of Architects, Washington, DC 20006.
- Archive of Folk Culture, Library of Congress, Washington, DC 20540.
- Early American Industries Association, c/o Daniel Reibel, Old Economy, Ambridge, PA 15003.

- Historic American Buildings Survey, National Park Service, Department of Interior, Washington, DC 20013.

- Historic American Engineering Record, National Park Service, Department of Interior, Washington, DC 20013.

- National Museum of American History, Smithsonian Institution, Washington, DC 20560.

- Pioneer America Society, c/o Frank Ainsley, Department of Earth Science, University of North Carolina, Wilmington, NC 28403.

- Prints and Photographs Division, Library of Congress, c/o C. Ford Peatross, Curator, Prints and Photographs Division, Library of Congress, Washington, DC 20540. This is the nation's storehouse, containing, among other collections, the documentation of the Historic American Buildings Survey, the Farm Security Administration photographs from the 1930s, and the American Folklife Center.

- National Trust for Historic Preservation, 1785 Massachusetts Ave. NW, Washington, DC 22236. This is the more or less official body in charge of telling Americans about trends and techniques in preservation activity. Still habitually elitist, the trust has upon occasion been interested in issues in rural preservation, the rejuvenation of small towns (through their "Main Street" programs), and vernacular buildings. Among their products are Harley McKee's excellent *Introduction to Early American Masonry* (1977), Steven Phillips's *Old-House Dictionary* (1992), Catherine Cole Stevenson and H. Ward Jandl's informative look at the business and culture of prefabrication, *Houses by Mail* (1986), and Dell Upton's *America's Architectural Roots* (1986).

- Society for the History of Technology, Department of Social Science, Houghton, MI 49931–1295.

The growth of outdoor museums is an important development in our understanding of housing in America. Many of these new museums attempt to conserve and reconstruct vernacular houses rather than simply the grand mansions of the elite or the famous. Thus, house museums and large outdoor history museums are an important source of information and interpretation of the history of American housing. Among the museums where accurate and well-researched "living history" is bringing new interpretations to life in the past are:

Plimouth Plantation; Old Sturbridge Village (Massachusetts)

The Farmer's Museum; Old Bethpage Village (New York)

Colonial Pennsylvania Plantation; Quiet Valley Living Historical Farm; Pennsylvania Farm Museum; Ephrata Cloister (Pennsylvania)

Museum of American Frontier Culture; Colonial Williamsburg; Turkey Run Farm (Virginia)

Strawberry Banke Museum (New Hampshire)

Shelburne Museum (Vermont)

National Colonial Farm; St. Mary's City (Maryland)

Hagley Museum (Delaware)

Old Salem (North Carolina)

Shakertown (Kentucky)

Georgia Agrirama; Old Westville (Georgia)

Greenfield Village and Henry Ford Museum (Michigan)

Gibbs Farm Museum (Minnesota)

Old World Wisconsin (Wisconsin)

Conner Prairie Pioneer Settlement (Indiana)

Ohio State Historical Society (Ohio)

Bishop Hill; John Deere Birthplace Museum; Clayville Rural Life Center (Illinois)

Vesterheim; Iowa Living History Farms (Iowa)

Missouri Town 1855; St. Louis County Parks and Recreation Department (Missouri)

Stuhr Museum of the Prairie Pioneer (Nebraska)

White House Ranch (Colorado)

Grant-Kohrs Ranch (Montana)

Winedale Historical Center; Institute of Texan Cultures (Texas)

Ronald V. Jensen Living Historical Farm (Utah)

Old Cienaga Village Museum; the Museum of International Folk Art (New Mexico)

Pioneer Arizona (Arizona)

Pioneer Museum and Haggin Galleries (California)

Bybee-Howell House and Pioneer Orchard (Oregon)

Kipahula Living Farm (Hawaii)

Many theme parks are operated by state agencies as well as private corporations and are devised purely for recreation and tourism. They present fabricated cultural history for the visitor—reconstructed or recreated historic houses that may or may not be based on valid scholarship and localized architectural research. Thus, Rocky Mountain–style log cabins are put in parks in the Appalachians and New England–style Colonial houses are put in a theme park in the South. These pervasive theme parks, as well as the countless local "historic house museums," are becoming increasingly important interpreters of authentic American culture for visitors from around the globe, so it is increasingly important that careful research be accomplished in order that these popular representations of the past be as accurate and correct as possible.

A number of specialized historical agencies and libraries have important collections pertaining to housing. These include the Society for the Preservation of New England Antiquities (Boston), Winterthur Museums and Gardens (Delaware), American Institute of Architects (Philadelphia), Colonial Williamsburg Foundation (Virginia), Western Historical Manuscripts Collection (Columbia, Missouri), and various federal agencies mentioned elsewhere.

Like the Smithsonian Institution's folklife programs and other units, the Library of Congress's American Folklife Center often produces reports on its field research projects, and these routinely contain information on housing. See for example, Lyntha Eiler, et al. (eds.), *Blue Ridge Harvest* (1981). Perhaps the most widely

known of the federal agency reports are those issued as part of the Historic American Buildings Survey (HABS) of the National Park Service.

Upon occasion, the HABS office, as well as its sister agency, the Historic American Engineering Record, publishes documentation of surveys of historic buildings and sites in particular states. Among these useful documentary resources are Virginia Historic Landmarks Foundation, *Virginia Catalog* (1976); Thomas Slade (ed.), *Historic American Buildings Survey in Indiana* (1983); Osmund Overby, *Historic American Buildings Survey Chicago Vicinity* (1962), *Historic Architecture of the Virgin Islands* (1966), *The Robie House, Frank Lloyd Wright* (1968), and *Historic American Buildings Survey Rhode Island Catalog* (1972); and Donald Sackheim (comp.), *Historic American Engineering Record Catalog 1976* (1976).

In addition, research conducted to document historic buildings as national parks and recreation areas are developed are sometimes issued, such as Robert Madden and T. Russell Jones, *Mountain Home* (1977); some of these reports can serve as planning documents as well as architectural and cultural materials documentation, such as Eiler, et al., (eds.), *Blue Ridge Harvest* (1981), and National Park Service (comp.), *Acadian Culture in Maine* (1992). Other units of the National Park Service that issue valuable publications and documentation include the Cultural Resources Management offices, and their periodical *CRM* is very useful. One cannot overemphasize the vital roles that federal agencies play in the study, interpretation, and conservation of the nation's storehouse of historic buildings and landscapes.

The American Institute of Architects, through its regional and local chapters, often sponsors publication of guides to significant buildings in specific areas. Although many of these guides center on high-style architecture and well-known architects, they often do contain valuable and detailed information on vernacular houses. One recent example is Gerald Sams (ed.), *AIA Guide to the Architecture of Atlanta* (1992).

The Society of Architectural Historians (SAH), through its journal, annual conferences, and publications, is a tremendously important resource. Recently, the SAH has embarked on a major project to develop a new book series describing the historic buildings in each state. Called "The Buildings of the United States," the series is edited by professor Osmund Overby of the University of Missouri. Among the first books to see publication in this important new series are David Gebhard and Gerald Mansheim's *Buildings of Iowa* (1992) and Kathryn Eckert's *Buildings of Michigan* (1992). State sponsorship often helps bring architectural surveys to publication, for example, Paul Touart's *Somerset: An Architectural History* (1990).

In addition, more standard museums of art and history occasionally mount important exhibitions that educate visitors about vernacular architecture. Ordinarily linked to the museums' collections or regions, these exhibitions often include catalogues with analytical essays. Among these are Howard Marshall and Richard Ahlborn's *Buckaroos in Paradise* (1980, reprint 1981), which accompanied a joint Library of Congress–Smithsonian exhibition, and Signe Betsinger's *Danish*

Immigrant Houses (1986), published to augment an exhibition at the University of Minnesota's Goldstein Gallery.

Both major and minor museums contain collections of art and decorative arts important in understanding vernacular housing. For examples of publications illuminating the interiors of houses and the fascinating area of folk art depictions of buildings and domestic life, see Beatrix Rumford, *The Abby Aldrich Rockefeller Folk Art Collection* (1975), Rodris Roth, *Floor Coverings in 18th Century America* (1967), and Deborah Federhen, et al., *Accumulation and Display* (1986), and for current thinking on interpreting interiors, Camille Wells, "Interior Designs" (1993). The changes that take place in a community via the usual forces of loss often mean that the physical artifacts have disappeared, leaving behind old photographs, newspaper articles, and memories. Many folk artists paint their own neighborhoods, houses, gardens, and other aspects of personal and family space. One excellent example of an instance where the folk artist has produced an invaluable pictorial narrative of a vanished cultural landscape is the work of Marijana Grisnik, who grew up in the Croatian-American neighborhood of Kansas City and saw it demolished by urban renewal projects and highway construction. Her paintings are vivid narratives as well as pictorial records of the past; see the catalog by Jennie Chinn (ed.), *Images of Strawberry Hill* (1985).

The historic preservation movement has begun paying attention to the vernacular landscape and many ordinary houses in need of study and interpretation. Although it is still rather an elitist movement in the United States, certain organizations are stimulating attention to the nearby commonplace house. Among these organizations are the Association for Preservation Technology, the Society for the History of Technology, and the American Association for State and Local History. All these produce newsletters and various publications helpful to the local community. For example, Donald Hutslar's booklet on specific techniques involved in proper reconstruction of log houses is only one contribution to a good series produced by the American Association for State and Local History aimed at local historical agencies and historic preservation practitioners.

One significant development in recent years is the cultural conservation movement, an effort by many scholars and public agency professionals to bring attention and preservation to bear on intangible cultural resources as well as tangible ones and to include folk culture as well as well-recognized elite culture. Two publications produced by the American Folklife Center of the Library of Congress (the leading federal agency in this field) that demonstrate this important trend and are guiding federal policies of preservation are Mary Hufford's *One Space, Many Places* (1986) and Thomas Carter and Carl Fleischhauer's *The Grouse Creek Cultural Survey* (1988). The basic reference is Ormond Loomis (comp.), *Cultural Conservation* (1983). Most importantly, folklife and localized traditions are beginning to be incorporated into preservation projects and programs involving federal funding and agencies such as the National Park Service. Closely related to these in spirit and also published by a leading federal agency is Robert Stipe (ed.), *New Directions in Rural Preservation* (1980).

REFERENCES

BOOKS AND ARTICLES

While our emphasis here is on American housing and culture, it is important to have a strong grounding in the heritage of building in "the old country" from whence Americans, and their longstanding preferences and traditions in architecture, derive. Thus, this checklist contains references to building elsewhere, but particularly to the British Isles.

Allen, Lewis F. (1860). *Rural architecture: Being a complete description of farm houses, cottages, and out buildings.* New York: Saxton.

Ames, Kenneth M., (Fall 1992). Doria F. Raetz, Stephen Hamilton, and Christine McAfee. Household archaeology of a southern northwest coast plank house. *Journal of Field Archaeology* 19(3): 275–290.

Armstrong, Robert Plant. (1971). *The affecting presence: An essay in humanistic anthropology.* Urbana: University of Illinois Press.

Banham, Reyner. (1971). *Los Angeles: The architecture of the four ecologies.* Harmondsworth: Penguin Books.

Barley, Maurice W. (1961). *The English farmhouse and cottage.* London: Routledge and Kegan Paul.

Bealer, Alex W. (1978). *The log cabin: Homes of the North American wilderness.* Barre, MA: Barre Publications.

Benjamin, Asher. [1797] (1972). *The country builder's assistant.* Reprint. New York: Da Capo Press.

———. [1830] (1972). *The practical house carpenter.* Reprint. New York: Da Capo Press.

Bernstein, Rebecca Sample, and Carolyn Torma. (1991). Exploring the role of women in the creation of vernacular architecture. In Thomas Carter and Bernard L. Herman (eds.), *Perspectives in vernacular architecture, IV* (pp. 63–72). Columbia: University of Missouri Press.

Betsinger, Signe T. Nielsen. (1986). *Danish immigrant houses: Glimpses from southwestern Minnesota.* Minneapolis: University of Minnesota, Goldstein Gallery.

Biddle, Owen. (1805). *The young carpenter's assistant.* Philadelphia: B. Johnson.

Birdwhistell, Ray L. (1970). *Kinesics and Context: Essays on Body Motion Communication.* Philadelphia: University of Pennsylvania Press.

Bishir, Catherine W. (1984). Black builders in antebellum North Carolina. *North Carolina Historical Review* 49: 423–61.

Bishir, Catherine W., C. Brown, C. Lounsbury, and E. Wood III. (1990). *Architects and builders in North Carolina: A history of the practice of building.* Chapel Hill: University of North Carolina Press.

Bishir, Catherine W., and Lawrence S. Earley (eds.). (1985). *Early twentieth-century suburbs in North Carolina.* Raleigh: North Carolina Department of Cultural Resources.

Blair, Don. (1964). *Harmonist Construction.* Indianapolis: Indiana Historical Society Publications.

Blumenson, John G. (1977). *Identifying American architecture: A pictorial guide to styles and terms, 1600–1945.* Nashville: American Association for State and Local History.

Bongartz, Roy. (October 1984). Sainte Genevieve, Missouri. *Early American Life* 15 (5): 44–47, 82–83.

Brassieur, C. Ray. (1990). The Duclos-Pashia house: Survival of Creole building traditions in the twentieth century. *Material Culture* 22 (2): 15–25.

Breisch, Kenneth A., and David Moore. (1986). The Norwegian rock houses of Bosque County, Texas: Some observations on a nineteenth-century vernacular building type. In Camille Wells (ed.), *Perspectives in vernacular architecture II* (pp. 64–71). Columbia: University of Missouri Press.

Bridenbaugh, Carl. (1950). *The Colonial craftsman.* New York: New York University Press.

Briggs, Martin S. (1925). *A history of the building crafts.* Oxford: Clarendon Press.

———. (1959). *Everyman's concise encyclopaedia of architecture.* London: J.M. Dent.

Bronner, Simon J. (1979). Concepts in the study of material aspects of American folk culture. *Folklore Forum* 12: 133–72.

———. (1983). Manner books and suburban houses: The structure of tradition and aesthetics. *Winterthur Portfolio* 18: 61–68.

———(ed.). (1985). *American material culture and folklife* (pp. 47–62). Ann Arbor, MI: UMI Research Press.

Bruce, Janet. (c. 1982). *The John Wornall House, 1858: The history and restoration of Kansas City's historic Wornall House Museum.* Kansas City: Jackson County Historical Society.

Brunskill, Ronald W. (1971; rev. ed. 1978). *Illustrated handbook of vernacular architecture.* New York: Universe Books.

———. (1982a). *Houses.* New York: Humanities Press.

———. (1982b). *Traditional buildings of Britain.* London: Victor Gollancz.

Brunskill, Ronald W., et al. (1964). *Taos adobes: Spanish Colonial and territorial architecture of the Taos Valley of New Mexico.* Albuquerque: University of New Mexico Press.

Bunting, Bainbridge. (1967). *Houses of Boston's Back Bay: An architectural history, 1840–1917.* Cambridge, MA: Belknap Press.

———. (1976). *Early architecture in New Mexico.* Albuquerque: University of New Mexico Press.

Burns, John A. (ed.). (1989). *Recording historic structures.* Washington: American Institute of Architects Press.

Candee, Richard M. (1976). The architecture of Maine's settlement: Vernacular architecture to about 1720. In Deborah Thompson (ed.), *Maine forms of American architecture* (pp. 15–44). Camden: Down East Magazine.

———. (1991). *Building Portsmouth: The neighborhood and architecture of New Hampshire's oldest city.* Portsmouth: Portsmouth Advocates.

Capen, Judith. (March–April 1993). Vernacular houses—The Washington row house. *Old-House Journal* 21 (2): 100.

Carson, Cary. (1978). Doing history with material culture. In Ian Quimby (ed.), *Material culture and the study of American life* (op. cit.) (pp. 41–64).

Carson, Cary, N. Barka, W. Kelso, G. Stone, and D. Upton. (summer, autumn, 1981). Impermanent architecture in the southern American colonies. *Winterthur Portfolio* 16 (2–3): 135–96.

Carter, Thomas R. (fall 1991). Traditional design in an industrial age: Vernacular domestic architecture in Utah. *Journal of American Folklore* 104 (414): 419–42.

Carter, Thomas R., and Carl Fleischhauer. (1988). *The Grouse Creek cultural survey: Inte-*

grating folklife and historic preservation field research. No. 13. Washington: American Folklife Center.

Carter, Thomas R., and Bernard L. Herman (eds.). (1989). *Perspectives in vernacular architecture III.* Columbia: University of Missouri Press.

———(eds.). *Perspectives in vernacular architecture IV.* (1991). Columbia: University of Missouri Press.

Chandler, Joseph E. (1915). *An architectural monograph on Colonial cottages.* White Pine Series of Architectural Monographs, 1. St. Paul, MN: White Pine Bureau.

Chappell, Edward A. (1980). Acculturation in the Shenandoah Valley: Rhenish houses in the Massanutten settlement. *Proceedings of the American Philosophical Society* 124 (1): 55–89.

———. (1989). Architects of Colonial Williamsburg. In Charles Reagan Wilson and William Ferris (eds.), *Encyclopedia of Southern culture* (pp. 59–61). Chapel Hill: University of North Carolina Press.

Chinn, Jennie A. (ed.). (1985). *Images of Strawberry Hill: Works by Marijana.* Topeka: Kansas State Historical Society.

Clark, Clifford E., Jr. (1986). *The American family home 1800–1960.* Chapel Hill: University of North Carolina Press.

Clay, Grady. (1980). *Close-up: How to read the American city.* Chicago: University of Chicago Press.

Cleaveland, Henry W., William Backus, and Samuel D. Backus. (1856). *Village and farm cottages: The requirements of American village homes considered and suggested.* New York: D. Appleton.

Condit, Carl W. (1968). *American building.* Chicago: University of Chicago Press.

Connally, Ernest Allen. (May 1960). *The Cape Cod house: An introductory study.* Reprint from *Journal of the Society of Architectural Historians* 19 (2): 45–76.

Cotter, John L., Daniel G. Roberts, and Michael Parrington. (1993). *The buried past: An archaeological history of Philadelphia.* Philadelphia: University of Pennsylvania Press.

Cromley, Elizabeth Collins. (1990). *Alone together: A history of New York's early apartments.* Ithaca: Cornell University Press.

———. (1991). A history of American beds and bedrooms. In T. Carter and B. Herman (eds.), *Perspectives in vernacular architecture IV* (op. cit.) (pp. 177–86).

Crouch, Dora P. (1985). *History of architecture: Stonehenge to skyscrapers.* New York: McGraw-Hill.

Cummings, Abbott Lowell. (1979). *The framed houses of Massachusetts Bay, 1625 to 1725.* Cambridge: Harvard University Press.

Deetz, James. (1967). *Invitation to archaeology.* New York: Natural History Press.

———. (1977). *In small things forgotten: The archaeology of early American life.* Garden City, NY: Anchor Books.

Denny, James M. (1984). A transition of style in Missouri's antebellum domestic southern architecture. *P.A.S.T.: Pioneer America Society Transactions* 7: 1–11.

———. (1989). The Georgian cottage in Missouri: An obscure but persistent alternative to the I-house in the upper south. *P.A.S.T.: Pioneer America Society Transactions* 12: 63–70.

Downing, Andrew Jackson. [1842] (1967). *Cottage residences, rural architecture and landscape gardening.* New York: Putnam. Reprinted. Watkins Glen, NY: Library of Victorian Culture.

———. [1850] (1969). *The architecture of country houses*. New York: D. Appleton. Reprinted. New York: Dover Publications.

Drury, John. (1967). *Historic Midwest houses*. New York: Bonanza Books.

Eastlake, Charles L. [1872] (1979). *A history of the Greek Revival*. 1872. Reprinted. Watkins Glen, NY: American Life Foundation.

Eckert, Kathryn Bishop. (1992). *Buildings of Michigan*. New York: Oxford University Press and Society of Architectural Historians.

Edwards, Jay D. (1980). Cultural syncretism in the Louisiana Creole cottage. *Louisiana Folklore Miscellany* 4: 9–40.

Eiler, Lyntha Scott, Terry Eiler, and Carl Fleischhauer (eds.). (1981). *Blue Ridge harvest: A region's folklife in photographs*. Washington, DC: Library of Congress, American Folklife Center.

Evans, E. Estyn. (1972). The cultural geographer and folklife research. In Richard M. Dorson (ed.), *Folklore and folklife: An introduction* (pp. 517–34). Chicago: University of Chicago Press.

Federhen, Deborah Ann, B. Brooks, L. Brockebank, K. Ames, and E. McKinstry. (1986). *Accumulation and display: Mass marketing household goods in America 1880–1920*. Winterthur, DE: Winterthur Museum.

Fenton, Alexander. (1977). *Scottish country life*. 2d ed. Edinburgh: John Donald.

———. (1981). *The hearth in Scotland*. Edinburgh: National Museum of Antiquities of Scotland.

Fenton, Alexander, and Bruce Walker. (1981). *The rural architecture of Scotland*. Edinburgh: John Donald.

Fife, Austin E. (Winter 1972). Stone houses of northern Utah. *Utah Historical Quarterly* 40 (1): 6–23.

Fitch, James Marston. (1973). *American building 1: The historical forces that shaped it*. New York: Schocken Books.

———. (1976). *American building 2: The environmental forces that shape it*. New York: Schocken Books.

Fitchen, John. (1988). *Building construction before mechanization*. Cambridge, MA: M.I.T. Press.

Fontana, Bernard L., et al. (October–December 1962). Johnny Ward's ranch: A study in historic archaeology." *The Kiva* 28 (1–2): 1–115.

Forman, Henry Chandlee. (1948). *The architecture of the Old South: The medieval style*. Cambridge, MA: Harvard University Press.

Fowler, Catherine S. (1990). *Tule technology: Northern Paiute uses of marsh resources in western Nevada*. Smithsonian Folklife Studies No. 6. Washington, DC: Smithsonian.

Fowler, Lemuel Hoadley. (1923). *Some forgotten farmhouses on Manhattan Island*. White Pine Series of Architectural Monographs 9 (1). St. Paul, MN: White Pine Bureau.

Foy, Jessica H., and Thomas J. Schlereth (eds.). (1992). *American home life 1880–1930: A social history of spaces and services*. Knoxville: University of Tennessee Press.

Francaviglia, Richard V. (1971). Mormon central-hall houses in the American West. *Annals of the Association of American Geographers* 61: 65–71.

Gailey, Alan. (1984). *Rural houses of the north of Ireland*. Edinburgh: John Donald.

Garrett, Wendell. (January 1993). History in houses—Dumbarton House in Georgetown, District of Columbia. *Antiques* 143 (1): 154–61.

Garvin, James L. (1981). The mail-order house plan and American vernacular architecture. *Winterthur Portfolio* 16 (4).

Gebhard, David, and Gerald C. Mansheim. (1992). *Buildings of Iowa.* New York: Oxford University Press and Society of Architectural Historians.

Giedion, Siegfried. (1948). *Mechanization takes command: A contribution to anonymous history.* New York: W.W. Norton.

———. (1967). *Space, time, and architecture.* Cambridge: Cambridge University Press.

Gilbert, Herbert. (1984). *The dream of the factory-made house.* Cambridge, MA: M.I.T. Press.

Glassie, Henry. [1968] (1975). *Pattern in the material folk culture of the eastern United States.* Philadelphia: University of Pennsylvania Press.

———. (Winter 1968). The central chimney continental log house. *Pennsylvania Folklife* 18 (2): 32–39.

———. (1968). The types of the southern mountain cabin. In Jan Harold Brunvand (ed.), *The study of American folklore* (pp. 338–70). New York: W.W. Norton.

———. (1972a). Eighteenth-century cultural process in Delaware Valley folk building. *Winterthur Portfolio* 7: 6–57. Reprinted in Dell Upton and J. Vlach (eds.), *Common places: Readings in vernacular architecture* (pp. 394–425). Athens: University of Georgia Press.

———. (1972b). Folk Art. In Richard M. Dorson (ed.), *Folklore and folklife: An introduction* (pp. 253–80). Chicago: University of Chicago Press.

———. (1975a). *All silver and no brass: An Irish Christmas mumming.* Bloomington: Indiana University Press.

———. (1975b). *Folk housing in middle Virginia: A structural analysis of the historic artifact.* Knoxville: University of Tennessee Press.

———. (1982). *Passing the time in Ballymenone: Culture and history in an Ulster community.* Philadelphia: University of Pennsylvania Press.

———. (Spring 1984). Vernacular architecture and society. *Material Culture* 16 (1): 5–24.

———. (1989). *The spirit of folk art.* New York: Harry N. Abrams.

Goode, James M. (comp.). (1992). *Bibliography of doctoral dissertations relating to American architectural history, 1897–1991.* Philadelphia: Society for Architectural Historians.

Goodman, William L. (1966). *The history of woodworking tools.* New York: D. McKay.

Gowans, Alan. (1964). *Images of American living: Four centuries of architecture and furniture as cultural expression.* Philadelphia: Lippincott.

———. (1986). *The comfortable house: North American suburban architecture 1890–1930.* Cambridge, MA: M.I.T. Press.

Gropius, Walter. (1965). *The new architecture and the Bauhaus.* Cambridge, MA: M.I.T. Press.

Groth, Paul (ed.). (1990). *Vision, culture, and landscape.* Berkeley, CA: University of California Department of Landscape Architecture.

Grove, Carol Edwards. (1992). The foursquare house type in American vernacular architecture. Masters thesis. University of Missouri, Columbia.

Hall, Edward T. (1959). *The silent language.* New York: Fawcett.

———. (1966). *The hidden dimension.* New York: Doubleday.

Hall, Robert DeZouche (ed.). (1972). *A bibliography on vernacular architecture.* Newton Abbot: David and Charles.

Hamlin, Talbot. (1944). *Greek Revival architecture in America.* New York: Oxford University Press.

Handlin, David P. (1985). *American architecture.* New York: Thames and Hudson.

Harris, Richard. (1989). The grammar of carpentry. *Vernacular Architecture* 20: 1–8.

Hart, John Fraser. (1975). *The look of the land.* Englewood Cliffs, NJ: Prentice-Hall.

Harvey, Nigel. (1970). *A history of farm buildings in England and Wales.* Newton Abbot: David and Charles.

Harvey, Thomas. (1981). Mail-order architecture in the twenties. *Landscape* 25 (3): 1–9.

Hawes, Elizabeth. (1993). *New York, New York: How the apartment house transformed the life of the city (1869–1930).* New York: Knopf.

Herman, Bernard L. (1987). *Architecture and rural life in central Delaware, 1700–1900.* Knoxville: University of Tennessee Press.

Hindle, Brooke. (1966). *Technology in early America.* Chapel Hill: University of North Carolina Press.

———(ed.). (1975). *America's wooden age: Aspects of its early technology.* Tarrytown, NY: Sleepy Hollow Restorations.

Hitchcock, Henry-Russell. (1946). *American architectural books: A list of books, portfolios, and pamphlets on architecture and related subjects published before 1895.* Minneapolis: University of Minnesota Press.

Hood, Graham. (1991). *The Governor's Palace in Williamsburg: A cultural study.* Chapel Hill: University of North Carolina Press.

Hoskins, W. G. (November 1953). The rebuilding of rural England, 1570–1640. *Past and Present* 4: 44–89.

———. (1970). *The making of the English landscape.* London: Pelican Books.

Hosley, William N., Jr., and Gerald W. R. Ward (eds.). (1985). *The Great River: Art and society of the Connecticut Valley, 1635–1820.* Hartford: Wadsworth Athenaeum.

Howe, Barbara J., D. Fleming, E. Kemp, and R. Overbeck. (1987). *Houses and homes: Exploring their history.* Nashville: American Association for State and Local History.

Hubka, Thomas. (1984). *Big house, little house, back house, barn.* Hanover, NH: University Press of New England.

———. (February 1979). Just folks designing: Vernacular designers and the generation of form. *Journal of Architectural Education* 32 (3): 27–29.

Hufford, Mary. (1986). *One space, many places: Folklife and land use in New Jersey's Pinelands National Reserve.* Washington, DC: American Folklife Center, Library of Congress.

Hutslar, Donald A. (1974). *Log cabin restoration.* Nashville, TN: American Association for State and Local History.

———. (1986). *The architecture of migration: Log construction in the Ohio country.* Columbus: Ohio Historical Society.

———. (1992). *Log construction of the Ohio country, 1750–1850.* Columbus: Ohio University Press.

Isham, Norman M., and Albert F. Brown. [1900] (1965). *Early Connecticut houses: An historical and architectural study.* New York. Reprinted. New York: Dover Publications.

Jackson, J. B. (1970). The public landscape. In Ervin H. Zube (ed.), *Landscapes: Selected writings of J. B. Jackson.* Amherst: University of Massachusetts Press.

———. (1972). *American space: The centennial years 1865–1876.* New York: W.W. Norton.

———. (1980). *On the necessity for ruins, and other topics.* Amherst: University of Massachusetts Press.

———. (1984). *Discovering the vernacular landscape.* New Haven: Yale University Press.

Jacobs, Jane. (1969). *The death and life of great American cities.* New York: Modern Library.

Jakle, John A., Robert W. Bastian, and Douglas K. Meyer. (1989). *Common houses in America's small towns: The Atlantic Seaboard to the Mississippi Valley.* Athens: University of Georgia Press.

Jandl, H. Ward (ed.). (1983). *The technology of historic American buildings.* Washington: Association for Preservation Technology.

Jellison, Katherine. (1993). *Entitled to power: Farm women and technology, 1913–1963.* Chapel Hill: University of North Carolina Press.

Jenkins, J. Geraint (ed.). (1969). *Studies in folk life: Essays in honour of Iorwerth C. Peate.* London: Routledge and Kegan Paul.

Jennings, Jan, and Herbert Gottfried. (1988). *American vernacular interior architecture 1870–1940.* New York: Van Nostrand Reinhold.

Johnson, Paula Jane. (1981). T houses in Texas: Suiting plain people's needs. Masters thesis. University of Texas, Austin.

Jordan, Terry. (1985). *American log building: An Old World heritage.* Chapel Hill: University of North Carolina Press.

Jordan, Terry, and Matti Kaups. (1989). *The American backwoods frontier: An ethnic and ecological interpretation.* Baltimore: Johns Hopkins University Press.

Kelly, Burnam. (1951). *The prefabrication of houses.* Cambridge, MA: Technology Press.

Kelly, J. Frederick. (1924). *The early domestic architecture of Connecticut.* New Haven: Yale University Press.

Kimball, Fiske. (1922). *Domestic architecture of the American colonies and of the early Republic.* New York: Scribner's.

Kimball, Gregg D. (1991). African-Virginians and the vernacular building tradition in Richmond City, 1790–1860. In T. Carter and B. Herman (eds.), *Perspectives in vernacular architecture IV* (op. cit.) (pp. 108–20).

Kniffen, Fred. (1936). Louisiana house types. *Annals of the Association of American Geographers* 26: 179–93.

———. (1986). Folk housing: Key to diffusion. In D. Upton and J. Vlach (eds.), *Common places* (op. cit.) (pp. 3–26).

Kniffen, Fred, and Henry Glassie. (1966). Building in wood in the eastern United States: A time-place perspective. In D. Upton and J. Vlach (eds.), *Common places* (op. cit.) (pp. 159–81).

Kontner, Sherry (comp.). (1982). *Vanishing Georgia.* Athens: University of Georgia Press.

Koop, Michael, and S. Ludwig. (1984). *German-Russian folk architecture in south eastern South Dakota.* Vermillion, SD: State Historical Preservation Center.

Kostof, Spiro. (1985). *A history of architecture: Settings and rituals.* London: Oxford University Press.

Kouwenhoven, John A. (1967). *The arts in American civilization.* New York: W.W. Norton.

———. [1961] (1988). *The beer can by the highway: Essays on what's "American" about America.* Baltimore: Johns Hopkins University Press.

Kubler, George. (1940). *The religious architecture of New Mexico.* Colorado Springs: The Taylor Museum.

———. (1964). *The shape of time: Remarks on the history of things.* New Haven: Yale University Press.

Lai, David Chuenyan. (1990). Cityscape of old Chinatowns in North America. In Paul Groth (ed.), *Vision, culture, and landscape* (pp. 69–77). Berkeley, CA: University of California Department of Landscape Architecture.

Lancaster, Clay. (1958). The American bungalow. *Art Bulletin* 40: 239–353.

———. (1961). *Antebellum houses of the bluegrass.* Lexington: University of Kentucky Press.

Langdon, Philip. (September 1984). The American house: What we're building and buying. *Atlantic* 254 (3): 45–73.

Langhorne, Elizabeth, K. Lay, and W. Reiley. (1989). *A Virginia family and its plantation houses.* Charlottesville: University Press of Virginia.

Lawrence, D. H. [1923] (1975). *Studies in classic American literature.* New York. Reprinted. New York: Viking Press.

Lewis, Pierce. (January 1975). Common houses, cultural spoor. *Landscape* 19: 1–22.

———. (July 1975). The future of the past: Our clouded view of historic preservation. *Pioneer America* 7 (2): 1–20.

Loomis, Ormond H. (comp.). (1983). *Cultural conservation: The protection of cultural heritage in the United States.* Washington, DC: Library of Congress, American Folklife Center.

Lowenthal, David. (1968). The American Scene. *Geographical Review* 58: 61–88.

Lupton, Ellen. (1993). *Mechanical brides: Women and machines from home to office.* New York: Princeton Architectural Press for Cooper-Hewitt, National Museum of Design, Smithsonian Institution.

Lynch, Kevin. (1972). *What time is this place?* Cambridge, MA: M.I.T. Press.

Lynes, Russell. (1955). *The tastemakers.* New York: Harper and Brothers.

McAlester, Virginia and Lee. (1984). *A field guide to American houses.* New York: Alfred A. Knopf.

McCue, George, Osmund Overby, and Norbury L. Wayman. (July 1976). Street front heritage: The Bremen/Hyde Park area of St. Louis. *Bulletin of the Missouri Historical Society* 43 (4) Part 1: 205–21.

McDaniel, George W. (1982). *Hearth and home: Preserving a people's culture.* Philadelphia: Temple University Press.

McKee, Harley J. (1970). *Recording historic buildings.* Washington: U.S. National Park Service.

———. (1971). Early ways of quarrying and working stone in the United States. *APT Bulletin* 3 (1).

———. (1977). *Introduction to early American masonry: Stone, brick, mortar and plaster.* Washington: National Trust for Historic Preservation.

McMurry, Sally. (1988). *Families and farmhouses in nineteenth century America.* New York: Oxford University Press.

———. (Spring 1988). Women in the American vernacular landscape. *Material Culture* 20 (1): 33–49.

Maas, John. (1972). *The Victorian home in America.* New York: Hawthorn Books.

Madden, Robert R., and T. Russell Jones. (1977). *Mountain home: The Walker Family Homestead, Great Smoky Mountains National Park.* Washington, DC: National Park Service.

Marshall, Howard Wight. (1981a). *American folk architecture: A selected bibliography.* Washington: Library of Congress.

———. (1981b). *Folk architecture in little Dixie: A regional culture in Missouri.* Columbia: University of Missouri Press.

———. (Summer 1986). The Pelster housebarn: Endurance of Germanic architecture on the Missouri frontier. *Material Culture* 18 (2): 65–104.

———. (1989). The sisters leave their mark: Folk architecture and family history. In Robert Walls, et al. (eds.), *The old traditional way of life: Essays in honor of Warren E. Roberts* (pp. 208–27). Bloomington, IN: Trickster Press.

———. (1989–90, 1990–91). The British Isles single-cell house in the American cultural landscape. *Folk Life, Journal of Ethnological Studies* 28: 31–40; 29: 97–98.

———. (1995). *Paradise Valley, Nevada: The people and buildings of our American place.* Tucson: University of Arizona Press.

Marshall, Howard Wight, and Richard Ahlborn. [1980] (1981). *Buckaroos in paradise: Cowboy life in northern Nevada.* Publications of the American Folklife Center, No. 6. Washington: Library of Congress. Reprint. Lincoln: University of Nebraska Press.

Martin, Charles. (1984). *Hollybush: Folk building and social change in an Appalachian community.* Knoxville: University of Tennessee Press.

Marx, Leo. (1964). *The machine in the garden.* Cambridge, MA: M.I.T. Press.

Mattson, Richard L. (Fall 1992). The landscape of a southern black community: East Wilson, North Carolina, 1890 to 1930. *Landscape Journal* 11 (2): 145–59.

Maxwell, Shirley, and James C. Massey. (March–April 1993). Rows and rows of row houses. *Old-House Journal* 21 (2): 52–57.

May, Cliff. (1950). *Sunset western ranch houses.* San Francisco: Lane.

Mercer, Eric. (1975). *English vernacular houses: A study of traditional farmhouses and cottages.* London: H.M.S.O.

———. (1980). The architectural personality of the British Isles. *Archaeological Cambrensis* 129.

Mercer, Henry Chapman. (1960). *Ancient carpenter's tools.* Doylestown, PA: Bucks County Historical Society.

Moore, Charles W. (1983). Trailers. In C. Moore, K. Smith, and P. Becker (eds.), *Home sweet home: American domestic vernacular architecture* (pp. 49–51). New York: Rizzoli.

Moore, Charles W., K. Smith, and P. Becker (eds.). (1983). *Home sweet home: American domestic vernacular architecture.* New York: Rizzoli.

Morgan, John. (1990). *The log house in east Tennessee.* Knoxville: University of Tennessee Press.

Morgan, Lewis Henry. (1881). *Houses and house-life of the American aborigines.* Washington: Government Printing Office.

Morgan, William N. (1980). *Prehistoric architecture in the eastern United States.* Cambridge: M.I.T. Press.

Morrison, Hugh. (1952). *Early American architecture from the first Colonial settlements to the national period.* New York: Oxford University Press.

Mosher, Anne E., and D. W. Holdsworth. (April 1992). The making of alley housing in industrial towns: Examples from late-nineteenth and early-twentieth century Pennsylvania. *Journal of Historical Geography* 18 (2): 174–89.

Mumford, Lewis. [1924] (1955). *Sticks and stones: A study of American architecture and civilization.* Reprint. New York: Dover Publications.

Murtagh, William J. (1957). The Philadelphia row house. *Journal of the Society of Architectural Historians* 16: 8–13.

———. (Winter 1957–58). Half-timbering in American architecture. *Pennsylvania Folklife* 9: 3–11.

Nabokov, Peter. (1981). *Adobe: Pueblo and Hispanic folk traditions of the Southwest.* Washington: Office of Folklife Programs, Smithsonian Institution.

Nabokov, Peter, and Robert Easton. (1989). *Native American architecture.* New York: Oxford University Press.

National Park Service (comp). (1992). *Acadian culture in Maine.* Washington: U.S. Department of Interior.

Newcomb, Rexford. (1937). *Spanish Colonial architecture in the United States.* New York: J. J. Augustin.

Noble, Allen G. (ed.). (1992). *To build in a new land: Ethnic landscapes in North America*. Baltimore: Johns Hopkins Press.

Norberg-Schulz, Christian. (1965). *Intentions in architecture*. Cambridge: M.I.T. Press.

O'Brien, Michael J., Robert E. Warren, and Dennis E. Lewarch. (1982). *The Cannon Reservoir human ecology project*. New York: Academic Press.

Oliver, Paul. (Fall 1986). Vernacular know-how. *Material Culture* 18 (3): 113–26.

———. (1987). *Dwellings: The house across the world*. Austin: University of Texas Press.

Overby, Osmund. (1962). *Historic American buildings survey Chicago vicinity*. Comp. John Poppeliers. Washington, DC: National Park Service.

———. (1966). *Historic architecture of the Virgin Islands*. Selections from the Historic Americans Buildings Survey, No. 1. Philadelphia, PA: National Park Service.

———. (1968). *The Robie House, Frank Lloyd Wright*. Palos Park, IL: Prairie School Press.

———. (1972). *Historic American buildings survey Rhode Island catalog*. Washington, DC: National Park Service.

———. (1981). Old and new architecture: A history. In National Trust for Historic Preservation, *Old and new architecture: Design relationships* (pp. 18–36). Washington: Preservation Press.

———. (Spring 1985). Architectural treasures of Sainte Genevieve. *Gone West!* 3 (2): 5–11.

Peate, Iorwerth C. (1944). *The Welsh house: A study in folk culture*. Liverpool: Hugh Evans.

Peterson, Charles E. (December 1950). Early house-warming by coal-fires. *Journal of the Society of Architectural Historians* 9: 21–24.

———. (April 1969). The technology of early American building. Association for Preservation Technology *Newsletter* 1: 3–17.

———. (1971). *The rules of work of the Carpenter's Company of the City and County of Philadelphia, 1786*. Philadelphia: Carpenter's Company.

———. (ed.). (1976). *Building early America: Contributions toward the history of a great industry*. Radnor, PA: Chilton Book Co.

Peterson, Fred W. (1992). *Homes in the heartland: Balloon frame farmhouses of the upper Midwest, 1850–1920*. Lawrence: University Press of Kansas.

Phillips, Steven J. (1992). *Old-house dictionary: An illustrated guide to American domestic architecture 1600 to 1940*. Washington: Preservation Press.

Pierson, William H. (1976). *American buildings and their architects: The Colonial and neo-Classical styles*. Garden City, NY: Anchor Books.

Pounds, Norman J. G. (1989). *Hearth and home: A history of material culture*. Bloomington: Indiana University Press.

Prawl, Toni M. (1986). The W. L. Cornett House, Linn County, Missouri: Cultural expression and family history through architecture and furniture, 1884–1986. Masters thesis. University of Missouri, Columbia.

Preiss, Peter J. (1973). Wire nails in North America. *Association for Preservation Technology Bulletin* 5 (4): 87–92.

Prown, Jules David. (1988). Mind in matter: An introduction to material culture theory and method. In R. St. George (ed.), *Material life in America, 1680–1800* (op. cit.) (pp. 17–37).

———. (Autumn 1980). Style as evidence. *Winterthur Portfolio* 15 (3): 197–210.

Quimby, Ian M. G. (ed.). (1978). *Material culture and the study of American life*. New York: W. W. Norton.

Rapoport, Amos. (1969). *House form and culture*. Englewood Cliffs, NJ: Prentice-Hall.

————. (1982). *The meaning of the built environment.* Beverly Hills, CA: Sage.

Rasmussen, Steen Eiler. (1959). *Experiencing architecture.* Cambridge, MA: M.I.T. Press.

Reps, John W. (1969). *Town planning in frontier America.* Princeton: Princeton University Press.

————. (1981). *The forgotten frontier: Urban planning in the American West before 1890.* Columbia: University of Missouri Press.

Richards, Lynne. (Summer 1993). Dwelling places: Log homes in Oklahoma's Indian Territory, 1850–1909. *Material Culture* 25 (2): 1–24.

Rikoon, J. Sanford. (Summer 1979). The Reusser House: A log structure in Iowa's "Little Switzerland." *The Annals of Iowa* 45 (1): 3–43.

Roberts, Warren E. (1972). Folk architecture. In Richard M. Dorson (ed.), *Folklore and folklife: An introduction* (pp. 281–94). Chicago: University of Chicago Press.

————. (1984). *Log buildings in southern Indiana.* Bloomington, IN: Trickster Press.

————. (1986). The tools used in building log houses in Indiana. In D. Upton and J. Vlach (eds.), *Common places* (op. cit.) (pp. 182–201).

————. (1988). *Viewpoints on folklife: Looking at the overlooked.* Ann Arbor, MI: U.M.I. Research Press.

Robinson, Philip. (1979). Vernacular housing in Ulster in the seventeenth century. *Ulster Folklife* 25: 1–28.

Roos, Frank J., Jr. (1968). *Bibliography of early American architecture.* Urbana: University of Illinois Press.

Rosen, Richard Allen. (Summer 1992). Rethinking the row house: The development of Lucas Place, 1850–1865. *Gateway Heritage* 13 (1): 20–27.

Roth, Leland M. (1979). *A concise history of American architecture.* New York: Harper and Row.

Roth, Rodris. (1967). *Floor coverings in 18th century America.* Washington, DC: Smithsonian Press.

————. (ed.). (1983). *America builds: Source documents in American architecture and planning.* New York: Harper and Row.

Rumford, Beatrix T. (1975). *The Abby Aldrich Rockefeller folk art collection.* Williamsburg, VA: Colonial Williamsburg Foundation.

Ruskin, John. [1849] (1974). *The seven lamps of architecture.* Reprint. New York: Noonday Press.

Russell, James S. (1994). The place of "public" in housing. *Architectural Record* 1: 26–45.

Sackheim, Donald E. (comp.). (1976). *Historic American engineering record catalog 1976.* Washington, DC: National Park Service, Historic American Engineering Record.

Saile, David G. (ed.). (1984). *Architecture in cultural change: Essays in built form and culture research.* Lawrence: University of Kansas School of Architecture and Design.

St. George, Robert Blair (1985). Artifacts of regional consciousness in the Connecticut River Valley, 1700–1780. In William N. Hosley, Jr., and Gerald W. R. Ward (eds.), *The Great River: Art and society of the Connecticut Valley, 1635–1820* (pp. 29–40). Hartford: Wadsworth Athenaeum.

————. (ed.). (1988). *Material life in America, 1600–1860.* Boston: Northeastern University Press.

Salter, Christopher. (1978). *San Francisco's Chinatown: How Chinese a town?* San Francisco: R and E Research Associates.

Sams, Gerald (ed.). (1992). *AIA guide to the architecture of Atlanta.* Atlanta: University of Georgia Press and American Institute of Architects.

Sandweiss, Eric. (1986). Building for Downtown living: The residential architecture of San Francisco's Tenderloin. In T. Carter and B. Herman (eds.), *Perspectives in vernacular architecture III* (op. cit.) (pp. 160–75).

———. (1991). Construction and community in South St. Louis, 1850–1910. Dissertation. University of California, Berkeley.

Saylor, Henry H. (1952). *Dictionary of architecture.* New York: John Wiley.

Schlebecker, John T. (ed.). (1976). *Selected living historical farms, villages and agricultural museums in the United States and Canada.* Washington, DC: Smithsonian Institution.

Schlereth, Thomas J. (ed.). (1982). *Material culture studies in America.* Nashville: American Association for State and Local History.

———. (1985). *Material culture: A research guide.* Lawrence: University Press of Kansas.

Scott, John S. (1974). *A dictionary of building.* Baltimore: Penguin Books.

Scott, Pamela, and Antoinette J. Lee. (1993). *Buildings of the District of Columbia.* New York: Oxford University Press.

Shaw, John. (1984). *Water Power in Scotland, 1550–1870.* Edinburgh: John Donald.

Shortridge, James R. (Fall–Winter 1980). Traditional rural houses along the Missouri–Kansas border. *Journal of Cultural Geography* 1 (1): 105–37.

Shurtleff, Harold R. (1939). *The log cabin myth.* Cambridge: Harvard University Press.

Simpson, Pamela H. (1986). Cheap, quick, and easy: The early history of rockfaced concrete block building. In T. Carter and B. Herman (eds.), *Perspectives in vernacular architecture III* (op. cit.) (pp. 108–18).

———. (Fall 1992). Cheap, quick, and easy: Pressed metal ceilings, 1880–1930. *Vernacular Architecture Newsletter* 53: 9.

Simpson, Pamela H., and Royster Lyle, Jr. (1977). *The architecture of historic Lexington.* Charlottesville: University Press of Virginia.

Slade, Thomas M. (ed.). (1983). *Historic American buildings survey in Indiana.* Bloomington: Indiana University Press.

Smith, J. T. (1969). The concept of diffusion in its application to vernacular building. In J. Geraint Jenkins (ed.), *Studies in folk life: Essays in honour of Iorwerth C. Peate* (pp. 60–78). London: Routledge and Kegan Paul.

Smith, Peter. (1975). *Houses of the Welsh countryside: A study in historical geography.* London: H.M.S.O.

Spears, Beverly. (1986). *American adobes: Rural houses of northern New Mexico.* Albuquerque: University of New Mexico Press.

Spier, Robert F. G. (1973). *Material culture and technology.* Minneapolis, MN: Burgess.

Sprague, Paul E. (1981). The origin of balloon framing. *Journal of the Society of Architectural Historians* 40: 311–19.

Stevenson, Catherine Cole, and H. Ward Jandl. (1986). *Houses by mail: A guide to houses from Sears, Roebuck and Co.* Washington: National Trust for Historic Preservation.

Stickley, Gustav. [1909] (1979). *Craftsman homes: Architecture and furnishings of the American arts and crafts movement.* New York. Reprinted. New York: Dover Publications.

Stilgoe, John R. (1982). *The common landscape of America, 1580–1845.* New Haven: Yale University Press.

Stipe, Robert E. (ed.). (1980). *New directions in rural preservation.* Washington: U.S. Department of the Interior.

Strawn, Phyllis J. (1980). *King's Row revisited: One hundred years of Fulton architecture.* Jefferson City, MO: Missouri Heritage Trust.

Swaim, Douglas (ed.). (1978). *Carolina Dwelling.* Raleigh: North Carolina State University School of Design.

Thayer, Robert L., Jr. (1990). Pragmatism in paradise: Technology and the American landscape. *Landscape* 30 (3): 1–11.

Thompson, Deborah (ed.). (1976). *Maine forms of American architecture.* Camden, ME: Down East Magazine.

Touart, Paul Baker. (1990). *Somerset: An architectural history.* Annapolis, MD: Maryland Historical Trust.

Upton, Dell. (Winter 1981). Ordinary buildings: A bibliographical essay on American vernacular architecture. *American Studies International* 19 (2).

———. (1982). Vernacular domestic architecture in eighteenth-century Virginia. *Winterthur Portfolio* 17: 95–119.

———. (1984). Pattern books and professionalism: Aspects of the transformation of domestic architecture in America, 1800–1860. *Winterthur Portfolio* 19: 107–50.

———. (1985). The power of things: Recent studies in vernacular architecture. *American Quarterly* 35: 262–79.

———. (1985). White and black landscapes of eighteenth-century Virginia. *Places* 2 (2): 59–92.

———. (ed.). (1986). *America's architectural roots: Ethnic groups that built America.* Washington: National Trust for Historic Preservation.

Upton, Dell, and John Michael Vlach (eds.). (1986). *Common places: Readings in American vernacular architecture.* Athens: University of Georgia Press.

van Ravenswaay, Charles. (1977). *The arts and architecture of German settlements of Missouri: A survey of a vanishing culture.* Columbia: University of Missouri Press.

Vaux, Calvert. (1864). *Villas and cottages.* New York: Harper.

Vennum, Thomas, Jr. (1974). *The drummaker.* Smithsonian Folklife Studies No. 2a. Washington, DC: Smithsonian. 16 mm film.

———. (1982). *The Ojibwa dance drum: Its history and construction.* Smithsonian Folklife Studies No. 2. Washington, DC: Smithsonian.

Venturi, Robert, et al. (1977). *Learning from Las Vegas: The forgotten symbolism of architectural form.* Cambridge, MA: M.I.T. Press.

Virginia Historic Landmarks Foundation. (1976). *Virginia catalog: A list of measured drawings, photographs, and written documentation in the survey.* Washington, DC: National Park Service, Historic American Buildings Survey; Charlottesville: University Press of Virginia.

Vlach, John Michael. (1976). The shotgun house: An African architectural legacy. *Pioneer America* 8: 57–70.

———. (1991). *By the work of their hands: Studies in Afro-American folklife.* Charlottesville: University Press of Virginia.

———. (1991). "Afro-American Housing in Virginia's Landscape of Slavery." In J. Vlach, *By the work of their hands* (op. cit.) (pp. 216–29).

———. (1993). *Back of the big house: The architecture of plantation slavery.* Chapel Hill: University of North Carolina Press.

Wallis, Allan D. House trailers: Innovation and accommodation in vernacular housing. In T. Carter and B. Herman (eds.), *Perspectives in vernacular architecture III* (op. cit.) (pp. 28–43).

Ward, Gerald W. R. (July 1992). Furnished houses [Strawberry Banke Museum, NH]. *Antiques* 142 (1): 66–75.

Waterman, Thomas Tiles. (1945). *The mansions of Virginia, 1706–1776.* Chapel Hill: University of North Carolina Press.

Watts, May Thielgaard. (1975). *Reading the landscape: An adventure in ecology.* New York: Macmillan.

Weiss, Ellen. (1993). *An annotated bibliography of African American architects and builders.* Philadelphia: Society of Architectural Historians.

Wells, Camille (ed.). (1982). *Perspectives in vernacular architecture.* Annapolis, MD: Vernacular Architecture Forum.

———. (1986). Old claims and new demands: Vernacular architecture studies today. In Camille Wells (ed.), *Perspectives in vernacular architecture II* (pp. 1–10). Columbia: University of Missouri Press.

———. (1986). *Perspectives in vernacular architecture II.* Columbia: University of Missouri Press.

———. (Spring 1993). Interior designs: Room furnishings and historical interpretations at Colonial Williamsburg. *Southern Quarterly* 31 (3): 88–111.

Weslager, C. A. (1969). *The log cabin in America.* New Brunswick, NJ: Rutgers University Press.

Wheat, Margaret M. (1967). *Survival arts of the primitive Paiutes.* Reno: University of Nevada Press.

Whiffen, Marcus, [1968] (1992). *American architecture since 1780: A guide to the styles.* Revised edition. Cambridge, MA: M.I.T. Press.

Whiffen, Marcus, and Frederick Koeper. (1981). *American architecture 1607–1860.* Cambridge, MA: M.I.T. Press.

William, Eurwyn. (1986). *The historical farm buildings of Wales.* Edinburgh: John Donald.

Williams, Michael Ann. (Winter 1990). Pride and prejudice: The Appalachian boxed house in southwestern North Carolina. *Winterthur Portfolio* 25 (4): 217–31.

Wilson, Charles Reagan, and William Ferris (eds.). (1989). *Encyclopedia of Southern culture.* Chapel Hill: University of North Carolina Press.

Wilson, Chris. (1991). Pitched roofs over flat: The emergence of a new building tradition in Hispanic New Mexico. In T. Carter and B. Herman (eds.), *Perspectives in vernacular architecture IV* (op. cit.) (pp. 87–97).

Wilson, Eugene M. (1975). *A guide to rural houses in Alabama.* Montgomery: Alabama Historical Commission.

Winter, Robert. (1980). *The California bungalow.* Los Angeles: Hennessey and Ingalls.

Wolfe, Tom. (1981). *From Bauhaus to our house.* New York: Farrar, Straus, Giroux.

Wolfe, Tom, and Leonard Garfield. (1989). "A new standard for living": The Lustron House, 1946–1950. In T. Carter and B. Herman (eds.), *Perspectives in vernacular architecture III* (op. cit.) (pp. 51–61).

Wood, Peter H. (Spring 1980). Whetting, setting and laying timbers: Black builders in the early South. *Southern Exposure* 8 (1): 3–8.

Wood-Jones, Raymond B. (1963). *Traditional domestic architecture of the Banbury Region.* Manchester: Manchester University Press.

Wright, Gwendolyn. (1981). *Building the dream: A social history of housing in America.* New York: Pantheon Books.

Yentsch, Anne Elizabeth, and Mary C. Baudry (eds.). (1992). *The art and mystery of historical archaeology: Essays in honor of James Deetz.* Boca Raton, FL: CRC Press.

Yip, Christopher L. (Spring 1978). A time for bitter strength: The Chinese in Locke, California. *Landscape* 22 (2).

Zelinsky, Wilbur. (1953). The log house in Georgia. *Geographical Review* 43: 173–93.
———. (1973). *The cultural geography of the United States.* Englewood Cliffs, NJ: Prentice-Hall.
Zube, Ervin (ed.). (1970). *Landscapes: Selected writings of J. B. Jackson.* Amherst: University of Massachusetts Press.

GUIDE TO PERIODICALS

American Quarterly

Annals of the Association of American Geographers

APT Bulletin

Chronicle of the Early American Industries Association

Folk Life: Journal of Ethnological Studies

Folklore Forum

Geographical Review

Historic Preservation

Historical Archaeology

History News

Journal of American Folklore

Journal of Cultural Geography

Journal of the Society of Architectural Historians

Landscape

Landscape Journal

Material Culture

Places: A Quarterly Journal of Environmental Design

Preservation News

Technology and Culture

Ulster Folklife

Vernacular Architecture

Vernacular Architecture Newsletter

Winterthur Portfolio

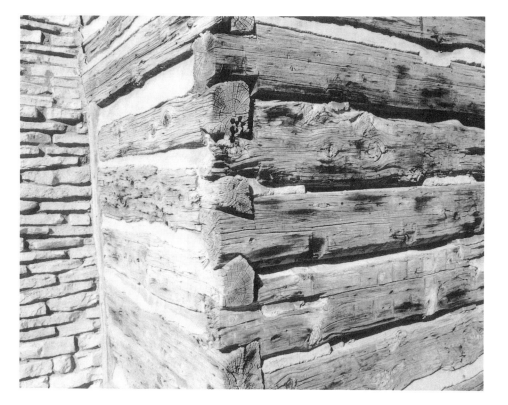

2

Researching the History of Housing

Josette H. Rabun and Betty McKee Treanor

Historical facts set the mold for society's agreement about how things should be.

—Fish (1979, p. 1)

This chapter is a guide to students, researchers, and historians seeking more information about the history of American housing or one particular area in the history of American housing. This chapter presents an intricate but succinct introduction to guides on American housing history, suggesting that this type of research involves input from many different sources.

Given the vastness of American housing literature, sources cited refer to the most classic examples. Non-inclusion in this chapter does not indicate lack of value of a work; rather, the decision for inclusion was based on the authors' judgment. We attempted to include a variety of reference sources, such as books, journal articles, magazines, government documents, technical reports, conference proceedings, and dissertations and theses. Many useful histories, museums, museum publications, textbooks, historical societies, and certain popular works on the history of American housing are identified through other sources or can be located in libraries through on-line computer systems. Databases available through reference librarians also can often lead researchers to a variety of sources and subjects. This chapter provides resources to further enrich readers in the study of American housing history.

HISTORIES

There are numerous histories of American architecture, but relatively few comprehensive histories of American housing. As architecture reflects society and its values, housing specifically reflects the social and cultural values of the people. Some historical studies approach housing strictly from the architectural perspective while others emphasize cultural or social aspects. A few have succeeded in combining some of these elements in a comprehensive manner.

Although the first settlers were of a mixture of cultural backgrounds, the temporary dwellings they constructed to provide the essential elements of protection were generally similar. Cultural differences emerged when the first frame houses were constructed, even though the settlers all used similar basic materials and building methods. As America grew and expanded in territory and population, the variations in housing became more numerous. This guide will include a variety of texts, each of which makes a unique contribution to the total history of American housing.

The first comprehensive history of American architecture was Lewis Mumford's *Sticks and Stones* (1924), which presented a survey of architecture as he had studied it. His book addressed the need for a documented record of the previous three centuries and the evolution of America and its people as reflected by architecture. Researchers, students, and historians will find this to be an essential primary source for the study of American housing and architecture. In later studies of American architecture this book is consistently referenced for its outstanding and significant coverage of the subject.

Thomas Eddy Tallmadge's *The Story of Architecture in America* (1927) covers the major styles as they developed and influenced both housing and public buildings. It gives a clear understanding of American housing from the colonial period to 1936 and emphasizes architectural history as it reflected the material culture and housing in America. Tallmadge's readable book is an essential source for those investigating both the literary styles and the cultural history of the people who settled specific sections of the colonies.

Following the two significant early books on American architecture, more expanded historical references included a larger geographic area, a longer time frame, and more stylistic developments. The examples cited in this section are considered to be excellent resources. Marcus Whiffin and Frederick Koeper's *American Architecture Since 1780* (1992) is an expanded general history in a chronological framework appropriately categorized to include significant reasons for changes occuring. The researched details contained in this text depart from other histories to include developments that occurred simultaneously to influence architecture as this country expanded. Although not limited to housing history, it is an excellent source of information on the architectural influences of immigrant groups who settled sections of the nation, displaying their unique and differing building methods. Talbot Hamlin's *The American Spirit in Architecture* (1926) also provides a comprehensive historical account that is pertinent to the subject.

Fiske Kimball's *Domestic Architecture of the American Colonies and of the Early Republic* (1922) presents the classic history of housing and explains the relationship between American dwellings and the background of their inhabitants. The text is a compilation of lectures that the author gave at the Metropolitan Museum of Art in 1920. It remains a significant source and contains an extensive section of notes on individual houses, including dates, authorship, and original form.

Later sources, essential for students or researchers to cover the scope of architecture, are combined with other cultural or environmental aspects; for example, James Marston Fitch's two volumes, *American Building 1: The Historical Forces That Shaped It* (1966) and *American Building 2: The Environmental Forces That Shaped It* (1972), and two volumes by William H. Pierson, Jr., *American Buildings and Their Architects, vol. 1: The Colonial and Neo-Classical Styles* (1970) and *American Buildings and Their Architects, vol. 2: The Corporate and Early Gothic Styles* (1978). These well-researched sources contain extensive bibliographies and cover some of the indigenous architecture of the Southwest prior to the appearance of European influence, typically included only in regional histories. Wayne Andrews's *Architecture, Ambition and Americans* (1955) investigates the extraordinary houses built by and for Americans of wealth and elevated architectural taste. This well-researched book on the builders and the purposes of their buildings should prove a valuable resource. A few public buildings are included in the study, but the majority of the work is devoted to housing. Excellent photographs and a comprehensive bibliography enhance Andrews's book.

To focus upon the housing aspect of American architecture, the following three references are essential for the understanding of the styles and typical characteristics of the earliest constructed dwellings. Harold Shurtleff's *The Log Cabin Myth* ([1939] 1967) is an essential resource for understanding much of the literature and writings of the early colonies. An outstanding feature of this work is the explanation of words used by the colonists. After studying the word-usage and the cultural backgrounds of the settlers, Shurtleff reaches the inevitable conclusion that the first dwellings built by the colonists were vastly different from the types portrayed in various artistic media. The book contains examples of log cabins and details concerning their construction. Norman M. Isham's *Early American Houses and a Glossary of Architectural Terms* (1928) presents a detailed study of the plans, exteriors, frames, details, and interiors of seventeenth-century dwellings. The book also contains some exceptional drawings and photographs and an extensively illustrated glossary. A researched survey of domestic architecture arranged by chronology and geographical sections and containing an excellent bibliography and extensive notes is Thomas Tilson Waterman's *The Dwellings of Colonial America* (1950).

Home Life in Colonial Days (1898) by Alice Morse Earle is one of the earliest books to present a researched account of everyday activities required for sustaining a household and a society. Earle uses the original names of household items, many of which had changed prior to the time of her writing. This excellent primary source for information about the structure of the homes as well as activities

of daily life includes some of the typical activities and crafts of selected ethnic groups located in New England.

The definitive work on Greek Revival architecture in America is Talbot Hamlin's *Greek Revival Architecture in America* (1944). Hamlin does not, however, cover domestic architecture exclusively. This authoritative book has an extensive bibliography that will be beneficial for further investigation.

As Americans did not consistently follow the most pristine examples of period architectural styles for their homes, we include some resources that illustrate both pure style characteristics and their variations. Henry-Russell Hitchcock's *Architecture* (1971) is a scholarly study of architectural and technological developments, including the American Revival styles. Some creative architects are discussed, and their designs are illustrated in this work. Not exclusively limited to housing, the book surveys the scope of architecture as it was practiced in America, including enough about housing to be well worth the researcher's attention. An excellent resource focusing on a specific portion of the nineteenth century is Vincent Scully's *The Shingle Style* (1955). This work presents a scholarly study of architecture in wood in the nineteenth century and provides an extensive bibliography. Janet Kardon's *The Ideal Home 1900–1920* (1993) provides an excellent coverage of the interior components of the houses of the same period. It is extremely well documented and contains outstanding photography and a bibliography. Henry-Russell Hitchcock and Philip Johnson's *The International Style* (1932) is possibly the most comprehensive study of that period in American architectural history and includes housing along with other structures. Donald Canty's *American Architecture of the 1980's* (1990) published by the American Institute of Architecture, reflects the total architectural picture of America, including domestic, religious, public, and educational structures. The publication contains excellent photographs of the examples discussed.

Numerous regional publications, some more scholarly than others, address specific geographical areas. Without attempting to address all of them, we note the following as some of the outstanding examples: Antoinette Downing and Vincent Scully, *The Architectural Heritage of Newport, Rhode Island, 1640–1915* (1967); Thomas Tilson Waterman, *The Mansions of Virginia: 1770–1776* (1945); R. Newcomb, *Old Kentucky Architecture* (1940); Henry Chandlee Forman, *The Architecture of the Old South* (1948); John Vlach, *Sources of the Shotgun House* (1977); Drury Blake Alexander, *Texas Homes of the Nineteenth Century* (1966); Harold Kirker, *California's Architectural Frontier* (1973); and Nicholas Markovich, *Pueblo Style and Regional Architecture* (1992). Many publications are more site-specific than those mentioned above.

When studying the architectural styles of American housing, the researcher will find numerous publications focusing on segments of the total architectural design. Selected examples of these works merit discussion. The first architectural books published in the United States were printed in the late eighteenth century. Henry-Russell Hitchcock's American architectural books will help the researcher access these on microfilm and in book form. In addition, many of Hitchcock's books

have been recently reproduced. Commonly known as pattern books, they usually identified major architectural elements, such as columns, door frames, chimney pieces, cornices, or moldings and explained some of the basic architectural concepts such as proportion and composition. The design and details of the drawings reflect a strong classical architectural approach, which indicates the author's education and prior building experience. The books provided a guide for craftsmen to learn and use the details on public buildings as well as dwellings. Some of the pattern books, however, were specifically addressed to the cottage builder. The earliest work compiled and published in the United States was John Norman's *The Town and Country Builder's Assistant* (1786). It explains rules for drawing and working with the orders of architecture, including columns, moldings, and door frames. The most prolific writer of the period for this type of publication was Asher Benjamin, who published thirty-three books between 1797 and 1845, including multiple editions and posthumously published works. *The Country Builder's Assistant* (1797) is the earliest of Benjamin's publications. Other authors, such as Owen Biddle, William Brown, and David Topping Atwood, produced similar books during the same period. C. P. Dwyer's *Immigrant Builder, or, Practical Guide to Handymen* (1892) was unique in that it was specifically directed toward building information for new immigrants. William S. Wicks's *Log Cabins* (1889) departed from the classical architectural details included in the publications above. It provided specific instructions on building and furnishing log dwellings of all types.

All of the pattern books discussed above lacked the details or plans for an entire structure. With the exception of Wicks's book, none included floor plans, exterior views, or other details relative to the total concept. This created a need for another type of pattern book that showed the most current trends in architectural style, floor plans, and unique ideas applicable to each house. When urban growth became evidenced by the spread of the residential areas, the outer areas of the city were called country or rural areas. This diversification created great demand for housing plans specifically designed for this type of location. Andrew Jackson Downing's *Cottage Residences* (1842) was one of the first publications to provide floor plans to the public. It was followed by other publications of floor plans that included drawings of the exterior of the buildings, so that the prospective client could visually comprehend the finished product.

By the mid-nineteenth century, the Gothic Revival style was becoming popular in America, and several plan books were published focusing specifically on that style. The publication of *The Architecture of Country Houses* (1850) made Andrew Jackson Downing one of the most widely read authors on the subject. The publication shows designs for cottages, villas, and farmhouses supplemented by an expanded text on the meaning of architecture and explanations of each plan to clarify the specific details and ideas introduced in it. Interiors, furnishings, and heating and ventilation were included as they indicated some of the technological developments of that particular era when comfort, fashion, and homes were of prime importance. Charles and George Palliser's *Pallisers' American Cottage Homes* (1878) was one of the first publications to show plans, elevations, perspectives,

and details of a large variety of house plans for a variety of locations, purposes, and prices. Other books emphasized convenience and cost. A. J. Bicknell published *Detail, Cottage and Constructive Architecture* (1873) for a diverse audience to cover details, plans, and elevations for dwellings as well as framing for barns, exhibition buildings, and bridges. It was to be the "all practical book for Architects, Builders, Carpenters and all who contemplate building or remodeling wood, stone or brick buildings." William T. Comstock's *Modern Architectural Designs and Details* (1881) was soon to follow and contained Queen Anne, Eastlake, and Elizabethan Revival designs in conjunction with plans for low-priced cottages. The last two books are extremely well illustrated with numerous clear and detailed drawings. They are two of the most studied reference books for that period of American housing history, and they remain classic primary references for researchers. David Arnot, Oliver Smith, John Bullock, Gervase Wheeler, Samuel Sloan, Henry Holly, and John Calvin Stevens published similar materials. The importance of housing to architecture is shown by the fact that the National Architect's Union published *Modern Homes* (1889) and continued this type of publication through 1893.

As the cities increased in size, the architectural community continued to be concerned with the kinds of houses being constructed. *The Honest House* (1914), written by Ruby Ross Goodnow, addresses the quest for the ideal house. She explores the concepts of what to consider in house design from the perspectives of aesthetics and function. Written for a prospective homeowner and endorsed by an architect, it is well illustrated with drawings, plans, and photographs. It is interesting reading not only for understanding the ideal home, but also for understanding the values of the society to which it is addressed. Soon afterwards, commercial homes were made available through mail-order catalogs. Sears, Roebuck and Company would deliver to the purchaser the complete plans and materials necessary for the construction of the home on the owner's property. An excellent resource on these houses is Katherine Stevenson and Ward Jandl's *Houses by Mail* (1986). Competitors of Sears, Roebuck were the Harris Brothers, who published *A Plan Book of Harris Homes* (1916). Charles Keefe's *The American House* (1922) contains a collection of illustrations and plans of the best country and suburban houses built in the United States. It is a most interesting source for research purposes, but it neglects to state upon what criteria the homes were selected and who served as judge. Another primary source is George Evertson Woodward's *Woodward's Architecture* (1869), which contains advice on a variety of topics, including the building itself. It presents advice on the location of the sleepings rooms as well as the cellar, with specific reasons for his recommendations. This extremely interesting publication is readily available on microfilm.

This connection between health (physical and mental) and the architectural environment became a popular topic in the mid-nineteenth century, and much was written about the relationship in moral and medical terms. William Andrus Alcott's *The Laws of Health* (1857) addresses the connection between health and everyday surroundings. He was among the most read authors of his day, his many

writings ranging from the design of schoolhouses to nurseries and directed at those responsible for the care of young children. Catharine Beecher and Harriet Beecher Stowe's *The American Woman's Home or Principles of Domestic Science* (1869) was one of the most influential writings of the era. This classic primary source, written from an extremely moralistic perspective, advised that woman's work be taught to all women so that they could better perform their role in life, that they might see the dignity and importance of it, and that they might thereby improve the status of women. The book addresses the Christian family and home before proceeding through the houseplan, the ventilation and heating, decoration, the health of the residents, the care and nurturing of the family, housekeeping, gardening, and the Christian neighborhood. Indeed, it was meant to be a complete guide for directing a woman's life. The section on kitchen planning contains many revolutionary ideas and has proven to be a major influence on later kitchen planning. This is one of many works by Catharine Beecher related to her activity as a crusader for women. Charles Eastlake's *Hints on Household Taste in Furniture, Upholstery, and Other Details* (1872) was first published in England but proved to have a major influence upon American taste and design in the Victorian period. The book is dedicated to elevating the common taste. Eastlake expresses distinct ideas concerning all rooms in the house, including the selection of accessories. The work is considered to be the classic reference on the house, reflecting the values and society of its author. An American primary source on the same topic is Almon Varney's *Our Homes and Their Adornments* (1882), which presents concepts for the ideal home's construction and the importance of its adornment in influencing the life of the individuals, especially the children, living within it. Emily Post's *Etiquette* (1932) ruled that specific areas of the proper house should be designed and decorated to reflect the gender of the user. Rooms for males should reflect what they do and who they are, whereas rooms for females should be based upon how the women look.

Since there is a chapter in this guide devoted exclusively to the topic of housing and social conditions, only some historical highlights will be included here. The demographics of America changed as the nation expanded and technology changed lives. One of the major factors in bringing about the social changes relating to housing in the nineteenth century was the rapid and extremely large population growth. Immigration, the Civil War, and industrial technology attracted new residents to the cities of the East Coast at a rate that caused New York City to have a population in 1900 equal to the total national urban population in 1850. Housing responded to these needs in diverse ways, making it impossible to discuss one popular style of home after the 1850s. The single-family dwelling may have remained the ideal, but for a growing number of families, it was not the reality.

When the ideal home was depicted, it was typically placed in a rural or suburban setting as opposed to the urban setting, which was considered to be completely undesirable for raising the ideal family. Fredricka Bremmer's *The Homes of the New World* (1853), a primary source on this topic, was written by a Euro-

pean woman who came to the United States to write about American homes and became engrossed in the social aspects of housing. Clifford Edward Clark, Jr.'s *The American Family Home, 1800–1960* (1986) is an excellent history of the ideal family as it related to the ideal home and how both evolved from the Victorian to the Modern age. His treatment of the Victorian era is supported by extensive notes and an excellent bibliography. Another equally important work is David Handlin's *The American Home* (1979). While similar to Clark's work, it does not review the Victorian mind in as much detail. More emphasis is placed on such things as neighborhoods, tenement housing, and mill and factory towns built for workers by specific companies. Although coverage in this essential reference ends with World War I, it contains excellent notes and bibliography. An in-depth study into the development of suburbs is Henry Binford's *The First Suburbs* (1985). John Coolidge's *Mill and Mansion* (1942) is a well researched and documented study of architecture and society in Lowell, Massachusetts, from 1820 to 1865. Alan Gowans's *Images of American Living* (1964) gives a comprehensive survey of the relationship between specific architectural styles and furnishings as they reflect the values, needs, and culture of the inhabitants. The author divides the contents by centuries and targets specific influences that changed the basic philosophy of the general population. Abundant excellent notes, photographs, and indexes make this book a most useful resource for the researcher. Apartment buildings became such an important housing option between 1869 and 1930 that they literally transformed city life. Elizabeth Hawes discusses these changes related to apartment buildings in *New York, New York* (1993), a scholarly study with an extensive bibliography.

Planned communities became a reality, and new towns were built from scratch. The flight to the suburbs and completely developed communities became more common, leading to the development of Levittown, one of the earliest sites designed to provide single-family dwellings for lower-middle-class workers. Herbert Gans's *The Levittowners* (1967) is the premier resource written about the community and provides an extensive bibliography.

Delores Hayden's *Redesigning the American Dream* (1984) details the changes in American housing and its present reality, including housing and subdivisions being planned and built by developers without input from urban planners or residents. Critics of such practices argue that they produce neighborhoods that fall far short of best meeting the needs of the families who live in them. The work is well documented and abounds with notes and a bibliography. Possibly the best resource about sociological aspects of twentieth century housing is Leslie Weisman's *Discrimination by Design* (1992). It discusses such topics as design for social inequality and public architecture as related to social status, covering discrimination by gender as well as race and age. It is an essential resource for clearly understanding this aspect of current housing and housing policy, particularly public housing. Karen Franck and Sherri Ahrentzen's *New Households, New Housing* (1991) covers some of the housing options that continue developing to meet the needs of many contemporary households as society changes.

BIOGRAPHICAL and RESOURCE GUIDES

Biographical

> It is fitting to look back, take stock and call attention to the part our housing
> leaders have played. —Robert Aquella, president of NAHB
> Mason (1982, p. 165)

Some outstanding indexes of American architects with biographical data are available in most university and public libraries. *Avery Obituary Index of Architects* (1980) references approximately five hundred obituary notices from periodicals currently indexed by the Avery Library. In addition to obituaries from the Avery periodicals, there are references in newspapers, chiefly the *New York Times*. The Avery Library has indexed obituaries of architects and artists from 1980 to the present; however, this index is not available in most libraries.

Two notable books published by Lawrence G. Wodehouse entitled *American Architects from the Civil War to the First World War* (1975) and *American Architects from the First World War to the Present* (1977) provide general reference books and selected annotated biographical bibliographical information on architects who have gained recognition in architectural histories, periodicals, and journals. The introductions to both books by Wodehouse contain valuable information that leads researchers to excellent reference material and to interpretive studies, including some leading journals in the field.

Since not all libraries have access to the above-mentioned bibliographies, other resources are available to offer researchers a guide. Henry F. Withey and Elsie Rathburn Withey's *Biographical Dictionary of American Architects (Deceased)* (1956) is the only dictionary of its kind listing two thousand American architects from 1740 to 1952. Withey and Withey were selective and have included only the leading architects of each era or those whom historians and critics deemed worthy. Dating back to 1964, *The Prairie School Review*, under the editorship of W. R. Hasbrouch, lists significant, but lesser known architects; however, it concentrates specifically on architects from Chicago and the Midwest. Wodehouse's *American Architects from the First World War to the Present* includes an annotation of all relevant articles from *The Prairie School Review*.

More specific biographical resource guides exist, such as those dedicated to the works of Frank Lloyd Wright. Harrye Black Lyons of the School of Design Library at North Carolina State University–Raleigh has produced an extensive unpublished bibliography of every reference to Frank Lloyd Wright in books, periodicals, and newspapers to 1968, over three thousand listings. In addition to Lyons, James R. Muggenberg published a paper entitled "Frank Lloyd Wright in Print, 1959–1970" in *The American Association of Architectural Bibliographies, Papers 9* (1972), which lists 135 books, catalogs, and general works, 414 periodicals, and 15 obituaries on Wright from 1959 (the year of Wright's death) to 1970.

When seeking biographical data on recently significant persons involved in American housing history, researchers should consult the numerous *Who's Whos* and newspaper obituary indexes. Anne Lee Morgan and Colin Naylor's *Contemporary Architects* (1987), a biographical source on notable people in housing, such as architects, planners, engineers, landscape architects, interior designers, and others in related fields, provides additional biographical data on significant persons, including those beyond 1976. In addition to these sources, Les Krantz's *American Architects* (1989) provides a cross reference to prominent living American architects and their works. Included in this publication are biographical sketches, particularly the specialty of each person and illustrations.

Numerous periodicals and journals publish research on biographical data in the field of American housing. *Historic Preservation*, published by the National Trust for Historic Preservation, the *Society of Architectural Historians' Journal*, and the Association for Preservation Technology's *APT Bulletin* are only a few examples of periodicals that focus on history of American housing.

Realizing the importance of housing leaders in the United States, the National Association of Home Builders (NAHB) established a Housing Hall of Fame in 1977. Through extensive research, some four hundred leaders were identified. Of that number, the NAHB voted to recognize only eighteen. Joseph B. Mason's *History of Housing in the United States, 1930–1980* (1982) includes an appendix containing short biographical sketches of these eighteen famous housing leaders and a listing of periodicals and trade magazines as secondary sources. In addition, researchers can contact the NAHB for any updated list of outstanding leaders.

To encourage research on the history of women in architecture, Lamia Doumato published *Architecture and Women* (1988). The introduction to her book describes the scope of the bibliography as well as other important sources invaluable to this book. Recognized in it are pioneers such as Harriet Morrison Irwin, supporter of the octagonal house, who patented the first house plan by a woman. In addition to Doumato's book, Ellen Perry Berkeley, editor of *Architecture: A Place for Women* (1989), explores the work of individual women architects throughout history.

Studies on women in the history of housing as well as documentation of minority leaders in housing are available through other biographical sources, including several that have already been cited in this section. Secondary sources such as *Architectural Digest, Interior Design, ASID Report, Architecture (AIA Journal),* and *Architectural Record*, to name a few that provide biographical information, should also be checked thoroughly.

Bibliographical Resource Guides

Several key words or phrases are used to reference American housing. Many bibliographies are available in subject areas such as *home, housing, domestic architecture, architecture, interior decoration* or *design*, or specific topics, such as *tenement, log cabin,* and *shelters*. Since the list of bibliographies or resource guides is extensive, the authors of this chapter have selected bibliographies noted by dif-

ferent authors or cited in several books as exemplary resources for the study of the history of American housing.

Helen Park's *A List of Architectural Books Available in America before the Revolution* (1973) is a basic bibliography for researchers of the early historical period of housing in America. Helen Park meticulously leads the scholar to books published during this period and to books that are available in America. Most of the sources are practical and detail stylistic, pictorial, and structural studies of colonial architecture. An informative introduction by Adolf K. Placzek outlines for researchers bibliographic sources for the next phase in American history. Placzek also recommends Henry-Russell Hitchcock's *American Architectural Books* (1946, reprinted 1962), which lists all architectural sources published in America before 1895. Any scholar researching housing of this time period should first review these two outstanding bibliographies.

Another bibliography that guides researchers to the American historical period prior to the Civil War is the Frank J. Roos, Jr.'s *Writings on Early American Architecture* (1943). The revised and updated work, entitled *Bibliography of Early American Architecture* (1968), contains 4,377 entries (1,600 entries more than the 1943 edition) of annotated books and articles published before 1860 in the eastern United States. In his introduction, Roos reminds researchers to use more common bibliographies, such as *Art Index* and *Reader's Guide*, to find scholarly resource material.

One of the most comprehensive guides to books, periodicals, and pamphlets for those involved in the research of planning, design, construction, and preservation of the built environment is F. C. Gretes's *Directory of International Periodicals and Newsletters on the Built Environment* (1992). Included in this guide are 1,199 titles from 53 countries with listings such as architecture, regional architecture, building types, historic preservation, planning, environmental design, and housing. Even though the guide cites resources from many countries, it still covers topics on the history of American housing quite well.

A guide of unusually high quality for periodicals is *The Avery Index to Architectural Periodicals*. Produced by Columbia University's Avery Library, one of the world's best collections of books, periodicals, and pamphlets on American architecture. The work includes all crucial American architectural periodicals under subject headings such as *domestic architecture* and comprehended in the widest sense from archaeology to interior design to city planning to housing.

The resource guide by Barbara Smith Shearer and Benjamin F. Shearer entitled *Periodical Literature on United States Cities* (1983) includes selected periodical articles published from 1970 to 1981 based on the informative value of each article and its availability outside its subject city. This guide is useful to students researching specific home types, such as brownstone houses, row houses, shotgun houses, historic homes, and company towns within urban environments.

Another periodical series, edited by Jean Hornstra and Trudy Heath, is *American Periodicals, 1741–1900* (1979). Students, researchers, and others involved in studying the history of American housing will find valuable resource guides, such as

indexes to microfilm on books, periodicals, newspapers, pamphlets, and government documents, in these volumes.

The *Bibliographic Index* provides a subject index to bibliographies printed in books, pamphlets, and periodicals. This helps researchers locate references to well-defined subjects. For example, the 1990 edition of the *Bibliographical Index* lists Mark A. Hewitt's *The Architecture and the American Country House, 1890–1940* as exceptional because of its extensive bibliography located on pages 299–307. Since many authors of books list exemplary primary and secondary sources, researchers should check the classic books on American housing listed under the "References" at the end of this chapter.

The Council of Planning Librarians (Chicago), an association dedicated to the professional interests of planning, provides bibliographies by individual issues and will assist researchers on a housing topic such as housing history. An annotated bibliography published by the Council of Planning Librarians, P. A. Coatsworth, et al., *An Annotated Bibliography and Index Covering CPL Bibliographies 1–253, January 1979–December 1989* (1989) makes reference to bibliographies, such as Joan Draper's *American Dwellings in the 19th and 20th Centuries* (May 1987) on the history of forms of housing and domestic architecture in the United States from 1800 to the present. Draper divided the bibliography into two sections, "Urban, Social, and Planning History," and "Houses and Housing," a list of recent interpretative histories of authoritative books and periodicals. Even though this particular bibliography offers excellent sources, it omits books that illustrate or describe historic houses. In addition, the Council of Planning Librarians, under the editorship of Jean S. Gottlieb, published *Comprehensive Index to CPL Exchange Bibliographies* (1979), containing three volumes (subject, author, and numerical index) and listing 1,565 bibliographies under one or more of 200 subject headings.

Databases are available at libraries through on-line access. The OLIS, an Internet information system, is a global computer network of universities, corporations, and government and private organizations. This smorgasbord of network data changes frequently; therefore, it needs to be explored often. These databases can lead researchers to newspapers, magazines and journal articles, reports, dissertations, government documents, and books on a variety of subjects. For example, researchers could use *Infotrac*, a general periodical index covering only the last three years and a national newspaper index of the top five newspapers. *ABI*, a computerized business index, has current listings on historic preservation and housing issues such as low-income housing and subsidized housing, minority housing, and emergency housing. *Marcive*, a Federal Depository Library publication issued by the U.S. government, includes books, maps, posters, pamphlets, and periodicals. The *Marcive* computer index arranges publications by the Superintendent of Documents–classified number and includes technical information on historic preservation and rehabilitation. In addition to these online databases are *Dissertation Abstracts*, where subjects such as Levittown, slum housing, minority housing, and other current topics can be found. Dissertations and theses

often have excellent bibliographies with current sources. Another on-line computer database that is immensely helpful is *America: History & Life*, which contains abstracts of scholarly journal articles, books, and dissertations on American history. These databases are readily available in most university libraries usually at no fee to researchers. Many additional indexes and databases are in the reference and document department of libraries. Your reference librarian should know about databases that could lead to newspapers, magazines and journal articles, reports, dissertations, government documents, and books on a variety of subjects.

The National Register of Historic Places, established in 1966 by the Department of the Interior, has a cumulative index of more than fifty thousand designations of historic structures. Many are historic houses worthy of preservation. Since the founding of the Historic American Building Survey in 1933, approximately twenty-two thousand historic structures throughout the United States have been documented through written studies, measured drawings, and photographs. Stored in the Library of Congress, this collection is accessible to the public.

One of the best guides to resources on history of American housing is the GEAC Library Information System, the on-line computer search available to students and researchers in most libraries. Resources on topics can be located by author, title, or subject index. In searching for general works on domestic architecture, we found well-indexed bibliographies in scholarly books, such as Albert Farwell Bemis and John Burchard, II, *Evolving House*, vol. 1 (1933), which has 20 pages of general bibliography of housing from its earliest times. Other superior books on housing in America are G. W. McDaniel's *Hearth and Home* (1982), A. Gowan's *The Comfortable House* (1986), C. E. Clark's *The American Family Home, 1800–1960*, (1986) and H. J. Gans's *The Levittowners* (1967).

In addition to discovering these books with well-documented bibliographies, we became aware that certain authors are authorities on specific American housing topics. For example, Herbert J. Gans has authored several books and articles on Levittown, Harold Roger Shurtleff and C. A. Weslager are two well-known authors of books on log cabins, and John Vlach has published several articles on shotgun houses.

THEORY

Theory will be addressed in each chapter as it relates to specific topics within this guide. There are so many aspects of theory as it applies to housing that we have chosen to present two very significant and wide-reaching resource books on the topic. Roger Scruton's *The Aesthetics of Architecture* (1979) studies the theoretical base of architecture and includes an extensive bibliography that would lead the researcher to other sources covering areas closely related to that field. Joy Monice Malnar and Frank Vodvarka's *The Interior Dimension* (1993) is an outstanding resource for theory as applied to enclosed spaces. Comprehensive in approach, well researched, and well illustrated, this book surveys the entire history of theory as it applies to the subject of all enclosed spaces. These two books

will direct the student, researcher, and historian to the significant works in this field.

SIGNIFICANT PEOPLE AND PLACES

Some of the people who significantly influenced the history of American housing, such as Asher Benjamin, A. J. Bicknell, and Catharine Beecher, have been mentioned earlier in this chapter. It would be impossible to list all of the many contributors to the variety of housing styles found across the country; this section will be limited to directing researchers to selected sources typical of the literature available. William H. Pierson, Jr.'s two volumes of *American Buildings and Their Architects* (1970, 1978) cover both residential and public buildings from the Colonial era through the Early Gothic style in an extended, in-depth manner. An extensive bibliography is included as well as excellent illustrations. A good overview of contemporary architecture can be found in Paul Heyer's *Architects on Architecture* (1978).

Samuel McIntire exerted a major individualistic influence on early housing. Frank Cousins and Phil Riley's *The Wood-Carver of Salem* (1916) is an excellent detailed study of his architecture and the carvings in his work. I. T. Frary's *Thomas Jefferson: Architect and Builder* (1931) is an excellent reference for researchers, although there are numerous other books about Jefferson as well as primary sources, including his writings and drawings relating to Monticello and other architecture. Orson Squire Fowler's *A Home for All* (1848) is the primary source for information supporting the theory that the octagon provides the perfect shape for all homes. Three other primary sources on housing in the Victorian period are Alexander J. Davis's *Rural Residences* (1837), showing plans and sketches of Victorian houses; Andrew Jackson Downing's *The Architecture of Country Houses* (1850), popularizing Carpenter Gothic plans and details; and Richard Upjohn's *Rural Architecture* (1852), focusing on the Italianate Revival style.

The classic work on H. H. Richardson is Henry-Russell Hitchcock's *The Architecture of H. H. Richardson and His Times* (1936). Leland M. Roth's *The Architecture of McKim, Mead and White 1870–1920* (1978) is an excellent resource on the firm and includes its history, a building list, and extensive photographic documentation of all completed works.

Some residences throughout American history are more famous than either their owners or their architects. The White House by William Thornton is one of the American national symbols, built for a variety of residents, but not typical of housing in America. The Breakers in Newport, Rhode Island, and Biltmore House in Ashville, North Carolina, are not examples of typical housing, but they are representative of some of the residences built for a select number of extremely wealthy citizens. Both of these buildings are discussed in Paul R. Baker's *Richard Morris Hunt* (1980). Richard Longstreth's *Julia Mae Morgan: Architect* (1977) features the career of the woman architect who designed Hearst Castle for William Randolph Hearst.

Frank Lloyd Wright has likely had more written about him than any other American architect, but there are a few essential resources that will lead the researcher to other information about the man. Frank Lloyd Wright's *Autobiography* (1943) is fundamental in researching the work he accomplished in the first part of his career. His *Natural House* (1954) explains his basic philosophy about design, materials, and housing. One of Wright's unique contributions to housing was his concept of the Usonian House, which was created as a workable, affordable dwelling in the post-Depression era. John Sergeant's *Frank Lloyd Wright's Usonian Houses* ([1939], 1976) is the classic work on this concept of housing. A more recent publication features one of Wright's most famous residences in Bear Run, Pennsylvania. It is Donald Hoffmann's *Frank Lloyd Wright's Fallingwater* (1978).

Charles and Henry Greene, two native California architects known for their use of the Shingle style, are the subjects of Randell L. Makinson's researched study in *Greene and Greene* (1977). Along with the Greene brothers, three other California architects were also extremely important in creating some of the major California houses as well as public structures that led to the creation of a definitive California style: Bernard Maybeck, Irving Gill, and R. M. Schindler. These architects are the subject of Ester McCoy's *Five California Architects* (1975). It is well documented and the photographs are outstanding. Sally Woodbridge and Richard Barnes' *Bernard Maybeck* (1993) is the most complete work published on this important and influential California architect.

Some contemporary architects have attracted attention in book-length studies because of their innovative design concepts. Arthur Drexler's *Charles Eames* (1973) is excellent in presenting the life and works of this contemporary architect and designer, including his architecture and furniture designs. Takenobu Mohri's *Bruce Goff in Architecture* (1970) is the best comprehensive study of this person's work. Paolo Soleri is one contemporary architect who does not represent the average approach to housing. His approach is both theoretical and practical, as evidenced in the city of Arcosanti being built in the desert of Arizona. His *Arcology* (1969) thoroughly explains his work and includes drawings of his planned cities.

TECHNICAL AND OTHER REFERENCES

The understanding of technology, terminology, or historical style that relates to a specific time period is an important factor in the study of historic American housing. Technology advances at such a rapid pace that we can no longer relate to only traditional methods. New materials and ideas as well as different types of families with varied patterns of living have changed the lifestyle of the home throughout history. Chapter 8 is dedicated to technology as it relates to housing, but we have cited certain references germane to this area of history.

Terminology

A premier book on historic housing terminology is Steven J. Phillips's *Old-House Dictionary* (1992), which includes 450 illustrations, 1,500 terms, 750 def-

initions, and 17 useful cross references. The resource section gives extensive listings of excellent dictionaries, encyclopedias, glossaries, and pictorial guides. Also included are selected technical books on historic preservation and restoration, building technology, ornamentation, decorative arts, and related works. Topical sections include books printed either before or after 1950.

A three-volume work by Russell Sturgis entitled *A Dictionary of Architecture and Building (1902)* is an excellent set of volumes for reviewing terminology prior to 1900. A highlight of these volumes, besides their descriptive text, is their pictorial features, which add more clarity for the researchers.

Dictionary of Architecture and Construction (1975), edited by Cyril M. Harris, provides 12,000 original definitions with 1,700 illustrations on all areas of architecture and design, including history of architecture, restoration, and construction methods. Harris also edited another book of value for understanding technical terms and period styles, *Historic Architecture Sourcebook* (1977), which has 5,000 definitions and 2,100 line drawings. Even though these references are not dedicated solely to American historical architecture, they are essential to a study of American housing, for the American house copied styles from different historical periods and from different countries.

James Stevens Curl's *Encyclopaedia of Architectural Terms* (1993) is another source that provides a comprehensive and practical guide to the terminology used in buildings. It contains over 3,500 terms covering various aspects of architecture. For those involved in the research of historic American house interiors, Martin Pegler's *Dictionary of Interior Design* (1966) offers a comprehensive, well-illustrated dictionary of terms. This dictionary helps to develop an understanding for the historical origin of a style as well as its current meaning.

Styles

Five glossaries and/or pictorial guides used for style identification are important to students researching American housing. Virginia McAlester and Lee McAlester's *Field Guide to American Houses* (1984) covers architectural styles and forms. The McAlesters provide a topical listing of house types in addition to a visual glossary. Carole Rifkind's *Field Guide to American Architecture* (1980) is a useful reference for identifying American architectural style types. Rifkind writes that her guide is for "the student in search of a tangible record of culture." There are more than 450 informative drawings of American buildings to represent architectural types, and Rifkind divides these drawings (mostly by the Historic American Building Survey [HABS] or the Historic American Engineering Record [HAER]) into four sections by building types—residential, ecclesiastical, civic, and commercial—and a general section on utilitarian buildings. The residential section covers from 1670 to 1940 and has a descriptive section on each style with discussions on the materials, the plan, and the elevation.

The third book of value is a style book by Marcus Whiffen, *American Architecture Since 1780* (1969, revised edition 1992), which identifies American architec-

tural styles. The book is both descriptive and pictorial. The above guide books give information on exterior architectural styles, not on historic interior styles. William Seale fills in this gap with his book, *Recreating the Historic House Interior* (1979), which includes methods of analyzing the historic house, specifically floors, wall coverings, and lighting. Seale includes over 100 illustration and an informative bibliography. Lastly, Stephen Calloway and Elizabeth Cromley's *Elements of Style* (1991) provides a comprehensive visual survey of the styles impacting American and British interior architecture. The 3,000 analytical drawings and historic engravings, 350 in color, and 1,000 black and white photographs provide a systematic guide to interior features, such as doors, windows, walls, floors, ceilings, and staircases. Visual surveys on small architectural details, such as moldings and door hardware, are also included. The authors devised a quick reference system using color-coded tabs to help users locate each feature.

Technical Data

One of the best sources for technical information is scattered throughout many books and periodicals. Two well-known periodicals that offer technical data about historic structures are *The Old House Journal* and *Association for Preservation Technology [APT] Bulletin*. *The Old House Journal*, probably the most popular and most recognized source, presents detailed information on a wide variety of restoration and preservation techniques. The *APT Bulletin* is the most scholarly and scientific technical journal, encompassing all architectural areas of preservation. Both periodicals offer excellent information on historic American buildings, including houses.

Many books offer technical knowledge on historic American houses. Two classic examples are Herbert Gottfried and Jan Jennings's *American Vernacular Design, 1870–1940* (1985) and Jennings and Gottfried's *American Vernacular Interior Architecture, 1870–1940* (1988). In the prefaces of both books, the authors describe their purpose and outline valuable references. *American Vernacular Design, 1870–1940* is for those interested in the study of architectural history, because it has an excellent glossary, discussions of exterior architectural components, and classification of architectural design styles. *American Vernacular Interior Architecture, 1870–1940* concentrates on the elements and systems of vernacular interiors. In addition to the technical information provided within the text of the book, the authors include an extensive bibliography, topically divided into government and university bulletins, general works, handbooks and dictionaries, monographs and articles, pattern books, and selected trade catalogs.

The National Park Service's Cultural Resources Program provides a variety of services, including the publishing and distributing of technical information in the form of books, technical leaflets, microfilm, microfiche, slide/tape shows, and databases. Technical data is also available through the periodical *Cultural Resource Management*, produced by the Cultural Resources Program. Some of the feature

articles cover preservation topics. The National Park Service encourages anyone needing technical assistance or a specific document to write to the national office.

The *Preservation Briefs*, published by the National Park Technical Information Service, assist persons interested in historic buildings in recognizing, solving, and repairing those problems. There are presently thirty-two *Preservation Briefs* addressing such topics as historic ornamental plaster, historic flat plaster, identifying significant interiors and finishes, and exterior paint problems. The National Technical Information Service also publishes *Preservation Tech Notes*, which provides solutions to specific historic house problems; for example, a typical article is "Temporary Protection of Historic Stairways." Periodically the National Park Technical Information Service publishes new editions of *Preservation Briefs* and *Preservation Tech Notes* as needed.

The U.S. Government Printing Office also offers more than fifteen thousand different sources, such as books, pamphlets, and periodicals, for purchase through the Superintendent of Documents. Information is published on a broad range of topics, including technical data pertaining to historic houses.

As previously mentioned, governmental technical information also can be located through on-line computers and databases such as *Marcive*. Organizations such as the National Trust for Historic Preservation, local historical societies, professional groups such as the American Institute of Architects, and local, state, and national museums offer technical services for historical research in America.

PERIODICALS

Journals and popular magazines containing articles on the history of American housing are more beneficial if divided according to chronological periods. Tracing the history of magazines through specific books offers this data. Frank Luther Mott's *History of American Magazines, 1741–1850* (1930) is a most informative publication on American magazines in general. Mott makes the point that many magazines were illustrated with engravings, which may be useful to architectural historians. The first lithograph printed in America, published in an 1819 magazine, was of a contemporary American house. Engravings by notable American architects could be found in a wide range of periodicals, not just architectural journals. For example, an 1801 edition of the legal journal *Port Folio* included an aquatint by the architect William Strickland. Magazines published as literary works may also have illustrations pertinent to the study of housing.

In addition to the above, many authors include useful appendices. Mott, for example, includes a chronological listing of magazines and a chronology showing relationships among periodicals; however, only those magazines listed in the text are cited, and no recording of the names of libraries where magazines are found is included. E. B. Titus (ed.), *Union List of Serials in Libraries of the United States and Canada* (1965), records over 150,000 titles and indicates holdings of each title in major United States and Canadian research libraries. To find current periodicals, check *Ulrich's International Periodicals Directory*, which list periodicals

under broad categories including architecture, interior design and decoration, and housing and urban planning.

It is important to students or researchers to acquire a general knowledge of periodicals. Gwendolyn Wright's *Moralism and the Model Home* (1980) presents the models of Chicago home and family over four decades. She mostly uses printed media of three kinds: professional press (architectural books and periodicals), practical press (trade books and journals), and popular press (popular magazines). Clifford E. Clark, Jr., *The American Family Home, 1800–1960* (1986), and "Shelter Magazines" in L. Taylor and Cooper-Hewitt Museum (eds.), *Housing: Symbol, Structure, Site* (1982), both have excellent bibliographies, including periodical data; however, for quick reference Clark's article gives a more succinct history of the popular magazine as it relates to housing in America. He states, "Thus, over the past century and half, the influence of housing and shelter magazine has remained fairly constant." With this idea in mind, the authors of this chapter decided to divide the discussion on periodicals into two sections, popular magazines and professional journals.

Popular Magazines

Godey's Lady's Book, started in 1830 as the *Lady's Book*, not only had an impact on the home, but also on the publication of other magazines in America and Europe. The publisher, Louis A. Godey, featured a section in his magazine to promote home ownership and showed American designs of farmhouses, cottages, villas, and other home designs. Due to this inclusion of home designs, some 450 model home plans were published between the years 1846 and 1898 (Wright 1980, p. 11).

Specific housing styles can be traced through popular magazines. As Clark describes in his article, the Gothic revival cottage was depicted by Godey as the perfect home for "a Christian family." From the *Godey's Lady's Book* plans over 4,000 houses were built (Clark 1986, p. 82). Other popular magazines, such as *Ladies Home Journal* (1883–present), *Woman's Home Companion* (1897–1957), and *Good Housekeeping* (1885–present), expanded the woman's vision on house decoration. Of these three *Ladies Home Journal* became the most popular (Clark 1986, p. 82). Edward Bok, editor of *Ladies Home Journal*, published "model *Journal* houses" that embodied middle-class demands (Wright 1980, p. 136).

The last quarter of the nineteenth century saw a great increase in popular magazines, such as *House Beautiful* (1896–present) and *House and Garden* (1901–present). *House Beautiful* included articles on social issues, such as tenement housing problems, while other articles appealed to the woman in the Christian home. Progression toward the twentieth century created another direction for these magazines. New designs by professional architects such as Frank Lloyd Wright, Charles White, Myron Hunt, and others of the Prairie School began to appear, showing a change from the traditional style house to the more progressive style of the early twentieth century.

In the early part of the twentieth century, Bok's *Ladies Home Journal* published two of Frank Lloyd Wright's model houses; the first had the title of "A Home in a Prairie Town" (Wright 1980, p. 137). His plans showed rooms designed around the hearth, a familiar picture of what was to come. Specialized magazines such as *The Craftsman* (1901–1916), edited by Gustav Stickley, and *Country Life in America* (1899–1901) featured the bungalow, a deviation from the Victorian house of the nineteenth century (Clark 1986, p. 83). These magazines appealed to upper-class Americans.

The late-nineteenth- and early-twentieth-century concerns for a healthy environment for the family created a crusade for magazines, such as *American Kitchen Magazine* (1894–1908) (Clark 1986, p. 83). Publishers of these magazines wrote about the healthy home as the prevalent design for the family.

Increased publication of these popular periodicals is evident from their proliferation in classic secondary sources or serial holdings. Today, magazines such as *Better Homes and Gardens* (1922–present) still features articles on housing for the middle class and concerns for today's housing problems including homelessness, slums, and emergency housing needs. Current magazines also reflect the interest of the middle class for renovation and remodeling. One of the leading home magazines of today, *Metropolitan Home* (1969–present) still depicts the importance of the suburban home and its traditional roots. Styles from the past are adapted to these contemporary houses.

For students or researchers of historic American housing, popular magazines are excellent resources. As Clark notes, popular magazines have been around for 150 years and are still providing for the needs of the middle class (Clark 1986, p. 83).

Professional Journals

William P. Longfellow, the first editor of the first professional journal for architects, *The American Architect and Building News* (1876–1938) published articles defining true architects as distinguished persons for their knowledge of design (Wright 1980, p. 48). Longfellow opposed the self-trained carpenter-builder who had captured the housing market during the 1880s. Many well-known architects of that era published their housing designs in this magazine. In February 1883, the *Inland Architect and Newsletter* (1883–1908) began publication in Chicago. This journal represented the Midwestern professional, while *American Architect* recognized the Eastern development (Wright 1980, p. 71).

During the late nineteenth and early twentieth centuries, there was great hostility between the professional architect and the carpenter-builder, who was more accepted by the middle class as a home designer. Many architects thought of themselves as elitists and therefore only designed large houses for the wealthy. In the 1880s, 1890s, and well into the 1900s, many publishers introduced magazines such as *National Builder* (1884–1924), *The Carpenter* (1881–1902), and *American Builder* (1868–1895) for the trade instead of professional periodicals. These trade

publications had wide circulations similar to popular magazines. "*National Builder*, for instance, could boast 9,000 subscribers by 1900, and 29,000 by 1910; *The Carpenter* had 15,000; the *Building Monthly* 16,000; and *Shoppell's Modern Houses* [1884–1894] 18,000 by that date. By comparison, the *Inland Architect* had only 4,000 and the *American Architect* 7,500" (Wright 1980, p. 184). While trade magazines such as *American Builder* published articles to help educate the carpenter-builder and illustrations of small cottages, suburban houses, and apartment houses, professional journals included articles about professional ideals, theory and criticism, and philosophical subjects.

Herbert Croly, editor of the New York–based *Architectural Record* (1891–present) between 1900 and 1909, wrote philosophical and theoretical papers claiming the authority of architects who were "to go forth like missionaries" (Wright 1980, p. 50) and to lead the country into the purity of educated ideas. *Architectural Record* is still published today, and when studying the history of American housing, readers will find it to be one of the most valuable primary sources available.

A survey of bibliographies in standard books published on the history of American housing verifies that most primary housing periodicals are popular magazines or builder trade magazines. The dominant three professional journals as primary sources are *American Architect, Inland Architect,* and *Architectural Record.*

On the other hand, numerous excellent secondary sources are available to students and researchers. To list all of these journals would be impossible; however, researchers can find something on most every type of housing. *The Society of Architectural Historians Journal* (1940–present) publishes scholarly articles on the history of American housing; *The Magazine Antiques* (1922–present) and *Architectural Digest* (1920–present) print informative materials on the history of significant mansions and on significant historical interiors. *Winterthur Portfolio* (1964–present) includes scholarly articles on historic topics and often on regional differences in American housing history, and the *American Anthropologist* (1899–present) contains articles on anthropological subjects such as Native American housing.

In addition, professional organizations publish their own scholarly journals, and some organizations may have several. For example, *Architecture (AIA Journal)* (1913–present), *Journal of Interior Design Education and Research* (1976–present), *American Planning Association Journal* (1925–present), and *Historic Preservation* (1949–present) include specific topics relative to the history of American housing.

Local and state historical societies have journals that cover topics on regional housing history; famous builders, architects, or housing developers from the past; significant mansions in the area; and technical or construction techniques unique to the region. Certain museums such as the Winterthur or the Museum of Southern Decorative Arts publish their own journals. Bibliographical guides reference these periodicals under a subject dealing with a specific period. The National Trust for Historic Preservation's *Index to Historic Preservation Periodicals* (1988) lists articles on preservation published since 1979.

Periodical index guides, books, computers, and knowledgeable librarians are

important guides to periodicals. Online computer databases include guides to periodical literature, such as the *Reader's Guide to Periodical Literature* (1983– present). It is important that researchers always check with a reference librarian to uncover what is available.

As researchers of American housing history become more familiar with their subject, it will become apparent that certain journals or magazines print certain subject areas. In fact, Clark notes that time has changed little as far as periodicals are concerned. Today we still have the popular magazine for the woman of the house, the professional magazines for the scholarly and educated, and the trade magazines for the professionals, builders, and tradesmen.

TOPICS FOR RESEARCH

> History seems to be more and more important for our understanding of where we are today.
> —Beyer (1965, p. vii)

Investigation into the history of American housing could make an impact upon the design of houses today. As Beyer stated, continued study of the history of American housing is of increasing importance. The answer to the future could be found in the lost knowledge of yesterday. Researchers of American housing history may be able to help solve the numerous problems facing America, such as homelessness, the growing number of elderly, and the redefinition of the family. With the advancement of women and the recognition of ethnic groups in America, a new field of research remains to be explored. The sample topics listed below are only to spur the imagination of students, researchers, and the historians.

Studies of historic housing designs to solve current housing problems.

Studies on lesser known architects involved in housing.

Research topics on the history of interiors relative to terminology, technology, and styles.

Research to document significant interiors in lesser known environments.

Studies on minorities involved in American housing history.

Photographic or video documentation of historic houses.

Research on unusual American housing, such as houseboats, waterhouses, and trailer houses.

Studies of regional housing adaptation in remote areas in relation to those in urban environments.

Surveys and documentation of remote company towns.

REFERENCES

BOOKS AND ARTICLES

Alcott, W. A. (1857). *The laws of health.* Boston, MA: J. P. Jewett.

Alexander, D. B. (1966). *Texas homes of the nineteenth century.* Austin, TX: University of Texas Press.

Andrews, W. (1955). *Architecture, ambition and Americans.* New York: Harper and Brothers.

Atwood, D. T. (1867). *Atwood's rules of proportion.* New York: D. T. Atwood.

Baker, P. R. (1980). *Richard Morris Hunt.* Cambridge, MA: MIT Press.

Beecher, C. E. and Stowe, H. B. (1869). *The American woman's home or principles of domestic science.* New York: J. B. Ford.

Bemis, A. F., and J. Burchard II. (1933). *The evolving house, vol. 1: A history of the home.* Cambridge, MA: The Technology Press.

Benjamin, A. (1797). *The country builder's assistant.* Greenfield, MA: T. Dickman.

Beyer, G. H. (1965). *Housing and society.* New York: Macmillan.

Bicknell, A. J. (1873). *Detail, cottage and constructive architecture.* New York: A. J. Bicknell.

Biddle, O. (1805). *The young carpenter's assistant.* Philadelphia, PA: Benjamin Johnson.

Binford, H. C. (1985). *The first suburbs: Residential communities on the Boston periphery 1815–1860.* Chicago, IL: University of Chicago Press.

Bremer, F. (1853). *The homes of the new world: Impressions of America.* M. Howitt (trans.). New York: Harper and Brothers.

Brown, W. (1848). *The carpenter's assistant.* Boston, MA: B. B. Mussey.

Canty, D. (1990). *American architecture of the 1980's.* Washington, DC: American Institute of Architects Press.

Clark, C. E., Jr. (1986). *The American family home, 1800–1960.* Chapel Hill, NC: University of North Carolina Press.

Comstock, W. T. (1881). *Modern architectural designs and details.* New York: Wm. T. Comstock.

Coolidge, J. (1942). *Mill and mansion: A study of architecture and society in Lowell, Mass., 1820–1865.* New York: Columbia University Press.

Cousins, F., and P. M. Riley. (1916). *The wood-carver of Salem: Samuel McIntire, his life and work.* Boston, MA: Little, Brown.

Davis, A. J. (1837). *Rural residences.* New York: "Published under the superintendence of several gentlemen, with a view to the improvement of American country architecture."

Downing, A. F. and V. Scully, Jr. (1967). *The architectural heritage of Newport, Rhode Island, 1640–1915.* 2nd ed. New York: Charles N. Potter.

Downing, A. J. (1842). *Cottage residences; or a series of designs for rural cottages and cottage villas, and their gardens and grounds, adapted to North America.* New York: Wiley and Putman.

———. [1850] (1969). *The architecture of country houses.* New York: D. Appleton. Reprinted. New York: Dover.

Drexler, A. (1973). *Charles Eames.* New York: Museum of Modern Art.

Dwyer, C. P. (1892). *Immigrant builder, or, practical guide to handymen.* Philadelphia: Claxton, Remsen and Haffelfinger.

Earle, A. M. (1898). *Home life in colonial days.* New York: Macmillan.

Eastlake, C. L. (1872). *Hints on household taste in furniture, upholstery and other details.* Boston, MA: James R. Osgood.

Fish, G. S. (ed.) (1979). *The story of housing.* New York: Macmillan.

Fitch, J. M. (1966). *American building 1: The historical forces that shaped it.* 2nd rev. ed. Boston, MA: Houghton Mifflin.

————. (1972). *American building 2: The environmental forces that shaped it.* 2nd rev. ed. Boston, MA: Houghton Mifflin.

Forman, H. C. (1948). *The architecture of the old South: The medieval style, 1585–1850.* Cambridge, MA: Harvard University Press.

Fowler, O. S. (1848). *A home for all, or, the gravel wall and octagon mode of building.* New York: Fowler and Wells.

Frank, K. A. and S. Ahrentzen. (1991). *New households, new housing.* New York: Van Nostrand Reinhold.

Frary, I. T. (1931). *Thomas Jefferson: Architect and builder.* Richmond, VA: Garrett and Massie.

Gans, H. J. (1967). *The Levittowners: Ways of life and politics in a new suburban community.* New York: Vintage.

Goodnow, R. R. (1914). *The honest house.* New York: Century.

Gowans, A. (1964). *Images of American living: Four centuries of architecture and furniture as cultural expression.* Philadelphia, PA: J. B. Lippincott.

————. (1986). *The comfortable house: North American suburban architecture 1890–1930.* Cambridge, MA: MIT Press.

Hamlin, T. F. (1926). *The American spirit of architecture.* New Haven, CT: Yale University Press.

————. (1944). *Greek revival architecture in America.* New York: Oxford University Press.

Handlin, D. P. (1979). *The American home: Architecture and society, 1815–1915.* Boston, MA: Little, Brown.

Harris Brothers. (1914). *Pleasant homes, practical barns and other buildings.* Minneapolis, MN: Rogers Lumber Co.

Hawes, Elizabeth. (1993). *New York, New York.* New York: Knopf.

Hayden, D. (1984). *Redesigning the American dream.* New York: W. W. Norton and Col.

Hewitt, M. A. (1990). *The architecture and the American country house 1890–1940.* New Haven, CT: Yale University Press.

Heyer, P. (1978). *Architects on architecture.* New York: Walter.

Hitchcock, H.-R. (1936). *The architecture of H. H. Richardson and his times.* New York: Museum of Modern Art.

Hitchcock, H.-R. (1971). *Architecture: Nineteenth and twentieth centuries.* Baltimore, MD: Penguin.

Hitchcock, H.-R., and P. Johnson. (1932). *The international style: Architecture since 1922.* New York: W. W. Norton.

Hoffmann, D. (1978). *Frank Lloyd Wright's Fallingwater: The house and its history.* New York: Dover.

Huntington, C. P. (1981). *Americans at home: Four hundred years of American houses.* New York: Coward, McCann and Geoghegan.

Isham, N. M. [1928] (1967). *Early American houses and a glossary of architectural terms.* New York: De Capo Press.

Kardon, J. (ed.). (1993). *The ideal home 1900–1920.* New York: Harry N. Abrams.

Keefe, C. (1922). *The American house: Being a collection of illustrations and plans of the best*

country and suburban houses built in the United States during the last few years. New York: UPC.

Kimball, S. F. (1922). *Domestic architecture of the American colonies and of the early Republic.* New York: Charles Scribner's Sons.

Kirker, H. (1973). *California's architectural frontier.* Santa Barbara, CA: Peregrine Press.

Longstreth, R. (1977). *Julia Mae Morgan: Architect.* Berkeley, CA: Berkeley Architectural Heritage Association.

McCoy, E. (1975). *Five California architects.* New York: Praeger.

McDaniel, G. W. (1982). *Hearth and home: Preserving a people's culture.* Philadelphia, PA: Temple University Press.

Makinson, R. L. (1977). *Greene and Greene: Architecture as a fine art.* Salt Lake City, UT: Peregrine Smith.

Malnar, J. M. and F. Vodvarka. (1993). *The interior dimension.* New York: Van Nostrand Reinhold.

Markovich, N. (1992). *Pueblo style and regional architecture.* New York: Van Nostrand Reinhold.

Mason, J. (1982). *History of housing in the U.S. 1930–1980.* Houston, TX: Gulf.

Mohri, T. (1970). *Bruce Goff in architecture.* Tokyo: Kenchiko Planning Center.

Mott, F. L. (1930). *A history of American magazines, 1741–1850.* New York: D. Appleton.

Mumford, L. (1924). *Sticks and stones.* New York: Boni and Liveright.

National Architect's Union. (1889). *Modern homes: The perspective views and building plans for sensible low cost houses.* Philadelphia, PA: National Architect's Union.

Newcomb, R. (1940). *Old Kentucky architecture: Colonial, Federal and Greek Revival.* New York: W. Helburn.

Norman, J. (1786). *The town and country builder's assistant.* Boston, MA: J. Norman.

Palliser, C., and G. Palliser. (1878). *Pallisers' American cottage homes.* Bridgeport, CT: Palliser.

Pierson, W. H., Jr. (1970). *American buildings and their architects, vol. 1: The Colonial and Neo-classical styles.* Garden City, NY: Doubleday.

———. (1978). *American buildings and their architects, vol. 2: The corporate and early Gothic styles.* Garden City, NY: Doubleday.

Post, E. (1932). *Etiquette: The blue book of social usage.* New and enlarged ed. New York: Funk and Wagnalls.

Roth, L. M. (1978). *The architecture of McKim, Mead and White, 1870–1920: A building list.* New York: Garland.

Scruton, R. (1979). *The aesthetics of architecture.* Princeton, NJ: Princeton University Press.

Scully, V. J. (1955). *The Shingle style: Architectural theory and design from Richardson to the origins of Wright.* Rev. ed. New Haven, CT: Yale University Press.

Sergeant, J. (1976). *Frank Lloyd Wright's Usonian houses.* New York: Whitney Library of Design.

Shurtleff, H. [1939] (1967). *The log cabin myth.* Reprint. Glouster, MA: P. Smith.

Soleri, P. (1969). *Arcology: The city in the image of man.* Cambridge, MA: MIT Press.

Stevenson, K. C. and H. W. Jandl. (1986). *Houses by mail: A guide to houses from Sears, Roebuck and Company.* Washington, DC: Preservation Press.

Tallmadge, T. E. (1927). *The story of architecture in America.* New York: W. W. Norton.

Taylor, L., and Cooper-Hewitt Museum (eds.). (1982). *Housing: Symbol, structure, site.* New York: Cooper-Hewitt Museum.

Thompson, E. K. (ed.). (1975). *Apartments, townhouses and condominiums.* New York: Mc-
 Graw-Hill.
Upjohn, R. (1852). *Upjohn's rural architecture.* New York: Putnam.
Varney, A. C. (1882). *Our homes and their adornments.* Detroit: J. C. Chilton & Co.
Vlach, J. M. (1976). The shotgun house: An African architectural legacy. *Pioneer America*
 8(1) 47–56; 8(2) 57–70.
———. (1977, Feb.). Shotgun houses. *Natural History* 86(2).
———. (1977). *Sources of the shotgun house.* Ann Arbor, MI: Microfilm transcript.
Waterman, T. T. (1945). *The mansions of Virginia: 1770–1776.* Chapel Hill: University of
 North Carolina Press.
———. (1950). *The dwellings of colonial America.* 3rd ed. Chapel Hill: University of North
 Carolina Press.
Weisman, L. K. (1992). *Discrimination by design.* Chicago: University of Illinois Press.
Weslager, C. A. (1969). *Log cabins in America.* New Brunswick, NJ: Rutgers University
 Press.
Wicks, W. S. (1889). *Log cabins.* New York: Forest and Stream.
Woodbridge, S. B., and R. Barnes. (1993). *Bernard Maybeck.* New York: Abbeville Press.
Woodward, G. E. (1869). *Woodward's architecture.* New York: Geo. E. Woodward.
Wright, F. L. (1943). *An autobiography.* New York: Duell, Sloan & Pearce.
———. (1954). *The natural house.* New York: Horizon Press.
Wright, G. (1980). *Moralism and the model home: Domestic architecture and cultural conflict
 in Chicago, 1873–1913.* Chicago: University of Chicago Press.
———. (1981). *Building the dream.* New York: Panteen.

BIOGRAPHICAL SOURCES

Avery Library. (1980). *Avery obituary index of architects.* 2nd ed. Boston: G. K. Hall.
Berkeley, E. P. (ed.). (1989). *Architecture: A place for women.* Washington, DC: Smithsonian
 Institute Press.
Doumato, L. (1988). *Architecture and women: A bibliography documenting women architects,
 landscape architects, designers, architectural critics and writers, and women in related
 fields working in the United States.* New York: Garland.
Hasbrouck, W. R. (ed.) *The Prairie School Review* (1964–present). Palos Park, IL.
Krantz, L. (1989). *American architects.* New York: Facts on File.
Lyons, Harrye B. (1968). Unpublished bibliography on Frank L. Wright to 1968. Harrye
 B. Lyons Design Library, North Carolina State University, Raleigh, NC.
Mason, J. B. (1982). *History of housing in the United States, 1930–1980.* Houston: Gulf.
Morgan, A. L., and C. Naylor (eds.). (1987). *Contemporary architects* 2nd ed. Chicago: St.
 James Press.
Muggenburg, J. R. (1972). Frank Lloyd Wright in print, 1959–1970. In W. B. O'Neal (ed.),
 The American Association of Architectural Bibliographies, Papers 9 (pp. 85–132). Char-
 lottesville: University of Virginia.
Withey, H. F., and E. R. Withey (1956). *Biographical dictionary of American architects (de-
 ceased).* Los Angeles: New Age.
Wodehouse, L. (1975). *American architects from the Civil War to the First World War: A
 guide to information sources.* Detroit: Gale Research.
———. (1977). *American architects from the First World War to the present: A guide to
 information sources.* Detroit: Gale Research.

BIBLIOGRAPHICAL AND RESOURCE GUIDES

Avery Library. (1975–). *Avery index to architectural periodicals.* 2nd ed., 13th sup. Boston: G. K. Hall.

Bibliographic index: A cumulative bibliography of bibliographies, 1938 to present. New York: H. W. Wilson.

Coatsworth, P. A., M. Ravenhall, J. Hecimovich, and Council of Planning Librarians. (1989). *An annotated bibliography and index covering CPL bibliographics 1–253, January 1979–December 1989.* Chicago, IL: Council of Planning Librarians.

Draper, J. E. (May 1987). *American dwellings in the 19th and 20th centuries: A bibliography.* 3 vols. Chicago, IL: Council of Planning Librarians.

Gottlieb, J. S. (ed.). (1979). *Comprehensive index to CPL exchange bibliographies.* Chicago, IL: Council of Planning Librarians.

Gretes, F. C. (1992). *Directory of international periodicals and newsletters on the built environment.* 2nd ed. New York: Van Nostrand Reinhold.

Hitchcock, H.-R. [1946] (1962). *American architectural books; A list of books, portfolios, and pamphlets on architecture and related subjects published in America before 1895.* Reprint. Minneapolis: University of Minnesota Press.

Hornstra, J., and T. Heath (eds.). (1979). *American periodicals, 1741–1900: An index to the microfilm collections—American periodicals 18th century, American periodicals, 1800–1850, American periodicals, 1850–1900, Civil War and Reconstruction.* Ann Arbor: University Microfilms International.

National Trust for Historic Preservation. (1988). *Index to historic preservation periodicals.* Boston, MA: G. K. Hall.

Park, H. (1973). *A list of architectural books available in America before the Revolution.* rev. ed. Los Angeles: Hennessey and Ingalls.

Roos, F. J. (1943). *Writings on early American architecture; An annotated list of books and articles on architecture constructed before 1860 in the eastern half of the United States.* Columbus: The Ohio State University Press.

———. (1968). *Bibliography of early American architecture; writings on architecture constructed before 1860 in eastern and central United States.* Urbana: University of Illinois Press.

Shearer, B. S., and B. F. Shearer. (1983). *Periodical literature on United States cities: A bibliography and subject guide.* Westport, CT: Greenwood.

Titus, E. B. (ed.). (1965). *Union list of serials in libraries of the United States and Canada.* New York: H. W. Wilson.

Ulrich's international periodicals directory, vols. 1–3. New Providence, NJ: R. R. Bowker.

TECHNICAL SOURCES

Calloway, S. and E. Cromley (1991). *The elements of style.* New York: Simon and Schuster.

Curl, J. S. (1993). *Encyclopaedia of architectural terms.* Rockville, MD: Preservation Resource Group.

Gottfried, H., and J. Jennings. (1985). *American vernacular design, 1870–1940: An illustrated glossary.* New York: Van Nostrand Reinhold.

Harris, C. M. (ed.) (1975). *Dictionary of architecture and construction.* New York: McGraw-Hill.

————. (ed.). (1977). *Historic architecture sourcebook*. New York: McGraw-Hill.

Jennings, J., and H. Gottfried. (1988). *American vernacular interior architecture, 1870–1940*. New York: Van Nostrand Reinhold.

McAlester, V., and A. L. McAlester. (1984). *A field guide to American houses*. New York: Knopf.

Pegler, M. M. (1966). *The dictionary of interior design*. New York: Crown.

Phillips, S. J. (1992). *Old-house dictionary: An illustrated guide to American domestic architecture, (1600–1940)*. Lakewood, CO: American Source.

Rifkind, C. (1980). *A field guide to American architecture*. New York: New American Library.

Seale, W. (1979). *Recreating the historic house interior*. Nashville, TN: American Association for State and Local History.

Sturgis, R. (1903). *A dictionary of architecture and building: Biographical, historical, and descriptive*. New York: Macmillan.

Whiffen, M., and Koeper, F. (1992). *American architecture since 1780: A guide to the styles*. Rev. ed. Cambridge, MA: MIT Press.

GUIDE TO SELECTED PERIODICALS

American Architect and Building News. Boston. 1876–1938.

American Builder. Chicago. 1868–1895.

American Homes and Gardens. New York. 1905–1915.

Analectic Magazine (Literary Gazette). Philadelphia. 1813–1821.

The Architect, Builder and Decorator. Minneapolis. 1882–1895.

Architects' and Builders' Edition of the Scientific American (Scientific American Building Monthly; Architects' and Builders' Magazine). New York. 1882–1911.

Architectural Record. New York. 1891–present.

Beautiful Homes. St. Louis. 1908–1910.

Beautiful Homes Magazine (Homebuilder; Keith's HomeBuilder; Keith's Magazine on Home Building; Keith's Beautiful Homes Magazine). Minneapolis. 1899–1931.

Better Homes and Gardens. Des Moines. 1922–present.

The Carpenter. Philadelphia. 1881–1902.

Country Life (Country Life in America). Philadelphia. 1899–1901.

The Craftsman. Eastwood, NY. 1901–1916.

Everyday Housekeeping (American Kitchen Magazine). Boston. 1894–1908.

Good Housekeeping. Holyoke, MA, and New York. 1885–present.

House Beautiful. Chicago. 1896–present.

House and Garden. New York and Philadelphia. 1901–present.

Inland Architect and Newsletter. Chicago. 1883–1908.

Ladies Home Journal (Ladies Home Journal and Practical Housekeeper). Philadelphia. 1883–present.

Lady's Book (Godey's Lady's Book). Philadelphia. 1827–1898.

Metropolitan Home. New York. 1969–present.

National Builder. Chicago. 1885–1924.

Port Folio. Philadelphia. 1809–1827.

Shoppell's Modern Houses. New York. 1884–1894.

Woman's Home Companion (Ladies' Home Companion). Springfield, IL. 1879–1957.

GUIDE TO CURRENT SELECTED PERIODICALS

Architectural Record. New York. 1891–present.

Architectural (AIA Journal). Washington, DC. 1913–present.

ASID Report [American Society of Interior Designers]. Washington, DC.

American Anthropologist. Washington, DC. 1899–present.

American Planning Association Journal. Chicago, IL. 1925–present.

Architectural Digest. Los Angeles. 1920–present.

Association for Preservation Technology Bulletin. Fredericksburg, VA. 1969–present.

Design Quarterly. Cambridge, MA. 1946–present.

Historic Preservation. Washington, DC. 1949–present.

Interior Design. New York. 1932–present.

Journal of Interior Design Education and Research. 1976–present.

The Magazine Antiques (Antiques). New York. 1922–present.

Metropolitan Home. New York. 1969–present.

Old House Journal. Brooklyn. 1973–present.

Professional Builder & Remodeler. 1936–present.

Society of Architectural Historians Journal. Philadelphia. 1940–present.

Winterthur Portfolio: A Journal of American Material Culture. Chicago. 1964–present.

COMPUTER DATA SEARCHES

ABI

America: History and Life

Dissertation Abstracts

Infotrac

Marcive

SELECTED LISTING OF GOVERNMENT DOCUMENTS

Historic American building survey. Washington, DC: U.S. Department of the Interior.

Historic American engineering record. Washington, DC: U.S. Department of the Interior.

National Park Information Services. *Preservation briefs,* nos. 1–23. Washington, DC: U.S. Department of the Interior.

National Park Information Services. *Preservation tech notes.* Washington, DC: U.S. Department of the Interior.

National Park Service Cultural Resources. *Cultural resources management.* Washington, DC: U.S. Department of the Interior.

National Register of Historic Places. Washington, DC: National Park Service, Secretary of the Interior.

National Trust for Historic Preservation. Washington, DC.

Superintendent of Documents. (Government books, pamphlets, leaflets, etc.). Washington, DC: U.S. Government Printing Office.

3

Housing and the Environmental Social Sciences

Benyamin Schwarz, Roberta Mauksch, and Sandra Rawls

We shape our buildings: thereafter they shape us.

—Sir Winston Churchill

Behind the whole development of free design was the insistent belief that man must live as a free human being, in close contact with nature, in order to realize his own potentialities. America consequently produced her most original monuments where one would after all expected to find them: in the home of individual men.

—Vincent Scully

Psychosocial approaches to residential environments have been developed in response to an increasing concern for the environmental qualities of residential settings. This chapter consists of titles of books, articles, and periodicals related to psychosocial aspects of residential environments. Emerged during the 1960s as the result of both scientific and societal concerns, the field of environmental psychology deals with the study of human behavior and well-being in relation to the sociophysical environment (Stokols and Altman, 1987). Numerous textbooks, research monographs, new journals, and several professional organizations are evidence of the rapid growth of the field in the past decades. Journals such as *Environment and Behavior* (1969), *Population and Environment* (1978), the *Journal of Environmental Psychology* (1981), the *Journal of Architectural Planning and Research* (1984), and organizations such as the Environmental Design Research Association and the environmental sections of the American Psychological Association, American Sociological Association, and the International Association

of Applied Psychology are clear indications of the proliferation of the scientific agenda posed by the environmental dilemmas. This chapter looks at residential environments in their broad sense of home and housing, neighborhood and community with special focus on environmental psychology. The term *environment-behavior* will be used in this chapter to refer to the study of the behavior of people within the context of their physical environment. Three interdependent components of this field—people, behavior, and physical setting—are used here simultaneously. The chapter is divided into two sections that look at the behavior of people that takes place in the physical settings of home and housing.

HOME

A considerable amount of literature investigating person–environment relationships has attempted to answer questions regarding the meaning of *home*. Several studies such as Baker et al. (1987), Csikszentmihalyi and Rochberg-Halton (1981), Hayward (1977), Rakoff (1977), Sebba and Churchman (1986), and Sixsmith (1986) have identified general categories of behavioral interpretations of home and its meaning to its occupants. These categories are listed in Despres (1991): home as a center of control and security for the individual; home as a symbol and reflection of one's ideas and values; home as a basis for physical, financial, and emotional involvement; home as a familiar place that provides its occupants with sense of belonging, rootedness, and place attachment; home as a place to secure and develop relationships with people that one cares for; home as a setting for work, hobby, and leisure activities; home as a haven or a place where one can control levels of social interaction, privacy, and independence; home as a place to symbolize social status; home as a material structure; and home as a place to own.

A variety of writers have discussed the centrality of home in the human existence. Norberg-Schultz (1971), Dovey (1978), and Seamon (1982) discuss the centering qualities of home. Tuan (1977) as well as Dovey (1985) in Altman and Werner (1985) refer to the concept of rootedness and the implications of home as a place from which to reach out and to which to return. The central nature of home is addressed in Jung's (1963) autobiography, which influenced Bachelard (1969). Bachelard also recognized the significance of experiences in people's childhood homes on their other life experiences.

Security and control are defined in the literature as outcomes of needs to satisfy human territorial needs. Taylor and Brower (1985) discussed the perceived and actual control of dwellers as a result of the definition of territory. People's desire to modify their home environments, to place items with special attributes or meaning within the house or around it, and to rearrange their furniture have been interpreted as territorial behaviors that are referred to as personalization. The definition of territory by markers in the neighborhood, property boundaries, as well as in the interior of the house, were also discussed by Brown and Altman (1981; 1983), Brown and Werner (1985), and Brown (1987). In 1966,

anthropologist Edward Hall published *The Hidden Dimension* and introduced the concept of proxemics.Hall explored the meanings that people from many different cultures attach to the use of space. Closely related to Hall's studies of the spatial norms of people is the concept of personal space. In *Personal Space* (1969), Robert Sommer defined it as the area around a person's body into which others may not intrude without provoking discomfort. These two classic books spurred considerable interest in the area of human spatial behavior and have led to the accumulation of a large number of studies during the past decades.

Home fulfills a hierarchy of human needs. On the very elementary basis it provides a shelter. On an additional level it provides psychological comfort by satisfying the human needs of light, comfortable temperatures, cleanliness, and eased movement (Appleyard, 1979). In *Home* (1986) Witold Rybczynski attempted to discover the meaning of comfort as a central concept in the home environment. The home also provides a center for the family and friends and a focal point for maintaining social interaction (Werner, 1987). As much as the home serves the human needs for social intercourse, it also provides the psychological needs for privacy and retreat. It is assumed that the home is where privacy is most needed. Privacy is an interpersonal boundary control process designed to pace and regulate interactions with others. *Desired* and *achieved* levels of privacy are conceived of as an interplay of dialectic forces involving different balances of opening and closing the self to others. Home is a place where persons can control and achieve their privacy goals through personal space, or the area immediately surrounding persons and groups. An uncontrollable feeling of privacy may be a result of isolation or too much interaction, as Westin described in *Privacy and Freedom* (1967). Westin provided systematic analysis of the concept of privacy as well as four functions of privacy: personal autonomy, emotional release, self-evaluation, and limited and protected communication. Anthony (1984) suggested that home environment may have a role in regulating family conflicts over issues of privacy.

Home ownership is associated with privacy in that it is perceived as a higher level of boundary regulation process than renting. Writers concerned with the issues of ownership include Pynoos et al. (1973), Altman and Gauvain (1981), Korosec-Serfaty and Bolitt (1986), and Lawrence (1987). In some cases, people prefer to own a house just for the sake of investment. Agnew (1982) suggests that owners' motivation of that sort predispose them toward a reduced sense of attachment to place.

Attachment to place has been defined as a positive affective association between persons and a geographic location. Shumaker and Taylor (1983) discussed the aspects of attachment to place in residential environments and the evolutionary advantages inherent in these strong bonds between people and places. Rubinstein (1989) described the characteristics of four different levels of attachment to place: knowing the place with no feelings or memories associated with it; having personalized attachment, whereby an individual has memories of place that are inseparable from personal experiences; experiencing highly emotional memories

with place referred to as extension; and embodying the boundaries between the
person and the environment that become blurred (the most intense level). Similar
experiences of individuals that have spent a lifetime in a house and elicited feelings
of attachment, whereby their personal identity became interwoven with the place
identity, were also described by Howell (1983). The passage of time appears to
be central in the process of developing attachment to place. Consequently, elderly
people are often the most strongly attached to their homes. Rowels (1988), and
Rubinstein and Parmelee (1992) Taylor (1988), and Rubinstein and Parmelee
(1992) are three examples out of many in this field. Last in this section is Altman
and Low (1992).

Home is also important in maintaining the bonds between people in their social
circles. Most family and marital relations occur within the home context. Saile
(1985) reflects a person's place in the family and role of the home in preserving
the family's social fabric. Extensive research literature exists on these topics.
Works concerned with the concept of home as a set of social interactions include
(Balton 1994), Cooper (1974), Horwitz and Tognoli (1982), Csikszentmihalyi
and Rochberg-Halton (1981), Tognoli and Horwitz (1982), and Staines and Pleck
(1983).

Home in sociocultural context attracted many anthropologists who often refer
to the terms *house* or *dwelling* rather than *home*. Amos Rapoport (1969) wrote
extensively on the connection between *house form and culture*, claiming that
physical features such as climate, construction methods, and availability of
materials may have a secondary role in the construction of houses. According to
Rapoport, the sociocultural factors such as way of life, societal ordering,
attendance to basic needs, family structure, position of women and men, privacy,
territoriality, and social organization and social relations are the primary factors
in the interplay of environmental and cultural interaction. In Duncan (1982),
Rapoport argued that the dwelling is an inseparable part of the culture in which
it is located. He noted that sociocultural identity of the dwelling is partly expressed
according to ordering systems such as front–back, male–female, sacred–profane,
and good–bad. A pivotal concept is Rapoport's conceptual framework stressing
that "in reality the main effect of environment on people is through choice or
habitat selection," where choice applies to issues such as design, habitat selection
at various scales, modification, furnishing, and other existing components of
home environments.

Acting as a transition between the two sections on home and housing is the
use of the terms *home* and *house* which seems to be used interchangeably too
often in the literature. Altman and Chemers (1980), for instance, treated *house*
and *home* as synonymous terms when they proposed several categories for
classifying homes according to their permanence, portability, homogeneity,
and communality. They suggested that North American homes tend to be
permanent, specialized/differentiated, and noncommunal. Likewise, Rapoport
treated the concept of the home environment as "part of a larger, culturally
variable system of settings within which a particular set of activities take place."

Other writers, however, preferred different definitions. Dovey (1985) asserted that "the phenomenon of home is an intangible relationship between people and places in which they dwell; it is not visible nor accurately measurable." He went on to argue that "reason responds to intangibility by reducing terms such as *home* to precise and bounded definitions. Rationally considered, a home becomes reduced to a house—the meaning and experience of home as a relationship becomes confused with object through which it is currently manifest" (p. 52).

HOUSING

While *home* is both a physical place and a cognitive concept, *housing* is a term that can be many different things to different people. The very multiplicity of meanings and uses of housing can be seen as a defining characteristic of the field. It may be defined as a form of built environment, but housing is not just hardware. It is also more than just the dwelling. *Housing* in this context defines the public rather than the private realm. This section reviews articles and books that emphasize the psychosocial aspects of housing as a set of physical and spatial parameters of human habitats. It deals with the following issues: aspects of cognitive evaluation, neighborhoods and communities, crowding, housing for special populations, and issues of race and class in housing.

Aspects of Cognitive Evaluation

Studies of cognitive evaluation of housing environment include those involving perception, preference, satisfaction, meaning and symbolism, psychological stress, development, and learning. Since housing constitutes a major unresolved societal problem, it attracted considerable investigation. Cooper (1975) noted that housing represents one of the most sociobehavioral, salient, and complex classes of built environments. Similar ideas were expressed by Weideman et al. (1982).

Housing perception research represents one of the aspects of cognitive evaluation that describe parameters of dwelling. Marans (1976) reviewed this issue, as have Garling (1972), who has studied the variation, umbrageousness, and openness; Taylor and Townsend (1976), who discussed the length of residence, the age of individual and size of residential area; Nasar (1979), who researched diversity, clarity, and decreasing building prominence; Tobey (1982), who investigated housing as symbol, art, and social status; Gobster (1983), who reported on complexity, contrast, naturalness, and visible development as predictors of suitability of residential structures; Canter et al. (1974), who discussed the influence of attention and activity on defining the focal point of a room; and Volkman (1981), who referred to issues of cleanliness, silence, privacy, energy efficiency, window views, and possible lowered socioeconomic class associations among residents of underground housing.

Housing preference is a second line of inquiry related to cognitive evaluation. Many studies in England, Australia, and the United States indicate that the free-

standing single-family house with a yard represents the ideal housing form that most people seek. Authors who have written about this preference include Michelson (1977), Ward (1976), Kaplan (1977), Cooper (1974), and *Professional Builder* (1985). Irregular forms of housing and those with the lowest levels of massing are also preferred, as Faletti (1979) argued. In some cases, studies refer to the nonpreference for multifamily housing, because such dwellings reduce residents' control and lack properties of self-expression (Robinson, 1980). People prefer styles of houses that bolster their image of themselves, as noted by Cherlnik and Wilderman (1986) and Nasar (1989).

A variety of studies on housing prove the anecdotal evidence that home buyers select the house they want on the basis of their aesthetic appeal. Nasar (1993) addressed this issue by looking at similarities and differences in preference and meaning across sociocultural groups and regions. Arias (1993a) explored the role of housing preference in design. Arias (1993b) studied whether consumer housing preference was altered by the outcomes of a design process. Sanoff (1973) examined significant factors that influence housing preferences among teenagers in conjunction with the types of houses reported. Issues such as modernism, humanism, stimulus-seeking/exploratory behavior, and territoriality were central preference factors.

Housing satisfaction is another area of concentration related to cognitive evaluation. Reference to satisfactory management–tenant concerns appeared in Cooper (1972), Newman (1972), and Anderson and Weidemann (1979). Comparison with other alternatives of residence seem to be another factor in housing satisfaction. If, for instance, the dwelling compared is perceived to be equal to or better than the current dwelling, residents will probably report dissatisfaction. However, if the dwelling compared is inferior, then it is likely that residents will experience satisfaction. Writers who focused on these aspects include Campbell et al. (1976), Michelson (1977), and Saegert (1980). Several researchers who dealt with housing satisfaction based on the characteristics of the physical setting referred to the availability of storage place, types of furniture, and room arrangement as indicators for satisfaction. Authors who approached satisfaction from this perspective include Lansing et al. (1970), Hanna and Lindamood (1981), Mackintosh (1982), and Morrissy and Handal (1981).

Most writers reviewed here tended to characterize settings in terms of stimulus dimensions and how these dimensions affect individuals who are exposed to them. Their approach most often emphasized housing as systems that individuals adapt to by conforming to demands from environmental stimuli or by changing the environment, causing it to conform to their needs by adjustment. Another point of view within the field of environment and behavior is that taken by physical designers, who are responsible for the success or failure of housing environments to meet the needs, goals, and day-to-day behaviors of their inhabitants. Written from this perspective is Studer (1988), which is focused on the issues and processes involved in the design of housing with emphasis on the sociophysical knowledge and its utilization in the design process of housing environ-

ments. John Zeisel is a researcher who tried to provide directions to overcome the impasse that seems to exist between theoretical knowledge generation and its utilization in the design field. Zeisel (1981) and Zeisel and Griffin (1975) are good examples of the effort to close the gap between theory and practice. Similar efforts are Brill (1982) and Cooper Marcus and Sarkissian (1986).

Meaning is another concept that is used in association with cognitive evaluation research of housing. The use of housing gives it its meaning, and at the same time meaning influences the way housing is used. Arias (1993a) is a collection of chapters by various contributors who focused their discussions on the interplay between cognitive and emotional reaction to housing as well as the actions that are supported by the sociophysical settings. In it Francescato (1993) argued that the term *meaning* signals the intention to approach housing from the communication point of view. According to Sadalla (1987), houses and their contents are part of the language of signs and gestures that individuals use to communicate with each other. Rubinstein and Parmelee (1992) argued that the orientation toward environmental meaning versus environmental function is a relatively new line of inquiry in the field of environment and behavior. Studies have indicated that environmental meaning results from individual experiences and factors such as personal and cultural filters or social constructs. This theme is central to Rapoport (1982), which describes how the environment takes on special human meanings in different social and physical settings. The approach to housing through its meaning raises questions such as for whom the meaning is defined (residents, architects, policy makers, housing managers, or other customers of the housing system), scale of reference (home, building, complex, neighborhood, community, city), use, and time.

Neighborhoods and Communities

In examining residential environments one has to address the impact of the location and the neighborhood as a central factor in housing quality. For city planners the neighborhood "has been conceived as a building block in creating larger communities and has been defined by particular physical boundaries and specific number of people" (Marans 1976, p. 132). Other researchers, such as Gans (1962) or Lee (1978), suggest that this conception may be less meaningful to residents than groups of houses, or one or two blocks. Connerly and Marans (1988) described neighborhood quality in four primary dimensions: (1) the quality of the physical environment, (2) proximity and convenience to shopping or work, (3) the quality of local services and facilities, and (4) the quality of the neighborhood's social and cultural environment. Other studies that attempted to develop systematic methods for observing neighborhoods include Clay (1980) and Jacobs (1985). Several researchers argued that using data to describe quality of neighborhoods has to be indicative of the quality of neighborhood life as experienced and perceived by the residents living there. Marans and Rodgers (1975), Scharf (1978), and Brudney and England (1982) are samples of this theme.

Goffman (1959) distinguished between the "front regions" of the house that are constantly exposed to the public and the "back regions" that usually are off-limits to visitors and where residents feel higher levels of privacy. It seems obvious that through physical proximity residents of one house are forced to interact with those living in nearby houses. Festinger et al. (1950) found that friendships are influenced by nearness of distance and shared paths. Neighborhood can be described in terms of physical characteristics such as size and area, type and condition of housing, and location, as mentioned in Taylor (1982). Greenberg et al. (1984) related neighborhood to crime. Other researchers described neighborhoods in terms of their social organization. Warren (1981) developed a typology of neighborhoods based on interaction, identification, and connections. He found that the social organization of a neighborhood was related both to the reciprocity among the neighbors and to general well-being.

Neighbors often serve as support systems for individuals, providing emotional and material aid; therefore, the concept of *neighboring* was studied by many researchers, including Gans (1962), Jacobs (1961), Suttles (1968), Michelson (1976), Heuman (1979), and Argyle and Henderson (1984). Altman and Gauvain (1981) studied the time and the expense that homeowners in middle-class suburban areas devote to the upkeep of the fronts of their houses. They argue in Liben et al. (1981) that by maintaining the yard and displaying appropriate amounts of holiday decoration, people show what "good neighbors" they are. All these writers emphasize social interaction that derives from community. Harshbarger (1976) described the psychological effects of a crisis and the need to consider neighborhood social network to accommodate neighbors' needs in planning environments.

Neighborhoods provide shelter and essential commodities for residents. The dual phenomena of neighborhood and neighbors reflect on a social foundation and interchange across individuals and groups that constitute the commerce of neighborhood life. Rivlin (1987) suggested that it is possible to consider neighbors as more than residents of a defined locale. The people who provide services or who "hang out" in an area help to define the social neighborhood's borders by their interaction with the local residents.

For some cultural groups the area of residence incorporates all aspects of life. Their neighborhood is where they shop, nurture children, acquire social services, celebrate holidays and events, recuperate from illness and tragedy, and enjoy recreation. However, this is not the typical experience of neighborhoods today. Out-migration and turnover have become more familiar patterns of neighborhoods. Changes in family structure and residential patterns have changed the function of local areas, as Horwitz and Tognoli (1982) noted. Members of families are dispersed and older adults stay in "naturally occurring retirement communities." Articles regarding these topics include Riche (1986) and Hunt and Ross (1990). Other neighborhood changes have come from the use of the automobile, which has extended people's horizons beyond their immediate areas, altering not only families' recreation patterns but also people's shopping habits. The intro-

duction of the mall and recreational shopping has contrasted sharply with the neighborhood-based stores and the open markets of the past, as Sommer (1981) argued.

In his book *The Fall of Public Man* (1978), Richard Sennett analyzed the "end of public culture" and the increasing privatization of life. Whether using computers for virtual-reality shopping and spending more hours in front of television sets will affect community life is a matter for speculation and further research. However, with the invasion of electronics and sophisticated technology into shopping, entertainment, and communication, there is little doubt about the major alterations in people's relationships to their homes and neighborhoods. In spite of the changes in human life and the fact that the local area is no longer the focus, as most people move across the environment to work, seek entertainment, visit families, and for other services, the neighborhood remains the model for urban planning. Neighborhoods still form the basis for new towns in the United States and abroad, as noted by Banerjee and Baer (1984) and Keller (1968).

The roles that community and neighborhood play in people's lives have attracted several studies. Proshansky (1983) described the contribution of the physical setting in forming persons' place identity. The neighborhood is a part of the social, emotional, and cognitive experience of children as they grow up, as noted by Unger and Wandersman (1985) and by Seamon (1979). Not only children are affected by their immediate area. Levinson (1986) has pointed out the relationships of people living in a community with others across the life cycle. Carp and Carp (1982) examined the specific role of the neighborhood in the housing experience of older people. And Rowles (1980) has identified qualities of residents' geographic experiences that "expressed a subtle meshing of place and time, embracing not only physical and cognitive involvement within their contemporary neighborhood, but also vicarious participation in an array of displaced environments" (p. 57).

It is hard to find consensus for the term *community*. Hillery (1955) reviewed 94 definitions of community found in the literature, noting that the three most commonly mentioned elements that define community were (1) social interaction, (2) common ties in the sense of a shared value system, and (3) geographical area. Additional community function as mentioned by Warren (1978) include community in the sense of production, distribution, and consumption of goods and services; socialization; social control; and mutual support. Research on community sentiment was divided by Shumaker and Taylor (1983) into three broad approaches: those focusing on community satisfaction, community attachment, and identity and community life. Studies of community satisfaction include Campbell et al. (1976), Guest and Lee (1983), Fried (1982), and Herting and Guest (1985). Studies of community attachment include Hunter (1978) Gerson et al. (1977), Sampson (1988), and Goudy (1982). Authors who discussed identity, place, and community sentiment include Lavin and Agatstein (1984), Rapoport (1982), Cochrane (1987), Goldfield (1987), Rivlin (1987), Altman and Wandersman (1987), Landman (1993), and Hummon (1990).

Van Vliet and Burgers (1987) argued that a combination of political lobbying, economic pressures, and the cultural climate in North America have driven the extensive residential development characterized by the single-family dwelling built in low densities. The authors claimed that these patterns of population densities do not provide the critical mass of people to support services and jobs in concentrated areas. Similar ideas are shared by authors who have studied the community concept at the neighborhood level, including Barnerjee and Baer (1984), Hallman (1984), and Wireman (1984). Social scientists have found the concept of *neighborhood* useful to describe the intermediate level of social organization between home and city. Neighborhoods allow people to achieve a sense of community, as McAndrew (1993) noted. The concept *sense of community* appeared in Holahan and Wandesman (1987) and Nisbet (1962). Chavis et al. (1986) defined the term as "a feeling that members have of belonging and being important to each other, and a shared faith that members' needs will be met by their commitment to be together" (p. 25).

Taylor (1988) argued that street blocks are the focus of neighborhood ties and are physically bounded behavior settings that encourage territorial control by inhabitants. Neighborhood norms develop on what constitutes acceptable behavior. Neighborhood turnover, instability, and lower quality housing decrease territorial marking, resident satisfaction, and the appearance of control, as Taylor (1987) argued. Research confirms the notion that neighborhoods consisting of multistory apartments are less cohesive and have less of a sense of community than neighborhoods with single-family dwellings; see, for instance, Weenig et al. (1990).

Neighborhood design is associated with the mistakes made in the design of public housing projects in many American cities. Errors in the design of public housing projects are magnified by the unfortunate circumstances faced by the residents of these types of housing. The demographic profile of people who most often need public housing consists of low-income and unemployed residents, the elderly, females, and minorities. The location of many of the public housing projects near areas with high crime rates combined with the lack of social networks in these neighborhoods breed feelings of fear and danger. Analysis of residents' experiences in neighborhoods of public housing may be found in Greenberg and Rohe (1986). Social scientists have tied the illnesses of life in public housing projects to their physical environment. The best known account of life in public housing and its linkage to the architecture occurred in the Pruitt-Igoe housing project in St. Louis, Missouri. Yancey (1971) described the fearful life of assault, rape, and drugs of Pruitt-Igoe residents. Rainwater (1970) provided a full description of the institutions and processes that determined the content and style of minority lower-class life in 1970s America. Many environmental and behavioral researchers jumped onto the theme that the design of Pruitt-Igoe did not consider the social and cultural needs of the prospective tenants and was not "defensible space" as defined by Newman (1972). The "failure" of much of public housing has been attributed to the failure of policy makers and architects to understand

the activity systems and aesthetic values of people in whose culture they themselves were not saturated. The breakdown of life in public housing projects was linked with economically built, badly maintained, dangerous-to-live-in high-rise structures. While the criticisms have some validity, they overlook a more fundamental issue. In contrast to many forms of housing in the United States, these large-scale high-rise projects are publicly owned. Public ownership, usually by municipal authorities, creates dependency upon public appropriation to fund regular maintenance and all degrees of rehabilitation and improvement. There is little doubt about the need of environmental designers to nurture a sensitivity to places in terms of their own experiences and to realize the experiences of the recipients of their design. One possible direction for housing design that enables people to make their own choices regarding their housing may be found in Turner (1976), Turner and Fichter (1972), and Habraken (1972). According to Habraken, for example, architects should be responsible only for the overall framework of housing and the inhabitants should be responsible for the infill. This approach to housing design limits the role of environmental designers to exterior structures and leaves the interiors for people's desires and needs. Nevertheless, the physical design of public housing is only one factor in its success or failure, but the discussion of this important issue is beyond the scope of this chapter.

The "New Towns" of the 1970s combined construction processes with community and regional issues. This housing program included thirteen new community projects funded by the Department of Housing and Urban Development (HUD). New Towns were planned to have combinations of dwellings with workplaces for both social and resource benefits. Another social goal was to create communities that would integrate people from various racial, ethnic, and income backgrounds. A third goal was the provision of better land use planning. Although idealistic in principles and planning, most of the New Towns failed due to problems with bureaucratic delays and inflation, difficulties with coordination of federal agencies, and corruption in the administrative and building agencies (Flannery, 1994). A look at the New Towns program is provided in three articles in Wedin and Nygren (1976, 1978). The articles, written several years apart, range from an idealistic discussion of the potential of the New Towns program to a "how did it happen" account of the failure of the program. The history of the New Town program is also examined in Vance (1988) and in Huttman (1988).

Two trends toward the restoration of community and concern for a more sustainable environment appear to address in their own ways crucial issues of our time. One is the New Urbanism movement, which tries to suggest alternatives to the present decline of America's cities and its poorly planned suburban growth. Katz (1994) provides a guide to this emerging movement through documented case studies of new designs that integrate housing, shops, workplaces, parks, and civic facilities into new communities. A closely related concept is *hybrid housing*, "a residential structure which contains both residential and business spaces and activities; residents of that structure occupy and manage both spaces; and such

housing is intentionally designed to incorporate both spaces" (Ahrentzen, 1991, p. 1.).

The second trend is manifested in collaborative communities, which attempt to take a holistic approach to housing by combining housing with gardening, shopping, and workplaces. The essence of collaborative housing is that community is created by meeting everyday needs in a communal way. Fromm (1991) describes communities where residents enjoy the advantages of private homes and the convenience of shared services and amenities. In spite of their vast differences, these trends exemplify the search for alternatives to the present sprawl and isolation of existing American suburbs.

Crowding

Since Malthus predicted in 1798 that overpopulation would lead to mass starvation, the issue of crowding has concerned society. Rowe (1993) discusses the historical issues of nineteenth-century crowds and tenements that led to the first attempt to establish housing standards and norms in the United States. The concepts *crowding* and *density* have been used interchangeably, and there were some concerns that housing too many people too close together would lead to social ills. Stokols (1972) and Altman (1975) have made the distinction between density and crowding. The most generally accepted definition is that *density* refers to an objective measure of the number of people in a given amount of space (feet, acres, miles). *Crowding,* in contrast, refers to a subjective psychological experience based on the situation, personal characteristics, and coping skills that often results in negative feelings. Regardless of the accepted definition in the literature, the U.S. Census Bureau gives an impractical and confusing definition of "overcrowded households" as those with more than one person per room without mentioning the size of the rooms or any personal characteristics.

Huttman and Van Vliet (1988) make the argument that there are several themes and approaches to understanding residential crowding and that no one approach dominates the field. The classic works that describe the different perspectives include the biological perspective in Sommer (1969), the cultural view in Hall (1966), the design perspective in Newman (1972), and the social structural perspective in Anderson (1972) and Mitchell (1971). Baldassare (1988) also discusses major problems and issues related to residential crowding literature, evaluations and suggestions for future research, and recommendations and assessments of future trends.

Zube and Moore (1989) describe the early historical context of crowding research with animals. They build the argument that while physiological evidence of density may be more clear in animal literature and the environment–behavior relationship among people is more complex, there is sufficient evidence that crowding affects physiological balance in humans. Seeking this balance in one's life may be particularly important at home, where there is the presence of the

primary group. Zube and Moore also make the case with research that crowding in transit or in the workplace is not as serious as crowding at home.

A comprehensive work on crowding is Stokols and Altman (1987), which considers the basic issues of residential crowding, population density and animal behavior, density and its correlation with social pathology, and experimental investigation of high density and crowding. In this text, Baum and Paulus (1987) consider the physiological effects of crowding, citing work on crowding and illness among prison inmates, crowding and task performance that considers noise and other stressors, and the social response of withdrawal in high-density areas. Baum and Paulus review the literature on mediating variables and response to crowding as a result of group size, architectural design, and individual differences. They also review studies of chronic exposure to crowding in settings such as prisons and dormitories. Finally, they direct the reader to emerging models of crowding by discussing theoretical approaches to overload, arousal theory, the density–intensity hypothesis, behavioral constraint, control, and integrating competing perspectives. In the conclusion they provide the reader with directions for future research in areas of tolerance, coping, and crowding stressors.

Other researchers that studied the issues of crowding include Zuravin (1986), Booth (1976), Fleming et al. (1987), who report on higher rates of stress and illness in crowded residential neighborhoods, Ruback and Pandey (1991), and Ruback and Innes (1988). Social researchers believe that persons' cultural backgrounds and personal histories of experience with crowding affect their responses to high density. Studies show that architectural features of buildings are the primary factors controlling how crowded people may feel in the environment. Savinar (1975), for example, found that higher ceilings are associated with less crowding. Other studies of the effects of architecture on the tolerance of crowding include Rotton (1987), Desor (1972), and Baum and Davis (1976).

Housing for Special Populations

Both the need for theoretical understanding of the relationship between people and their surroundings and pragmatic concern over mismatch among people, institutions, communities and designed environments have provided the impetus for the paradigm of environment–behavior design. This model, which was based on the conflation of social sciences and architecture, focused on the human beings who occupied buildings and communities, the users. A number of architects and social scientists have anticipated that by incorporating social-behavioral sciences into the architectural design process, the resulting buildings would function better for users and occupants.

However, an examination of the literature in environment–behavior studies reveals that not all of the types of housing are evenly explored. Some housing types were researched more than the others while still other areas were left almost untouched, as one may discover in Wener and Szigeti (1988). It appears that the requirement for matching the needs of human beings with the environment is

more urgent in the cases of housing for special populations. Three special groups have accordingly received considerable attention: the elderly, children, and the developmentally disabled. Housing for these populations are reviewed in the following sections.

In the past thirty years several groups have protested the ways in which American society has attempted to exclude people with disabilities. They have pointed to the architectural environment as the most obvious symbol of how the able-bodied population handicaps the disabled. For a brief history of the various social movements of the 1960s and 1970s as they relate to physically disabled people's activism, see Dejong (1981). Nevertheless, the recent passage of civil rights laws—the Americans with Disabilities Act and the Fair Housing Amendments Act—have extended accessibility into every realm of the built environment, both public and private. The concept of designing for people of all ages and abilities, known as universal design, is a meaningful response to the law as well as to the changing demographics of the aging American society. Universal design is a holistic approach to creating environments and products that are usable by all people regardless of their abilities or age. Lifchez (1987) discusses an innovative experiment in architectural education that took place at the University of California, Berkeley.

Another enlightened approach to housing accessibility is what is called adaptive housing. "This approach specifies that some common access features will be fixed and installed at construction time and that others be made adjustable, and a few other specific features could be added or removed when needed by particular occupants" (Mace, 1990, p. 50). More books about issues of accesibility, disabilities, and adaptive housing may be found in Chapter 7 of this book.

Housing for the Elderly

The subfield of environment and aging developed from the same awareness of the two-way relationship between person and the environment. Still, from its early stages it dealt with the reality that elderly are, statistically speaking, more vulnerable to environmental pressures than the young and therefore the impact of deficits in the environment on their behavior is greater, as Lawton and Simon (1968) noted. Implicit in the provision of housing for the elderly and the research on their impact was the assumption that physical as well as interpersonal aspects of the environment affect outcomes, as Carp (1987) observed. Pastalan (1984) argued that the research paradigm that links life-span changes to design must match "the demands of the physical environment with the competence level of the individual over the life span" (p. 200).

Several investigators developed theoretical models that directly address the definitions of personal and environmental competence. These studies include Lawton and Nahemow (1973), Kahana and Kahana (1983), Carp and Carp (1984), Schooler (1982), Scheidt and Windley (1985), and Moos and Lemke (1980; 1984). The essence of most of these models suggests that the ability of individuals to function within any environmental setting depends on their capabilities and the characteristics of the setting. Gelwicks and Newcomer (1974) have drawn on

the work of Lawton and Nahemow and suggested a model that takes into account an individual's competence to cope with environments and views the problem of functioning as one of matching individuals to the most appropriate setting. The model suggests that the ability to function is the result of interaction between individual capabilities, such as physical health and environmental support, and resources and incentives in the environment for use of services. Describing the model, Faletti (1984) noted that the match of individual capabilities with an environment of a particular structure happen within a zone or range of adaptability. Mismatches that create oversupport lead to dependency, whereas those that create undersupport can result in diminished levels of functioning and increased levels of stress.

As people age they must make a fundamental decision whether to stay in their existing dwelling and age in place or to move to a new location that may offer a completely different type of living accommodation. Golant (1992) reviewed the options that confront older people seeking to change their housing situation to fit their changing lifestyles. Under the housing options that encourage residential relocation by older persons Golant listed age-segregated conventional shelter strategies, such as planned retirement communities; financial strategies, such as low-rent government-subsidized rental accommodations; household strategies, such as relocation to a child's residence; and group shelter strategies, including congregate housing, board and care, assisted living facilities, continuing care retirement communities, and nursing homes. Under the housing options allowing older people to stay put in their current dwelling Golant listed five categories of aging in place: (1) financial strategies; (2) household strategies, such as family caregiving assistance; (3) home-based service strategies, such as home nursing care or case management; (4) community-based service strategies, such as respite care or adult day care; and (5) group shelter strategies, such as assisted living facilities in congregate housing facilities.

In spite of the numerous options, the available housing alternatives for the elderly are far from being perfect. Older people discover that their lifestyles, values, attitudes, personalities, and mental and physical disabilities clash with the features of most available options. As Golant noted, "They find that most options require them to sacrifice something: their control, autonomy, or privacy; the rhythms of their everyday life; their ability to be alone; their capacity to act spontaneously; their familiar surroundings; their sense of being conventional; and their attachment to people and objects of their past" (p. 11). Many researchers explored this fundamental issue in housing for the elderly.

There is little doubt that the focus on the functional aspects of person–environment relations in late life has generated important insights. Nevertheless, the functional orientation ignored meaningful facets of elderly people's lives. As Lawton (1987) noted:

The docility and proactivity conceptions underline what I see as a basic dialectic in conceptualizing services for the elderly: support versus autonomy. Decline and deprivation

demand support, but the human spirit demands autonomy. The view that either aspect of this duality tells the whole story is sheer fantasy. Proactive environments, such as institutions, were not constructed to crush human spirit but to attempt to adjust the average press level of vulnerable people to one consistent with their competence. Our errors have come in assuming that all forms of press are negative and that autonomy ends once competence is low enough to require a specialized environment. (pp. 37–38)

Older people tend to understate their housing problems, as several studies observed, including Golant (1986), Lawton (1985), and Rabushka and Jacobs (1980). The reasons and factors that appear to be responsible for this phenomenon may be found in Golant (1984a) in Altman et al. (1984), and Lawton (1980). Several studies identified an array of physical conditions that create difficulties or uncomfortable occupancy and use of housing; of these works Hiatt (1985) and Regnier and Pynoos (1987) are good examples. Several books and articles on the psychological aspects may be found in the field of psychology of aging. One may find chapters related to housing issues in Birren and Schaie (1990). Because of the nature of the field of aging and the environment, some of the books and articles mentioned may be more theoretical in their content. One example of this sort is Lawton, Windley, and Bayerts (1982), which deals with environments inhabited by older persons through theoretical models. The authors claim that "for both the researcher and the designer, the instance of environmental match and mismatch, if examined within a more general theoretical framework, are highly instructive and pave the way toward improving the environment for people of all ages" (p. vii).

The need to be in control of one's life is particularly important in old age, as Langer (1983) noted. Other books and articles that explored aspects of control and dependency in aging include Baltes and Werner-Wahl (1987), Seligman (1975), Perlmuter et al. (1986), Rodin (1986), White and Janson (1986), and Fry (1989). Closely related to the issue of control is the issue of autonomy, which has attracted several studies. Articles and books about autonomy include Hofland (1990), Collopy (1988), and Agich (1993).

Older people list six factors contributing to the mismatch between their neighborhoods and their competence level: (1) poor location, (2) alternative transportation options, (3) limited choice of nearby alternative housing accommodations, (4) dislike of the people in the neighborhood, (5) high crime level, and (6) inadequately maintained houses and apartments. These issues are discussed in Carp (1986) in Newcomer et al. (1986), Golant (1992), Struyk and Soldo (1980), and Ward et al. (1988). When their physical or mental impairments become unmanageable, older people may have to relocate to more appropriate settings. This may be a cause for stress and anxiety, as observed in Pastalan (1983) and Tobin and Liberman (1976). The alternative for moving to an undesired setting may be found in several options of aging in place.

Aging in place is a strongly held preference of older persons. The concept represents a transaction between an aging individual and his or her residential

environment. Most simply the term *aging in place* "means not having to move from one's present residence in order to secure necessary support services in response to changing needs," as Pastalan (1990) defined it. According to Pynoos (1990), aging in place has emerged as a social problem due to three factors: (1) existing housing units are not designed to meet physical, social, and service needs of their aging occupants; (2) many frail elderly in nursing homes could be cared for in noninstitutional settings; and (3) forces in the housing market such as rising rents and increased property taxes affect the ability of older persons to remain in their homes. Additional chapters in Tilson (1990) explore the issue from different perspectives. Other works that deal with the concept of aging in place and its implications include Miller (1991), Holshouser (1988), and Cohen and Weisman (1991).

Two other topics are characterized by Cohen and Weisman (1991): design guidelines for housing for the elderly and special care units for people with dementia. Design guidelines that address physical, psychological, and social needs of older persons were written by researchers, consultants, and organizations and associations focused on the market of elderly housing. In many of these publications one can find the essence of environment and behavior design. Books of this sort include Zeisel, Epp, and Demos (1977), Zeisel, Welch, Epp, and Demos (1983), Valins (1988), Weal and Weal (1988), Howell (1980), and Carsten (1985).

Special care units for people with dementia have been built in recent years all around the United States and in other parts of the world. Consequently, the topic has attracted research in the literature. Thoughtfully designed architectural environments represent potentially valuable, albeit typically underutilized, therapeutic resources in the care of people with dementia. It has been argued that many of the behaviors attributed to Alzheimer's disease are, in part, a consequence of a counter-therapeutic settings. This notion and the hope that the physical environment combined with policies, programming, and management of facilities may assist in the therapy of dementia. For example, see Coons (1991), Lawton, Fulcomer, and Kleban (1984), Sloane and Mathew (1991), Calkins (1988), Hiatt (1987), and Cohen and Day (1993).

Other books that are directed toward the audiences of environment–behavior researchers, designers, and care providers include Koncelik (1976), Pastalan and Carson (1970), Hoglund (1985), Raschko (1982), Spivac and Tamer (1984), Golant (1984b), Rowles and Ohta (1983), Willcocks et al. (1987), Regnier et al. (1991), and Regnier (1994). Victor Regnier's book is written from an architectural and interior design standpoint about an emerging model of residential care for frail elderly, defined by Kane and Wilson (1993) as "any residential group program that is not licensed as a nursing home, that provides personal care to persons with need for assistance in daily living, and that can respond to unscheduled needs for assistance that might arise" (p. xi). More information about the topic may be found in Mollica et al. (1992), Wilson (1993), and Newcomer (1992).

Housing and Children

Children are a significant user group of housing. Still, descriptions of the life of children in residential environments are uncommon. Children spend most of their days in institutional environments such as school, and when they lead a "normal" life in their homes they have relatively little freedom, as Michelson (1985) observed. Ahrentzen (1982) offered one of the most comprehensive collections about this topic. Research about children and the environment have focused on schools and, to a lesser extent, playgrounds. However, schools represent only a fraction of the environments to which children are exposed as Zimring et al. (1987) noted. Several researchers discussed children within their family context. Barker and Wright (1951), for example, studied the behaviors and activities of children using a process of simple observation of all the activities of a single child during a single day.

Neighborhood spaces are used by children for recreational and social activities. Lynch (1977) has described how children in different cities around the world including the United States engage with the built environment. Michelson et al. (1979) approached the issue from a somewhat different perspective. Children can turn any part of the built environment into a setting for play; however, research has shown that children in low-rise apartment complexes have much easier access to play areas. Cooper Marcus (1974) concluded that this is also one of the reasons why parents prefer to live in these settings rather than in high-rise apartments, where access to the outdoors, as well as control of children, is more limited.

Explaining the rationale and the purpose of their book, *Housing as if People Mattered* (1986), Cooper Marcus and Sarkissian wrote: "The book is primarily about housing for families with children. This group forms the majority of households needing public and private housing" (p. 12). The book emphasizes children's needs "not because they are the chief users of outdoor common space, and most influenced by their design, but because designers frequently ignore their needs" (p. 13).

A significant amount of research exists in the field of environmental cognition in childhood that incorporates aspects of housing environments. Examples of research of this kind include Beil's (1982) study of judgments of relative distance from one point in a child's neighborhood to two others; Cousins et al.'s (1983) study of assessment of landmark, route, and configurational knowledge, based on walks over terrain near school; and other studies presented in Heft and Wohlwill (1987). These studies add the empirical dimension to the notion that many individuals' most powerful memories revolve around environments associated with their childhood. People remember the houses where they grew up, the neighborhoods where they played, and the secret places of childhood and adolescence, as Cooper Marcus (1992) described. The meaning of childhood homes and children's special affinity or bond for certain places was explored by Sebba (1991) and by Chawla (1992). Chawla (1993) examined some major cultural interpretations of the significance of remembered childhood homes through four case studies.

Boschetti (1987) proposed that an environmental autobiography can generate useful concepts for interior designers. Environmental autobiography is one method of research used for the studies of children and the environment. Other methods and studies may be found in Altman and Wohlwill (1978) Ziegler and Andrews (1987) in Bechtel et al. (1987).

Housing for the Developmentally Disabled

The population of developmentally disabled may live in institutional settings that may be the only form of housing these individuals will ever experience. The research about this housing environment focused on three dimensions: the impact of the environment on the behavior in terms of the needs and the abilities of the individuals, the design of the physical environment, and the social and temporal organizational factors.

Heal, Seligman, and Switzky (1978) and Wolfensberger (1972) observed that mentally retarded persons have been seen as objects of dread, reverence, menace, charity, obligation, and love, and these attributes have been reflected in the built environment for this population. Butler and Bajaanes (1978) listed the assumptions and axioms that have been adopted in the United States for normalization: "(1) it is the right of everyone to have patterns of everyday life that are as similar to the mainstream as possible, such as having sexual and romantic life, a physical separation between the work and living, a homelike living environment, and so on; (2) institutions are inherently incapable of supporting growth and development and as a result should be used only for people requiring medical support; (3) smaller, more homelike community facilities are inherently more supportive of development by residents" (Zimring, Carpman, and Michelson (1987), pp. 927–28).

Studies exist on the living environments for a variety of social groups defined as developmentally disabled. Gunzberg (1973) emphasized the importance of the use of everyday settings for care. Wineman and Zimring (1986) suggest that the fit between the physical design of the home and objectives of the management are effective predictors of the treatment and care provided in group homes. Research examining the nature and the impact of environment on institutionalized people has existed for several years now. There seems to be consensus about the destructiveness of institutions. However, there is limited empirical research about the implications of the size of facilities, rigidity of routines, and so forth. As a result, several studies focused on the alteration and changes that were performed in institutions. Zimring, Weitzer, and Knight (1982) suggested that the transition to a smaller, more controllable setting may have a positive impact on residents. Other researchers that dealt with changes in institutions include MacEachron (1983), Landesman-Dwyer (1984) and Hemming et al. (1981).

Size enters into most discussions of environments for the developmentally disabled. Most research suggests that larger settings are dehumanizing and impersonal and have a negative impact on residents. Other researchers, such as Balla et al. (1974), found no relationships between the improvement of residents and

the size of the facilities. Other researchers to have dealt with the issue include Landsman-Dwyer et al. (1980) and Baroff (1980).

Housing and Issues of Race and Class

Housing is shaped by social, political, and economic forces that embody the values and relations of race, class, gender, occupation, age, and disability in the society. Creating housing involves moral choices that reflect and reinforce the nature of human inequality in the social context of the built environment (Weisman, 1992). Perhaps indicative is the fact that the goal of decent, safe, and sanitary housing for all Americans has not been achieved after decades of federal legislation, presidential mandates, and governmental initiatives. Clearly, the nation's racial and ethnic minorities have not benefited from the changing housing opportunity structure to the same extent as their white counterparts. By all standards of measurement, a significant disparity in housing conditions by race, ethnicity, and income persists in the United States, Davis (1967) stated: "Too many people in our country are badly housed. According to the 1960 census, 10.6 million units of the 58.3 million housing units were considered substandard. . . . Except where aided by grants or subsidies, the poor of the nation are found in substandard housing" (p. 409). The U.S. census for 1990 showed that the housing needs of America's poor and moderate-income families are still immense and growing. While the nation spends nearly $100 billion on housing, too little of it is used to meet the needs of people who are homeless or who live in dilapidated homes or housing they cannot afford. Stegman (1991), in his background paper on the limits of privatization, considers the national commitment to provide more housing and to provide it more fairly.

Housing is always considered in connection with its location. According to Dahmann (1985) the quality of residential environment declines with increasing size of settlements and with increasing centrality within settlements. Berry and Kasarda (1977) pointed out that older sites often bear the stamps of "obsolescence, high density, high industrialization, and aging inhabitants" (p. 221). Their ecological approach to cities, with the addition of skepticism about big initiatives and sweeping programs, is shared by several architects and urban designers. Fisher (1994) reports on a symposium at Yale in which the questions of violence and depopulation of America's inner cities were raised. Design professionals in this symposium tended to portray cities as physical artifacts used to create and sustain culture. In contrast, most economists and policy analysts perceived cities as places of economic exchange or social conflict. While designers believe that cities demand a high concentration of diverse people in close proximity, economists argue that if the global economy no longer needs dense cities, then they can be changed. And if keeping the peace means separating or dispersing people, then it should be done.

Several studies have been conducted on the topic of minority housing. The sociological concept *minority* relates to power differentials. The treatment of mi-

norities results in their physical separation and segregation in the society. Minorities are held back in terms of their education, employment opportunities, and countless other ways by inadequate and segregated housing. Books and articles about minorities and public housing include Bingham (1975), Bratt (1985), Fox (1984), Klutznick (1985), Meehan (1983), Miller and DePallo (1986), and Weidemann and Anderson (1982).

Women tend to be confined to the traditional division of labor within the family and to limited labor force participation, in part as a result of housing design and location (Hayden, 1981; Weisman, 1992). Housing patterns tend to keep classes, races, and subcultures separate and often anatagonistic. In this way, the housing crisis today expresses and perpetuates the economic and social divisions that exist within the society as a whole (Achtenberg and Marcuse, 1983).

The subject of residential segregation has been studied intensely by social science scholars over the past forty years. Housing segregation is defined as "the spatial separation of different population groups with a given geographical area" (Saltman, 1991, p. 1). Spatial segregation of living quarters occurs in all human societies. What differs from one society to the other is the extent of segregation, the patterns of segregation, and the specific basis for it. That basis is rooted in the history of each society. In the United States ethnic and racial minorities are clustered in different parts of the country. However, most of the problems associated with segregation occur in areas within cities and metropolitan regions where minorities are concentrated. Sociopsychological explanations of residential segregation focus on human preferences and choices of locations. One explanation of segregation in the United States refers to whites' preference of all-white neighborhoods and their exclusion of blacks from their neighborhoods. Schuman et al. (1985) proved that whites perceive blacks as holding different and undesirable values. O'Brien and Lange (1986) reported that whites associate racial integration with neighborhood decline and rising crime. Issues of housing segregation of minorities can be found in Huttman (1991), Blalock (1982), Darden (1977; 1983a; 1983b; 1986), Farley (1983; 1984), Gabriel (1984), Hirsch (1983), Massey (1983), Spriggs (1984), and Taeuber (1975).

Several studies attempted to answer whether, and to what extent, the legislative and political history of federal public housing influenced the segregated character of public housing. Books and articles concerning minorities, housing policy, and housing politics include Braid (1984), Darden (1983a), Glaszer (1970), Goering (1982), Hartman (1975), Kivisto (1986), Marcuse (1990), Struyk et al. (1978), and Welfeld (1985).

Homelessness is an extreme instance of poverty. Although not a recent phenomenon, homelessness is a tragedy that today represents a full range of household types, ages, and races. According to Hopper and Hamberg (1986), the homelessness phenomenon stems from changes taking place in the housing market, the labor market, the structure of American urban areas, and public policies designed for "dependent" populations. The problem of homelessness is not confined to one area in the nation. "The driving dynamic behind it is a widening gap

for many households between the cost of their subsistence needs and the resources available to meet them. The growing scarcity of affordable housing operates in reciprocal fashion with the progressively deteriorating situation of individual households. The upshot is the dearth of housing as a procurable good" (Hopper and Hamberg, 1986, p. 14). Books and articles regarding homelessness include Bassuk (1984), Baxter and Hopper (1982), Canton (1989), Carlson (1986), Crystal (1984), Goldman and Morrissey (1985), Hombs and Snyder (1983), Kaufman (1984), McGerigle and Lauriat (1984), and Sloss (1984).

Housing in the United States is determined by demographic trends, economic changes, and public policies. Clearly, the housing experience of any given individual is shaped by systems that generate diversity, inequalities, and contradictions. Some Americans live in the most luxurious housing in the world while others can hardly find a minimal shelter. The future of housing in the United States holds the promises for the balance between healthy diversity and social downfall.

REFERENCES

BOOKS AND ARTICLES

Home

Agnew, J. (1982). Home ownership and identity in capitalist societies. In J. S. Duncan (ed.), *Housing and identity: Cross-cultural perspectives* (pp. 60–97). New York: Holmes & Meier.

Altman, I., and M. Chemers. (1980). *Culture and environment.* Monterety, CA: Brooks/Cole.

Altman, I., and M. Gauvain. (1981). A cross-cultural and dialectic analysis of homes. In L. Liben, A. Patterson, and N. Newcombe (eds.), *Spatial representation and behavior across the life span: Theory and application* (pp. 283–320). New York: Academic.

Altman, I., and S. M. Low (eds.). (1992). *Place attachment.* New York: Plenum.

Altman, I., and C. M. Werner. (1985). *Home environments.* New York: Plenum.

Anthony, K. H. (1984). The role of the home environment in family conflict: Therapists' viewpoints. In D. Duerk and D. Campbell (eds.), EDRA 15–1984 *Proceedings: The challenge of diversity* (pp. 219–26). Washington, DC: Environmental Design Research Association.

Appleyard, D. (1979). Home. *Architectural Association Quarterly* 11 (3): 4–20.

Bachelard, G. (1969). *The poetics of space.* Boston: Beacon.

Baker, M. W., E. Kramer, and G. Gilbert. (dirs.). (1987). *The Pier I Imports study of the American home (Study No. 871025).* New York: Louis Harris and Associates.

Balton, R. E. (1994). *Houses and households: A comparative study.* New York: Plenum.

Brown, B. B. (1987). Territoriality. In D. Stokol and I. Altman (eds.), *Handbook of environmental psychology.* New York: John Wiley & Sons.

Brown, B. B., and I. Altman. (1981). Territoriality and residential crime: A conceptual framework. In P. J. Brantingham and P. L. Brantingham (eds.), *Environmental criminology* (pp. 55–76). Beverly Hills, CA: Sage.

————. (1983). Territoriality, street form, and residential burglary: An environmental analysis. *Journal of Environmental Psychology* 3: 203–20.

Brown, B. B., and C. M. Werner. (1985). Social cohesiveness, territoriality, and holiday decorations: The influence of cul-de-sacs. *Environment and Behavior* 17: 539–65.

Cooper, C. (1974). The house as symbol of the self. *Design and Environment* 3 (3): 30–37.

Csikszentmihalyi, M., and E. Rochberg-Halton. (1981). *The meaning of things: Domestic symbols and the self*. New York: Cambridge University Press.

Despres, C. (Summer 1991). The meaning of home: Literature review and directions for future research and theoretical development. *The Journal of Architectural and Planning Research* 8: 2, 96–115.

Dovey, K. (1978). Home: An ordering principle in space. *Landscape* 22(2): 27–30.

————. (1985). Home and homelessness. In I. Altman and C. M. Werner (eds.), *Home environments*. New York: Plenum.

Duncan, J. S. (ed.). (1982). *Housing and identity: Cross-cultural perspectives*. New York: Holmes & Meier.

Hall, E. T. (1966). *The hidden dimension*. New York: Doubleday.

Hayward, J. (February 1977). Psychological concepts of "home." *HUD Challenge* 10–13.

Horwitz, J., and J. Tognoli. (1982). Role of home in adult development: Women and men living alone describe their residential histories. *Family Relations* 31: 335–41.

Howell, S. C. (1983). The meaning of place in old age. In G. Rowles and R. Ohta (eds.), *Aging and milieu: Environmental perspectives on growing old*. New York: Academic.

Jung, C. G. (1963). *Memories, dreams and reflections*. New York: Vintage.

Korosec-Serfaty, P., and D. Bolitt. (1986). Dwelling and the experience of burglary. *Journal of Environmental Psychology* 6: 329–44.

Lawrence, R. J. (1987). What makes a house a home? *Environment and Behavior* 19: 154–68.

Norberg-Schultz, C. (1971). *Existence, space and architecture*. New York: Praeger.

Pynoos, J., R. Schafer, and C. Hartman (eds.). (1973). *Housing urban America*. Chicago: Aldine.

Rakoff, R. M. (1977). Ideology in everyday life: The meaning of the house. *Politics and Society* 7(1): 85–104.

Rapoport, A. (1969). *House form and culture*. Englewood Cliffs, NJ: Prentice-Hall.

Rowels, G. D. (1980). Growing old "inside": Aging and attachment to place in an Appalachian community. In N. Datan and N. Lohmann (eds.), *Transition of aging*. New York: Academic.

Rubinstein, R. L. (1989). The home environments of older people: A description of the psychological process linking person to place. *Journal of Gerontology* 34: 545–53.

Rubinstein, R. L., and P. A. Parmelee. (1992). Attachment to place and the representation of the life course by the elderly. In I. Altman and S. M. Low, *Place attachment*. New York: Plenum.

Rybczynski, W. (1986). *Home: A short history of an idea*. New York: Penguin.

Saile, D. G. (1985). The ritual establishment of home. In I. Altman and C. M. Werner (eds.), *Home environments* (pp. 87–111). New York: Plenum.

Seamon, D. (1982). The phenomenological contribution to environmental psychology. *Journal of Environmental Psychology* 2: 119–40.

Sebba, R., and A. Churchman. (1986). The uniqueness of the home. *Architecture and Behavior* 3(1): 7–24.

Shumaker, S. A., and R. B. Taylor. (1983). Toward a clarification of people–place relation-

ships: A model of attachment to place. In N. Feimer and E.S. Geller (eds.), *Environmental psychology: Directions and perspectives.* New York: Praeger.

Sixsmith, J. (1986). The meaning of home: An exploratory study of environmental experience. *Journal of Environmental Psychology* 6: 281–98.

Sommer, R. (1969). *Personal space: The behavioral basis of design.* Englewood Cliffs, NJ: Prentice-Hall.

Staines, G. L., and J. H. Pleck. (1983). *The impact of work schedules on the family.* Ann Arbor, MI: University of Michigan, Institute for Social Research, Survey Research Center.

Stokols, D., and I. Altman. (1987). *Handbook of environmental psychology.* New York: John Wiley & Sons.

Taylor, R. B. (1988). *Human territorial functioning.* Cambridge, UK: Cambridge University Press.

Taylor, R. B., and S. Brower. (1985). Home and near-home territories. In I. Altman and C. M. Werner (eds.), *Home environments* (pp. 183–212). New York: Plenum.

Tognoli, J., and J. Horwitz. (1982). From childhood home to adult home: Environmental transformations. In P. Bart, A. Chen, and G. Francescato (eds.), *Knowledge for design: Proceedings of the 13th Environmental Design Research Association conference* (pp. 321–28). Washington, DC: Environmental Design Research Association.

Tuan, Y. (1977). *Space and place: The perspective of experience.* Minneapolis: University of Minnesota Press.

Werner, C. M. (1987). Home interiors: A time and place for interpersonal relationships. *Environment and Behavior* 9(2): 169–79.

Westin, A. F. (1967). *Privacy and freedom.* New York: Atheneum.

Housing

Aspects of Cognitive Evaluation

Anderson, J. R., and S. Weidemann. (1979). *Development of an instrument to measure residents' perceptions of residential quality.* Paper presented at the International Conference on Housing, Miami, FL.

Arias, E. G. (ed.). (1993a). *The meaning and use of housing.* Brookfield, VT: Ashgate.

———. (1993b). User group preferences and their intensity: The impacts of residential design. In E. G. Arias (ed.), *The meaning and use of housing* (pp. 169–99). Brookfield, VT: Ashgate.

Brill, M. (1982). *Do buildings really matter? Economic and other effects of designing behaviorally supportive buildings.* New York: Educational Facilities Laboratories, Academy for Educational Development.

Campbell, A., P. Converse, and W. Rogers. (1976). *The quality of American life: Perceptions, evaluations and satisfactions.* New York: Russell Sage Foundation.

Canter, D., J. Gilchrist, J. Miller, and N. Roberts. (1974). An empirical study of the focal point in the living room. In D. Canter and T. Lee (eds.), *Psychology and the built environment* (pp. 29–37). New York: Halsted.

Cherlnik, P. D., and S. K. Wilderman. (1986). Symbols of status in urban neighborhoods: Contemporary perceptions of nineteenth-century Boston. *Environment and Behavior* 18: 604–22.

Cooper, C. (1972). Resident dissatisfaction in multi-family housing. In W. M. Smith (ed.),

Behavior, design and policy aspects of human habitats (pp. 119–45). Green Bay: University of Wisconsin–Green Bay Press.

———. (1974). The house as symbol of the self. In J. Lag, C. Burnette, W. Moleski, and D. Vachon (eds.), *Designing for human behavior* (pp. 130–46). Stroudsburg, PA: Dowden, Hutchinson, and Ross.

———. (1975). *Easter Hill Village: Some social implications of design.* New York: Free Press.

Cooper Marcus, C., and W. Sarkissian. (1986). *Housing as if people mattered: Site design guidelines for medium-density family housing.* Berkeley: University of California Press.

Faletti, M. V. (1979). An experimental investigation of cognitive processing underlying judgments of residential environments by different observer groups. (Doctoral dissertation, University of Miami, FL). *Dissertation Abstracts International* 40(4): 1924B–1925B.

Francescato, G. (1993). Meaning and use: A conceptual basis. In E. G. Arias (ed.), *The meaning and use of housing.* Aldershot, UK: Avebury.

Garling, T. (1972). Studies in visual perception of architectural spaces and rooms: Aesthetic preference. *Scandinavian Journal of Psychology* 13(3): 222–27.

Gobster, P. H. (1983). Judged appropriateness of residential structures in natural and developed shoreland settings. In D. Amedeo, J. B. Griffin, and J. J. Potter (eds.), *EDRA 1983: Proceedings of the 14th international conference of the Environmental Design Research Association* (pp. 105–12). University of Nebraska–Lincoln.

Hanna, S., and S. Lindamood. (1981). *Components of housing satisfaction.* Paper presented at the 12th Environmental Design Research Association Conference, Iowa State University, Ames, IA.

Huttman, E., and W. Van Vliet (eds.). (1988). *Handbook of housing and the built environment in the United States.* Westport, CT: Greenwood.

Kaplan, S. (1977). *The dream deferred: People, politics and planning in suburbia.* New York: Random House.

Kent, S. (ed.). (1990). *Domestic architecture and the use of space.* Cambridge, UK: Cambridge University Press.

Lansing, J. B., R. W. Marans, and R. B. Zehner. (1970). *Planned residential environments.* Ann Arbor: Institute for Social Research, University of Michigan.

Mackintosh, E. (1982). High in the city. In P. Bart, A. Chen, and G. Francescato (eds.), *Knowledge for design: Proceedings of the 13th Environmental Design Research Association conference* (pp. 424–34). Washington, DC: Environmental Design Research Association.

Marans, R. W. (1976). Perceived quality of residential environments: Some methodological issues. In K. H. Craik and E. H. Zube (eds.), *Perceiving environmental quality: Research and applications* (pp. 123–47). New York: Plenum.

Michelson, W. (1977). *Environmental choice, human behavior and residential satisfaction.* New York: Oxford University Press.

Morrissy, E., and P. J. Handal. (1981). Characteristics of the Residential Environment Scale: Reliability and differential relationship to neighborhood satisfaction in divergent neighborhoods. *Journal of Community Psychology* 9(2): 125–32.

Nasar, J. L. (1979). The impact of visual aspects of residential environments on hedonic responses, interests, and fear of crime. (Doctoral dissertation, Pennsylvania State University). *Dissertation Abstracts International* 40(4): 1963B.

———. (1989). Symbolic meanings of house style. *Environment and Behavior* 21: 235–57.

————. (1993). Connotative meanings of house styles. In E. G. Arias (ed.), *The meaning and use of housing* (pp. 143–67). Brookfield, VT: Ashgate.

Newman, O. (1972). *Defensible space: Crime prevention through urban design.* New York: Macmillan.

Professional Builder. (1985). What 1986 buyers want in housing. 50: 68–85.

Rapoport, A. (1982). *The meaning of the built environment: A nonverbal communication approach.* Beverly Hills: Sage.

Robinson, J. (1980). Images of housing, Minneapolis: A limited study of urban residents' attitudes and values. Unpublished Master's thesis. University of Minnesota, Minneapolis.

Sadalla, E. K., B. Vershure, and J. Burroughs. (1987). Identity symbolism in housing. *Environment and Behavior* 19: 569–87.

Saegert, S. (1980). Masculine cities and feminine suburbs: Polarized ideas, contradictory realities. *Signs: Journal of Women in Culture and Society* 5 (Suppl. 3): 96–111.

Sanoff, H. (1973). Youth's perception and categorization of residential cues. In W.E.F. Preiser (ed.), *Environmental design research, vol. 1: Proceedings of the 4th Environmental Design Research Association conference* (pp. 84–97). Stroudsburg, PA: Dowden, Hutchison, and Ross.

Studer, R. G. (1988). Design of the built environment: The search for usable knowledge. In E. Huttman and W. Van Vliet (eds.), *Handbook of housing and the built environment in the United States.* Westport, CT: Greenwood.

Taylor, C. C., and A. R. Townsend. (1976). The local sense of place as evidenced in northeast England. *Urban Studies* 13: 133–46.

Tobey, N. H. (1982). Connotative messages of single family homes: A multidimensional scaling analysis. In P. Bart, A. Chen, and G. Francescato (eds.), *Knowledge for design: Proceedings of the 13th Environmental Design Research Association* (pp. 449–63). Washington, DC: Environmental Design Research Association.

Volkman, N. (1981). User perceptions of underground houses and implications for site planning. In A. E. Osterberg, C. P. Tiernan, and R. A. Findlay (eds.), *Design research interactions: Proceedings of the 12th Environmental Design Research Association conference* (pp. 277–81). Washington, DC: Environmental Design Research Association.

Ward, B. (1976). *The home of man.* New York: Norton.

Weideman, S., J. R. Anderson, B. I. Butterfield, and P. M. O'Donnell. (1982). Residents' perception of satisfaction and safety: A basis for change in multifamily housing. *Environment and Behavior* 14: 615–724.

Weisman, L. K. (1992). *Discrimination by design: A feminist critique of the man-made environment.* Chicago: University of Illinois Press.

Zeisel, J. (1981). *Inquiry by design: Tools for environment-behavior research.* Monterey, CA: Brooks/Cole.

Zeisel, J., and M. Griffin. (1975). *Charlesview housing: A diagnostic evaluation.* Cambridge, MA: Harvard University, Architecture Research Office.

Neighborhoods and Communities

Ahrentzen, S. (1991). *Hybrid housing: A contemporary building type for multiple residential & business use.* Milwaukee, WI: Center for Architectural and Planning Research, University of Wisconsin–Milwaukee.

Altman, I., and M. Gauvain. (1981). A cross-cultural and dialectical analysis of homes. In

I. Liben, A. Patterson, and N. Newcombe (eds.), *Spatial representation across the life span*. New York: Academic.

Altman, I., and A. Wandersman. (1987). *Neighborhood and community environments*. New York: Plenum.

Argyle, M., and M. Henderson. (1984). The rules of friendship. *Journal of Social and Personal Relationships* 1, 211-237.

Banerjee, T., and W. C. Baer. (1984). *Beyond the neighborhood unit: Residential environments and public policy*. New York: Plenum.

Brudney, J. L., and R. E. England. (March–April 1982). Urban policy making and subjective service evaluations: Are they compatible? *Public Administration Review* 42: 127–35.

Campbell, A., P. E. Converse, and W. L. Rodgers. (1976). *The quality of American life: Perceptions, evaluations, and satisfactions*. New York: Russel Sage Foundation.

Carp, F. M., and A. Carp. (1982). Perceived environmental quality of neighborhoods: Development of assessment scales and their relations to age and gender. *Journal of Environmental Psychology* 2: 295–312.

Chavis, D. M., J. H. Hogge, D. W. McMillan, and A. Wandersman. (1986). Sense of community through Brunswik's lens: A first look. *Journal of Community Psychology* 14: 24–40.

Clay, G. (1980). *Close-up: How to read the American city*. Chicago: University of Chicago Press.

Cochrane, T. (1987). Place, people, and folklore: An Isle Royale case study. *Western Folklore* 46: 1–20.

Connerly, C. E., and R. W. Marans. (1988). Neighborhood quality: A description and analysis of indicators. In E. Huttman and W. Van Vliet (eds.), *Handbook of housing and the built environment in the United States*. Westport, CT: Greenwood.

Duncan, J. S. (ed.). (1982). *Housing and identity: Cross-cultural perspectives*. New York: Holmes & Meier.

Festinger, L., S. Schacter, and K. Back. (1950). *Social pressures in informal groups: A study of human factors in housing*. Stanford, CA: Stanford University Press.

Flannery, B. A. (1994). *Trends in housing*. Unpublished manuscript.

Franck, K. A. (1988). Women's housing and neighborhood needs. In E. Huttman and W. Van Vliet (eds.), *Handbook of housing and the built environment in the United States*. Westport, CT: Greenwood.

Fried, M. (1982). Residential attachment: Sources of residential and community satisfaction. *Journal of Social Issues* 38 (3): 107–200.

Fromm, D. (1991). *Collaborative communities: Cohousing, central living and other new forms of housing with shared facilities*. New York: Van Nostrand Reinhold.

Gans, H. J. (1962). *The urban villagers: Group and class in the life of Italian Americans*. New York: Free Press.

———. (1967). *The Levittowners*. New York: Pantheon.

Gerson, K., C. A. Steuve, and C. S. Fischer. (1977). Attachment to place. In C. S. Fischer, R. M. Jackson, C. A. Steuve, K. Gerson, L. M. Jones, and M. Baldassare (eds.), *Networks and places: Social relations in the urban setting*. New York: Free Press.

Goffman, E. (1959). *The presentation of self in everyday life*. New York: Doubleday.

Goldfield, D. R. (1987). Neighborhood preservation and community values in historical perspective. In I. Altman and A. Wandersman (eds.), *Neighborhood and community environments* (pp. 223–56). New York: Plenum.

Goudy, W. J. (1982). Further considerations of indicators of community attachment. *Social Indicators Research* 11: 181–92.

Greenberg, S. W., and W. M. Rohe. (1986). Informal social control and crime prevention in modern neighborhoods. In R. Taylor (ed.), *Urban neighborhoods: Research and policy*. New York: Praeger.

Greenberg, S. W., W. M. Rohe, and J. R. Williams. (1984). *Informal citizen action and crime prevention at the neighborhood level*. Research Triangle Park, NC: Research Triangle Institute.

Guest, A. M., and B. A. Lee. (1983). Sentiment and evaluation as ecological variable. *Sociological Perspectives* 26: 158–84.

Habraken, J. (1972). *Supports: An alternative to mass housing*. New York: Praeger.

Hallman, H. W. (1984). *Neighborhoods: Their place in urban life*. Beverly Hills, CA: Sage.

Harshbarger, D. (1976). An ecological perspective on disaster intervention. In H. J. Parad, H. L. Resnick, and L. Parad (eds.), *Emergency and disaster management: A mental health service book*. Bowie, MD: Charles Press.

Herting, J. R., and A. M. Guest. (1985). Components of satisfaction with local areas in the metropolis. *The Sociological Quarterly* 26: 99–115.

Heuman, L. F. (1979). Racial integration in residential neighborhoods: Towards more precise measures and analysis. *Evaluation Quarterly* 3(1): 59–79.

Hillery, G. A. (1955). Definitions of community: Areas of agreement. *Rural Sociology* 20: 111–123.

Hiss, T. (1990). *The experience of place*. New York: Knopf.

Holahan, C. J., and A. Wandesman. (1987). The community psychology perspective in environmental psychology. In D. Stokols and I. Altman (eds.), *Handbook of environmental psychology* (pp. 827–61). New York: John Wiley and Sons.

Horwitz, J., and J. Tognoli. (1982). Role of home in adult development: Women and men living alone describe their residential histories. *Family Relations* 31: 335–41.

Hummon, D. M. (1990). *Commonplaces: Community ideology and identity in American culture*. Albany: State University of New York Press.

Hunt, M. E., and L. E. Ross. (1990). Naturally occurring retirement communities: A multiattribute examination of desirability factors. *Gerontologist* 30: 667–74.

Hunter, A. (1978). Persistence of local sentiment in mass society. In D. Street (ed.), *Handbook of urban life* (pp. 133–62). San Francisco: Jossey-Bass.

Huttman, E. (1988). New communities in the United States. In E. Huttman and W. Van Vliet (eds.), *Handbook of housing and the built environment in the United States*. Westport, CT: Greenwood.

Jacobs, A. B. (1985). *Looking at cities*. Cambridge, MA: Harvard University Press.

Jacobs, J. (1961). *The death and life of great American cities*. New York: Random House.

Katz, P. (1994). *The new urbanism: Toward an architecture of community*. New York: McGraw-Hill.

Keller, S. (1968). *The urban neighborhood: A sociological perspective*. New York: Random House.

Landman, R. H. (1993). *Creating community in the city: Cooperatives and community gardens in Washington D.C.* Westport, CT: Bergin & Garvey.

Lavin, M. W., and F. Agatstein. (1984). Personal identity and the imagery of place: Psychological issues and literary themes. *Journal of Mental Imagery* 8: 51–66.

Lee, T. R. (1978). A theory of socio-spatial schemata. In S. Kaplan and R. Kaplan (eds.), *Humanscape: Environments for people*. North Scituate, MA: Duxbury.

Levinson, D. J. (1986). A conception of adult development. *American Psychologist* 41: 3–13.

Liben, L., A. H. Patterson, and N. Newcombe (eds.). (1981). *Spatial representation across the life span: Theory and application.* New York: Academic.

McAndrew, F. T. (1993). *Environmental psychology.* Pacific Grove, CA: Brooks/Cole.

Marans, R. W. (1976). Perceived quality of residential environments: Some methodological issues. In K. H. Craik and E. H. Zube (eds.), *Perceiving environmental quality: Research and applications* (pp. 123–47). New York: Plenum.

Marans, R. W. and W. Rodgers. (1975). Toward an understanding of community satisfaction. In A. Hawley and V. Rock (eds.), *Metropolitan America in contemporary perspective* (pp. 299–352). New York: John Wiley and Sons.

Michelson, W. (1976). *Man and his urban environment: A sociological analysis.* Reading, MA: Addison-Wesley.

Newman, O. (1972). *Defensible space: Crime prevention through urban design.* New York: Macmillan.

Nisbet, R. A. (1962). *Community and power: A study in the ethics of order and freedom.* New York: Oxford University Press.

Proshansky, H. M., A. K. Fabian, and R. Kaminoff. (1983). Place-identity: Physical world socialization of the self. *Journal of Environmental Psychology* 3: 57–83.

Rainwater, L. (1970). *Behind ghetto walls: Black family life in a federal slum.* Chicago: Aldine.

Rapoport, A. (1982). Identity and environment. In J. S. Duncan (ed.), *Housing and identity: Cross-cultural perspectives.* New York: Holmes & Meier.

———. (1990). *History and precedent in environmental design.* New York: Plenum.

Riche, M. F. (1986). Retirement's lifestyle pioneers. *American Demographics* 8(1): 42–44, 50, 52–54, 56.

Rivlin, L. G. (1987). The neighborhood, personal identity, and group affiliations. In I. Altman and A. Wandersman (eds.), *Neighborhood and community environments.* New York: Plenum.

Rowles, G. D. (1980). Toward a geography of growing old. In A. Buttimer and D. Seamon (eds.), *The human experiences of space and place* (pp. 55–72). New York: St. Martin's.

Sampson, R. J. (1988). Local friendship ties and community attachment in mass society: A multilevel systematic model. *American Sociological Review* 53: 766–79.

Scharf, S. A. (1978). *The social psychology of neighborhood satisfaction.* Unpublished doctoral dissertation. University of Chicago.

Seamon, D. (1979). *A geography of the lifeworld.* New York: St. Martin's.

Sennett, R. (1978). *The fall of public man.* New York: Vintage.

Shumaker, S. A., and R. B. Taylor. (1983). Toward a classification of people–place relationships: A model of attachment to place. In N. R. Feimer and E. S. Geller (eds.), *Environmental psychology* (pp. 219–51). New York: Praeger.

Sommer, R. (1981). The behavioral ecology of supermarkets and farmer's markets. *Journal of Environmental Psychology* 1: 13–19.

Suttles, G. (1968). *The social order of the slum.* Chicago: University of Chicago Press.

Taylor, R. B. (1982). Neighborhood physical environment and stress. In G. W. Evans (ed.), *Environmental stress.* New York: Cambridge University Press.

———. (1987). Toward an environmental psychology of disorder: Delinquency, crime and fear of crime. In D. Stokols and I. Altman (eds.), *Handbook of environmental psychology,* vol. 2. New York: John Wiley and Sons.

———. (1988). *Human territorial functioning.* Cambridge University Press.

Turner, J.F.C. (1976). *Housing by the People*. New York: Pantheon.

Turner, J.F.C., and R. Fichter (eds.). (1972). *Freedom to build*. New York: Macmillan.

Unger, D. G., and A. Wandersman. (1985). The importance of neighbors: The social, cognitive and affective components of neighboring. *American Journal of Community Psychology* 13(2): 139–60.

Vance, M. (1988). *New towns: Journal articles, 1980–1988*. Monticello, IL: Vance Bibliographies.

Van Vliet, W., and J. Burgers. (1987). Communities in transition: From the industrial to the postindustrial era. In I. Altman and A. Wandersman (eds.), *Neighborhood and community environments* (pp. 257–90). New York: Plenum.

Warren, D. I. (1981). *Helping networks*. Notre Dame, IN: University of Notre Dame Press.

Warren, R. L. (1978). *The community in America*. 3rd ed. Chicago: Rand McNally.

Wedin, C. S., and L. G. Nygren. (1976). *Housing perspectives: Individuals and families*. Edina, MN: Burgess.

———. (1978). *Housing perspectives: Individuals and families*. 2nd ed. Edina, MN: Burgess.

Weenig, M.W.H., T. Schmidt, and C.J.H. Midden. (1990). Social dimensions of neighborhoods and the effectiveness of information programs. *Environment and Behavior* 22: 27–54.

Wireman, P. (1984). *Urban neighborhoods, networks, and families: New forms for old values*. Lexington, MA: D. C. Heath.

Yancey, W. L. (1971). Architecture, interaction, and social control: The case of a large-scale public housing project. *Environment and Behavior* 3: 3–21.

Crowding

Altman, I. (1975). *Environment and social behavior: Privacy, personal space, territory, and crowding*. Pacific Grove, CA: Brooks/Cole.

Anderson, E. N. (1972). Some Chinese methods of dealing with crowding. *Urban Anthropology* 1: 143–50.

Baldassare, M. (1988). Residential crowding in the United States: A review of research. In E. Huttman and W. Van Vliet (eds.), *Handbook of housing and the built environment in the United States*. Westport, CT: Greenwood.

Baum, A., and G. Davis. (1976). Spatial and social aspects of crowding perception. *Environment and Behavior* 8: 527–44.

Baum, A., and P. B. Paulus. (1987). Crowding. In D. Stokols and I. Altman (eds.), *Handbook of environmental psychology* (pp. 533–70). New York: John Wiley and Sons.

Booth, A. (1976). *Urban crowding and its consequences*. New York: Praeger.

Desor, J. A. (1972). Toward a psychological theory of crowding. *Journal of Personality and Social Psychology* 21: 79–83.

Fleming, I., A. Baum, and L. Weiss. (1987). Social density and perceived control as mediators of crowding stress in high-density residential neighborhoods. *Journal of Personality and Social Psychology* 52: 899–906.

Hall, E. T. (1966). *The hidden dimension*. New York: Doubleday.

Huttman, E., and W. Van Vliet. (1988). *Handbook of housing and the built environment in the United States*. Westport, CT: Greenwood.

Mitchell, E. T. (1971). Some social implications of high density housing. *American Sociological Review* 38: 18–29.

Newman, O. (1972). *Defensible space*. New York: Macmillan.

Rotton, J. (1987). Hemmed in and hating it: Effects of shape of room on tolerance for crowding. *Perceptual and Motor Skills* 64: 285–86.

Rowe, P. G. (1993). *Modernity and housing.* Cambridge, MA: MIT Press.

Ruback, R. B., and C. A. Innes. (1988). The relevance and irrelevance of psychological research: The example of prison crowding. *American Psychologist* 43: 683–93.

Ruback, R. B., and J. Pandey. (1991). Crowding, perceived control, and relative power: An analysis of households in India. *Journal of Applied Social Psychology* 21: 315–44.

Savinar, J. (1975). The effect of ceiling height on personal space. *Man-Environment Systems* 5: 321–24.

Sommer, R. (1969). *Personal space: The behavioral basis of design.* Englewood Cliffs, NJ: Prentice-Hall.

———. (1972). *Design awareness.* San Francisco: Reinhart.

Stokols, D. (1972). On the distinction between density and crowding: Some implications for future research. *Psychological Review* 79: 275–77.

Stokols, D., and I. Altman (eds.). (1987). *Handbook of environmental psychology.* New York: John Wiley and Sons.

Zube, E., and G. T. Moore (eds.). (1989). *Advances in environment, behavior, and design.* New York: Plenum.

Zuravin, S. J. (1986). Residential density and urban child maltreatment: An aggregate analysis. *Journal of Family Violence* 1: 307–22.

Housing for Special Populations

Dejong, G. (1981). *Environmental accessibility and independent living outcomes: Directions for disability policy and research.* East Lansing: University Center for International Rehabilitation, Michigan State University.

Lifchez, R. (1987). *Rethinking architecture: Design students and physically disabled people.* Berkeley: University of California Press.

Mace, R. L. (1990). Design for special needs. In Lisa Taylor (ed.), *Housing: Symbol, structure, site.* New York: Rizzoli.

Peloquin, A. A. (1994). *Barrier-free residential design.* New York: McGraw-Hill.

Wener, R., and F. Szigeti (eds.). (1988). *Cumulative index to the proceedings of Environmental Design Research Association: Volumes 1–18, 1969–1987.* Washington, DC: EDRA.

Housing for the Elderly

Agich, G. J. (1993). *Autonomy and long-term care.* New York: Oxford University Press.

Altman, I., P. Lawton, and F. Wohlwill. (1984). *Elderly people and the environment.* New York: Plenum.

Baltes, M. M., and H. Werner-Wahl. (1987). Dependence in aging. In L. L. Carstensen and A. B. Edelstein (eds.), *Handbook of clinical gerontology* (pp. 204–21). New York: Pergamon.

Birren, J. E., and K. W. Schaie (Eds.). (1990). *Handbook of the psychology of aging.* New York: Van Nostrand Reinhold.

Calkins, M. (1988). *Design for dementia: Planning environments for the elderly and the confused.* Owing Mills, MD: National Health Publishing.

Carp, F. M. (1986). Neighborhood quality perception and measurement. In R. J. Newcomer, M. P. Lawton, and T. O. Byerts (eds.), *Housing an aging society: Issues, alternatives, and policy.* New York: Van Nostrand Reinhold.

———. (1987). Environment and aging. In D. Stokold and I. Altman (eds.), *Handbook of environmental psychology* (pp. 329–60). New York: John Wiley & Sons.

Carp, F. M., and A. Carp. (1984). A complementary/congruence model of well-being or mental health for the community elderly. In I. Altman, J. Wohlwill, and M. P. Lawton (eds.), *Elderly people and the environment.* New York: Plenum.

Carstens, D. (1985). *Site planning and design for the elderly: Issues, guidelines, and alternatives.* New York: Van Nostrand Reinhold.

Cohen, U., and K. Day. (1993). *Contemporary environments for people with dementia.* Baltimore, MD: John Hopkins University Press.

Cohen, U., and J. Weisman (1991). *Holding on to home: Designing environments for people with dementia.* Baltimore, MD: John Hopkins University Press.

Collopy, B. J. (June 1988). Autonomy in long-term care: Some crucial distinctions. *Gerontologist* 28 (Supplement): 10–17.

Coons, D. H. (ed.). (1991). *Specialized dementia care units.* Baltimore, MD: John Hopkins University Press.

Faletti, M. V. (1984). Human factors research and functional environments for the aged. In I. Altman, M. P. Lawton, and J. F. Wohlwill (eds.), *Elderly people and the environment.* New York: Plenum.

Fry, P. S. (ed.). (1989). *Psychological perspectives of helplessness and control in the elderly.* North Holland: Elsevier.

Gelwicks, L. E. and R. J. Newcomer. (1974). *Planning housing environments for the elderly.* Washington, DC: National Council on the Aging.

Golant, S. M. (1984a). The effects of residential and activity behaviors on old people's environmental experiences. In I. Altman, M. P. Lawton, J. Wohlwill (eds.), *Elderly people and the environment* (pp. 239–78). New York: Plenum.

———. (1984b). *Place to grow old: The meaning of environment in old age.* New York: Columbia University Press.

———. (1986). Subjective housing assessments by the elderly: A critical information source for planning and program evaluation. *Gerontologist* 26: 122–27.

———. (1992). *Housing America's elderly: Many possibilities/Few choices.* Newbury Park, CA: Sage.

Gordon, P. (1988). *Developing retirement facilities.* New York: Wiley.

Hiatt, L. G. (1985). Understanding the physical environment. *Pride Institute Journal of Long Term Home Health Care* 4: 12–22.

———. (1987). Environmental design and mentally impaired older people. In H. Altman (ed.), *Alzheimer's disease: Problems, prospects and perspectives* (pp. 309–20). New York: Plenum.

Hofland, B. (ed.). (1990). Autonomy and long-term care practice. *Generations* 14.

Hoglund, D. (1985). *Housing for the elderly: Privacy and independence in the environments for the aging.* New York: Van Nostrand Reinhold.

Holshouser, W. L., Jr. (1988). *Aging in place: The demographics and service needs of the elderly in urban public housing.* Boston: Citizens Housing and Planning Association.

Howell, S. (1980). *Designing for aging: Patterns for use.* Cambridge: MIT Press.

Hunt, M. E., et al. (1984). *Retirement communities an American original.* New York: Haworth.

Institute of Medicine Staff. (1987). *The social and built environment for an aging society.* Washington, DC: National Academy Press.

Kahana, E., and B. Kahana. (1983). Environmental continuity, futurity and adaptation of

the aged. In G. D. Rowles and R. J. Ohta (eds.), *Aging and milieu* (pp. 205–28). New York: Academic.

Kane, R. A., and K. B. Wilson. (1993). *Assisted living in the United States: A new paradigm for residential care for frail older persons?* Washington, DC: American Association of Retired Persons.

Koncelik, J. (1976). *Designing the open nursing home.* Stroudsburg, PA: Dowden, Hutchinson, and Ross.

Langer, E. J. (1983). *The psychology of control.* Beverly Hills, CA: Sage.

Lawton, M. P. (1975). *Planning and managing housing for the elderly.* New York: Wiley and Sons.

———. (1980). *Environment and aging.* Monterey: Brooks/Cole.

———. (1985). Housing and living environments of older people. In R. H. Binstock and E. Shanas (eds.), *Handbook of aging and the social sciences,* 2nd ed. (pp. 450–78). New York: Van Nostrand Reinhold.

———. (1987). Environment and the need satisfaction of the aging. In L. L. Carstensen and B. A. Edelstein (eds.), *Handbook of clinical gerontology* (pp. 33–40). New York: Pergamon.

Lawton, M. P., M. Fulcomer, and M. Kleban. (1984). Architecture for the mentally impaired elderly. *Environment and Behavior* 16: 730–57.

Lawton, M. P., and L. Nahemow. (1973). Ecology and the aging process. In C. Eisdorfer and M. P. Lawton (eds.), *Psychology of adult development and aging.* Washington, DC: American Psychology Association.

Lawton, M. P., and B. Simon. (1968). The ecology of social relationships in housing for the elderly. *Gerontologist* 8: 108–15.

Lawton, M. P., P. G. Windley, and T. O. Byerts (eds.). (1982). *Aging and the environment.* New York: Springer.

Miller, J. A. (1991). *Community-based long-term care: Innovation models.* Newbury Park, CA: Sage.

Mollica, R. L., R. C. Ladd, S. Dietsche, K. B. Wilson, and B. S. Ryther. (1992). *Building assisted living for the elderly into public long term care policy: A guide for states.* Portland, ME: Center for Vulnerable Populations, National Academy for State Health Policy & Brandeis University.

Moos, R. H., and S. Lemke. (1980). The multiphasic environmental assessment procedure. In A. Jager and B. Slotnick (eds.), *Community mental health.* New York: Plenum.

———. (1984). Supportive residential settings for older people. In I. Altman, J. Wohwill, and M. P. Lawton (eds.), *Elderly people and the environment.* New York: Plenum.

National Association of Homebuilders. (1987). *Seniors housing: A development and management handbook.* Washington, DC: NAHB.

Newcomer, R. (1992). *Best practices in residential care for the elderly: Draft notes.* Mimeo. San Francisco: University of California at San Francisco, Institute for Health & Aging.

Newcomer, R. J., M. P. Lawton, and T. O. Byerts (eds.). (1986). *Housing an aging society.* New York: Van Nostrand Reinhold.

Parmelee, P. A., and M. P. Lawton. (1990). The design of special environments for the aged. In J. Birren and K. W. Schaie (eds.), *Handbook of the psychology of aging,* 3rd ed. (pp. 464–88). San Diego, CA: Academic.

Pastalan, L. A. (1983). Environmental displacement. In G. D. Rowles and R. J. Ohta (eds.), *Aging and milieu* (pp. 189–203). New York: Academic.

————. (1984). Architectural research and life-span changes. In J. C. Snyder (ed.), *Architectural research*. New York: Van Nostrand Reinhold.

————. (1990). *Aging in place: The role of housing and social supports*. New York: Haworth.

Pastalan, L. A., and D. H. Carson (eds.). (1970). *Spatial behavior of older people*. Ann Arbor: University of Michigan Press.

Perlmuter, L. C., R. A. Monty, and F. Chan. (1986). Choice, control, and cognitive functioning. In M. M. Baltes and P. B. Baltes (eds.), *Aging and the psychology of control*. New Jersey: Lawrence Erlbaum.

Pynoos, J. (1990). Public policy and aging in place: Identifying the problems and potential solutions. In D. Tilson (ed.), *Aging in place: Supporting the frail elderly in residential environments*. Glenview, IL: Scott, Foresman.

Rabushka, A., and B. Jacobs. (1980). *Old folks at home*. New York: Free Press.

Raschko, B. (1982). *Housing interiors for the disabled and elderly*. New York: Van Nostrand Reinhold.

Regnier, V. (1985). *Behavioral and environmental aspects of outdoor space use in housing for the elderly*. Los Angeles: School of Architecture, Andrus Gerontology Center, University of Southern California.

————. (1994). *Assisted living housing for the elderly: Design innovations from the United States and Europe*. New York: Van Nostrand Reinhold.

Regnier, V., J. Hamilton, and S. Yatabe. (1991). *Best practice in assisted living: Innovations in design, management and financing*. Los Angeles: National Eldercare Institute on Housing and Supportive Services.

Regnier, V., and J. Pynoos (eds.). (1987). *Housing the aged: Design directives and policy considerations*. New York: Elsevier.

Rodin, J. (1986). Health, control, and aging. In L. L. Carstensen and A. B. Edelstein (eds.), *Handbook of clinical gerontology*. New York: Pergamon.

Rowles, G. D., and R. J. Ohta (eds.). (1983). *Aging and milieu*. New York: Academic.

Scheidt, R. J., and P. G. Windley. (1985). The ecology of aging. In J. Birren and K. W. Schaie (eds.), *Handbook of the psychology of aging*, 2nd ed. (pp. 245–58). New York: Van Nostrand Reinhold.

Schooler, K. K. (1982). Response of the elderly to environment: A Stress-theoretical perspective. In M. P. Lawton, P. G. Windley, and T. O. Byerts (eds.), *Aging and the environment: Theoretical approaches*. New York: Springer.

Seligman, M. E. P. (1975). *Helplessness: On depression, development, and death*. San Francisco: W. H. Freeman.

Sloane, P. D., and L. J. Mathew (eds.). (1991). *Dementia units in long-term care*. Baltimore, MD: John Hopkins University Press.

Spivac, M., and J. Tamer. (1984). *Institutional setting: An environmental design approach*. New York: Human Sciences.

Struyk, R. J., and B. J. Soldo. (1980). *Improving the elderly's housing*. Cambridge, MA: Ballinger.

Tilson, D. (ed.). (1990). *Aging in place: Supporting the frail elderly in residential environments*. Glenview, IL: Scott, Foresman.

Tobin, S. S., and M. A. Liberman. (1976). *Last home for the aged*. San Francisco: Jossey-Bass.

Urban Land Institute. (1983). *Housing for maturing population*. Washington, DC: Urban Land Institute.

Valins, M. (1988). *Housing for the elderly people: A guide for architects and clients.* New York: Van Nostrand Reinhold.

Ward, R. A., M. LaGory, and S. S. Sherman. (1988). *The environment for aging: Interpersonal, social, and spatial contexts.* Tuscaloosa: University of Alabama Press.

Weal, F., and F. Weal. (1988). *Housing for the elderly: Options and design.* New York: Nichols.

Welch, P., V. Parker, and J. Zeisel. (1984). *Independence through interdependence.* Boston: Department of Elder Affairs.

White, C. B., and P. Janson. (1986). Helplessness in institutional settings: Adaptation or Iatrogenic disease? In M. M. Baltes and P. B. Baltes (eds.), *Aging and the psychology of control.* New Jersey: Lawrence Erlbaum.

Willcocks, D. M., S. Peace, and L. Kellaher. (1987). *Private lives in public places.* New York: Tavistock.

Wilson, K. B. (1993). Developing a viable model of assisted living. In P. Katz, R. L. Kane, and M. Mazey (eds.), *Advances in long-term care.* New York: Springer.

Zeisel, J., G. Epp, and S. Demos. (September 1977). *Low-rise housing for elderly people: Behavioral criteria for design.* #HUD–483. Washington, DC: U.S. Government Printing Office.

Zeisel, J., P. Welch, G. Epp, and S. Demos. (1983). *Mid-rise elevator housing for older people.* Boston: Building Diagnostics.

Housing and Children

Ahrentzen, S. (1982). *Children and the built environment: An annotated bibliography of representative research of children and housing, school design and environmental stress.* Architecture Series, NO A-764. Monticello, IL: Vance Bibliographies.

Altman, I., and J. F. Wohlwill. (1978). *Children and the environment.* New York: Plenum.

Barker, R. G., and H. F. Wright. (1951). *One boy's day.* New York: Harper & Row.

Bechtel, R., R. Marans, and W. Michelson (eds.). (1987). *Methods in environmental and behavioral research.* New York: Van Nostrand Reinhold.

Beil, A. (1982). Children's spatial representation of their neighborhood: A step towards a general spatial competence. *Journal of Environmental Psychology* 2: 193–200.

Boschetti, M. A. (1987). Memories of childhood homes: Some contribution of environmental autobiography to interior design education and research. *Journal of Interior Design Education and Research* 13(2): 27–36.

Chawla, L. (1992). Childhood place attachment. In I. Altman and S. M. Low (eds.), *Place Attachment.* New York: Plenum.

———. (1993). Home is where you start from: Childhood memories in adult interpretations of home. In E. G. Arias (ed.), *The meaning and use of housing: International perspectives, approaches and their applications.* Brookfield, VT: Ashgate.

Cooper Marcus, C. (1974). Children's play behavior in low-rise inner-city housing development. In D. Carson (ed.), *Man–environment interactions: Evaluations and applications.* Washington, DC: Environmental Design Research Association.

———. (1992). In I. Altman and S. M. Low (eds.), Environmental memories. *Place attachment.* New York: Plenum.

Cooper Marcus, C., and W. Sarkissian. (1986). *Housing as if people mattered: Site design guidelines for medium-density family housing.* Berkeley, CA: University of California Press.

Cousins, J. H., A. W. Siegel, and S. E. Maxwell. (1983). Way finding and cognitive mapping

in large scale environments: A test of a developmental model. *Journal of Experimental Child Psychology* 35: 1–20.

Heft, H., and J. F. Wohlwill. (1987). Environmental cognition in children. In D. Stokols and I. Altman (eds.), *Handbook of environmental psychology.* New York: John Wiley and Sons.

Lynch, K. (ed.). (1977). *Growing up in cities: Studies of the spatial environment of adolescents in Cracow, Melbourne, Mexico City, Salta, Toluca, and Warszawa.* Cambridge, MA: MIT Press.

Michelson, W. (1985). *From sun to sun: Daily obligations and community structure in the lives of employed women and their families.* Totowa, NJ: Rowman & Allenheld.

Michelson, W., A. V. Levine, and A. R. Spina. (1979). *The child in the city: Changes and challenges.* Toronto: University of Toronto Press.

Sebba, R. (1991). The landscapes of childhood: The reflection of childhood's environment in adult memories and in children's attitudes. *Environment and Behavior* 23: 395–442.

Ziegler, S., and H. F. Andrews. (1987). Children and built environments: A review of methods for environmental research and design. In R. B. Bechtel, R. W. Marans, and W. Michelson (eds.), *Methods in environmental and behavioral research.* New York: Van Nostrand Reinhold.

Zimring, C., J. R. Carpman, and W. Michelson. (1987). Design for special populations: Mentally retarded persons, children, hospital visitors. In D. Stokold and I. Altman (eds.), *Handbook of environmental psychology* (pp. 919–49). New York: John Wiley and Sons.

Housing for the Developmentally Disabled

Balla, D. A., E. C. Butterfield, and E. Ziegler. (1974). Effects of institutionalization on retarded children: A longitudinal cross-institutional investigation. *American Journal of Mental Deficiency* 78: 530–79.

Baroff, G. S. (1980). On "size" and the quality of residential care: A second look. *Mental Retardation* 18: 113–17.

Butler, E. W., and A. T. Bajaanes. (1978). Activities and use of time by retarded persons in community care facilities. In G. P. Sackett (ed.), *Observing behavior: Vol. 1. Theory and applications in mental retardation.* Baltimore, MD: University Park Press.

Gunzberg, H. C. (1973). The physical environment of the mentally handicapped VIII: 39 steps leading towards normalized living practices for the mentally handicapped. *British Journal of Mental Subnormality* 19: 91–99.

Heal, L. W., C. K. Seligman, and H. N. Switzky. (1978). Research on community residential alternatives for the mentally retarded. In N. R. Ellis (ed.), *International review of research in mental retardation (vol. 9.).* New York: Academic.

Hemming, H., T. Lavender, and R. Pill. (1981). Quality of life of mentally retarded adults transferred from large institutions to new small units. *American Journal of Mental Deficiency* 86: 157–69.

Landsman-Dwyer, S. (1984). Residential environments and the social behavior of handicapped individuals. In M. Lewis (ed.), *Beyond the dyad.* New York: Plenum.

Landsman-Dwyer, S., G. P. Sackett, and J. S. Kleinman. (1980). Relationship of size to resident and staff behavior in small community residences. *American Journal of Mental Deficiency* 85: 6–17.

MacEachron, A. E. (1983). Institutional reform and adaptive functioning of mentally re-
 tarded persons: A field experiment. *American Journal of Mental Deficiency* 88: 2–12.
Wineman, J. D., and C. M. Zimring. (1986). *Group homes for the mentally retarded* (Final
 Rep.). Washington, DC: National Endowment for the Arts.
Wolfensberger, W. (1972). *The principles of normalization in human services.* Toronto, Can-
 ada: National Institute on Mental Retardation.
Zimring, C., J. R. Carpman, and W. Michelson. (1987). Design for special populations:
 Mentally retarded persons, children, hospital visitors. In D. Stokols and I. Altman,
 (eds.), *Handbook of environmental psychology* (pp. 919–49). New York: John Wiley
 & Sons.
Zimring, C. M., W. Weitzer, and R. C. Knight. (1982). Opportunity for control and the
 designed environment: The case of an institution for the developmentally disabled.
 In A. Baum and J. Singer (eds.), *Advances in environmental psychology: Vol. 4. Envi-
 ronment and health.* Hillsdale, NJ: Erlbaum.

Housing and Issues of Race and Class

Achtenberg, E., and P. Marcuse. (1983). Toward the decommodification of housing: A
 political analysis and a progressive program. In C. Hartman (ed.), *America's housing
 crisis: What is to be done?* Boston: Routledge and Kegan Paul.
Bassuk, E. L. (1984). The homelessness problems. *Scientific America* 25(1): 40–46.
Baxter, E., and K. Hopper. (1982). The new mendicancy: Homeless in New York City.
 American Journal of Orthopsychiatry 52(3): 393–408.
Berry, B.J.L., and J. D. Kasarda. (1977). *Contemporary urban ecology.* New York: Macmillan.
Bingham, R. D. (1975). *Public housing and urban renewal: An analysis of federal–local relations.*
 New York: Praeger.
Blalock, H. M., Jr. (1982). *Race and ethnic relations.* Englewood Cliffs, NJ: Prentice-Hall.
Braid, R. M. (1984). The effects of government housing policies in a vintage filtering model.
 Journal of Urban Economics 16(3): 272–96.
Bratt, R. G. (1985). Controversies and contributions: A public housing critique. *Journal of
 Housing* 42(5): 165–73.
Canton, C. (ed.). (1989). *People without homes: The homeless in America.* New York: Oxford
 University Press.
Carlson, P. (1986). Homeless: The shanty builders. *People Weekly* 25(7): 94–100.
Crystal, S. (1984). Homeless men and homeless women: The gender gap. *Urban and Social
 Change Review* 17(2): 2–6.
Dahmann, D. C. (1985). Assessments of neighborhood quality in metropolitan America.
 Urban Affairs Quarterly 20(4): 511–35.
Darden, J. T. (1976). The residential segregation of blacks in Detroit, 1960–1970. *Inter-
 national Journal of Comparative Sociology* 17(1 & 2): 84–91.
———. (1977). Blacks in the suburbs: Their number is rising, but patterns of segregation
 persist. What are the causes? *Vital Issues* 27(4): 1–4.
———. (1983a). Demographic changes 1970–1980: Implications for federal fair housing.
 In U.S. Commission on Civil Rights (Ed.), *Shelter crisis: The state of fair housing.*
 (pp. 5–30). Washington, DC.
———. (1983b). The residential segregation of Hispanics in cities and suburbs of Michi-
 gan. *The East Lake Geographer* 18: 25–37.
———. (1986). Accessibility to housing differential residential segregation for blacks, His-

panics, American Indians, and Asians. In J. A. Momeni (ed.), *Race, ethnicity, and minority housing in the United States*. Westport, CT: Greenwood.

Davis, T. L. (1967). Cooperative self-help housing. *Law and Contemporary Problems* 32(2): 409–15.

Farley, J. E. (1983). Metropolitan housing segregation in 1980: The St. Louis case. *Urban Affairs Quarterly* 18(3): 347–59.

———. (1984). Housing segregation in the school age population and the link between housing and school segregation: A St. Louis case study. *Journal of Urban Affairs* 6(4): 65–80.

Fisher, T. (May 1994). Bosnia in America? *Progressive Architecture*: 25, 32.

Fox, C. (1984). Public housing's future: A look ahead. *Journal of Housing* 41(6): 192–95.

Gabriel, S. A. (1984). Slipover effects of human service facilities in racially segmented housing market. *Journal of Urban Economics* 16(3): 339–50.

Glaszer, N. (1970). Dilemmas of housing policy. In D. P. Moynihan (ed.), *Toward a national urban policy* (pp. 50–65). New York: Basic.

Goering, J. M. (1982). Race, housing, and public policies: A strategy for social science research. *Urban Affairs Quarterly* 17(4): 463–89.

Goldman, H. H., and J. P. Morrissey. (1985). The alchemy of mental health policy: Homelessness and the fourth cycle of reform. *American Journal of Public Health* 75(7): 727–31.

Hartman, C. (1975). *Housing and social policy*. Englewood Cliffs, NJ: Prentice-Hall.

Hayden, D. (1981). *The grand domestic revolution: A history of feminist designs for American homes, neighborhoods, and cities*. Cambridge, MA: MIT Press.

Hirsch, A. R. (1983). *Making the second ghetto: Race and housing in Chicago, 1940–1960*. Cambridge, UK: Cambridge University Press.

Hombs, M. E., and M. Snyder. (1983). *Homelessness in America: A forced march to nowhere*. Washington DC: Community for Creative Non-Violence.

Hopper, K., and J. Hamberg. (1986). The making of America's homeless: From skid row to new poor, 1945–1984. In R. Bratt, C. Hartman, and A. Meyerson (eds.), *Critical perspectives on housing*. Philadelphia: Temple University Press.

Huttman, E. D. (ed.). (1991). *Urban housing segregation of minorities in Western Europe and the United States*. Durham, NC: Duke University Press.

Kaufman, N. K. (1984). Homelessness: A comprehensive policy approach. *Urban and Social Change Review* 17(1): 21–26.

Kivisto, P. (1986). An historical review of changes in public housing policies and their impacts on minorities. In J. A. Momeni (ed.), *Race, ethnicity, and minority housing in the United States*. Westport, CT: Greenwood.

Klutznick, P. M. (1985). Poverty and politics: The challenge of public housing. *Journal of Housing* 42(1): 9–12.

McGerigle, P., and A. S. Lauriat. (1984). *More than shelter: A community response to homelessness*. Boston: United Community Planning and Massachusetts Association for Mental Health.

Marcuse, P. (1990). United States of America. In W. Van Vliet (ed.), *International handbook of housing policies and practices*. Westport, CT: Greenwood.

Massey, D. S. (1983). A research note on residential succession: The Hispanic case. *Social Forces* 61(3): 825–33.

Meehan, E. J. (1983). Is there a future for public housing? *Journal of Housing* 40(3): 73–76.

Miller, T. R., and M. DePallo. (1986). Desegregating public housing: Effective strategies. *Journal of Housing* 43(1): 11–21.

Momeni, J. A. (1987). *Housing and racial/ethnic minority status in the United States: An annotated bibliography with a review essay.* New York: Greenwood.

Myers, D. (ed.). (1990). *Housing demography: Linking demographic structure and housing markets.* Madison: University of Wisconsin Press.

O'Brien, D., and J. Lange. (1986). Racial composition and neighborhood evaluations. *Journal of Urban Affairs* 8: 43–62.

Saltman, J. (1990). *A fragile movement: The struggle for neighborhood stabilization.* Westport, CT: Greenwood.

———. (1991). Theoretical orientation: Residential segregation. In E. D. Huttman (ed.), *Urban housing segregation of minorities in Western Europe and the United States.* Durham, NC: Duke University Press.

Schuman, H., C. Steeh, and L. Babo. (1985). *Racial attitudes in America.* Cambridge: Harvard University Press.

Sloss, M. (1984). The crisis of homelessness: Its dimensions and solutions. *Urban and Social Change Review* 17(2): 18–20.

Spriggs, W. (1984). Measuring residential segregation: An application of trend surface analysis. *Phylon* 45(4): 249–63.

Stegman, M. A. (1991). *More housing, more fairly: Report of the Twentieth Century Fund Task Force on Affordable Housing.* New York: Twentieth Century Fund Press.

Struyk, R. J. (1980). Public housing modernization: An analysis of problems and prospects. *Journal of Housing* 37(9): 492–96.

Struyk, R. J., S. A. Marshall, and L. J. Ozanne. (1978). *Housing policy for the urban poor.* Washington, DC: The Urban Institute.

Taeuber, K. E. (November 1975). Racial segregation: The persisting dilemma. *Annals of the American Academy of Political and Social Science* 422: 87–96.

Weidemann, S., and J. R. Anderson. (1982). Residents' perceptions of satisfaction and safety: A basis for change in multifamily housing. *Environment and Behavior* 4(6): 659–724.

Weisman, L. K. (1992). *Discrimination by design: A feminist critique of the man-made environment.* Urbana: University of Illinois Press.

Welfeld, I. H. (1985). Policies or programs: Legislative origins of PHA problems. *Journal of Housing* 42(4): 140–41.

GUIDE TO PERIODICALS

Activities Adaptation and Aging

Adult Residential Care Journal

AIA Journal

Applied Ergonomics

American Anthropologist

American Behavioral Scientist

American Journal of Orthopsychiatry

American Journal of Psychiatry

American Journal of Psychotherapy

American Journal of Sociology

American Psychologist

American Sociological Review

Annual Review of Psychology

Architectural Forum

Architectural Psychology (London)

Architectural Record

Architectural Review, The (London)

Architecture and Comportment

Archives of Environmental Health

Behavioral Analysis and Social Action

Behavioral Science

Behavior Analyst

Building Design and Construction

Built Environment

Children's Environments Quarterly

Clinical Social Work Journal

Criminal Behavior and Mental Health

Design Research News

Ekistics

Environmental Design Research Association Proceedings

Environmental Psychology

Environment and Behavior

Ergonomics

Generations

Geographical Review

Gerontologist, The

Hastings Center Studies

Housing and Society: Journal of the American Association of Housing Educators

Human Behavior and Environment Advances in Theory and Research

Human Relations

International Journal of Aging and Human Development

International Journal of Comparative Sociology

International Journal of Technology and Aging

International Social Science Journal

Journal of Abnormal Psychology

Journal of Aging and Health

Journal of Applied Behavioral Science

Journal of Applied Gerontology

Journal of Applied Social Psychology

Journal of Architectural Planning and Research

Journal of Architectural Education

Journal of Community Psychology

Journal of Consulting and Clinical Psychology

Journal of Contemporary Ethnography

Journal of Educational Research

Journal of Environmental Education

Journal of Environmental Psychology

Journal of Experimental Research in Personality

Journal of Gerontological Social Work

Journal of Health and Social Behavior

Journal of Housing

Journal of Housing for the Elderly

Journal of Human Ecology

Journal of Interior Design Education and Research

Journal of Leisure Research

Journal of Psychology

Journal of Psychomatic Research

Journal of Social Issues

Journal of Sociology and Social Welfare

Journal of the American Institute of Planners

Journal of the American Medical Association

Journal of the American Planning Association

Journal of the Society of Architectural Historians

Journal of Urban Affairs

Journal of Urban Economics

Journal of Vocational Behavior

Journals of Gerontology

Lifestyles

Man Environment Systems

Perceptual and Motor Skills

Physiology and Behavior

Population and Environment

Progressive Architecture
Psychology Today
Psychosocial Rehabilitation Journal
Social Forces
Social Indicators Research
Social Problems
Social Science International
Social Work
Sociological Focus
Sociological Forum
Urban Affairs Quarterly
Urban and Social Change Review
Urban Anthropology
Women and Environments

4

Art and Popular Media

Jackie Donath

The embellishment and arrangement of a home are a graphic (and sometimes symbolic) representation of public and private cultural attitudes to domesticity and family life. More interestingly, they are also an indication of how these attitudes are changing.

—Witold Rybcznski, *Home: A Short History of an Idea*

It is our ingrained American restlessness . . . unique in the world for geographic scope and endurance, that demands we nurse—in our various temporary camps—the idea of home as icon and amulet.

—Reynolds Price, "Home: An American Obsession"

Shelter is basic, primal, and necessary for existence, but it also defines and shapes life. Americans are obsessed with the idea of home, and the house is an important icon of the American Dream, providing a visual image of our national goals and personal desires. The ideals of house and home are intertwined with other central cultural concepts, Mom and apple pie. The symbolic powers of myths of the home and the images of domestic life which are embodied in the icon of the house play major roles in the American system of values. What follows is an examination of American popular housing as image and icon, focusing on the arts and popular media as channels of visual and symbolic information and communication.

THEORIES

Icon comes from the Greek word *eikon* which means "image" or "picture." A basic resource for the study of icons is Erwin Panofsky's *Studies in Iconology*

(1962), which delineates a system of description, classification, and analysis within the framework of art historical research. Guilio Carlo Argan's "Ideology and Iconology" (1975) argues for an expansion of Panofsky's method beyond the figurative tradition to consideration of fields such as architecture and the decorative arts. He suggests that such an approach would permit additional sociological and psychoanalytic research and insights. Clare Cooper has written a number of articles on the house as a symbolic construct that illustrate Argan's points. For example, her short but pungent essay "The House as Symbol" (1972) builds on Amos Rapoport's anthropological classic, *House Form and Culture* (1969). A longer and more developed piece is her "The House as Symbol of Self" (1974). John Ely Burchard's chapter on architecture in *Symbols and Society* (1955), edited by Lyman Bryson, discusses the centrality of symbolism to meaning and function in architecture. Two volumes edited by Ray Browne and Marshall Fishwick, *Icons of America* (1978) and *Icons of Popular Culture* (1970), offer essays that treat a number of artifacts and behaviors as symbolic. According to Fishwick, "objects in general, and icons in particular, are the building blocks of reality. They are sensitive indicators of who we are, where we come from and where we intend to go" (Browne and Fishwick, 1978, p. 8). Icons stand for attitudes, beliefs, and myths. The iconography of American domestic architecture is brilliantly discussed and illustrated in *Learning from Las Vegas* (1972) by Virginia Carroll, Denise Scott Brown, and Robert Venturi. The architectural firm of Venturi and Rauch were also responsible for a museum installation and catalog entitled *Signs of Life* (1976). Houses are included in their analysis of the urban landscape.

Semiotics, the study of signs, offers another set of theoretical and methodological justifications for studying the symbolic meanings of artifacts and images. Using a combination of linguistics, structural anthropology, and Hegelian phenomenological philosophy, semioticians approach symbols as a kind of code or language system. The Vance bibliography "Semiotics and Architecture" (1981) by Carol Cable provides a fine introduction to major texts and articles on this subject. *Signs of Our Times* (1988) by Jack Solomon is a collection of his semiotic "readings" of American culture and experience. It includes an entertaining and informative chapter entitled "The Human Landscape." Donald Prezioni's *Semiotics of the Built Environment* (1979) is another excellent though difficult example of a semiotic perspective on the social meanings of buildings. Finally, Umberto Eco, one of the most important practitioners of semiotics, has summarized the method in a succinct article entitled "Functions and Signs" (1973). Paul Oliver's *Shelter, Sign and Symbol* (1975) offers a more anthropological treatment of architecture as sign. This volume provides a thorough introduction to these ideas in terms of vernacular architecture, including houses. Essays focus on ritual, the expression of belief, religion, and social organization in the traditional shelters of various groups.

Communication theory is another useful resource for researchers looking for theoretical and practical guidelines for the study of American popular housing as icon and image. Acting as channels of visual and symbolic information, images and iconic artifacts communicate pictorially. In *Signs, Symbols and Ornaments*

(1975) Richard Smeets offers a historical approach to decorative communication. To illustrate his contention that a code of signs and symbols is central to all cultures, Smeets discusses ornament in folk art, fine art, the industrial arts, and architecture. Alan Gowans's *Images of American Living* (1976) offers the concepts *image*, *symbol*, and *idea* as contexts for his history of American architectural and design styles. In his article "Material Culture as Non-Verbal Communication" (1980) Kenneth Ames discusses parlor organs in Victorian American culture by explaining several concepts of nonverbal communication and then focusing on individual examples of the advertising cards by which the instruments "communicated" to prospective buyers.

Research into housing icons and images within a communication model should begin with a basic work of anthropology, such as *Culture and Communication* (1976) by Edmund Hall. A dip into mass communication theory would also be in order, and newcomers to this area will profit from knowledge of the work of the British scholar John Fiske, whose *Introduction to Communication Studies* (1982) and, with John Hartley, *Reading Television* (1982) are fine basic volumes. One of the fathers of American mass communications study, Harold Lasswell, in such works as *The Comparative Study of Symbols* (1952) provided a systematic structure for communication study, allowing for consideration of the producer as well as the product, the target as well as the actual audience. Paraphrasing Lasswell, a researcher in iconic communication might ask, "Who makes what sort of icon for whom, as part of what sort of sociocultural and historical shifts?" The various ways artifacts are presented and exploited are central to their iconic power. In photographs, advertisements, and various media, both popular and elite, images reinforce an icon's power and ability to communicate to various audiences. As icons of American culture, houses and their images are rich resources.

HOUSING AND INTERIORS IN THE VISUAL ARTS

Bibliographic and Resource Guides

Collections of and reference works on visual materials in American art history are rich and underexploited sources of information on American housing and interiors. For newcomers to the study of the visual arts, handbooks and research guides are logical starting points. Elizabeth Sacca and Loren Singer are the authors of the very basic but useful *Visual Arts Reference and Research Guide* (1983), which includes information on how to locate and use a variety of reference tools, including films, bibliographies, and archives. Elizabeth Pollard's *Visual Arts Research* (1986) leads researchers step by step through visual art research strategies. Lois Swan Jones offers a basic guide to study, resources, and references in her *Art Research Methods and Resources* (1984). Gerd Muesham's *Guide to Basic Information Services in the Visual Arts* (1978) introduces the researcher to core materials and sources for information about individual artists, works of art, periods of art history, technical information and institutional details. Two Vance bibliographies

also offer material on houses in the visual arts: Anthony White's *Architecture as an Art Subject* (1984) and Carol Cable's *Listing of Cartoons on Architectural Subjects Within Selected Anthologies* (1985) are suggestive of the variety of resources and approaches to images of house and home in American art.

Investigation of the images of American domestic buildings must often include at least a few hours at a library index and abstract table. Among the central sources are four worth consideration here. Art periodicals from 1929 to the present are collected in the *Art Index*. This resource focuses on articles in English and includes subject headings such as "Houses, as Works of Art," "Architecture and Motion Pictures," and "Interior Design." Bernard Karpel has edited the four-volume *Arts in America* (1979), which has annotated listings on the fine arts, decorative arts, Native American art, design, photography, film, theater, dance, and music. The Archives of American Art has organized an index to its *Collection of Exhibition Catalogs* (1979), a rich resource of microfilmed catalogs issued in the United States between the early nineteenth century and the 1960s. Although the microforms must be used in the archive field offices or borrowed from the Detroit headquarters, exhibition catalogs are, in general, underutilized sources of information and images. Paul Wasserman and Esther Herman's *Catalog of Museum Publications and Media* (1980) is another, more up-to-date source of information on exhibition catalogs.

Paintings as Resources

Images of houses and interiors appear in works by both academically trained and "folk" painters. Harold L. Peterson's *American Interiors from the Colonial Times to the Late Victorians* (1971) is a survey and chronology of oil paintings, watercolors, drawings, advertisements, and photographs. It is an excellent source of images—all, unfortunately, reproduced in black and white. Elisabeth Donaghy Garrett's *At Home* (1990) performs a similar function, with a number of excellent color reproductions. Edgar Mayhew and Minor Meyers, Jr., have also done a fine job of collecting images of interiors from a variety of sources in their *Documentary History of American Interiors from the Colonial Era to 1915* (1980).

It may be worth noting that, from the Puritans to the mid-nineteenth century (and to a lesser extent in modern times), portraits were primary communicators of display, revealing class, status, and world view through domestic details. The work of Colonial "limners," or itinerant traveling painters, was derivative of medieval and sixteenth-century Northern European court painting. In the northern colonies, portraits focused on the person being painted, and decorative details were few but significantly symbolic. For example, in *Mrs. Freake and Daughter Mary* (c. 1674), arguably one of the most important American paintings of the seventeenth century, the subjects are perched on a Cromwellian sidechair, upholstered in turkeywork, a symbol of their wealth. In the southern colonies, paintings such as the portrait of Eleanor Darnell (c. 1710) by the limner Justus Englehardt Kuhn, were more Baroque and included architectural and garden de-

tails of the family plantation, "The Woodyard." Later in the eighteenth century, portraits such as *Mr. and Mrs. Hills* (c. 1750–51) and *Mr. and Mrs. Richard Bull* (1747) began to include interior decorative detail as well as fastidious attention to the sitters' costumes.

In general, seventeenth-century American portraits are too sitter-centered and simple to offer much in the way of information about housing and interiors. Eighteenth-century painting is often too stylized and neoclassical to be of consistent value for research of this sort, although many portraits of the mid- to late eighteenth century include finely detailed chairs and fabrics and an occasional peek at a Georgian-style exterior.

Nineteenth-Century Paintings and Prints

Nineteenth-century paintings and prints are often rich resources of images and ideas about Americans at home. Images of domestic life became the ritual icons of the cult of domesticity, a worship of the home that dominated American social life from the 1840s to 1900. Idealized homes, uniting popular Christianity and domestic life, were the predominate images promoted in popular visual arts and material culture. While much of the research on the Victorian cult of domesticity centers on artifacts and advice literature, George A. Slater focuses on images of the Northeast in *The Hills of Home* (1931). In *Pastoral Inventions* (1989) Sarah Burns discusses the nostalgic image of the homestead by investigating lithographs and etchings of domestic settings and scenes.

The most successful purveyors of such images were Currier and Ives, who made their fortunes by making art available to middle-class Americans in the nineteenth century. Nathaniel Currier began a lithography business in 1832, and when John Ives joined the company, demand for his prints required the services of a three-story factory. Prints of more than seven thousand subjects were produced before the company closed its doors in 1898. Currier and Ives included a number of domestic scenes in their catalog. Images of houses were very popular, with the four-print set "The American Homestead" (1868–1869), illustrating each of the seasons of the year, among their most profitable runs. Images of houses found in prints such as "Home Sweet Home" (1869), "My Boyhood Home" (1872), and "My Cottage Home" (1866) presented the popular image of an ideal home—a vaguely Colonial cottage with a significant number of large windows, set in a fertile domesticated garden. Other, less suburban settings, such as the "Home in the Wilderness" (1870), reveal the persistent strength of the log cabin as an icon, acting as a refuge and sanctuary from the harshness of a snowy, hostile landscape.

Reproductions of these lithographs and prints, in volumes such as *Currier and Ives Prints* (1970) by Frederick Conningham and *Currier and Ives's Chronicles of America* (1968) are excellent resources. Emphasis on subject matter, which made the prints "inferior" art by traditional aesthetic standards, is the very element that makes Currier and Ives lithographs superior sources of popular images of nineteenth-century domestic life and architecture. Currier and Ives prints reveal Vic-

torian ideas about the meaning of home and remain powerful illustrations of an American mythology that persists today.

Among the "fine arts," American genre paintings are also fine sources of information about American houses and domestic interiors. In painting, *genre* is a term used to describe works that depict scenes of the everyday. American genre painters focused on the work, leisure, and domestic lives of ordinary people. Books on individual painters such as William Sidney Mount, John Lewis Krimmel, Henry Sargent, George Caleb Bingham, and Thomas Eakins will offer the researcher a treasure trove of images and information. These narrative paintings are often filled with a paradoxical combination of realistic detail and symbolic materiality. Barbara Novak discusses this important and influential movement in her *American Painting of the Nineteenth Century* (1969). Herman W. Williams, Jr., includes a wide variety of painters and styles in his historical survey, *Mirror to the American Past* (1973). Lloyd Goodrich provides an excellent introduction to this school of painting in his essay accompanying the catalog for a 1935 Whitney Museum of Art exhibition entitled *American Genre*. Elizabeth Johns's *American Genre Painting* (1991) contextualizes these paintings within the dark, often conflicted stream of antebellum American culture.

Exhibition catalogs are also rich sources of information on genre paintings. For example, the R. W. Norton Gallery in Shreveport, Louisiana, published *Louisiana Landscape and Genre Paintings of the Nineteenth Century* in 1981. This illustrated catalog includes a number of reproductions of paintings of houses in its discussion of the "romantic anthropology" of local genre works. Almost ninety American genre paintings are collected in *Domestic Bliss* (1991), a publication of the Margaret Woodbury Strong Museum in Rochester, New York. Elaine K. Dines-Cox's *Everydayland* (1988) records a contemporary reworking of genre conventions at a 1988 exhibit at the Laguna Art Museum. The works of the eight southern California artists in the show were attempts to "recapture our everyday experience from the homogenization of the mass media" (p. 7) and to act as "transcriptions of objective and interior worlds" (p. 11).

Twentieth-Century Painting

In the twentieth century, images of houses and interiors in the "fine arts" are often either nostalgic and sentimental, as in the works of Andrew Wyeth, Grandma Moses, and Norman Rockwell, or symbolic and critical. Mira Schor analyzes the iconic nature of domestic interiors and exteriors in contemporary works of art in "You Can't Leave Home Without It" (1992), discussing the work of several important American artists, including Richard Artshwager, Robert Gober, Cady Noland, Faith Ringgold, Gordon Matta-Clark, and Vito Acconci. Acconi has focused on the house as an icon, and his work is given careful attention in an exhibition catalog by Kate Linker, *The House and Its Furnishings as Social Metaphor* (1986).

Group exhibits also include the image of the house and home in contemporary American art. In 1972, the Feminist Art Program at the California Institute of Art

organized *Womanhouse*, an exhibit in which individual artists such as Judy Chicago displayed and installed work with domestic contexts. Works on feminist art, such as Norma Broude and Mary Garraro's *The Power of Feminist Art* (1994) include information on this collaborative effort. *The Image of the House in Contemporary Art, Exploring the Relationship between Art and Architecture to Society* (1981) by Charmaine Locke records an exhibit at the Lawndale Annex of the University of Houston. A 1983 exhibit of constructions and installations at the California State University, Fullerton, was accompanied by *The House That Art Built*, a catalog by Frankel et al. which included essays entitled "On Space and Place," on the nature of the house; "The Architecture Within," a discussion of the symbolism of the interiors of the exhibit's constructions; and "The House That Art Built," an investigation of early interpretations of architecture in nonarchitectural media.

Pattern Books

While eighteenth-century portraits and historical paintings may be frustratingly devoid of domestic material, the researcher in visual arts of the period may have better luck with drawings and illustrations from architectural design books. Andrea Palladio's sixteenth-century drawings of Roman and Greek architecture, collected in *The Four Books of Architecture* (1965), were very influential in the English-speaking world of the eighteenth century. His work and that of the European architectural theorists influenced by his ideas were significant resources and inspirations for American designers and architects. As Helen Park's *List of Architectural Pattern Books Available in America Before the Revolution* (1973) reveals, more than one hundred titles, most published in England between 1720 and 1780, found their way into Colonial libraries. Works by Robert Morris, William Pain, and William Halfpenny offered Renaissance versions of the classical design vocabulary as suggestions for middle- and upper-class homes. London architect Abraham Swan's *Collection of Designs* ([1745] 1967) and Batty Langley's *City and Country Builder* ([1750] 1967) were particularly influential sources for builders of American Georgian-style houses. The owners of these houses communicated their good taste and educated appreciation of classical architecture, art, and philosophy by constructing buildings characterized by exterior and interior symmetry and a self-conscious use of classical architectural details.

Throughout the nineteenth century, pattern books continued to be important and popular resources for professional and amateur architects and builders. Henry-Russell Hitchcock lists publishers and places of publication of an explosion of books in his *American Architectural Books* (1976). There were also significant style changes, as the nation turned away from the imperialistic Roman neoclassicism of the eighteenth century and embraced a Federal, or Greek neoclassical, vocabulary more appropriate for a new republic.

By the middle of the nineteenth century, another European design tradition, the Gothic, was also enjoying a peculiarly American-flavored revival. From the 1830s through the 1860s, American Gothic became increasingly common, and

was, for a time, promoted as the only "proper" style for American homes, although its popularity never reached that of the neoclassical styles. The most outspoken and well-received American champion of the domestic Gothic style was Andrew Jackson Downing, who argued that a house expressed and could affect the character of the family living in it. By the middle of the nineteenth century, both the Gothic and neoclassical began to decline in popularity, swamped by a flood of interest in "new" historical styles. Downing's popular *Rural Cottages* (1974) and *The Architecture of Country Houses* (1968) illustrated a plethora of acceptable choices for domestic interiors and exteriors, including Romanesque, Elizabethan, Italian, seventeenth- and eighteenth-century French, and Renaissance styles.

Pattern books of the nineteenth century, such as Calvert Vaux's *Villas and Country Cottages* (1968), the Woodward brothers' *Country Homes* (1865), Lewis F. Allen's *Rural Architecture* (1860), Amos Bicknell's *Village Builder* (1976), and *Palliser's New Cottage Homes and Details* (1975) are often available as reprints and demonstrate the growing American conviction that democracy and the national well-being were tied to the housing and domestic lives of individual citizens. David Gebhard's introduction to a reprint of Samuel and Joseph Newsom's *Picturesque California Homes* ([1884] 1978) offers a regional context for pattern books and suggests that in addition to their value as "a rich array of popular architectural images of the past, they also give us a clue to how each period thought about (as well as looked at) visual forms" (p. v). Gebhard et al.'s exhibition catalog, *Samuel and Joseph Cather Newsome* (1979) reinforces their significance.

For the most part, twentieth-century magazines provide the richest sources of patterns for contemporary interior and exterior designs and are treated in the "Periodicals" section at the end of this chapter. Collections of home plans for the middle class, in the tradition of nineteenth-century pattern books, continue to sell well, especially in a soft-bound format—for example, the *Beautiful Home Plans* series, which began in 1972. Several books are also worth mentioning as collections of house designs. Gustav Stickley's early twentieth-century arts and crafts plans for owner-built (or at least owner-commissioned) houses have been collected in his *Best of Craftsmen Homes* (1979). Charles E. White, Jr., developed a lively trade in design books in the 1920s with volumes such as *Successful Houses and How to Build Them* (1921) and *The Bungalow Book* (1923). Taking advantage of the demand for housing after World War II, Harold Group published his *House-of-the-Month Book of Small Houses* in 1946. In the 1950s and 1960s the bungalow became the ranch, and books such as Waldo Kirkpatrick's *House of Your Dreams* (1958) offered plans and pictures of different designs.

Commentators on the importance of pattern books include William B. O'Neal, whose "Pattern Books and American Architecture, 1730–1930" (1984) provides a concise, well-detailed historical treatment of this genre. Dell Upton's "Pattern Books and Professionalism" (1984) offers a social and professional context for this phenomenon. The pattern book format was eventually transformed into a different sort of commercial product, and James Garvan's "Mail-Order Houses and American Victorian Architecture" (1981) discusses how mail-order house

plans became a thriving and influential business opportunity in nineteenth-century America. Robert Schweitzer and Michael W. R. Davis highlight mail-order catalogs as resources in their informative *America's Favorite Homes* (1986).

Photography

Photography is another visual art form with much to offer the researcher in American popular housing images. In addition to their artistic expressiveness, photographs offer documentation of domestic buildings and interiors. James Bochert's "Analysis of Historical Photographs" (1981) offers a useful introduction to the communicative possibilities of photographs. Historical societies and archives can offer rich collections of images for study. For his exhibition and catalog, *At Home: Domestic Life in the Post-Centennial Era, 1876–1920* (1976), George Talbot analyzed a number of photographs selected from six hundred images and artifacts exhibited by the State Historical Society of Wisconsin in order to reveal the period's social life and taste cultures.

The camera's documentary function is at the center of William Seale's *Tasteful Interlude* (1982). Although images of the interiors of the prosperous and wealthy predominate, houses belonging to working class and marginal groups such as Shakers, miners, and hunters are also included. Maren Stange's *Symbols of Ideal Life* (1989) also collects a wide range of domestic images. James Guimond's study of American documentary photographers, *American Photography and the American Dream* (1991), includes some images of houses and domestic settings that express or contest the idea of the American Dream in the twentieth century.

Investigation of the work of individual photographers may also yield valuable images and information. For example, Clay Lancaster's introduction to his *New York Interiors at the Turn of the Century* (1985) chronicles the life and work of Joseph Bryon, an English emigrant who, as a professional photographer, recorded the homes of both rich and poor. This volume includes a selection of photographs of domestic scenes taken before 1914, culled from a large museum collection. Sally Pierce's treatment of nineteenth-century commercial photographers in Boston, *Whipple and Black* (1991), includes a substantial group of residential photographs taken by the duo.

Photographic work may also exploit a self-conscious artistic agenda. For example, the photomontages of Martha Rose offer the domestic interior as a metaphor. Brian Wallis's "Living Room War" (1992), an article on Rose's work from 1967 to 1973, discusses her use of images from *House Beautiful* magazines in combination with *Life* magazine photographs of the Vietnam war. These montages deal with issues of race, class, and home by opening the image of the domestic interior to "invasion" by images of outside events and foreign cultures. Images of the domestic interior were manipulated in enlightening and frightening ways by a 1991 Museum of Modern Art–sponsored exhibit entitled "The Pleasures and Terrors of Domestic Comfort." Carolyn Squiers's provocative *ArtForum* review of

the exhibit, "Domestic Blitz" (1991), includes excellent reproductions of some of the photographs in the exhibit.

While there have been some attempts to examine American domestic architecture as a culturally expressive form, no one has written a truly comprehensive examination of the image of the American home. Nor, for that matter, have there been many examinations of the home as an icon for specific historical periods or social movements. The image of the home in American art history has not been adequately investigated, and as a result, the rich resources for research into nineteenth-century images of the home in both popular and elite art forms remain untapped. Term papers, short essays, and books might easily and fruitfully examine the works of specific artists who used the house or domestic interiors as settings; genre painters and female artists would be worthy subjects. Other topics for research include application of visual art theories, such as iconology, to the image of the house and domestic spaces and consideration of images of the home as socially, personally, and emotionally expressive. Scholars interested in these materials as resources should consider changes in the meanings and images of American houses and interiors across time and space. For example, anthropologists and ethnographers will find rich photographic resources in the interiors and elevations captured by amateur snapshots.

HOUSING AND INTERIOR DESIGN AS ART

The Architect as Artist

The professionalization of architecture in the late nineteenth and early twentieth centuries has led to the elevation of the person (and personality) of the architect and the definition of the designed building as a work of art. In addition, the passage of time and the gloss of nostalgia have caused a similar improvement in the status of historic dwellings or homes of the famous or at least locally influential. Having no grand ruins of public buildings, castles, or temples, American culture has chosen to venerate the house—for its story as much as for its architectural significance.

Jan Cohn discusses the notable house as shrine in "History, Myth and Nostalgia" in *The Palace or the Poorhouse* (1979) and suggests that interest in these buildings led, in the mid-nineteenth century, to the creation of a "minor literary genre: the historical house essay" (p. 194). In the 1850s Putnam published *Homes of American Authors* (1853) and *Homes of American Statesmen* (1855), both collections of drawings and essays by various authors. The 1870s saw an increase in books and magazine articles about American homes and their individual and historical associations. Of particular note are William Cullen Bryant's *Picturesque America* (1872–74) and Mrs. Martha J. Lamb's *Homes of America* (1879).

By the early twentieth century, the popularity of this genre of book supported the publication of a fourteen-volume series by Elbert Hubbard entitled *Little Journeys to the Homes of Great Men* (1914), which made the connection between a

house and the person who lived in it an organic one. Such books on historic homes as Irwin Haas's *America's Historic Houses and Restorations* (1966), *Historic Midwest Houses* (1947) and Henry L. Williams's *Great Houses of America* (1969) have continued in this vein. Christopher Geist's "Historic Sites and Monuments as Icons" (1978) provides an excellent cultural context for this phenomenon.

A late twentieth-century descendant of the historic house essay is the architectural photo essay cum travelogue that often appears as a coffee table book during the Christmas buying season. Useful for their glossy photographs, these books include Bruce Curt's *Great Houses of New Orleans* (1977) and *Great Houses of San Francisco* (1974), which make a plea for architectural preservation; John Zukowsky's *Hudson River Villas* (1985) which includes aerial photos; Charles Jencks's *Daydream Houses of Los Angeles* (1978), which reveals the "Hollywood" effect on twentieth-century domestic design in southern California; and Charles Goins and J. W. Morris's *Oklahoma Homes Past and Present* (1980), a prototypical celebration of local domestic architecture and personalities.

Another facet of this veneration and celebration of the American home as an art form, albeit in its most elite forms, is the cult of the architect. One might begin research in this area by investigating books on the careers of important American architects, such as Frank Lloyd Wright, H. H. Richardson, Bruce Goff, Venturi and Rauch, and so on. One excellent source is *Conversations with Architects* (1973) by John Cook and Heinrich Klotz, an anthology of interviews with nine architects, including Philip Johnson, Charles Moore, Robert Venturi, and Denise Scott Brown.

There are also books that focus on the high art quality of the domestic designs of famous American architects. For instance, Robert A. M. Stern's self-aggrandizing *American Homes of Robert A. M. Stern* (1991) has an introduction by architectural historian Clive Aslet to provide a legitimating perspective on Stern's contributions to domestic design. Kay and Paul Breslow give a more refined and technical evaluation in *Charles Gwathmey and Robert Siegel* (1977). Walter F. Wagner, Jr., and Karin Schlegel celebrate architects' homes in *Houses Architects Design for Themselves* (1979), a lavishly illustrated volume. The architect is also the unsung hero of volumes such as Herbert Weisskamp's *Beautiful Homes and Gardens in California* (1964) and William J. Hennessey's *America's Best Small Houses* (1949), which highlights designs chosen by the staff of *American Homes* magazine.

In addition to primary source information on the work of American architects, one should also investigate the rich resources offered by the Vance Bibliography Architectural series, which since 1978 has covered a wide range of architectural topics. Domestic architecture as a category of production and research is well represented in imaginative bibliographies such as Robert Harmon's *Dream Houses* (1981) and Donald Dyal's *Sun, Sod and Wind* (1982). The series also includes a number of more conventionally conceived topics. For example, Lamia Doumato has done an excellent job in *Houses by Frank Lloyd Wright* (1987). Other Vance bibliographies of note on the subject of domestic architecture include Carol Ca-

ble's *Contemporary American and Japanese Architect and His Residence* (1992), which discusses the homes of Frank Gehry, Philip Johnson, Charles Moore, and F. L. Wright; and Dale E. Casper's *Historic Houses* (1988) and *Interiorscapes of Houses* (1987), both of which index journal articles examining contemporary American domestic designs. Mary Vance's *Domestic Architecture* (1979) focuses on books on the subject published between 1970 and 1978 and includes a helpful keyword list.

Architectural History and Concepts

As a natural adjunct to interest in specific architects and their domestic designs, and the elevation of domestic architecture to the status of an art form, researchers in popular housing may feel a need to deepen their understandings of the historical and conceptual aspects of architecture as an art and as a design process. While some attention has been given to this topic in previous sections of this chapter, what follows is a decidedly cursory look at resources that can help contextualize American popular housing history, trends, and examples within the context of general architectural practice and the careers of notable individuals in the twentieth century.

At the turn of the century, architecture in America was essentially a regional activity and a freewheeling, vaguely structured community of designers, engineers, and builders who were just beginning to develop a professional consciousness. As a result, the very lack of standardization that was something of a problem in terms of education and training allowed for the receptivity of these architectural practioners to new ideas and procedures. As a result, American architects were able to respond to changing social and economic realities with new specialized forms and methods. Excellent general American architectural histories, such as Marcus Whiffen and Frederick Koeper's *American Architecture 1607–1976* (1981) and John E. Burchard and Albert Bush-Brown's *Architecture of America* (1966) make this clear and include information on notable domestic designs and architects.

In his *Images of American Living* (1976) Alan Gowans traces the changes and continuities of housing styles and interior appointments from the Puritans to middle of the twentieth century. This is a basic volume for the student of American architectural history, whether domestic, civic, or commercial. Unfortunately, the photographs accompanying this lively and informative text are generally of remarkably poor quality. Despite this flaw, Gowans's book can provide an introduction to significant houses, interior designs, and social concerns in American architectural history. His effort is noteworthy for its use of the homes and interiors of everyday Americans as resources of information and insight. Armed with this work, one may make better use of special-interest books such as Julian Cavalier's *American Castles* (1973), a rather disappointing discussion of the crenellated house form in the United States.

Using *Images of American Living* as a base, Alan Gowans's *Styles and Types of*

North American Architecture (1992) offers a comprehensive study of the intersections of nine architectural styles with the social functions and social symbolism of various types of structures from the Colonial period to the present. This volume is an important supplement to the National Images of North American Living slide collection, 30,000 images collected between 1955 and 1989. Gowans discusses four sorts of American domestic structures in this volume—the shelter, the homestead, the palace, and the mansion—in terms of their functions, elements, and evocative and psychic qualities. His interest in and wide-ranging discussion of American housing is unusually thorough, particularly within a general architecture history format. The volume's conceptual framework, large number of black and white illustrations, and basically chronological organization make it a good introductory text; at the same time it offers a number of provocative ideas for research.

The house form has always been an important one for American architects and a special strength of American architecture. It is often also a rich testing ground for new ideas and designs. Not surprisingly, housing design is often an arena for nonconforming or individualistic professional architects. One of the most famous of these was Frank Lloyd Wright, who devoted himself to the problems of individual residences throughout his life. This was unusual, as architects in the twentieth century tend to "graduate" from house design to more profitable (and, to some, more challenging) commercial and industrial projects.

Wright's early residential designs were known as "prairie houses," ground-hugging, horizontal structures with low-pitched roofs, which he designed in seemingly endless variations as he worked to develop an organic architecture. In the 1930s he developed a plan for "Broadacre City," his utopian American urban setting, and he began experimenting with "Usonian" houses: small, affordable dwellings that would offer privacy and distinctive architectural design at a modest price. Wright spent a good deal of his time philosophizing about architecture, and *An Organic Architecture* (1939) and *An Autobiography* (1942) are worth investigating for an indication of how far ahead of his times he was. John Sergeant has done a first-rate job of researching and explaining Wright's Usonian concept in *Frank Lloyd Wright's Usonian Houses* (1976). Vincent Scully's biography, *Frank Lloyd Wright* (1960), contextualizes Wright's architectural theories and designs within the events of his fascinating personal life.

Domestic designs of the 1920s through the 1940s built on technological and conceptual changes in turn-of-the-century American architecture and on the rise of modernism in Europe. European-trained architects, such as Richard Neutra and Rudolf Shindler, brought the International Modern style to southern California, where it created a new vocabulary of domesticity that included concrete or stucco surfaces, open floorplans, and a sense of the interpenetration of indoors and outdoors. Neutra wrote a tract on his architectural theories in 1954, entitled *Survival Through Design*. Thomas Hines's biography of Neutra, *Richard Neutra and the Search for Modern Architecture* (1982) does a very good job of discussing the International Modern movement's influence on American housing. In *Modernity*

and Housing (1993), Peter Rowe includes discussion of American domestic architecture in his review of the theories, goals, and constructions of modern house designers.

Postwar architects such as Philip Johnson, Charles Eames, Harwell Hamilton Harris, Bruce Goff, and Marcel Breuer manipulated the International Modern architectural vocabulary in a number of ways—some very idiosyncratic—but were actually responsible for a relatively small number of American houses. David Masello's *Architecture Without Rules* (1993) uses these architects' works as case studies of the theoretical and structural concepts underpinning International Modernism's domestic design philosophy. Philip Johnson has been an important chronicler and practitioner of modern architecture, and his *Writings* (1979) is a fine introduction to the philosophy and theories of this movement.

Most postwar houses are "development" houses of no discernible historical style that are built as part of suburban community developments. Edward Eichler's *Merchant Builders* (1982) is a very readable history of the processes and personalities associated with this phenomenon.

Trying to describe American residential architecture in the late twentieth century is something of a problem, primarily because its only common characteristic seems to be diversity. In part, this pluralism is the result of a postmodern revolt against the rationality of design and the industrial symbolism and structures of International Modern architecture. Postmodern architecture celebrates everything that the modern despised: popular culture, commercialism, historicism, and ornament.

One of the first to question the authority of the International Style was architect Robert Venturi in his 1966 book, *Complexity and Contradiction in Architecture*, and the house he designed for his mother in Philadelphia in 1962 is something of a three-dimensional manifesto of his ideas about form and symbolism in architecture. Robert A. M. Stern and Raymond Gastil have also written an apologia for these new trends, entitled *Modern Classicism* (1988). Another group of postmodern architects whose work signaled major changes in domestic design were known as the "Five," or the "New York School," when architectural historians and critics Kenneth Frampton and Colin Rowe wrote about them in *Five Architects* (1972). They also spoke for themselves in 1975 in a volume edited by Peter Eisenman, *Five Architects: Eisenman, Graves, Gwathmey, Hejduk and Meier* (1975). Researchers who wish to understand the postmodern program would do well to read Charles Jencks's *Language of Post-Modern Architecture* (1984) as an introduction to the history and vocabulary of the movement and its central practitioners around the world.

At the opposite end of the design spectrum from professionally designed dwellings are the vernacular shelters made by everyday people. Houses built without the use of formal architectural plans are known as "folk" or "vernacular" buildings. Folk housing as an art form is also worth consideration by the student of the American house as icon and image. Howard Wright Marshall's *American Folk Architecture* (1981) is a major resource for study of this area, as is Henry Glassie's

classic *Patterns of Material Folk Culture of the Eastern United States* (1971). Mac E. Barrick's "Log Cabin as Cultural Symbol" (1986) is centered in the iconic significance of this folk form. Simon Bronner includes a chapter on housing as folk art in his entertaining and valuable book on twentieth-century folk expressions, *Grasping Things* (1989). The chapter, entitled "Entering Things," focuses on the impact of etiquette and advice literature on the amateur architects of nineteenth- and twentieth-century folk housing. Michael Owen Jones's "L. A. Add-ons and Re-dos" (1980) is a readable and informative introduction to contemporary issues in folk architecture. Books such as *Handmade Houses* (1973) by Art Boericke and Barry Shapiro reveal the vitality and expressiveness of American folk housing. Two Vance bibliographies offer an introduction to the wonders of the vernacular: John A. Jackle et al., *American Common Houses* (1981) and Lamia Doumato, *Vernacular Houses in the U.S.A.* (1987).

In working with housing as an art form, the researcher needs to consider the relationships among the artist, the work of art, and the communicative, social, personal, and emotive functions of both individual examples and general styles of domestic design. Possible topics for further research include: investigations of American houses as art forms reflecting various taste cultures, from the elite to the folk; studies of the manipulations of the images of historically or artistically significant houses and sites, such as Mt. Vernon, the White House, and so on; consideration of the domestic works of individual architects; examination of the elevation of architectural drawings to the status of elite art; ethnographic studies of individual vernacular houses and their owner-builders; houses as tourist attractions; analysis of specific houses and their iconic meanings; consideration of the haunted house as an amusement park attraction; and Disneyland's manipulations of house images.

MUSIC

Perhaps because music is seen as a complex art form, mystical and "difficult," research in this area has been left to musicologists and other experts. However, music's cultural contexts and functions make it a significant subject for examination. Several basic reference guides are worth noting. Roman Iwaschkin's *Popular Music* (1986) is an important and useful source of information on popular, country, cajun, jazz, black, and screen music. It provides biographies of artists and composers, technical information, periodical and book lists, and industry information. Mark Booth's *American Popular Music* (1983) is an annotated bibliography of popular culture and musical information.

Books of American musical history also offer important material for the researcher in American popular housing. H. Wiley Hitchcock's *Music in the United States* (1969) is a comprehensive, authoritative, and engagingly written text. Of particular interest is his discussion of "household" music of the mid-nineteenth century. Other excellent introductory histories include Barbara Tischler's *An*

American Music: The Search for a Musical Identity (1986) and Daniel Kingman's multicultural *American Music: A Panorama* (1990).

Information about specific songs is also generally available. *The Popular Song Index* (1975) by Patricia P. Havlice indexes 301 songbooks published between 1940 and 1972. A 1978 supplement increases this volume's value. The two works include a bibliography of the songbooks, and the musical works are indexed by title, first line of the song, and first line of the chorus. There is also a composer and lyricist index. Roger Lax and Frederick Smith have organized their *Great American Song Thesaurus* (1989) by title, subject, keyword, and category. The thesaurus chronicles popular songs since 1558 and includes hymns, disco songs, commercial jingles, leider, folk songs, and sea chanties. The book lists over two hundred songs under the sections "Home" and "House," ranging from "Home, Sweet Home" to "I'm Gonna Hire a Wino to Decorate Our Home." One might also examine collections of songs. A charming compilation of music and lyrics that includes a number of house and home songs is Roberta McLaughlin and Lucille Wood's *Sing a Song of Holidays and Seasons* (1960).

The house and home as a subject of song lyrics and orchestral music have not been critically examined and would no doubt prove to be a rich resource for researchers who could both describe and analyze different types of music and/or the music of different periods (the nineteenth century in particular appears to be an undervalued treasure).

MASS MEDIA

Film

The mass media are powerful and compelling sources of ideas and images of house and home. Film and television are so much a part of our cultural memory that they influence and reflect the pictures we carry in our heads, our sense of the parameters and details of the physical world around us. For example, movies such as Steven Speilberg's *E.T.* (1982) and *Close Encounters of the Third Kind* (1977) and television situation comedies and soap operas draw much of their "reality" from their recreation of what the audience recognizes as details of everyday life in suburbia. Similarly, in "slasher" movies and suspense dramas, tension and horror arise from the reversal of our expectations about the safety of hearth and home.

Houses and the icon of the home have been the subject of a number of treatments in a variety of cinematic genres. The peculiar "pleasures" of home ownership provide the comic thread in films such as the classic *Mr. Blandings Builds His Dream House* (1948), based on an article by Eric Hodgins, and *The Money Pit* (1986). *Home Before Dark* (1958) and *House of Games* (1990) exploit the house as a symbol of sanctuary in the midst of the perils of modern life.

The most common use of house and home in film, however, is as a setting fraught with danger and horror, a narrative device that may be traced, in American

literature, back to the works of Nathaniel Hawthorne and Edgar Allen Poe. From the opening credits of films such as Alfred Hitchcock's *Psycho* (1960) and Wes Craven's original *Nightmare on Elm Street* (1984) and *The People Under the Stairs* (1990), the audience knows that unspeakable horrors will take place in the house. Films such as *House of Horrors* (1946), *House of Fear* (1945), *House of a Thousand Candles* (1936), *House on Haunted Hill* (1958), *House on Sorority Row* (1983), and *House* (1984) and *House II: The Second Story* (1987) all exploit the idea of a haunted house or the house as a threatening and unsafe environment.

However, the image of the house in film and television may also play a less frightening role. In an interview in *Design Book Review* (1992), Donald Albrecht, Curator of Production Design/Exhibitions at the Museum of the Moving Image in Astoria, New York, discusses the importance of films such as *Bringing Up Baby* (1938) to the formation of American popular ideas about suburban life and the ideal of domesticity. To some degree, audience observation of houses and home life in film and on television have become central elements in the associations we bring to our own experiences in the real world. For instance, the "ideal" domesticity of Levittown for consumers of the 1950s, suggests Albrecht, was based on film images of the 1930s and 1940s. Albrecht also argues that films such as the nostalgic Andy Hardy series were used as models for the situation-comedy subject and format that have been staples of commercial network television since its first broadcasts in the early 1950s, adding another layer of visual reinforcement.

Albrecht's *Designing Dreams* (1986) was the first serious attempt in English to analyze the use of architecture in film. Albrecht's interest in and knowledge of the cinematic, architectural, and sociocultural contexts of production design and his commitment to understanding and analyzing their interrelationships make his work particularly significant and informs his efforts at the Museum of the Moving Image. This museum is the only one in the world to collect production design materials in any sort of focused way. The collection includes props, sketches, models, working drawings, and behind-the-scenes memorabilia.

With the invention of the electronic media, the popular house and its interior entered a new universe of iconic meaning. On television and in movies, set design manipulates a commonly understood vocabulary of domestic symbolism that enriches the narrative and energizes the action. The fusion of narrative and design gives these settings a function not common in architecture: they are self-reflexive, acting as powerful influences on perception. For example, on television the image of the domestic interior must conform to the narrative requirements of the medium, regardless of any architectural functionality. So most sitcom sets have the front door clearly in view, because movement from an entry hall to the living room would take up precious time in the twenty-two minutes alloted to plot. Information about individual programs is available in volumes such as Alex McNeil's *Total Television* (1991). The West Coast is a rich resource of materials associated with the entertainment industries, and librarian Linda H. Mehr has compiled a union catalog entitled *Motion Pictures, Television and Radio* (1981) to aid the researcher in uncovering the treasures available.

As an art form, production and set design is a generally underdeveloped area of scholarly research. Basic information about this activity may be found in film indexes, histories, and encyclopedias. The *Film Index* (1948–85) includes a section on set design in volume 1. Although Terence Marner's handbook, *Film Design* (1974), focuses on British films, it does include basic useful information on set dressing and studio design as part of the production process. The classic on this subject is Leon Barascq's *Calgari's Cabinet and Other Grand Illusions* (1976). Barascq's volume is poorly illustrated, especially given the visual nature of this art form, but he does provide an international history of film design and an important introduction to the technical considerations of this craft.

Perhaps as part of the modern cult of personality, art directors have become increasingly visible members of the film production team. Movie art director Carlos Clarens and Mary Corliss celebrate the work of eleven practitioners in "Designed for Film" (1978). This is a significant resource, offering interviews, filmographies, and critical discussion of the work of some of Hollywood's most famous and influential art directors. In contrast to Calrens and Corliss, Brian Henderson's "Notes on Set Design and Cinema" (1988) argues for a nonauteurial approach to film art design, emphasizing instead the corporate nature of film production.

Rather than treating set design biographically, Howard Mandelbaum and Eric Myers celebrate a historical style in *Screen Deco* (1985). A chatty text accompanies, of course, black-and-white (a favorite Deco color scheme) movie stills. Although the focus of a world exposition in Paris in 1920, Art Deco design was introduced to most Americans in Hollywood movies of the late 1920s and 1930s. Mandelbaum and Myers call attention to the most often used domestic settings in an informative chapter entitled "The Rich Are Always With Us." They do a similarly self-consciously camp treatment in *Forties Screen Style* (1991).

Specific investigation of the home as setting and symbolic motif in American films may also yield useful material. Richard Selcer's "Home Sweet Movies" (1990) discusses the importance of the idea of home in films of the 1930s. Jerry Grisowld's "There's No Place But Home" (1987) investigates the similarities and differences between the two narratives. In "Going Home" (1991), R. A. Blake sees the search for a home as a dominant theme in director John Ford's work and a metaphor for his sense of the human condition.

One might also turn to books on specific films of note, which in addition to close analysis, often also provide production histories and information on contemporary popular and critical response. This would be a likely strategy for films in which a house plays a central, if not title, role. For example, interest in Tara might lead one to *GWTW* (1973) by Gavin Lambert, a lavishly illustrated volume that analyzes the film and provides a chatty production history. Similar volumes are available for films such as *Psycho* and *Citizen Kane*.

Basic resources in film and television study offer the scholar of popular American housing helpful technical, historical, and analytical information. The *Film/ Literature Index*, a common volume in university libraries, provides information on journal articles since 1973. *Halliwell's Film Guide* (1985), updated every few

years, provides an idiosyncratic list of important films, annotated with production information, plot synopses, and occasional critical comments by Leslie Halliwell. Robert A. Armour's *Film:—A Reference Guide* (1960) is a helpful introduction to the issues of cinematic research. Linda H. Mehr has edited a union catalog for motion pictures, television, and radio that offers a compilation of manuscripts and special collections in the trans–Mississippi West. The researcher's library would also benefit from an introductory film-study text. Two worth consideration are Joseph M. Boggs's *Art of Watching Film* (1978) and Louis Gianetti's *Understanding Movies* (1990), which offer highly readable and well-organized introductions to technical, aesthetic, and historical information about movies. Both Boggs and Gianetti discuss setting and set design, and Gianetti provides a framework for systematic analysis.

Television and Video

The invention and proliferation of cable and video technologies in the last quarter of the twentieth century has increased the media's hunger for programming and the audience's use of television and video for information and education, as well as for entertainment.

Two video series on architecture include programs on domestic American design. In Robert A. M. Stern's *Pride of Place* (1985) the "Dream Houses" episode traces the mythology and theory behind American housing of the nineteenth and twentieth centuries. Stern focuses on historically or architecturally significant homes, but his discussion of the manipulations of the meaning of home by homeowners and architects is informative and sophisticated. Another episode in the series, "Suburbs: Arcadia for Everyone," also includes a well-conceived treatment of the suburban cottage as an ideal American house type. Architectural historian and college professor Spiro Kostof offers a similar guided tour through the American landscape in his series, *America by Design* (1987a; 1987b).

The Public Broadcasting System is the primary venue of home improvement programming, including *Hometime* and *This Old House*. Often episodes of these series are available on videotape, are transmitted on cable, or inspire book treatments or subsidiary texts.

LITERATURE

In his 1960 meditation "The American Concept of Home," Earl Rovit argues that the American interest in the idea and image *home* may be directly related to what he understands as uniquely American historical and cultural experiences, which he traces back to the Puritans. Rovit provides a provocatively brief, elegantly written overview of the idea and image of home as a clue to American cultural preoccupations. Using Robert Frost's "The Death of a Hired Man," as a jumping-off point, he discusses the preponderance of destroyed and "corrupted" homes in American literature by writers from Brockden Brown to Faulkner and

Nabokov. Rovit also casts a passing glance at painting and architecture as he argues that the image of home in these visual arts is a key to understanding the complexity of modern American life.

A more developed and significant resource for the student of American housing as symbol, image, and idea is Jan Cohn's *The Palace or the Poorhouse* (1979). While this volume is dated by Cohn's reliance on mostly print sources in her examination of the idea and image of American domestic architecture from the earliest European settlers to postwar housing, her methodology and insights were an inspiration for this chapter.

Cohn's argument—that the house appears in American literature as an icon capable of revealing and blending sociohistorical, political, and individual agenda—also provides the rationale for a number of more recent treatments of the idea and image of house and home in American literature. Marilyn Chandler's *Dwelling in the Text* (1991) surveys American literature from Thoreau's *Walden* to Marilynne Robinson's *Housekeeping,* examining houses and interiors as central dramatic and metaphoric elements. McCarthy's article, "Houses in *Walden*" (1987) does a splendid job of contextualizing the image of home in an important Transcendental document. Thoreau's interest in American domesticity is the focus of a more "culturally" inspired essay by Steven Fink, "Building America" (1987).

Domestic dwellings play major roles in a number of fictional works. Although no comprehensive index or list of titles exists, several classics of American literature must be mentioned in this regard, works by Henry James (*The Spoils of Poynton*), Nathaniel Hawthorne (*House of Seven Gables*), Willa Cather (*The Professor's House*), and Edith Wharton (*House of Mirth*), to name just a few. Analytical examinations of novels in which houses and rooms play a significant narrative or symbolic part include Stillman's *Houses That James Built* (1961), Allister's "Faulkner's Aristocratic Families" (1983), Arac's "House and the Railroad" (1978), Gallagher's "A Domestic Reading of *The House of Seven Gables*" (1989), and Adams's "Architectural Imagery in Melville's Short Fiction" (1979).

Feminism and feminist criticism have had an important influence on research in authorship and the female "voice" and perspective in literature. Judith Fryer's "Women and Space" (1984), discusses the relationships between female characters and their domestic environments. Ruth Gordon and Jan MacArthur (1984) used women writers of the nineteenth century as sources for insights into living patterns. Anthologies such as Mary E. Gibson's *Homeplaces* (1991) collect stories illustrating the meaning and transformation of home in Southern fiction. Ann Romines's *Home Plot* (1992) is a discussion of the home and home economics in fiction, focusing on the domestic fiction of several women writers. Helen F. Levy provides a critical history of the works of six women in her *Fiction of the Homeplace* (1992). Both the image of the home and the structure and elements of domestic fiction are examined in her analysis. Investigation of an individual author's work or a particular novel or story may also yield intriguing information. For example, D. G. Griffin's "House as Container" (1986) and A. Bukoski's "Burden of Home"

(1987) in journals concerned with the study of fiction offer insights into the effect of gender on the home as a literary icon.

A final, less-developed area of literary research worth considering is the use of domestic imagery in children's books. Nursery rhymes often include house imagery, as in "Old Mother Hubbard." Fairy tales especially seem to make a good deal of house and home, particularly the cottage in the woods: the story of Snow White, for example, involves housekeeping for the dwarves in just such a dwelling; Hansel and Gretel are drawn toward the witch's gingerbread house not realizing the danger lurking there; and in the widely known Russian story of Baba Yaga, the witch's house is elevated on dancing chicken feet. Similarly, the castle is an important symbolic motif in both Sleeping Beauty and Cinderella. Not surprisingly, the journal *Children's Literature* is an important resource for information on this topic. Librarian W. Moebius's "Room With a View" (1991) includes an extensive bibliography. V. L. Wolfe's "From Myth to Wake of Home" (1990) is a survey of the image of house and home in children's fiction. A relatively short but important introduction to the cultural implications of imaginative literature and the area of children's literature as a subject of study may be found in R. Gordon Kelly's "Literature and the Historian" (1974).

Research on the house in literature has proceeded with some vigor, but there are plenty of individual texts, authors, and historical periods to go around. In addition, formula fiction, gender issues, reader response theory, and consideration of childrens' literature are basically unexplored territories in terms of the image of the house and interior and the function of domestic settings in literary narratives. Scholars might wish to examine and analyze specific housing types in different literary genres, or consider the uses and meanings of different house settings, such as castles, tree houses, penthouses, tepees, cottages, and so on.

"How to" Manuals

Advice literature is an important category of American popular literature for adults, with "how to" books and instruction manuals on various subjects consistently flooding the shelves of American bookstores. The home, interior decoration, and housekeeping have all been subjects of numerous tomes, particularly since the nineteenth century, which was preoccupied with correct behavior and propriety in all facets of social and personal life. Karen Halttunen's *Confidence Men and Painted Women* (1982), a discussion of Victorian advice literature, includes a fine chapter on the issue of house and home in this regard. Colleen McDannell's *The Christian Home in Victorian America 1840–1900* (1986) narrows the focus on Victorian domesticity to argue for the centrality of religious iconography in the making of middle-class Victorian domesticity.

As part of the Victorian drive to educate, civilize, and Christianize, the house and home received their fair share of attention. Harriet Beecher Stowe was among the writers who extolled the importance of a "proper" home environment. In her extraordinarily popular *Uncle Tom's Cabin* (1962) she explained and illustrated

the life-shaping and life-enhancing qualities of the domestic environment, allow-ing her hero Tom to enjoy a life of domestic harmony despite his bondage, making clear that the villainy of Simon Legree stemmed from his rejection of hearth and home. Stowe was a major figure in the nineteenth-century domestic reform move-ment. Using the pseudonym Christopher Crowfield, she wrote a group of essays entitled the *House and Home Papers* (1865), and with her sister, Catherine Beecher, produced an influential advice book, *American Woman's Home* (1971). The uto-pian flavor of the Beecher sisters' efforts in domestic reform was also an element of books such as William Alcott's *The House I Live In* (1972) and Charlotte Perkins-Gilman's *The Home, Its Work and Influence* (1976).

In addition to literature offering advice on domestic life, the nineteenth century saw the development of the decoration handbook genre. English architect Charles Eastlake's *Hints on Household Taste in Furniture, Upholstery and Other Details* (1967) was an early, extremely influential publication, affecting furniture production and interior design in the United States through the 1870s and 1880s. Clarence Cook's *House Beautiful* (1980) first appeared as a series of five articles in *Scribner's Monthly*. This volume was a treatise on decorative taste in general and its particular ex-pression in the entry, the living room, the dining room, and the bedroom. Edith Wharton and Ogden Codman, Jr., provided a similar service for twentieth-century Americans in their *Decoration of Houses* (1978). Like Eastlake, novelist Wharton and designer Codman offered specific advice as to what was desirable and un-desirable in planning and furnishing various rooms of the house. Codman's par-ticipation in this project and his subsequent career was the focus of an exhibition at the Boston Athenaeum and the accompanying book by Pauline Metcalf (1988).

Practical handbooks offering advice about the construction, decoration, organ-ization, maintenance, and improvement of houses have proliferated in the twen-tieth century. Examples of this genre include the lavishly illustrated *House Book* (1976) and *New House Book* (1985) by Sir Terence Conran, which were bestsellers in the United States despite (or perhaps because of) their very British tone. George Nelson, an important American industrial designer, and Henry Wright advocated the application of modern design principles to the domestic architecture of post-war America in *Tomorrow's House* (1946). Waldo Kirkpatrick's *House of Your Dreams* (1958) is less a modernist manifesto than a practical handbook. There have even been notable satires on American domestic architecture. T. H. Robs-john-Gibbings, an interior designer and culture maven of the postwar period, offered a scathing indictment of modern home designs and architectural styles in his *Homes of the Brave* (1954). This short, cartoony polemic was a precursor to the better-known, more culturally literate attack on modernism, *From Bauhaus to Our House* (1981) by Tom Wolfe. Wolfe's trenchant observations of middle- and upper-middle-class houses and interiors and their symbolic meanings offers a finely tuned excursion into iconology and irony.

In addition to these sorts of sophisticated advice manuals, there has also been a stream of a more "nuts and bolts" approach, as evidenced by the Time-Life series on home repair and improvement, which includes *Cabins and Cottages*

(1978). Other books in this category are *The Family Handyman Home Improvement Book* (1973), Richard Nunn's *Popular Mechanics Complete Manual of Home Repair and Improvement* (1972), and John Normile et al.'s *Home Improvement Ideas* (1953).

NEWSPAPERS AND MAGAZINES

In addition to the home-building and house magazines listed in the "Periodicals" section of this chapter and the volumes of decorating, building, and maintenance advice discussed above, information about American housing of interest to researchers may also be found in two important branches of the popular print media: newspapers and special-topic publications. Newspapers in all parts of the country, in both large and small markets, offer some sort of housing column, often syndicated from a news service or metropolitan paper. Any weekly house and garden supplement usually includes advice on decorating, home improvement projects, and house plans. Illustrated articles about trends in domestic design and building are often part of the weekly real estate section. The newspaper is also an underutilized resource of information on regional housing issues and matters of historical interest.

Publishers of house plans and designs have taken advantage of the magazine format since the popularity of the pattern book in the nineteenth century. Public libraries, newsstands, and university libraries offer a rich assortment of these softcover guides. Since the end of World War II, magazine publishers have often sponsored collections of material under their banners. For example, the 1952 collection *Five Star Homes*, edited by Marshall A. Souers, Jr., was published by Better Homes and Gardens; Lane Magazine and Book Company has created a number of special interest magazines, such as its 1967 *Sunset Ideas for Planning Your New Home*; House Beautiful has compiled an annual *Houses and Plans* since 1969; and the F. W. Dodge Corporation has periodically provided collections of photographs of the interiors and exteriors of notable houses from the pages of *Architectural Record*.

Some publishers offer independent designs to consumers, collecting their offerings in magazines that illustrate elevations and plans and offer access to blueprints and building supply lists. One excellent example of this phenomenon is the "Design for Convenient Living" series, including Charles W. Fallcott's *115 Homes for Family Living* (1956). Dale E. Casper's Vance bibliography, *Domestic Architecture* (1987) provides a thorough set of annotations on periodicals that publish house plans and designs.

The mass media's use of homes and interiors as icons and the mass dissemination of images of American houses and domestic settings is another area of research that will yield important information about American popular housing. The application of the theories and methodologies of communications studies could provide the researcher with insights into this subject. The theories behind the choices made for film, theater, and television settings also deserve careful and

focused analysis. Directors, art directors, and set designers are rich and underutilized sources of information about the uses and symbolism of domestic settings in the mass media. A comphrehensive history of set design in film and television has not yet been written. Possible topics for research in this area include: analysis of images of houses and interiors in specific films, theater productions, television programs, magazines, books, comic books and cartoons; interviews with set designers, art directors, magazine editors, and advertising executives; analysis of the relationship between housing styles, images in the mass media, and popular design trends and fads; analysis of the symbolism of domestic interiors in television soap operas; consideration of the house in horror films and other cinematic and television genres over time or in the course of a season; a longitudinal study of the images of houses in building magazines and house and home periodicals; and a directory of home improvement and decoration videos.

REFERENCES

BOOKS AND ARTICLES

Adams, Timothy D. (1979, Fall). Architectural imagery in Melville's short fiction. *American Transcendental Quarterly* 44: 265–77.

Albrecht, Donald. (1986). *Designing dreams: Modern architecture in the movies.* New York: Harper and Row.

———. (1992, Fall). Dialogue: "American museum of the moving image." *Design Book Review:* 35–37.

Alcott, William. (1972). *The house I live in.* New York: Arno.

Allen, Lewis F. (1860). *Rural architecture: Being a complete description of farm houses, cottages, and outbuildings.* New York: Saxon.

Allister, M. (1983, Autumn). Faulkner's aristocratic families: The grand design and the plantation house. *Midwest Quarterly* 25: 90–101.

Ames, Kenneth. (1980). Material culture as non-verbal expression. *Journal of American Culture* 3: 619–40.

Arac, J. (1978, March). House and the railroad: Dombey and son and the house of seven gables. *New England Quarterly* 51: 3–22.

Archives of American Art. (1979). *Collection of exhibition catalogs.* Boston: G. K. Hall.

Argan, Guilio Carlo. (1975, Winter). Ideology and iconology. *Critical Inquiry* 2: 297–305.

Armour, Robert A. (1960). *Film—A reference guide.* Westport, CT: Greenwood.

Art Index. (1929–). New York: H. W. Wilson.

Barascq, Leon. (1976). *Caligari's cabinet and other grand illusions: A history of film design.* Boston: New York Graphic Society.

Barrick, Mac E. (1986). The log cabin house as cultural symbol. *Material Culture* 18: 1–19.

Beautiful Home Plans. (1978). 16th ed. New York: House Plan Headquarters.

Betsky, Celia. (1985). Inside the past: The interior and the Colonial revival in American art and literature, 1860–1918. In Alan Axelrod (ed.), *The Colonial revival in America.* New York: W. W. Norton, H. F. DuPont Winterthur Museum.

Bicknell, Amos. (1976). *Bicknell's village builder: A Victorian architectural guidebook.* Watkins

Glen, NY: Athenaeum Library of 19th Century America/American Life Federation and Study Institute.

Blake, R. A. (1991, June). Going home: The films of John Ford. *Thought* 66: 179–95.

Bochert, James. (1981, Fall). Analysis of historical photographs: A method and a case study. *Studies in Visual Communication* 7: 30–63.

Boericke, Art, and Barry Shapiro. (1973). *Handmade houses: A guide to the woodbutcher's art.* New York: Scrimshaw.

Boggs, Joseph M. (1978). *The art of watching film.* Menlo Park, CA: Benjamin Cummings.

Booth, Mark. (1983). *American popular music: A reference guide.* Westport, CT: Greenwood.

Breslow, Kay, and Paul Breslow. (1977). *Charles Gwathmey and Robert Siegel: Residential works, 1966–1977.* New York: Architecture.

Bronner, Simon. (1989). *Grasping things: Folk material culture.* Ann Arbor: UMI Research Press.

Broude, Norma, and Mary D. Garraro, (eds.). (1994). *The power of feminist art: The American movement of the 1970s, history and impact.* New York: Harry N. Abrams.

Browne, Ray, and Marshall Fishwick (eds.). (1970). *Icons of popular culture.* Bowling Green, OH: Popular.

———. (1978). *Icons of America.* Bowling Green, OH: Popular.

Bryant, William Cullen (ed.). (1872–74). *Picturesque America: Or the land we live in.* New York: Appleton.

Bukoski, A. (1987, Summer). The burden of home: Shirley Ann Grau's fiction. *Critique* 28: 181–93.

Burchard, John E. (1955). Architecture. In Lyman Bryson (ed.), *Symbols and society.* New York: Harper and Row.

Burchard, John E., and Albert Bush-Brown. (1966). *The architecture of America.* Boston: Little, Brown.

Burns, Sara. (1989). *Pastoral inventions: Rural life in 19th century American art and culture.* Philadelphia: Temple University Press.

Byron, Joseph. (1976). *New York interiors at the turn of the century.* New York: Dover; Museum of the City of New York.

Casper, Dale. (1987). *Domestic architecture: Designs and plans 1983–1987.* Vance Bibliography A1935.

Cavalier, Julian. (1973). *American castles.* New York: A. S. Barnes.

Chaffee, P. (1978, Winter). Houses in the short fiction of Eudora Welty. *Studies in Short Fiction* 15: 112–14.

Chandler, Marilyn. (1991). *Dwelling in the text: Houses in American fiction.* Berkeley: University of California Press.

Clarens, C., and M. Corliss. (1978, May–June). Designed for film: The Hollywood art director. *Film Comment* 14: 25–60.

Cohn, Jan. (1979). *The palace or the poorhouse: The American home as cultural symbol.* East Lansing: Michigan University Press.

Conningham, Frederick. (1970). *Currier and Ives prints: An illustrated checklist.* New York: Crown.

Conran, Terence. (1976). *The house book.* New York: Crown.

———. (1985). *Terence Conran's new house book: The complete guide to home design.* New York: Villard.

Cook, Clarence. (1980). *The house beautiful: Essays on beds and tables, stools and candlesticks.* New York: North River.

Cook, John, and Heinrich Klotz. (1973). *Conversations with architects.* New York: Praeger.

Cooper, Clare. (1972, Fall). The house as symbol. *Design and Environment* 3: 30–37.

———. (1974). The house as symbol of self. In John Lang et al. (eds.), *Designing for human behavior.* Stroudsberg, PA: Dowden, Hutchinson, and Ross.

Currier and Ives. (1979). *The great book of Currier and Ives' America.* New York: Abbeville.

Curt, Bruce. (1974). *Great houses of San Francisco.* New York: Knopf.

———. (1977). *Great houses of New Orleans.* New York: Knopf.

Dines-Cox, Elaine K. (1988). *Everydayland: Imagined genre scene painting in southern California.* Laguna, CA: Laguna Art Museum.

Domestic bliss: Family life in American painting 1840–1910. (1991). Rochester, NY: Margaret Woodbury Strong Museum.

Downing, Andrew Jackson. (1968). *The architecture of country houses.* Reprint. New York: Da Capo.

———. (1974). *Rural cottages.* Reprint. New York: Da Capo.

Drury, John. (1974). *Historic Midwest houses.* Minneapolis: University of Minnesota Press.

Eastlake, Charles. (1967). *Hints on household taste in furniture, upholstery and other details.* New York: Dover Reprints.

Eco, Umberto. (1973). Functions and signs: Semiotics of architecture. *VIA* 2: 130–53.

Eichler, Edward. (1982). *The merchant builders.* Cambridge, MA: MIT Press.

Eisenman, Peter (ed.). (1975). *Five architects: Eisenman, Graves, Gwathmey, Hedjuk, and Meier.* New York: Rizzoli.

Falcott, Charles W. (ed.). (1956). *115 homes for family living.* Design for Convenient Living Series. Detroit: Universal.

The family handyman home improvement book. (1973). New York: Scribner's.

Film index: A bibliography. (1948–85). New York: Museum of Modern Art Writer's Program.

Film/literature index. (1973–present). Albany: Filmdex.

Fink, Steven. (1987). Building America: Henry Thoreau and the American home. *Prospects: An Annual of American Cultural Studies* 11: 327–66.

Fiske, John. (1982). *Introduction to communication studies.* New York: Metheun.

Fiske, John, and John Hartley. (1982). *Reading television.* New York: Metheun.

Frampton, Kenneth, and Colin Rowe. (1972). *Five Architects.* New York: Wilborn.

Frankel, D., J. Butterfield, and M. H. Smith. (1983). *The house that art built.* Fullerton, CA: Main Art Gallery Visual Arts Center.

Fryer, Judith. (1984). Women and space: The flowering of desire. *Prospects: An Annual Journal of American Culture Studies* 9: 187–230.

F. W. Dodge Corporation. (1952). *82 distinctive houses from architectural record.* New York: McGraw-Hill.

Gallagher, S.V.Z. (1989, Spring). A domestic reading of *The house of seven gables. Studies in the Novel* 21: 1–13.

Garrett, Elisabeth D. (1990). *At home: The American family from 1750–1870.* New York: Harry N. Abrams.

Garvan, James. (1981, Winter). Mail-order houses and American Victorian architecture. *Winterthur Portfolio* 16: 309–34.

Gebhard, David, Harriet Von Breton, and Robert W. Winter. (1979). *Samuel and Joseph Cather Newsome: Victorian architectural imagery in California 1878–1908.* Santa Barbara: Santa Barbara Art Museum.

Geist, Christopher D. (1978). Historic sites and monuments as icons. In Ray B. Browne and Marshall Fishwick (eds.), *Icons of America.* Bowling Green, OH: Popular.

Gianetti, Louis. (1990). *Understanding movies*. 5th ed. Englewood Cliffs, NJ: Prentice-Hall.

Gibson, Mary E. (1991). *Homeplaces: Stories of the South by women writers*. Columbia: University of South Carolina Press.

Glassie, Henry. (1971). *Patterns in material folk culture of the eastern United States*. Philadelphia: University of Pennsylvania Press.

Goins, Charles, and J. W. Morris. (1980). *Oklahoma homes past and present*. Norman: University of Oklahoma Press.

Gordon, Jean, and Jan McArthur. (1984). Living patterns in antebellum America as depicted by nineteenth century women writers. In Ian Quimby (ed.), *Winterthur Portfolio*, vol. 19. Charlottesville: University Press of Virginia.

Gowans, Alan. (1976). *Images of American living: Four centuries of architecture and furniture as cultural expression*. Rev. ed. New York: Harper and Row.

———. (1992). *Styles and types of North American architecture: Social function and cultural expression*. New York: Harper Collins.

Griffin, D. G. (1986, Fall). The house as container: Architecture as myth in Eudora Welty's *Delta wedding*. *Mississippi Quarterly* 39: 521–35.

Griswold, Jerry. (1987, Fall). There's no place but home: *The wizard of oz* in film and literature. *Antioch Review* 45: 462–75.

Group, Harold E. (ed.). (1946). *House-of-the-month book of small houses*. Garden City, NY: Garden City.

Guimond, James. (1991). *American photography and the American dream*. Chapel Hill: University of North Carolina Press.

Haas, Irwin. (1966). *America's historic houses and restorations*. New York: Castle.

Hall, Edmund. (1976). *Culture and communication: The logic by which symbols are connected*. New York: Cambridge University Press.

Halliwell, Leslie. (1985). *Halliwell's film guide*. 4th ed. New York: Charles Scribner's Sons.

Halttunen, Karen. (1982). *Confidence men and painted women: A study of middle-class culture in America 1830–1870*. New Haven: Yale University Press.

Havlice, Patricia P. (1975). *The popular song index*. Metuchen, NJ: Scarecrow.

———. (1978). *The popular song index: First supplement*. Metuchen, NJ: Scarecrow.

———. (1984). *The popular song index: Second supplement*. Metuchen, NJ: Scarecrow.

———. (1987). *The popular song index: Third supplement*. Metuchen, NJ: Scarecrow.

Henderson, Brian. (1988, Fall). Notes on set design and cinema. *Film Quarterly* 42: 17–28.

Hennessey, William J. (1949). *America's best small houses*. New York: Viking.

Hines, Thomas. (1982). *Richard Neutra and the search for modern architecture: A biography and history*. New York: Oxford University Press.

Hitchcock, H. Wiley. (1969). *Music in the United States: A historical introduction*. 2nd ed. Englewood Cliffs, NJ: Prentice-Hall.

Hitchcock, Henry-Russell. (1976). *American architectural books*. New York: Da Capo.

Homes of American authors. (1853). New York: Putnam.

Homes of American statesmen. (1855). New York: Putnam.

House beautiful. (1969). *Houses and plans*. New York: Conde-Nast.

Hubbard, Elbert. (1916). *Little journeys to the homes of great men*. 14 vols. New York: W. H. Wise.

Iwaschkin, Roman. (1986). *Popular music: A reference guide*. New York: Garland.

Jencks, Charles. (1978). *Daydream houses of Los Angeles*. New York: Rizzoli.

———. (1984). *The language of post-modern architecture*. 4th ed. New York: Rizzoli.

Johns, Elizabeth. (1991). *American genre painting: The politics of everyday life.* New Haven: Yale University Press.

Johnson, Philip. (1979). *Writings.* New York: Oxford University Press.

Jones, Lois Swan. (1984). *Art research methods and resources.* Dubuque: University of Iowa Press.

Jones, Michael Owen. (1980). L.A. add-ons and re-dos: Renovation in folk art and architectural design. In Ian G. Quimby and Scott Swank (eds.), *Perspectives on American folk art.* New York: W. W. Norton.

Karpel, Bernard (ed.). (1979). *Arts in America: A bibliography.* 4 vols. Washington, DC: Smithsonian Institution Press.

Kelly, R. Gordon. (1974, May). Literature and the historian. *American Quarterly* 26: 141–59.

Kingman, Daniel. (1990). *American music: A panorama.* 2nd ed. New York: Scribner's.

Kirkpatrick, Waldo A. (1958). *The house of your dreams: How to plan and get it.* New York: McGraw-Hill.

Kostof, Spiro. (1987a). *America by design.* New York: Oxford University Press.

———. (1987b). *America by design.* Part 1: *The house.* Video. New York: Guggenheim Productions/Public Broadcasting Corporation.

Lancaster, Clay. (1985). *New York interiors at the turn of the century.* New York: Crown.

Lamb, Mrs. Martha J. (1879). *The homes of America.* New York.

Lambert, Gavin. (1973). *GWTW: The making of Gone with the wind.* Boston: Little, Brown.

Lane Magazine and Book Company. (1967). *Sunset ideas for planning your new home.* Menlo Park, CA: Sunset Magazine.

Langley, Batty. ([1750] 1967). *City and country builder.* Reprint. New York: Da Capo.

Lasswell, Harold. (1952). *The comparative study of symbols, an introduction.* Stanford, CA: Stanford University Press.

Lax, Roger, and Frederick Smith. (1989). *The great American song thesaurus.* 2nd ed. New York: Oxford.

Leonard, Harold (ed.). (1966). *The film index: A bibliography.* New York: Arno.

Levy, Helen. (1992). *Fiction of the homeplace: Jewtt, Cather, Glasgow, Porter, Welty, and Naylor.* Jackson: University Press of Mississippi.

Linker, Kate. (1986). *The house and its furnishings as social metaphor.* Tampa: Univerity of South Florida Art Gallery.

Locke, Charmaine. (1981). *The image of the house in contemporary art, exploring the relationship between art and architecture to society.* Houston; University of Houston.

McCarthy, P. (1987, Spring). Houses in *Walden:* Thoreau as "real-estate broker," social critic, idealist. *Midwest Quarterly* 28: 323–39.

McDannell, Colleen. (1986). *The Christian home in Victorian America 1840–1900.* Bloomington: University of Indiana Press.

McLaughlin, Roberta, and Lucille Wood. (1960). *Sing a song of holidays and seasons: Home, neighborhood, and community.* Englewood Cliffs, NJ: Prentice-Hall.

McNeil, Alex. (1991). *Total television, including cable: A comprehensive guide to programming from 1948 to the present.* New York: Penguin.

Mandelbaum, Howard, and Eric Meyers. (1985). *Screen deco: A celebration of high style in Hollywood.* New York: St. Martin's.

———. (1991). *Forties screen style: A celebration of high pastiche in Hollywood.* New York: St. Martin's.

Marner, Terence St. John. (ed.). (1974). *Film design.* New York: A.S. Barnes.

Marshall, Howard Wright. (1981). *American folk architecture: A selected bibliography*. Washington, DC: American Folklife Center.

Marsello, David. (1993). *Architecture without rules: The houses of Marcel Breuer, and Herbert Beckhard*. New York: Norton.

Mayhew, Edward, and Minor Meyers, Jr. (1980). *A documentary history of American interiors from the Colonial era to 1915*. New York: Charles Scribner's Sons.

Mehr, Linda Harris (ed.). (1981). *Motion pictures, television and radio—A union catalog of manuscripts and special collections in the western United States*. Boston: G. K. Hall.

Metcalf, Pauline c. (ed.). (1988). *Ogden Codman and the decoration of houses*. Boston: Boston Athenaeum and D. R. Godine.

Moebius, W. (1991). Room with a view: Bedroom scenes in picture books. *Children's Literature* 19: 53–74.

Muesham. Gerd. (1978). *Guide to basic information services in the visual arts*. Santa Barbara: Oxford University Press.

National Images of North American Living. Slide collection. National Images of North American Living Research and Archival Center. 524–2020 F. Street NW, Washington DC, 20026.

Nelson, George, and Henry Wright. (1946). *Tomorrow's house: A complete guide for the home builder*. New York: Simon and Schuster.

Neutra, Richard. (1954). *Survival through design*. New York: Oxford University Press.

Newsom, Samuel and Joseph. ([1884] 1978). *Picturesque California homes*. Reprint. Los Angeles: Hennessey and Ingalls.

Normile, John, Guy Neff, and Jay Karr. (1953). *Home improvement ideas*. Des Moines: Meredith.

Novak, Barbara. (1969). *American painting of the nineteenth century: Realism, idealism, and the American experience*. New York: Praeger.

Nunn, Richard V. (1972). *Popular Mechanics complete manual of home repair and improvement*. New York: Hearst.

Oliver, Paul. (1975). *Shelter, sign and symbol*. London: Barrie and Jenkins.

O'Neal, William B. (1984). Pattern books and American architecture, 1720–1930. In *Building by the Book* (pp. 47–74). Vol. 1. Center for Palladian Studies in America. Charlottesville, VA: University Press of Virginia.

Palliser, Palliser and Company. (1975). *Palliser's new cottage homes and details*. Reprint. New York: Da Capo.

Palladio, Andrea. (1965). *The four books of architecture*. Reprint. New York: Dover.

Panofsky, Erwin. (1962). *Studies in iconology: Humanistic themes in the art of the Renaissance*. New York: Harper and Row.

Park, Helen. (1973). *A list of architecture pattern books available in America before the Revolution*. Los Angeles: Hennessey and Ingalls.

Perkins-Gilman, Charlotte. (1976). *The home, its work and influence*. Reprint. Tulsa: Source Book Press.

Peterson, Harold L. (1971). *American interiors from the Colonial times to the late Victorians: A pictorial sourcebook of American domestic interiors with an appendix on inns and taverns*. New York: Charles Scribner's Sons.

Pierce, Sally. (1991). *Whipple and black: Commercial photographers in Boston*. Boston: Boston Athenaeum.

Pollard, Elizabeth. (1986). *Visual arts research: A handbook*. Westport, CT: Greenwood.

Pratt, John L. (ed.). (1968). *Currier and Ives' chronicles of America*. Maplewood, NJ: Hammond.

Prezioni, Donald. (1979). *The semiotics of the built environment: An introduction to architectural analysis*. Bloomington: Indiana University Press.

Price, Reynolds. (1977, November 26). Home: An American obsession. *Saturday Review*: 12–15.

Rapoport, Amos. (1969). *House form and culture*. Englewood Cliffs, NJ: Prentice-Hall.

Robsjohn-Gibbings, T. H. (1954). *Homes of the brave*. New York: Alfred A. Knopf.

Romines, Ann. (1992). *The home plot: Women, writing, and domestic ritual*. Amherst: University of Massachusetts Press.

Rovit, Earl H. (1960). The American concept of home. *American Scholar* 29: 521–30.

Rowe, Peter. (1993). *Modernity and housing*. Cambridge, MA: MIT Press.

R. W. Norton Gallery. (1981). *Louisiana landscape and genre paintings of the nineteenth century*. Shreveport: R. W. Norton Gallery.

Rybcznski, Witold. (1987). *Home: A short history of an idea*. New York: Penguin.

Sacca, Elizabeth, and Loren B. Singer. (1983). *Visual arts reference and research guide*. Montreal, Quebec: Prospecto.

Schor, Mira. (1992, October). You can't leave home without it (images of home in recent art). *ArtForum* 30: 114–19.

Schweitzer, Robert, and Michael W. R. Davis. (1986). *America's favorite homes: Mail order catalogs as a guide to popular early 20th century houses*. Washington, DC: Preservation.

Scully, Vincent J. (1960). *Frank Lloyd Wright*. New York: G. Braziller.

Seale, William. (1982). *Tasteful interlude: American interiors through the camera's eye 1860–1917*. Nashville: American Association of State and Local History.

Selcer, Richard F. (1990, Summer). Home sweet movies: From Tara to Oz and home again. *Journal of Popular Film and Television* 18: 52–63.

Sergeant, John. (1976). *Frank Lloyd Wright's Usonian houses: The case for organic architecture*. New York: Whitney Library of Design.

Signs of life: The symbols of the American city. (1976). Washington, DC: Smithsonian Institution Press.

Slater, George A. (1931). *The hills of home: American life pictured in New England in the last half of the nineteenth century*. New York: William Edwin Rudge.

Smeets, Richard. (1975). *Signs, symbols and ornaments*. New York: Van Nostrand Rheinhold.

Solomon, Jack. (1988). *Signs of our times: The secret meanings of everyday life*. New York: Harper and Row.

Souers, Marshall A., Jr. (ed.). (1952). *Better Homes and Gardens five star homes*. Des Moines: Meredith.

Squiers, C. (1991, October). Domestic blitz: The modern cleans house. *ArtForum* 30: 88–91.

Stange, Maren. (1989). *Symbols of ideal life; Social documentary photography in America 1890–1950*. New York: Cambridge University Press.

Stern, Robert A. M. (1985). *Pride of place: Building the American dream*. Video. Princeton: Films for the Humanities.

———. (1986). *Pride of place: Building the American dream*. Boston: Houghton Mifflin.

———. (1991). *The American houses of Robert A. M. Stern*. New York: Rizzoli.

Stern, Robert A. M., with Raymond Gastil. (1988). *Modern classicism*. New York: Rizzoli.

Stickley, Gustav. (1979). *Best of craftsman homes*. Santa Barbara: Peregrine Smith.

Stillman, R. W. (1961). *The houses that James built*. East Lansing: Michigan University Press.

Stowe, Harriet Beecher [Christopher Crowfield, pseud]. (1865). *The House and home papers*. Boston: Ticknor and Fields.

Stowe, Harriet Beecher. (1962). *Uncle Tom's cabin, or life among the lowly*. New York: Collier.

Stowe, Harriet Beecher, and Catherine Beecher. (1971). *American women's home; or principles of domestic science, being a guide to the formation and maintenance of economical, healthful, beautiful and Christian homes*. Facsimile reprint. New York: Arno.

Swan, Abraham. ([1745] 1967). *Collection of designs*. Reprint. New York: B. Blom.

Talbot, George. (1976). *At home: Domestic life in the post-centennial era 1876–1920*. Madison: State Historical Society of Wisconsin.

Time-Life (ed.). *Cabins and cottages*. Alexandria, VA: Time-Life.

Tischler, Barbara. (1986). *An American music: The search for a musical identity*. New York: Oxford University Press.

Tuthill, William B. (1975). *Interiors and interior details: Fifty-two large quarto plates comprising a large number of original designs of halls, staircases, parlors, libraries, dining rooms, etc.* Reprint. New York: Da Capo.

Upton, Dell. (1984, Summer/Autumn). Pattern books and professionalism: Aspects of the transformation of domestic architecture in America 1760–1860. *Winterthur Portfolio* 19(213): 107–50.

Vaux, Calvert. (1968). *Villas and country cottages*. Reprint. New York: Da Capo.

Venturi, Robert. (1966). *Complexity and contradiction in architecture*. New York: Museum of Modern Art.

Venturi, Robert, Denise S. Brown, and Steven Izenour. (1972). *Learning from Las Vegas*. Cambridge: MIT Press.

Wagner, Walter F., Jr., and Karin Schlegel. (1979). *Houses architects design for themselves*. New York: McGraw-Hill.

Wallis, Brian. (1992, February). Living room war. *Art in America* 80(2): 56–60.

Wasserman, Paul, and Esther Herman. (1980). *Catalog of museum publications and media*. New York: Greenwood.

Weisskamp, Herbert. (1964). *Beautiful homes and gardens in California*. New York: Harry N. Abrams.

Wharton, Edith, and Ogden Codman, Jr. (1978). *The decoration of houses*. Reprint. New York: Norton.

Whiffen, Marcus, and Frederick Koeper. (1981). *American architecture 1607–1976*. Cambridge, MA: MIT Press.

White, Charles E., Jr. (1921). *Successful houses and how to build them*. New York: Macmillan.
———. (1923). *The bungalow book*. New York: Macmillan.

Whitney Museum of Art. (1935). *American genre: The social scene in paintings and prints*. New York: Whitney Museum of American Art.

Williams, Henry L., and K. Ottalic. (1969). *Great houses of America*. New York: Putnam.

Williams, Herman W., Jr. (1973). *Mirror to the American past: A survey of American genre painting 1750–1900*. Greenwich: New York Graphic Society.

Woodward, George E. (1865). *Woodward's country homes*. New York: Woodward.

Woodward, George E., and Edward G. Thompson. (1975). *Woodward's national architect: Containing 1000 original designs plans and details to working scale for the practical construction of dwelling houses for the country, suburb, and village with full and complete sets of specifications and an estimate of the cost of each design*. Reprint. New York: Da Capo.

Wolfe, Tom. (1981). *From Bauhaus to our house*. New York: Farrar, Straus, Giroux.

Wolfe, V. L. (1990). From myth to wake of home: Literary houses. *Children's Literature* 18: 53–67.

Wright, Frank Lloyd. (1939). *An organic architecture: The architecture of democracy*. London: Lund Humphries.

———. (1942). *An autobiography*. New York: Duell, Sloan and Pearce.

Zukowsky, John. (1985). *Hudson River villas*. New York: Rizzoli.

PERIODICALS

The following list is suggestive rather than complete. Images of houses and interiors appear in a variety of sources, from popular magazines to academic journals.

Out of publication

American Film

American Home

Arts and Architecture (name change in 1982 to *California Arts and Architecture*)

Beautiful Homes (various titles, including *Home Builder*, *Keith's Home Builder*, and *Keith's Beautiful Homes*)

Musical America

Rodale's New Shelter

Rodale's Practical Homeowner

Television Quarterly

Currently in circulation

Americana

Architectural Digest

Architectural Record (regional editions)

Better Homes and Gardens

Connoisseur

Design Book Review

Design Quarterly

The Family Handyman

Film Comment

Good Housekeeping

House and Garden (HG)

House Beautiful

Journal of American Culture

Journal of Popular Film and Television

Ladies Home Journal

McCall's

The Magazine Antiques

Metropolis

Metropolitian Home (title varies: *Apartment Ideas, Apartment Life*)

Mother Earth News

Popular Mechanics

Redbook

Sunset

Southern Living

TV Guide

VANCE BIBLIOGRAPHIES

This resource is a collection of bibliographies drawn from periodicals and books prepared by librarians. The following may prove particularly helpful to researchers interested in popular housing as American images and icons: *Vance Bibliographies*, Architecture Series. Monticello, Illinois, no. 1 (1978)–present.

Cable, Carol. (1992). *The contemporary American and Japanese architect and his residence.* A2501.

———. (1987). *The historic house museum in the United States: Recent periodical literature.* A1914.

———. (1985). *A listing of cartoons on architectural subjects within selected anthologies.* A1482.

———. (1985). *Semitotics of architecture.* A1346.

Casper, Dale. (1988). *Architects' houses: Recent reviews 1982–1988.* A2076.

———. (1988). *Architecture viewed by the artist: Journal articles 1982–1988.* A2181.

———. (1987). *Domestic architecture: Designs and plans 1983–1987.* A1935.

———. (1988). *Historic houses: Architects' records of past accomplishments, 1983–1988.* A2146.

———. (1987). *Interiorscapes of houses: Design and construction 1983–1987.* A1960.

———. (1988). *Photography and architecture: Journal articles 1982–1988.* A2238.

———. (1988). *Vernacular American architecture 1982–1988.* A2150.

Doumato, Lamia. *A. J. Davis 1803–1892.* A353.

———. (1987). *Houses by Frank Lloyd Wright.* A1783.

———. (1987). *Vernacular houses in the U.S.A.* A1739.

Dyal, Donald H. (1982). *Sun, sod, and wind: A bibliography of ranch house architecture.* A793.

Harmon, Robert B. (1981). *Dream houses: Some considerations on the possible: Selected annotated bibliography.* A583.

Jackle, John A. (1981). *American common houses: A selected bibliography of vernacular architecture.* A574.

Vance, Mary. (1968). *A. J. Downing 1815–1852.* A1990.

———. (1979). *Domestic architecture: A selected list of books.* A68.

White, Anthony G. (1984). *Architecture as an art subject: A selected bibliography.* A1294.

5

Housing and Public Administration

Andrew D. Seidel

Housing is both a product and a process. Housing is the immediate physical
environment, largely man-made, in which families live, grow, and decline.
—Cileman Woodbury

INTRODUCTION

The United States of America and its political subdivisions have been directly and
indirectly involved in the provision of housing for their residents probably since
their founding. This chapter discusses how our governments have developed pol-
icies and programs to produce housing. The emphasis is on providing a very brief
overview and structure for this topic with direction for the reader to many ad-
ditional journals, articles, books, and bibliographies.

Much has been written about housing. The source of this information is highly
fractionated, just as is the production of housing itself. Architects, builders, en-
gineers, constructors, community groups, tenants, home owners, all levels of gov-
ernment, and, of course, scholars themselves all have a particular viewpoint to
represent. Even social workers have been brought into the fray of attempting to
solve the housing problem (see Reamer, 1989). Some see the problem as per-
manent (Salins, 1986). Others claim that there would be no problem had there
not been regulatory intervention in housing markets since the 1930s (Sellon,
1990; Levin, 1987). Fredland and MacRae (1978) even provide a comprehensive
survey (from 1960 to 1977) of econometric models for measuring market impact
of policies. Probably no other area of public and private endeavor requires the

coordination of such diverse expertise and interests and has generated such a diverse commentary.

Beyer (1958, 1965) wrote the primary examinations of the demand and supply factors in the housing market of the period. He discussed factors of production, tenure, design criteria, and environmental considerations. Beyer's works are an explicit call for further research to better understand both the housing problem and how governmental intervention could improve the situation. His work lays an important foundation for how debates over housing policy will be framed. Over the past four decades many subsequent volumes have been written to define a framework for studying the housing problem, its markets, and the policies and problems that have developed (Birchall, 1992; Lord, 1977; Mandelker and Montgomery, 1973; Montgomery and Rogers, 1980; Phares, 1977; Plunz et al., 1980; Salins, 1987; Schwartz, 1987).

Many periodicals—including some scholarly journals such as *Annals of the American Academy of Political and Social Science, Business and Society Review, Housing and Society, Housing Law Bulletin, Journal of the American Planning Association, Journal of Architectural and Planning Research, Journal of Housing, Journal of Urban Affairs, Policy Studies Journal, Policy Studies Review, Real Estate Review, Urban Affairs Quarterly,* and *Urban Studies,* and some magazines such as *Builder, Fortune, National Journal, Professional Builder, Social Work,* and *Urban Land*— have included articles that summarize the national housing programs from 1937 forward and provide calls for renewed invigoration of policies and programs (*Journal of Housing,* 1987, 1988; Diez, 1988; Heinly, 1988a, 1988b; Erie, 1989; German and Fletcher, 1989; *Housing Law Bulletin,* 1990; Hula, 1990; Kuntz, 1989; McLeister, 1987; Perlman, 1990; Richman, 1989; Rosen, 1988; Sichelman, 1987; Stegman, 1990; Steinbach, 1990, 1991). Some journals (*Urban Studies,* 1990) have devoted entire issues to examining housing policies.

Other authors address housing programs implemented on a local level (Drier and Keating, 1990). Even general interest, if highly intellectual, journals such as *The Public Interest* and the *National Journal* (Welfeld, 1988) have addressed the housing issue in detail. The Council of Planning Librarians and the Vance bibliography series also provide useful directions for research (Aryanpour, 1987; Brownlow, 1991; Casper, 1988, 1989; Coppa, 1979; Dowall and Mingilton, 1979; Duensing, 1982; Hallowell, 1975; Horowitz, 1986; Milles, 1986; Moe, 1980; Morales, 1991; Vance, 1988, Worsham, 1979).

Many research monographs (often republished as books) have attempted to examine the extent of the housing policy problem. The Pacific Institute for Public Policy Research's report (1982) as well as the National Association of Home Builders report (1986) are examples. The latter work examines what its authors believe to be the causes of a housing crisis: government controls, availability of financing, inflation, condominium conversion, zoning, economic factors, rent control, the costs of public services, and property rights. Other monographs (such as Keyes and DiPasquale, 1988) provide an overview of the housing policy problem.

Some works, such as van Vliet's *International Handbook of Housing Policies and*

Practices (1990), take a multinational perspective, examining a number of countries individually. Taking a similarly broad approach, Huttman and van Vliet's *Handbook of Housing and the Built Environment in the U.S.* (1988) addresses the broad social setting of housing, including neighborhood quality, residential density, affordability and housing subsidies, and the housing needs of special groups. Marcuse's chapter (1990) on the United States of America in Van Vliet (1990) provides an excellent statistical overview. DiPasquale and Keyes (1990) provide an overview and call for a renewed commitment of all levels of government for a decent home for every American. There are even directories (State of California, 1987) that catalog the array of housing programs and articles that provide the experience in one city or state (Wolkoff, 1990).

Other authors clearly represent a particular, if highly legitimate, point of view. Barnes (1987), presents the need for policies and programs to serve low-income households, examining their need for subsidies and the programs that work best. He concludes that housing programs must continue, that the existing programs are cost effective, and that policies should be developed to increase their ability to be customized to individual circumstances. Turner and Reed (1990), Newman (1992), and Roisman (1990a,b,c) similarly present particular perspectives.

Many government documents record the trials of government agencies attempting to develop programs to address the housing issue (c.f. U.S. Dept. of HUD, 1990a,b; U.S. Congress Senate, 1987, 1989; Zuckman, 1990).

A report from the Council of State Governments (1974) represented its constituents by examining the role, responsibility, and opportunity of state governments "in their formulation and implementation of housing policy" (p. vii). It is no surprise, of course, that its authors concluded that individual states must identify their own major housing problems and devise localized resolutions. Similarly representing a special interest, in this case the National Low Income Coalition, Dolbeare (1989a, 1989b) presents a case for the need for subsidy.

The public sector has been involved in housing in a wide variety of *direct* and *indirect* ways. Housing has been provided directly through, for example, apartment owned and provided by a city's public housing authority leased to tenants at highly subsidized rates. It has been provided indirectly by the federal government through grand subsidies to all families with levels of income sufficiently high that they are able to participate in home ownership (e.g., the federal income tax deduction for home mortgage note interest). Many of these indirect and direct methods have affected several levels of government. For example, most local housing authorities providing apartments might not exist had the funds for construction not originally been provided by federal and state governments. The situation can become quite complex, with direct and indirect programs interacting and different levels of government intersecting and, perhaps, interfering in each other's missions. Therefore, for this discussion, the role of public administration and policy for housing is divided into the direct and indirect programs. Within each division, books, articles, and periodicals that may be of further interest to the researcher and reader are identified.

BACKGROUND AND OVERVIEW

This complexity through which the public sector is involved in the provision of housing did not occur all at once. Rather, it was created over time and within societal contexts. The industrial revolution brought about advancing technologies and increasing concentrations of populations. Advances in technology caused industries to become increasingly mechanized and agriculture to be rationalized. This, in turn, resulted in large populations moving to cities. The provision of publicly funded housing was seen as a way of improving the health and living conditions of a growing urban poor, as well as the level of crime in urban society generally. The prevailing notion was that public intervention in housing markets was not only possible but also desirable. Such intervention was justified by the needs for "safe and sanitary" housing by those unable to obtain it through normal market channels, and by the belief that, with minimum living conditions provided, other negative aspects of urban living conditions, such as various crimes against both property and persons, would be reduced. These public housing programs were primarily direct programs.

The foundation for governmental involvement in housing in the United States was laid early in this century. Early 1900s legislation aimed to improve housing conditions. In 1934, the federal government unsuccessfully attempted to construct housing for the poor with the Public Works Administration (PWA). Lykins (1992) examines a part of the PWA's experience. Although this program proved to be a failure, it was the starting point for substantial governmental involvement in housing.

The growth of suburbs are usually seen as a phenomenon that occurred primarily after World War II with the provision of low-interest guaranteed mortgages to returning soldiers, an indirect program. That certainly was a period of explosive growth for the suburbs, but it was not their beginnings. The growth of suburbs accompanied the industrial revolution. Nonetheless, increasing suburbanization led housing research questions to focus on the building of homes in low-density settings removed from the traditional cities. Transportation technology was necessary so that suburbanites could get to employment, commerce, and recreation centers. Suburbs focused on life in new, relatively homogeneous housing areas.

This growth of suburbs, of course, created a residual effect in the cities. With the suburbanism movement, cities had to cope with a proportionally increasing, less-than-affluent, often minority population. The direct provision of housing in urban centers was saddled with an additional responsibility, the duty of urban renewal to stop the deterioration of central cities. Of course, this meant that the housing projects were often constructed in what were formerly the worst neighborhoods.

More recently, various direct programs have attempted to provide housing for low-income populations in suburban settings, too. A concept of "fair share" has developed whereby suburban localities are encouraged to house their share of the low-income populations in their region. Publicly funded housing for elderly res-

idents has used a significant proportion this funding, but the situation remains that direct programs primarily fund housing for low-income populations and indirect programs primarily subsidize the housing needs of the remainder of the population.

Additional authors have examined the role of the president in creating national housing policy. While Caves (1989) and Hays (1990) take a historical perspective, Hartman (1983) and Johnson (1991) discuss the goals of the Reagan administration to decrease the role of the federal government in the provision of housing. From their perspectives, these goals were to eliminate all programs that add directly to the available housing stock for lower-income households; to reduce housing subsidies and require residents to devote higher proportions of income to housing; to reduce existing stock of subsidized housing through conversion (privatization), demolition, sale, and planned deterioration; and to rely exclusively on supply-side economics, with direct cash subsidies to low-income households.

DIRECT PROGRAMS

One of the primary programs providing the direct provision of housing by the federal government was the Public Housing Administration, created by the U.S. Housing Act of 1937, which also created the U.S. Housing Authority (USHA). USHA provided loans and annual contributions to local public housing agencies for low-rent housing and slum clearance projects. Because aid could only be provided to public bodies, local housing authorities were established for the purpose of building and operating these projects.

The Housing Act of 1949 expanded the earlier legislation by recognizing slums as a national problem. This act identified that many elements, in addition to the physical structure of the housing itself, were necessary for decent housing. These elements included the neighborhood; the educational, recreational, and commercial facilities; the availability of public transportation; the proximity of employment; and the quality of government services. The goal of the National Housing Policy as expressed in the Housing Act of 1949 was the attainment of a decent home and suitable living environment for every American. The slum-clearance programs, or "urban renewal," were seen as the primary vehicle for implementation.

Aaron (1972) examined who benefits from federal housing policies. During the 1960s, there had been a growing concern about inadequate housing and deteriorating neighborhoods. This concern culminated in the Housing and Urban Development Act of 1968. Federal assistance was pledged for the construction or rehabilitation of 26 million housing units. Aaron examined how the benefits from this act were distributed over six major categories of recipients: (1) implicit tax subsidies to home owners, (2) mortgage insurance and loan guarantees, (3) increased flexibility for lending institutions for mortgage operations, (4) subsidies to low-income renters through low-rent public housing, (5) subsidies to low- and

middle-income renters and homeowners; and (6) subsidized loans to rural home-owners.

Egan et al. (1981) examined the need for and the role of mediating structures (such as family, church, neighborhood, and voluntary associations) in bringing housing services from governmental agencies together with individual needs. He warned of the danger of such mediating structures becoming bureaucracies of their own and forgetting their important role as mediators.

Public Housing

The public housing program established by the Housing Act of 1937 meant to serve several purposes: to assist the depressed construction industry, to reduce unemployment, to demolish slums, and to make cheap housing available to low-income families. The Housing Act of 1949 intended to eliminate substandard housing, revive housing construction, and provide a decent home and suitable living environment for every American family. This was a renewed commitment to public housing. The U.S. Department of Housing and Urban Development (1965) has published a history of the low-rent housing legislation. The common misconception of public housing is of ugly developments with poor maintenance and management, containing mostly minority families, and isolated from surrounding communities. Yet about 38 percent of public housing residents are elderly, and a small but growing number of public housing units are occupied by young middle-aged single people with some sort of physical disability. Families and individuals who live in public housing are generally poor, and most public housing tenants are members of racial or ethnic minorities. Public housing projects are managed by public housing authorities (PHAs). Public housing is a means-tested, noncash transfer program. From the time of the federal program's establishment in 1937 until the 1980s, each decade saw more public housing units completed than the decade before.

By the mid-1960s, the environment of PHAs had changed. The number of very low-income families in public housing increased. With a growing proportion of tenants on low, fixed incomes, an increasing need for social services, and the rising cost of maintaining an aging building stock, the rental receipts of PHAs were no longer sufficient to cover the cost of operation. A different operating system had to be devised. HUD implemented an operating subsidy in 1971 based on an "interim funding formula," which became the forerunner of the current formula-based performance funding system (PFS). PFS was implemented in 1975 and was intended to encourage sound housing management practices; however, some view this as overregulation. They believe that HUD frequently issues rigid regulations that restrict management prerogatives and impose unnecessary costs on all housing authorities no matter how well they are managed.

The Housing and Urban-Renewal Recovery Act of 1983 appropriated no funds for the construction of new public housing except for a small Native American program and a program for the elderly and handicapped. Eligible households

received direct housing subsidies in the form of housing vouchers. Vouchers offered tenants an opportunity to shop around for better housing in better neighborhoods. A voucher program was introduced in 1983 in an experiment intended to reach fifteen thousand families. However, many welfare housing payments, such as these vouchers, are not enough to cover the cost of providing standard-quality housing. Therefore, recipients may live in substandard units. Clay and Wallace (1988) analyzed this need, while Dickerson (1985) and Meyer (1979) provided case studies to illustrate techniques for effective management of public housing.

Ashley (1991) argues that as sources of funding have changed, the role of the state has increased, placing the states in a position to show the federal government the multiple options that are available. Davis (1994) and Goetz (1993) discuss how local governments contribute to the solution of providing low-income housing. Gormley (1991) addresses the impact of the potential privatization of publicly owned housing units. Many other authors have suggestions for revising direct programs (Atlas and Dreier, 1993; Chandler et al., 1993; Connerly, 1986).

Public Housing Maintenance

In the 1970s, a need was recognized for the modernization of public housing. Benitez's (1976) guidebook instructed municipalities on the need for rehabilitation. As the existing public housing stock aged, maintenance and modernization became a growing concern. As an answer to improving existing public housing projects, HUD created the first public housing modernization program in 1968. Although this was a tremendous help to housing authorities, the structure of the program made it difficult for PHAs to make any substantial improvements. Congress created the Comprehensive Improvement Assistance Program (CIAP) in 1980 to deal with the problem of improvement of public housing projects. Under the CIAP, public housing authorities are required to develop comprehensive plans to upgrade whole projects and to improve their management capacities. It was concluded that despite large federal investments, more modernization of public housing projects is needed. The House of Representatives Report on the Housing and Community Development Act (HCDA) of 1987 created a new modernization system that would provide PHAs with funds based on five-year comprehensive plans and annual statements of work.

INDIRECT PROGRAMS

A network of indirect programs and policies have existed with the intent of expanding home ownership generally. They have been designed to make it possible for more Americans to afford to own their own homes. These have included funding to preserve and revitalize existing neighborhoods; to prevent them from turning into slum areas while new neighborhoods are being built (e.g., community development block grant funds); direct assistance to lower-income households;

federal government guarantees for mortgage loans; and local government actions such as taxation, rent controls, landlord–tenant regulation, rehabilitation and urban renewal, planning, zoning, and land-use controls.

On the national level, the Federal Housing Administration's (FHA) programs have played a major role in the indirect subsidy of housing. The original intent was to create a sounder mortgage system by providing government insurance for residential mortgages made on long-term, self-amortizing bases. By insuring these loans, interest rates could be slightly lower (due to reduced risk) and new construction could be encouraged, the assumption being that as someone moved into a newly constructed house, someone else could move into the residence that had been vacated, thereby improving the overall quality of occupied housing. Of course, the FHA does not itself lend the money; rather, it encourages lending institutions to loan money on both new and older residential properties by insuring their loans.

A number of federal government agencies set up programs that encouraged the purchase of housing, in addition to the FHA. The Veterans Administration (VA) initiated a program to assist returning ex-soldiers to purchase housing on a liberal basis. The primary requirement needed to qualify was evidence of a job or income that would indicate good repayment possibilities. This program guaranteed a part of a loan made by a lending institution. While the FHA required that the home purchaser have funds to make a down payment (thereby reducing risk to the lender and to the FHA), the VA required minimal capital, often only one dollar, from the purchaser.

The Home Loan Bank Board chartered and supervised federal savings and loans associations and operated the Federal Savings and Loan Insurance Corporation (FSLIC) to insure the accounts of savings and loan associations and similar institutions, which were a primary source of mortgage loan funds for home purchases. The FSLIC provided stability for the entire savings and loan industry for decades, insuring the continuity of deposits and, therefore, the availability of funds for home purchase loans. During the 1980s, savings and loan institutions faced a high default rate, and the federal government was faced with the necessity of repaying depositors. Some blame these defaults on the deregulatory policies of the federal government of that decade, some on Congress's lack of oversight, some on mismanagement of the savings and loan institutions. While that debate cannot be settled here, the depositors were paid up to the insurance limitations, and the availability of loans for home mortgages was maintained even through that crisis period.

The Federal National Mortgage Association (FNMA) was created under Title III of the Housing Act of 1934. This act provided for the establishment of national mortgage associations, which were to be private organizations operating under the supervision of the FHA and authorized to borrow money needed for their programs through the public sale of notes, bonds, and debentures. This creation of a secondary market for mortgage loans also increased the availability of funds for home mortgage loans. The Community Facilities Administration was created

as a constituent agency of the Housing and Home Finance Agency. It provides aids to private housing through programs for elderly housing, a college housing program, advances for public works planning, a public facility loan program, and a school construction program.

The Home Owner's Loan Corporation (HOLC) was created to relieve the distress of homeowners faced with foreclosure and to aid lending institutions. HOLC accepted poor-risk mortgages held by private financial institutions in exchange for HOLC bonds. The delinquent mortgages were refinanced through the issuance to homeowners of new mortgages at lower interest rates and with longer repayment periods. The HOLC remained in existence until 1951.

During the Depression, the PWA was created as a part of the National Industry Recovery Act to stimulate employment. The act used federal funds to finance low-cost housing, slum clearance, and subsistence homesteads. The principal reason for housing construction provided through the PWA, however, was the need to create jobs, not the need for adequate housing. Nonetheless, it is clear that for many decades and still today the federal government, through a variety of programs, has taken an active if indirect role in subsidizing the housing of the vast majority of homeowning Americans.

Tax reduction has been used to create a variety of incentives to increase home ownership. The primary incentive is the income tax deductions allowed for mortgage interest and real estate taxes. Another indirect program, rent control, although currently only in very limited use, stabilized or greatly reduced rents tenants would have to pay. Of course, in many circumstances, these controls also created strong disincentives for ownership of rental property, a major cause of the deterioration and abandonment of existing rental properties by their owners. Rent control has operated primarily on a local basis. Some local and state governments have also implemented landlord–tenant regulation to assure that minimum standards are met in the quality of rented dwellings.

A number of authors have called to alternative approaches to providing housing for low-income families. The Citizens' Commission of Civil Rights (1983) decries the failure of existing housing policies. Goetze (1983) calls for adaptive renovation and reuse of the existing housing stock. Bratt (1989) calls for rebuilding housing policy as an approach of cooperation among federal, state, and local governments. Levine (n.d.) analyzes a variety of housing policy options for the Congressional Budget Office. Robbins (1992) addresses how to remove regulatory barriers. The House Committee on Banking, Finance, and Urban Affairs of the U.S. Congress (1991) annually produces a report summarizing the working of the FHA.

Housing Standards

Government on all levels may set minimum construction and amenity standards that housing must meet. While these minimum standards often appear to become the maximum provided by the builder, they are nonetheless an indirect method of providing housing of a specified quality. Dowall and Mingilton (1979)

list numerous sources examining, for example, the effect of increased land use and environmental regulation on housing costs and how such regulatory costs were considered by developers to be more significant than direct costs such as fees and assessments.

The basis of housing standards rests in the protection of the safety, health, and welfare of the occupants of housing. The first national housing standards were established by the Housing Act of 1949. In general terms, the act established the goal of "a decent home and a suitable living environment for every American family," yet no definitions of "a decent home" or "a suitable living environment" were specified. They are difficult if not impossible to define, because different groups of people have different goals when it comes to housing and their environment.

In addition to construction quality, some housing standards include: environmental standards such as noise level, open space, housing density, and school locations; local codes, including dwelling unit occupancy provisions; sleeping room occupancy provisions, required facilities for bathrooms, kitchens, heating, and electrical service; solid and liquid waste disposal; lighting; and ventilation. Blair et al. (1984) even provide a test book for evaluating the inspection process. State, regional, and local agencies often provide reports of how well codes are being administered (Capital Region Planning Commission, 1968). Nonetheless, the most important objective of housing policy traditionally has been to improve housing quality for the poor. However, another problem arose. The higher the minimum standard that was set for housing quality, the fewer low-rent properties that would participate in any program, thereby reducing the housing available for low-income populations.

Federal Fair Housing Policy

So-called fair housing policy is a subject of recent controversy. The implementation of a fair housing policy is intended to expand housing choices for all races on a metropolitan area–wide basis and to achieve both freedom of choice (FOC) and stable racial integration (SRI). FOC and SRI mean the expansion of options for minority as well as majority households to live in stable, racially integrated neighborhoods. How one accomplishes these laudable goals still remains unclear, even if the goals are viewed as complementary. Project HOPE of the U.S. Department of Housing and Urban Development (1990a) set a number of laudable goals in the development of an affordable housing program, including empowering people with the opportunity to manage their own homes and enter the economic mainstream, increasing access to home ownership, and increasing dignity and independence of low-income people by offering support services. Hoben (1982) discusses what states can do to increase the availability of affordable housing. Suchman (1990) examines public and private partnerships to provide affordable housing. Bratt (1985), Clay (1987), Downs (1983), Goetz (1991), Marullo (1985), Mayer (1984), Stone (1990), Susskind (1990), and Tucker

(1991), as well as a number of agencies of the federal government (U.S. Congress, House Select Committee on Aging, 1988; U.S. Department of Housing and Urban Development, 1989; U.S. General Accounting Office, 1985, 1989) all examine aspects of the affordable housing problem.

Financing Home Ownership

Housing is more than shelter; it is an asset. Major factors in the country's economic life include housing construction and the overall housing stock. Home-owners face increasing housing cost burdens influenced by a variety of conditions, including the price of land and land availability, mortgage interest rates, the efficiency of the construction industry, and types of subsidies available. In recent years, there has been a drop in the nation's home ownership rate. While small, the drop has been taken as a sign that fewer people are able to afford the down payments and monthly costs. Homeownership depends on long-term financing. It is a process of purchasing a home over time. Homeownership emphasizes the ability to buy and the ability to keep. The fewer the available resources, the more likely that affordability is a perceived and real problem, especially in an economy where housing costs have been rising rapidly.

In the 1930s a series of legislative acts laid the foundations for a well-defined and regulated home finance system. The first characteristic of this system was the separation of financial institutions according to function. Second, to prevent a repetition of large-scale financial failure in the future, Congress set up special federal agencies to oversee the activities of financial institutions. Third, the federal government put the mortgage market on sound footing by insuring mortgages, and thus lenders, against default. Fourth, the FHA was instrumental in originating and standardizing the long-term, self-amortizing fixed-rate mortgage, the instrument that became the mark of the American home finance system. Fifth, the FHA also created a secondary mortgage market by establishing the FNMA.

The Lincoln Institute of Land Policy (1984) questioned the free-market approach to financing housing during the Reagan administration. Cerf (1988) examined the use of a housing tax credit for low-income families, while Clancy (1988) and Goolsby and Williams (1990) examined tax incentives more generally. Durning (1992) reviews the use of mortgage revenue bonds. Florida (1986) and Greendale (1976) address changing methods of finance and regulation. Hays (1993) addresses the future of housing policy. Lowry (1980) and Fallis (1993) analyze the effects of a housing voucher program. Kadakia (1994) calls for a reexamination of housing policy in the current environment. Schwartz (1988a, b) identifies housing assistance programs developed and administered by employers for the benefit of their employees.

Ball et al. (1988) see a growing structural crisis in the provision of housing. They argue that the advances in housing conditions that have occurred since 1945 are not likely to continue due to deregulation of formerly specialized housing finance institutions (usually savings and loan associations). While this may in-

crease competition in housing lending, making the market more efficient and thereby lowering lending costs, it will also increase risk associated with lending. In addition to summarizing housing conditions and various government policies, Lowry (1989) discusses how during the 1990s there will be a shift of federal housing assistance from dwelling subsidies (direct programs) to household subsidies (indirect programs).

CONCLUSION

Public housing programs have attempted to address three types of housing problems: low quality, inadequate space, and excessive cost. Yet for a variety of reasons, existing housing programs have been criticized for failing to serve the people most in need. One of the most common conclusions about existing housing programs is that they do not necessarily result in much improvement in quality. As Gressel (1976) reports, the tightening of federal budgets has led many local communities to take a more active interest themselves in housing rehabilitation programs. Yet the combination of rapidly rising housing prices and periodically increasing mortgage interest rates has generated much concern that home ownership is becoming less affordable, particularly to young, first-time home buyers. While there are statistics that provide a useful description of households who purchased homes in a particular year, there are no comparable statistics to provide a profile of potential first-time buyers who want to purchase a home but cannot afford to do so. Also, we need to be cautious looking for a single determinant of affordability. Housing markets are local in nature, and significantly different market conditions occur across regions.

American housing subsidy programs have concentrated on capital costs and have been marked by a tendency to rely on housing intermediaries to convey housing subsidies. Much has been done to improve the housing situations of low-income households, but the growth of housing assistance has failed to keep pace with the growth of poor households. Nenno (1991) argues that during the 1990s the housing problem will be self-correcting. The housing built to accommodate the baby boom generation will result in an oversupply and a stabilization of or even reduction in prices. Even if her conclusions are correct, they may not address how housing will become available for a reasonable proportion of a low-income family's total income.

Throughout this century, housing has been a persistent concern at all levels of government. But as the various programs and policy initiatives are scattered across all levels of government, so are the sources of information. While some sources are encyclopedic or bibliographic, the most current information can be found in articles dispersed across many journals and magazines.

This dispersion of information is perhaps indicative of the nature of the subject. The provision of housing in the United States is accomplished by many groups of actors: architects, engineers, large and small builders, community and volunteer groups, and all levels of government. Each group has its own sets of interests and

objectives. The task of government has been to establish policies that can influence the actions of these diverse groups to improve the quality of housing provided. Yet, the notion that housing quality for lower income groups will improve due to a trickle down effect of indirect subsidies to middle- and upper-income groups remains unproven. The reality may be that for every citizen to have "decent" housing, the funds must simply be provided from tax revenues.

Housing standards set a minimum level of construction. That standard of construction may only be met for a specifiable minimum cost, and that cost may be above what low-income occupants are able to pay. Assuming that we shall continue to have low-income groups, those groups will require a subsidy to afford housing that meets the minimum standards. Even if we do not accept that assumption (e.g., low income is eliminated due to job creation, education, etc.), it still appears to return to a question of financing.

One way or another, it may only be marginally a matter of design expertise, engineering expertise, or construction technology and organization. Of course, each of those areas should seek to find innovative ways to reduce costs, but costs must be met if every American is to have a decent habitat. It is on that question that government policy has focused and will continue to focus for the foreseeable future: what way of spending money is most effective in providing standard housing to people who could not otherwise afford it themselves. Some studies and articles will continue to be self-serving of the group or political viewpoint their authors represent. Yet legitimate research will continue to respond to that very important and temporally pressing question.

REFERENCES

BOOKS AND ARTICLES

Aaron, Henry J. (1972). *Shelter and subsidies: Who benefits from federal housing policies?* Washington: Brookings Institution.

Aryanpour, Azar. (1987). *The American housing market: A bibliography.* Monticello, IL: Vance Bibliographies.

Ashley, Dayna. (1991). *Constructing local solutions: Affordable housing.* Denver, CO: National Conference of State Legislatures.

Atlas, John, and Peter Dreier. (January 1993). From "projects" to communities: How to redeem public housing. *Journal of Housing* 50 (1).

Ball, Michael, Michael Harloe, and Maartje Martens. (1988). *Housing and social change in Europe and the USA.* New York: Routledge.

Barnes, William R. (1987). *A time to build up: A survey of cities about housing policy.* Washington, DC: National League of Cities.

Benitez, A. William. (1976). *Housing rehabilitation: A guidebook for municipal programs.* Washington, DC: National Association of Housing and Redevelopment Officials.

Beyer, Glenn H. (1958). *Housing: A factual analysis.* New York: Macmillan.

———. (1965). *Housing and society.* New York: Macmillan.

Birchall, Johnston. (1992). *Housing policy in the 1990s.* New York: Routledge.

Blair, Judy. (1984). *Conducting MSPA housing inspection: Test book.* Washington, DC: U.S. Department of Labor, Employment Standards Administration, Wage and Hour Division.

Bratt, Rachel G. (Summer 1985). Housing for low income people: A preliminary comparison of existing and potential supply strategies. *Journal of Urban Affairs* 7 (3).

———. (1989). *Rebuilding a low-income housing policy.* Philadelphia: Temple University Press.

Brownlow, Judith. (1991). *Fair share housing: A partially annotated bibliography.* Chicago, IL: Council of Planning Librarians.

Capital Region Planning Commission. (1968). *Codes and administration reports.* Baton Rouge, LA: Author.

Casper, Dale E. (1988). *Public housing: A review of recent trends.* Monticello, IL: Vance Bibliographies.

———. (1989). *Public regulation of housing policy: Journal articles, 1982–1989.* Monticello, IL: Vance Bibliographies.

Caves, Roger W. (February 1989). An historical analysis of federal housing policy from the presidential perspective: An intergovernmental focus. *Urban Studies* 26 (1).

Cerf, Alan R. (1988). *The low income housing tax credit: Public policy and private incentives.* Berkeley, CA: Center for Real Estate and Urban Economics, University of California, Berkeley.

Chandler, Mittie Olion, Virginia O. Benson, and Richard Klein. (Summer 1993). The impact of public housing: A new perspective. *Real Estate Issues* 18 (1): 29.

Citizens' Commission on Civil Rights. (1983). *A decent home . . . : A report on the continuing failure of the federal government to provide equal housing opportunity.* Washington, DC: Author.

Clancy, Patrick E. (1988). *Tax incentives and federal housing programs: Proposed principles for the 1980s.* Cambridge, MA: Massachusetts Institute of Technology, Center for Real Estate Development.

Clay, Phillip L. (1987). *At risk of loss: The endangered future of low-income rental housing resources.* Washington, DC: Neighborhood Reinvestment Corporation.

Clay, Phillip L., and James E. Wallace. (1988). *Preservation of the existing stock of assisted private housing.* Cambridge, MA: MIT Housing Policy working papers, Center for Real Estate Development.

Connerly, Charles E. (Spring 1986). What should be done with the public housing program? *Journal of the American Planning Association* 52 (2) : 33.

Coppa, Frank J. (1979). *Housing: A bibliographical overview.* Monticello, IL: Vance Bibliographies.

Council of State Governments. (1974). *A place to live: Housing policy in the states.* Lexington, KY: Author.

Davis, John Emmeus. (1994). *The affordable city: Toward a third sector housing policy.* Philadelphia: Temple University Press.

Dickerson, Harvey. (1985). *Case studies of effective management practices within public housing agencies.* Washington, DC: U.S. Department of HUD.

Diez, Roy L. (April 1988). Support in the war for a new housing policy. *Professional Builder* 53: 11.

DiPasquale, Denise, and Langley C. Keyes (eds.). (1990). *Building foundations.* Philadelphia, PA: University of Pennsylvania Press.

Dolbeare, Cushing N. (1985). *Federal housing assistance: Who needs it? Who gets it?* Washington, DC: National League of Cities.

———. (1989a). *Low income housing needs.* Washington, DC: National Low Income Housing Coalition.

———. (1989b). *Out of reach: Why everyday people can't find affordable housing.* Washington, DC: Low Income Housing Information Service.

Dowall, David E., Jessie Mingilton. (1979). *Effects of environmental regulations on housing costs.* Chicago, IL: CPL Bibliographies.

Downs, Anthony. (January 1983). The coming crunch in rental housing. *The Annals of the American Academy of Political and Social Science* 465: 76–85.

Dreier, Peter, and W. Dennis Keating. (December 1990). The limits of localism: Progressive housing policies in Boston, 1984–1989. *Urban Affairs Quarterly* 26: 191–216.

Duensing, Edward. (1982). *State housing finance agencies.* Monticello, IL: Vance Bibliographies.

Durning, Danny W. (ed.). (1992). *Mortgage revenue bonds: Housing markets, home buyers, and public policy.* Boston: Kluwer Academic.

Egan, John J. (1981). *Housing and public policy: A role for mediating structures.* Cambridge, MA: Ballinger.

Erie, Steven L. (July 1989). Open your eyes to the housing crisis. *Real Estate Today* 22: 58–60.

Fallis, G. (1993). On choosing social policy instruments: The case of non-profit housing, housing allowances or income assistance. *Progress in Planning* 40.

Florida, Richard L. (1986). *Housing and the new financial markets.* New Brunswick, NJ: Center for Urban Policy Research.

Fredland, J. Eric, and C. Duncan MacRae. (1978). *Econometric models of the housing sector: A policy-oriented survey.* Washington, DC: Urban Institute.

German, Brad, and June Fletcher. (July 1989). Playing politics with housing: Housing in the '90s conference. *Builder* 12: 24ff.

Goetz, Edward G. (1991). Promoting low income housing through innovations in land use regulations. *Journal of Urban Affairs* 13 (3).

———. (1993). *Shelter burden: Local politics and progressive housing policy.* Philadelphia: Temple University Press.

Goetze, Rolf. (1983). *Rescuing the American Dream: Public policies and the crisis in housing.* New York: Holmes and Meier.

Goolsby, William C. and Gwyn D. Williams. (Spring 1990). Maximizing low-income housing tax benefits. *Real Estate Review* 20 (1) : 78.

Gormley, William T., Jr. (1991). *Privatization and its alternatives.* Madison, WI: University of Wisconsin Press.

Greendale, Alexander, and Stanley F. Knock, Jr. (eds.). (1976). *Housing costs and housing needs.* New York: Praeger.

Gressel, David. (1976). NAHRO publication no. N585. *Financing techniques for local rehabilitation programs.* Washington, DC: National Association of Housing and Redevelopment Officials.

Hallowell, Ila M. (1975). *Rehabilitation of marginal housing stock in urban areas: A selected annotated bibliography.* Monticello, IL: Council of Planning Librarians.

Hartman, Chester W. (ed.). (1983). *America's housing crisis: What is to be done?* Boston: Routledge and Kegan Paul.

Hays, R. Allen. (Summer 1990). The president, Congress, and the formation of housing

policy: A reexamination of redistributive policy-making. *Policy Studies Journal* 18 (4).

———. (1993). *Ownership, control, and the future of housing policy.* Westport, CT: Greenwood.

Heinly, David. (January 1988a). Alan Cranston writes a new housing policy. *Professional Builder* 53: 182.

———. (April 1988b). Reagan's last dance with housing: HUD budget. *Professional Builder* 53: 36.

Hoben, James E. (1982). *Affordable housing: What states can do.* Washington, DC: U.S. Dept. of Housing and Urban Development, Office of Policy Development and Research.

Horowitz, Carl F. (1986). *Housing indicators and public policy.* 2nd ed. Monticello, IL: Vance Bibliographies.

Housing Law Bulletin. (May–June 1990). HOPE and Federal Housing Programs. *Housing Law Bulletin* 20.

Hula, Richard C. (December 1990). Rediscovering housing policy. *Urban Affairs Quarterly* 26: 313–19.

Huttman, Elizabeth, and Willem van Vliet (eds.). (1988). *Handbook of housing and the built environment in the U.S.* New York: Greenwood.

Johnson, William G. (Winter 1991). Housing policy under the Reagan presidency: The demise of an iron triangle. *Policy Studies Review* 10 (4).

Journal of Housing. (September–October 1987). 50 years of housing legislation. *Journal of Housing* 44 (5).

———. (January–February 1988). Keeping the commitment: An action plan for better housing and communities for all. *Journal of Housing* 45 (1).

Kadakia, Tania Jay. (Winter 1994). A review of "Beyond bricks and mortar: Reexamining the purpose and effects of housing assistance" by Sandra J. Newman and Ann B. Schnare. *Journal of the American Planning Association* 60 (1) : 128.

Keyes, Langley Carleton, and Denise DiPasquale. (1988). *Housing policy for the 1990s.* MIT Housing Policy Project working papers. Cambridge, MA: Center for Real Estate Development.

Kuntz, Phil. (March 18, 1989). Housing policy: Cranston, Gonzalez head off in different directions. *Congressional Quarterly Weekly Report* 47: 590–91.

Levin, Melvin R. (1987). *Planning in government: Shaping programs that succeed.* Washington, DC: Planners Press, American Planning Association.

Levine, Martin D. (n.d.). *Federal housing assistance: Alternative approaches.* Washington, DC: U.S. Congressional Budget Office.

Lincoln Institute of Land Policy. (1984). *Housing in the eighties: Financial and institutional perspectives: Papers prepared for the Lincoln Institute's land policy roundtables on housing; December, 1983 and April, 1984.* Cambridge, MA: Author.

Lord, Tom Forrester. (1977). *Decent housing: A promise to keep: Federal housing policy and its impact on the city.* Cambridge, MA: Schenkman.

Lowry, Ira S. (ed.). (1980). *The design of the housing assistance supply experiment.* Santa Monica, CA: Rand.

———. (Winter 1989). Housing policy for the 1990s: A planner's guide. *Journal of the American Planning Association* 55: 93–100.

Lykins, Lisa Dianne. (1992). *Building public housing: The PWA in Lexington, Kentucky, 1934–1937.* Lexington, KY: n. p.

McLeister, Dan. (February 1987). Time to renew our housing policy. *Professional Builder* 52: 52.

Mandelker, Daniel R., and Roger Montgomery (eds.). (1973). *Housing in America: Problems and perspectives.* Indianapolis, IN: Bobbs-Merrill.

Marcuse, Peter. (1990). United States of America. In Willem van Vliet (ed.), *International handbook of housing policies and practices.* Westport, CT: Greenwood.

Marullo, Sam. (March 1985). Housing opportunities and vacancy chains. *Urban Affairs Quarterly* 20: 364–88.

Mayer, Neil S. (Summer 1984). Conserving rental housing: A policy analysis. *Journal of the American Planning Association* 50: 311–25.

Meyer, David D. (1979). *Housing rehabilitation:* A case study. Unpublished thesis, California State University.

Milles, James. (1986). *The law of urban housing and neighborhood reinvestment strategies: Selected list of readings, 1970–1986.* Monticello, IL: Vance Bibliographies.

Moe, Christine. (1980). *Housing cooperatives.* Monticello, IL: Vance Bibliographies.

Montgomery, Roger, and Marshall Rogers (eds.). (1980). *Housing policy for the 1980s.* Lexington, MA: Lexington.

Morales, Leslie Anderson. (1991). *Empowering public housing residents: A bibliography.* Monticello, IL: Vance Bibliographies.

National Association of Home Builders. (1986). *Low- & moderate-income housing: Progress, problems & prospects.* Washington, DC: Author.

Nenno, Mary K. (January–February 1991). National housing policy: A national policy perspective on three strategic issues. *Public Administration Review* 51: 86–90.

Newman, Sandra J. (1992). *Beyond bricks and mortar: Reexamining the purpose and effects of housing assistance.* Washington, DC: Urban Institute Press.

Pacific Institute for Public Policy Research. (1982). *Resolving the housing crisis: Government policy, decontrol, and the public interest.* San Francisco, CA: Author; Cambridge, MA: Ballinger.

Perlman, Martin. (February 1990). New beginnings: Housing agenda for 1990s. *Builder* 13: 62.

Phares, Donald (ed.). (1977). *A decent home and environment: Housing urban America.* Cambridge, MA: Ballinger.

Plunz, Richard, C. Jara, A. Medioli, and S. Abrams (eds.). (1980). *Housing form and public policy in the United States.* New York: Praeger.

Reamer, Frederic G. (January 1989). Affordable housing crisis and social work. *Social Work* 34: 5–9.

Richman, Louis S. (March 27, 1989). Housing policy needs a rehab. *Fortune* 119: 84–87 ff.

Robbins, Carol T. (1992). *Removing regulatory barriers to affordable housing: How states and localities are moving ahead.* Washington, DC: U.S. Department of Housing and Urban Development, Office of Policy Development and Research.

Roisman, Florence Wagman. (May–June 1990a). Establishing a right to housing: An advocate's guide: Part 1: State and local legislation dealing expressly with shelters or housing, general assistance and similar laws. *Housing Law Bulletin* 20.

———. (July–August 1990b). Establishing a right to housing: An advocate's guide: Part 2. *Housing Law Bulletin* 20.

———. (September–October 1990c). Establishing a right to housing: An advocate's guide: Part 3. *Housing Law Bulletin* 20.

Rosen, David. (Fall 1988). Affordable housing: The American day dream. *Business and Society Review* (67): 67–70.

Salins, Peter D. (Fall 1986). Toward a permanent housing problem. *The Public Interest* (85): 22–33.

———. (ed.). (1987). *Housing America's poor*. Chapel Hill, NC: University of North Carolina Press.

Schwartz, David C. (May–June 1987). Wanted: A new housing policy. *Journal of Housing* 44: 109 *ff*.

———. (Spring 1988a). Corporate action on affordable housing: Employer-assisted housing programs. *Business and Society Review* (65): 4–10.

———. (August 15, 1988b). Business can attack housing costs: Employee home ownership plans. *Fortune* 118: 85 *ff*.

Sellon, Gordon H., Jr. (1990). The role of government in promoting homeownership: The U.S. experience. Paper presented at International Conference on Central and East European Housing Finance, Budapest. *Economic Review* (Federal Reserve Bank of Kansas City) 75: 37–43 (July–Aug.).

Sichelman, Lew. (February 1987). The housing agenda: 100th Congress. *United States Banker* 98: 56.

State of California. (1987). *Directory of housing programs: Local, state, federal*. 3rd ed. Sacramento, CA: State of California, Business, Transportation and Housing Agency, Department of Housing and Community Development.

Stegman, Michael A. (July 1990). A glimmer of hope: HUD priorities for the 1990s. *Urban Land* 49 (7).

Steinbach, Carol. (March 10, 1990). The hourglass market: Housing affordability. *National Journal* 22 (10).

———. (June 29, 1991). Housing the "haves": Home buying and the middle class. *National Journal* 23 (26).

Stone, Michael E. (1990). *One-third of a nation: A new look at housing affordability in America*. Washington, DC: Economic Policy Institute.

Suchman, Diane R. (1990). *Public/private housing partnerships*. Washington, DC: Urban Land Institute.

Susskind, Lawrence. (1990). *Affordable housing mediation: Building consensus for regional agreements in the Hartford and Greater Bridgeport areas*. Cambridge, MA: Lincoln Institute of Land Policy.

Tucker, William. (1991). *Zoning, rent control, and affordable housing*. Washington, DC: Cato Institute.

Turner, Margery Austin, and V. M. Reed. (eds.). (1990). *Housing America: Learning from the past, planning for the future*. Washington, DC: Urban Institute.

Urban Studies. (December 1990). Housing finance and policy: A special issue. *Urban Studies* 27 (6).

U.S. Congress, House Select Committee on Aging, Subcommittee on Housing and Consumer Interests. (1988). *Losing assisted housing units: Elderly and low-income Americans at risk*. Hearing before the Subcommittee on Housing and Consumer Interests of the Select Committee on Aging, House of Representatives, One Hundredth Congress, second session, January 21, 1988, Seattle, WA. Washington, DC: GPO.

U.S. Congress, House Committee on Banking, Finance, and Urban Affairs, Subcommittee on Housing and Community Development. (1991). *Federal Housing Administration: Internal controls and the 1990 annual report*. Hearing before the Subcommittee on

Housing and Community Development of the Committee on Banking, Finance, and Urban Affairs, House of Representatives, One Hundred Second Congress, first session. Washington, DC: GPO.

U.S. Congress, Senate Committee on Banking, Housing, and Urban Affairs, Subcommittee on Housing and Urban Affairs. (1987). *Affordability of housing: One hundredth Congress, first session, on the declining ability of first time homebuyers to purchase a home, September 14, 1987, Memphis, TN.* Washington, DC: GPO.

———. (1989). *Affordable Housing Act of 1989, one hundred first Congress, July 10, 1989, Boston, MA.* Washington DC: GPO.

U.S. Department of Housing and Urban Development. (1965). *Low-rent public housing program: Legislative history.* Washington, DC: GPO.

———. (1989). *A report on homeless assistance policy and practice in the nation's five largest cities.* Washington, DC: GPO.

U.S. Department of Housing and Urban Development, Office of Policy Development and Research. (1990a). *HOPE: Homeownership and opportunity for people everywhere.* Washington, DC: GPO.

———. (1990b). *Regulatory barriers to affordable housing: A resource guide.* Washington, DC: GPO.

U.S. General Accounting Office. (1985). *Federal rental housing production incentives: Effect on rents and investor returns: Report.* Washington, DC: GPO.

———. (1989). *Rental housing: Housing vouchers cost more than certificates but offer added benefits: Report to the chairwoman, Subcommittee on HUD-Independent Agencies, Committee on Appropriations, U.S. Senate.* Washington, DC: GPO.

Vance, Mary A. (1988). *Low income housing in the United States: A bibliography.* Monticello, IL: Vance Bibliographies.

Van Vliet, Willem (ed.). (1990). *International handbook of housing policies and practices.* Westport, CT: Greenwood.

Welfeld, Irving. (Summer 1988). Poor tenants, poor landlords, poor policy. *The Public Interest* 92: 110–20.

Wolkoff, Michael J. (1990). *Housing New York: Policy challenges and opportunities.* Albany: State University of New York Press.

Worsham, John P. (1979). *Government and state housing finance agencies: A selected bibliography.* Monticello, IL: Vance Bibliographies.

Zuckman, Jill. (October 20, 1990). Conferees' authorization bill marks turnabout in policy. *Congressional Quarterly Weekly Report* 48: 3514–16.

6

Housing Finance, Marketing, Economics and Management

Raedene Combs

The costs of occupying, operating and furnishing homes represent over 30 percent of total U.S. household consumption expenditures.
—Randall Johnston Pozdena
The Modern Economics of Housing

Housing possesses a number of characteristics that provide special challenges for consumers and those in the housing industry. Housing is often expensive and thus requires complex systems of financing. Housing is bulky, durable, and difficult to move from one location to another; thus there are numerous local housing markets where appropriate prices need to be determined and mechanisms for matching buyers with sellers are prevalent. Because housing is a major component of the national economy, careful attention is placed on what is happening in the various markets and in the country as a whole. The number of housing starts is related to how well the economy is doing, as the housing industry employees vast numbers of people. The volume of housing sales, the prices received for housing in various markets, and the availability of financing have various impacts on the industry and on housing consumers. Housing finance, marketing, management, and economics compose a broad area that draws information from a number of diverse sources.

It is the purpose of this chapter to identify some of those sources. First, general sources of information, such as indexes and bibliographies, are identified, along with some of the keywords that would lead one to information of interest. Second, specific references are discussed for each of the areas: housing finance, marketing,

economics, and management. These areas are not mutually exclusive, and some references address several or all of these components of housing. It is hoped that this brief introduction to the world of housing finance, marketing, economics and management will help guide readers to articles and books that address their specific needs.

RESOURCE GUIDES

General information from magazines can be accessed through *The Readers' Guide to Periodical Literature*. Keywords to begin one's search include *housing, construction industry, housing finance, mortgages,* and *housing costs.* A widely used periodical directory is *Ulrich's International Periodical Directory*. It lists about 71,000 periodicals worldwide, arranged by broad subject classification. The *Business Periodicals Index* is a popular basic business index that indexes over 300 business periodicals. Its strength is in the coverage of general business and management matters, rather than information on product and industry developments. Keywords (and sub-headings) for locating articles of interest include *houses* (apartment houses, condominiums, home ownership, house buying, house selling), *housing* (rental, rural); *housing finance* (building loans, collaterized mortgage obligations, discrimination in mortgage lending, Federal Home Loan Mortgage Corporation, Federal National Mortgage Corporation, home equity conversion, home equity loans, home improvement loans, mortgage bonds and notes, mortgages), *housing management* (landlord and tenant, apartment houses, real estate management), *housing supply and demand, construction industry statistics, housing industry,* and *housing starts.* Many libraries will provide this index as an online computer database that can be accessed through the H.W. Wilson files on a computerized library system.

The *Public Affairs Information Service Bulletin* (*PAIS*) focuses on current economic, social and political concerns. It indexes books, documents, conference proceedings, pamphlets and reports in addition to periodicals. Arrangement in *PAIS* is by subject. Keywords include *housing buying and selling, home ownership* (finance, insurance aspects, tax aspects), and *housing* (discrimination, finance, subsidies).

InfoTrac is a fast, easy-to-use laserdisc bibliographic database indexing some 900 periodicals and newspapers. Although described as an index to popular periodical literature, it is heavily weighted toward business and the social sciences. It is accessed at microcomputer stations. Keywords to access information include *housing finance, discrimination in mortgages, home equity conversions, home improvement loans, housing subsidies, mortgages, housing economics,* and *housing markets. ABI/INFORM ONDISC* is a compact disc database that covers all phases of business management and administration. It abstracts over 800 publications and is available on three compact discs, covering 1971–1980, 1981–1986, and 1986 to date. It is updated monthly with the most recent articles about three months old.

Congressional Information Services publishes three sets of indexes and ab-

stracts that locate publications of interest in the areas of finance, marketing, econ-omy, and management. One set, the *American Statistical Index,* lists publications by agencies of the U.S. government. The primary agency of interest for housing is the Department of Housing and Urban Development. Keywords for locating publications include *housing* (with many subheadings), *housing construction, hous-ing costs and financing, housing discrimination, housing sales, housing starts, housing supply and requirements* and *real estate business.* Brief abstracts are provided in a second volume for each of the publications. Abstracts are classified as periodicals (i.e., *Survey of Mortgage Lending Activity, Secondary Market Prices and Yields and Interest Rates for Home Loans, Survey of Mortgage Lending Activity, Gross Flows, FHA Single Family Trends*) or as annuals and biennials (i.e., *FHA Homes—Characteristics of FHA Home Mortgage Operations; FHA Trends of Home Mortgage Characteristics*). Other publications abstracted under the Policy Development and Research section of HUD include a biennial publication, *Characteristics of HUD-Assisted Renters and Their Units;* a series publication, *Housing Discrimination*; and special and irregular publications such as *Evaluation of Low-Income Housing Tax Credits.* An online serv-ice for this set of abstracts and indexes is available.

The second set of indexes and abstracts published by the Congressional Infor-mation Service; *Index to International Statistics, Abstracts,* provides access to publications around the world. The volume containing the index has the same format of keywords as found in the above publication. However, the publications listed under these keywords are organized by continent (i.e., Africa, Asia, Europe, Latin America, North America, and Worldwide). One can then refer to the vol-ume(s) containing the abstracts for a short description of the publication.

The third set of indexes and abstracts published by the Congressional Infor-mation Services, *Statistical Reference Index,* indexes and abstracts publications and articles by private U.S. organizations and state governments that contain impor-tant statistics on business, industry, finance, and general economic conditions. It indexes and abstracts over 1,000 issuing source organizations, including (1) trade, professional, and other nonprofit associations and institutes; (2) business organ-izations; (3) commercial publishers; (4) independent research organizations; (5) state government agencies; and (6) universities and other research centers. Like the others, it is issued on a monthly basis, with annual editions and multiple year cumulations. The relevant keywords are the same as in the previous two sets of publications.

For those interested in accessing newspaper coverage of housing finance, mar-keting, management, and economics, there are indexes for the *New York Times* and the *Wall Street Journal.* The *New York Times Index* contains abstracts of the significant news stories, editorials, and special features published in the news-paper, classified by subject (i.e., *housing).* The *Wall Street Journal Index* provides abstracts and comprehensive indexes of all articles in the three-star eastern edition of the *Wall Street Journal.* Subject headings such as *housing and housing starts, construction industry, housing discrimination, housing subsidies, mortgages,* and *rent*

control are subdivided geographically so that one can easily identify news stories for a particular region.

For those who like to be on the cutting edge, the *Economics Working Papers Bibliography* identifies draft papers that have not yet been published. These papers usually contain more detailed source data than is possible to include in a published version, and some papers are never published. The housing topics are of interest to economists and are listed under keywords such as *housing, housing construction, housing credit, housing market, housing mortgages, housing ownership,* and *housing rent.*

Those interested in housing from a women's studies perspective can access abstracts in *Women Studies Abstracts. Housing* is listed in the index, along with *homelessness, homeownership, public housing, shelters,* and *urban planning.* Short abstracts of articles are provided.

Several bibliographies cover real estate marketing, finance, and management. *Real Estate Industry* (1987) by Laura Harris presents an annotated list of books and journals appropriate for students and practitioners. Categories of titles include *finance, market analysis, property management,* and *appraisal.* Addresses of government agencies, associations, and organizations are included. *Real Estate* (1983) by Peter Haikalis and Jean Freeman is a bibliography of monographs and has a separate chapter for housing, finance, real estate business, and investment, among other topics, listing titles and authors.

Other bibliographies that are narrower in scope can be obtained from the U.S. Superintendent of Documents. *Construction Industry* (1987a) is a selectively annotated bibliography of federal publications. *The Home* (1987b) lists documents on maintenance and selecting and financing a home.

HUD User is a service provided by the Department of Housing and Urban Development. Documents related to housing affordabiliy, discrimination, the elderly, housing finance, building technology, economic development, and housing for special groups can be obtained by calling 1-800-245-2691 or writing *HUD User,* P.O. Box 6091, Rockville, MD 20850. *HUD User Online* is an online computer database that includes abstracts of these documents and reports.

The *Handbook of Business Information* (1988) by Diane Wheeler Strauss provides a comprehensive listing of information resources in the area of real estate.

HOUSING FINANCE

Books and Articles

Because housing is expensive, few people are able to pay cash for their housing. Instead, buyers tend to finance their homes over a number of years by making payments that include principal and interest. Buyers are concerned with how much interest they will have to pay to have access to the borrowed money, how many years they will have to pay back their loans, what penalties they will incur if they prepay their loans, what different mortgage alternatives are available from

which to choose, who they might approach for a loan, and whether they should get a VA mortgage, an FHA mortgage, an FMHA mortgage, or a conventional loan. There are many facets that consumers must explore as they make decisions regarding the financing of a home.

A number of consumer-focused resources exist that present information on financing a home purchase. Most of these resources discuss financing within the broader context of buying a home. One resource that helps the consumer think through topics such as housing needs and wants; whether to rent, buy, or build; how much house can one afford; professionals who can help; purchase arrangements; financing; insurance; and maintenance is *Your Housing Dollar* (1984). Several government agencies publish pamphlets that provide consumer-oriented information. The Department of Housing and Urban Development, the Department of Agriculture, and the Federal Trade Commission can each be contacted for their latest publications for perspective homeowners. Their publications contain information on topics such as advantages and disadvantages of owning a home, selecting a home, purchase contracts, home financing, mortgage types, the closing process, settlement costs, money management, and home maintenance and repair.

There are several recent books on the market that present general information for consumers interested in purchasing a home. Robert Irwin's *Tips and Traps When Buying a Home* (1988) covers the basics, such as the right time and reason to buy, how to negotiate, what is affordable, choosing the right agent, inspecting the house, making a successful offer, understanding the sales agreement, counter-offers, getting the right financing, closing costs, buying a lot and building a home, buying a condominium, buying a new home from a builder, and the closing. Another good reference for general information for the potential homebuyer is Sylvia Porter's *Home of Your Own* (1989). Additional topics covered in this reference are borrowing from one's family and choosing the right insurance. Michael Thomsett's *How to Buy a House, Condo, or Co-op* (1990) covers much of the same information as the previous books, and includes a separate chapter on buying a condominium or a cooperative. *Bob Vila's Guide to Buying Your Dream Home* (1990) covers similar topics: whether to buy or rent, how to study the market, how to narrow the search, understanding the cooperative and condominium alternatives, how much will it cost, putting it in writing, shopping for the mortgage, the loan application process, closing, and debts and taxes. Another popular book that covers similar areas is *The Kiplinger/Changing Times Guide to Buying and Selling a Home* (1987). Warren Boroson and Ken Austin's *The Home Buyer's Inspection Guide* (1993) covers such topics as choosing and working with a home inspector, the case of disclosure documents, the ins and outs of warranties, energy efficiency, and the more common areas to inspect both inside and outside the home. It also contains a chapter on health hazards that might be found in a home and a chapter on inspecting for burglar protection.

A somewhat different slant is presented by Martin Shenkman and Warren Boroson's *How to Buy a House with No (or Little) Money Down* (1989), which analyzes

alternative financial scenarios in light of the new tax laws. Included are topics such as how to take advantage of sharing and equity kicker mortgages, what seller financing is, how to use lease options, and what parents must know if they help their child. The goal is to help buyers in an expensive market where traditional bank mortgages may not solve the problem.

For consumers desiring a more in-depth understanding of mortgages, Robert Irwin's *Tips and Traps When Mortgage Hunting* (1992) is an informative reference source. This easy-to-read guide to the mortgage arena will be useful even to the most unlearned. The author discusses how to get a mortgage, how to speak and understand "mortgageese," how to get a bigger mortgage, credit problems and solutions, adjustable-rate mortgages, biweekly and 15-year mortgages, the seller as a source of financing, making balloon payments work, convertible mortgages and piggy-backs, buydowns, lines of credit, refinancing, government mortgages, reverse annuity mortgages, tax considerations, paying mortgages off early, settlement costs, and more. John R. Dorfman's *Mortgage Book* (1992) covers mortgage basics, types of mortgages, and mortgage miscellany such as refinancing, paying ahead, and escrow accounts. Peter Miller's *Common Sense Mortgage* (1994) provides a good background on how the lending system works. These insights are followed by information on how to compare loan formats. The book contains a thorough discussion of alternative mortgages and identifies loans to avoid. Miller also addresses issues related to refinancing the home. For those who want to know how much the mortgage payment will be, *Monthly Interest Amortization Tables* (1984) includes tables that calculate the monthly payment required to amortize a loan, loan progress charts, and tables showing proration. Another good source that presents tables for calculating the effects of time and interest on money is *Compound Interest and Annuity Tables* (1993) by Jack Estes and Dennis Kelley. This resource provides monthly, quarterly, semi-annual and annual compounding tables.

While consumers must choose among a variety of mortgage alternatives as they move toward homeownership, real estate agents and lending institutions also must develop and maintain an understanding of possible mortgage alternatives that they might offer. *A Guide to Alternative Mortgage Instruments* (1985) helps real estate students understand the various alternative mortgage instruments, including their major advantages and disadvantages. The package includes different mortgage plans that reduce initial payments, that accelerate amortization, that provide for variable payments, and that allow borrowers to benefit from the rising value of equity in their homes without having to sell or refinance.

The financial world of real estate is more than mortgage alternatives. For newcomers interested in gaining a solid foundation in the basic principles and terminology of real estate finance, John Wiedemer's *Real Estate Finance* (1990) presents the most commonly used methods of financing real property and familiarizes readers with the terminology used in the financial community. The book is written so that a novice can understand the language of the professional. The book includes a discussion of such topics as money and interest rates, notes and mortgages, sources of mortgage money, secondary markets, federal programs,

property appraisal, analyzing borrowers, residential loan analysis, and settlement procedures.

Consumer and industry decisions do not exist in a vacuum. Housing financial institutions and methods have been changing rapidly since the mid-1970s. Several references help inform readers of the new ways of financing housing. Anthony Downs's *Revolution in Real Estate Finance* (1985) explores the implications of the revolutionary changes. He describes how this revolution has affected the financing of residential property, how it has affected first-time homebuyers, and what it has meant to the housing affordability problem. Richard Florida's *Housing and the New Financial Markets* (1986) covers topics such as the new-deal system of housing finance, early deregulation initiatives, the new financial regulations, the reorganization of the thrift industry, the secondary mortgage market, alternative mortgage instruments, and the future of housing finance.

The Federal Home Loan Bank of San Francisco's *Housing Finance* (1991) presents the proceedings of its sixteenth annual conference. The theme is the massive changes that have been made in the housing finance sectors and the resulting adaptations. Issues discussed include the restructure of mortgage finance and what will happen to home prices in the 1990s. The proceedings reflect the importance of federal home loan banks and their members in the support of housing finance.

Because housing is so expensive and generally requires large sums of money to construct, a particular concern is the financing of housing for low- and moderate-income households. Traditional strategies have not proved effective in recent years. Diane Suchman et al.'s *Public/Private Housing Partnerships* (1990) looks at public–private partnerships between state and local governments and the private sector as a way of aggregating and coordinating various resources to produce affordable housing for low- and moderate-income households. This book provides "in-depth information on how a selected group of program-based housing partnerships were formed, how they operate, and how they are evolving."

Kenneth T. Rosen's *Affordable Housing* (1984) takes a different approach in addressing the financial aspects of creating more affordable housing. The objective is to present a study of mortgage and housing policy that analyzes what might be done to bring housing prices into the reach of more households. Rosen uses his knowledge of the mortgage market, agencies, and regulations to prepare his analyses. He discusses the magnitude and distribution of housing demand in the 1980s, the supply and demand for mortgage credit, cyclical instability, land use and rent control regulations, the restructuring of the housing finance system, new mortgage instruments to make housing affordable, and new directions for housing and mortgage policy.

Periodicals

Because change is rapid in the financial world, current information for housing consumers is provided by a number of periodicals. *Money* is a monthly magazine that provides easy-to-read general information for the consumer and small inves-

tor. In addition to occasional feature articles related to housing financial issues, regular sections present information on the leading 30-year adjustable and fixed-rate mortgages and the leading home equity lines in the largest metro areas. A magazine with a similar focus is *Kiplinger's Personal Finance Magazine*. For those interested in housing finance directed to the needs of minority groups, *Black Enterprise* contains relevant articles.

Professionals dealing with mortgages need to obtain current information related to the advantages and disadvantages of various mortgage instruments under changing economic conditions. Keywords to access such information include: *mortgage banking, business conditions, home financing, real estate financing, savings and loan associations, commercial banks, credit unions, loans, adjustable rate mortgages, fixed rate mortgages,* and *underwriting.* One periodical that contains a number of relevant articles is *Real Estate Review.* Contributors include lawyers, appraisers, heads of limited partnerships, real estate consulting firms, and real estate analysts. Articles focus on topics such as reverse mortgages and full costs of a home mortgage loan. While many of the articles deal with commercial property, there will likely be one or two housing-related articles per issue.

An important component of the financial world of housing is secondary mortgage markets. A strong secondary mortgage market is an essential source of funding for the housing industry. With volatility in the financial markets, tax law revisions, and new investor needs, there was a proliferation of the secondary mortgage markets in the 1980s, and it is anticipated that the secondary mortgage market will become an even more significant source of housing funds in the 1990s. Mortgage funds are attractive to a variety of investors such as mutual funds, commercial banks, pension funds, and insurance companies. To keep abreast of changes in the secondary mortgage markets, search current periodicals using keywords such as *secondary market, banking industry, mortgages, savings and loan associations, government agencies, financial institutions, mortgage backed securities, adjustable rate mortgages,* and *REMICs.* One good source of current information is *Mortgage Banking.*

For those interested in reports of theoretical and empirical research on a broad range of housing issues focusing on home mortgage finance, international housing finance, and related housing policy, the *Journal of Housing Research* is excellent. This journal is published on an irregular basis by the Federal National Mortgage Association's (FNMA) Office of Housing Policy. The journal publishes primary research on theoretical models, empirical studies, and statistical analyses. A recent issue (vol. 3, no. 1) focused on comparing efficiency in housing finance in developed countries. Other topics include measuring the size and distributional effects of homeowner tax preferences, residential mortgage default, and housing affordability.

Another relevant journal is *Housing Finance Review.* Published by the Federal Home Loan Mortgage Corporation, it presents the latest research in housing finance. It covers topics such as homeownership, discrimination, the various types of mortgages, consumer protection issues, and secondary mortgage markets.

Another journal that covers financial issues is *Housing Policy Debates*, published quarterly by the Office of Housing Research of FNMA The goal of this publication "is to stimulate thoughtful and insightful discussion on a broad range of housing issues, including housing policy, home mortgage finance, and international housing finance." The journal is organized in three sections: *Forum* (reviewed articles and comments by leading experts in the field), *Articles* (reviewed by members of the Office of Housing Research Advisory Board and other scholars), and *Current Issues* (current policy discussion in housing and finance). The journal also publishes articles presented at the FNMA Annual Housing Conference.

MARKETING

Books and Articles

Because housing is a relatively durable commodity located in a specific geographic area, consumers often move from one house to another as their needs change; thus there exists the need not only to buy homes but also to sell them. Resources are available for the general population that provide how-to information on selling homes. Robert Irwin's *The For Sale by Owner Kit* (1993) presents practical hands-on information. Irwin recommends tax planning before selling the home, and also covers salesmanship, getting the right price, dealing with documents and legalities, preparing the house for showing, getting the word out, working with agents, how to handle buyers, mortgage basics, the art of disclaiming, and the closing process. Another good source for home sellers is Martin M. Shenkman and Warren Bowson's *How to Sell Your House in a Buyer's Market* (1990). This book presents background information and detailed advice on preparing to sell, promoting the house, financial strategies to promote a sale, and wrapping up the deal.

While some homeowners try to sell their own homes, most use the services and expertise provided by realtors. For those interested in becoming realtors, Frank Blankenship's *Semenow's Questions and Answers on Real Estate* (1993) is an easy-to-use reference to help applicants successfully obtain their real estate licenses. The tenth edition covers such topics as real estate law and practices, exclusionary zoning, tax considerations, the broker's duty to the seller and buyer, ethical standards, and consumer rights. More than four hundred commonly used terms are explained, and there are a number of questions to test one's knowledge of the real estate process.

Taking a slightly different approach, William Monroe Shenkel's *Marketing Real Estate* (1985) is a resource for those engaged in marketing real estate. Part 1 focuses on developing marketing skills (i.e., communicating with prospects, presenting houses); part 2 describes the selling operation (i.e., real estate advertising, negotiation skills); part 3 discusses how to improve the sales organization (i.e., selecting qualified salespersons, incentive plans to increase sales); part 4 deals

with the technical aspects of selling (i.e, federal regulations affecting real estate brokers, selling the financial plan). The role of the computer is emphasized.

Another good reference that provides an overall coverage of the real estate market is *Real Estate Fundamentals* (1993) by Wade E. Gaddy, Jr., and Robert E. Hart. The authors begin with a discussion of the nature and description of land, then move to more specific topics such as acquiring and transferring title, how homeownership is held, title records, contracts, real estate brokerage, taxation, appraisal, financing instruments and markets, fair housing laws and ethical practices, real estate transactions, and real estate mathematics.

Real estate brokerage involves selling, buying, and leasing of residential, commercial, industrial, and farm properties. A number of real estate dictionaries and encyclopedias are available to help both the lay person and the professional understand and operate. Jerome S. Gross's *Webster's New World Illustrated Encyclopedic Dictionary of Real Estate* (1987) presents an illustrated glossary, a portfolio of real estate forms, and a directory of national real estate organizations. *The Allen and Wolfe Illustrated Dictionary of Real Estate* (1983) defines more than three thousand terms and includes commonly used real estate forms and the code of ethics of the National Association of Realtors. Bagby and Bagby's *Real Estate Dictionary* (1981) defines more than two thousand terms and includes tables commonly used in real estate transactions. Investment-related terms are presented in *Real Estate Investor's Desk Encyclopedia* (1982) by Paul Lyons and Matthew Bowker. This resource is intended primarily for a lay audience. *Barron's Real Estate Handbook* (1993) by Jack Harris and Jack Friedman contains definitions of more than two thousand terms and has extensive mortgage tables and samples of business and legal forms, with an up-to-date bibliography. It also contains a home buyer's guide, a home seller's guide, median sales prices of existing single-family homes from 1982 to 1991, a section on analyzing real estate investment opportunities, how to read an appraisal report, real estate regulations, and careers in real estate.

Jerome J. Dasso's *Real Estate* (1989) is written for those seeking a clear understanding of the decisions involved in acquiring, owning, and disposing of real estate. The book is divided into various components of the decisionmaking cycle and includes information on defining property rights, acquiring ownership rights, finance, markets, and value analyses and investment. Included are case problems, key terms, references, and illustrations. *The Real Estate Handbook* (1980), edited by Maury Seldin, has sixty-seven chapters, covering topics such as real estate transactions, real estate analyses, real estate marketing, real estate financing, and real estate investment.

A more specialized dictionary is *Real Estate Appraisal Terminology* (1981) by Byrl Boyce. The focus is on appraisal; illustrations of different housing features are included as well as formulas for depreciation methods and valuation models.

For those interested in real estate as a possible career, Kenneth W. Edwards's *Your Successful Real Estate Career* (1993) offers information relative to a number of important considerations when choosing real estate as a career. It includes

suggestions on getting a license, choosing a company, listing and selling residential property, avoiding problems, and conducting client follow-up and referral.

Periodicals

Two periodicals provide important information to those interested in buying and selling real estate. *Real Estate Today* focuses on providing information for those selling, leasing, and managing real estate. It contains a number of advertisements for products and services. Feature articles, such as "Selling Hope in Urban America," are combined with regular department reports such as "Sales Strategies." *Real Estate Business for Brokerage Managers and Residential Sales Specialists* provides information that is quick, timely, and useful. Along with feature articles, there are regular department reports, such as "Market Trends."

A scholarly approach to real estate is provided by *Real Estate Issues.* It provides a medium for expression of individual opinions concerning empirical and theoretical approaches to problems and topics in the broad field of real estate. Contributors include university professors, heads of real estate services, and research economists. Housing topics of interest include multi-family housing, property management, home equity conversion for the elderly, and housing demand.

HOUSING ECONOMICS

Books and Articles

The housing industry is a major component of the U.S. economy; therefore, economists and policy makers closely follow happenings in the housing market and other housing related activities. Statistics on housing demand and supply, housing starts, new home sales, and existing home sales provide essential gauges of the health of the housing industry.

An excellent, although a somewhat older, reference is Michael Sumichrast's *Housing Markets* (1977), which provides an excellent overview of the important components of the housing market. Decision makers, societal goals, and the residential construction industry are discussed. Sections include housing economics (i.e., the concept of the housing market, the relationship of demographic factors to housing demand, housing supply) and factors related to the making of decisions in the housing market.

While Sumichrast's books provides a foundation for understanding the housing market, Leland Smith Burns's *Future of Housing Markets* (1986) attempts to show what will happen in the housing market in the future and why. It deals with a range of social phenomena that influence the market and looks at the changing demographic base of housing demand, the socioeconomic trends that affect household formation, housing in people's life cycles, and future demand changes and supply responses.

Dowell Myers's *Housing Demography* (1990) focuses on changes in the life cycle

composition of the U.S. population and how that relates to the demand for housing.

Judith Feins and Terry Saunders Lane's *How Much for Housing?* (1981) presents a close analysis of housing trends since 1960. The authors observe that old rules of thumb do not reflect the actual housing market; rather, public policy should allow for variations in housing expenditure according to various family characteristics, such as income, age, sex, and size of household.

An excellent source dedicated to a discussion of the economic behavior of the housing market is Randall Johnston Pozdena's *Modern Economics of Housing* (1988). This book provides a conceptual background that permits the reader to apply the knowledge gained to the rapidly changing marketplace. It incorporates important theoretical insights of modern housing economics so that they are understandable by the nontechnical reader. Graphical material and citations to original empirical research are included. Experiences of other countries are used to illustrate certain points. While the book is academic in format, it can also be of use to real estate professionals. The book presents a historical perspective on housing in America, developing a conceptual framework "that can be used to evaluate the effects of the economic environment and government policy on the housing market." Covered are the determinants of housing demand, the fundamentals of housing supply, the market of land and improvement, the pattern of housing location, the determination of housing prices and rents, the market for rental housing, the mortgage market, the market for housing quality, cycles in housing activity, and the future of American housing.

Richard F. Muth and Allen C. Goodman's *Scholarly Economics of Housing Markets* (1989) covers theoretical issues in housing market research, including special theoretical problems associated with the durability and heterogeneity of housing, and topics in empirical urban housing research. While mathematical notations are used, the authors have tried to make the discussion as readable as possible.

Focusing on the rental market, John I. Gilderbloom and Richard P. Applebaum's *Rethinking Rental Housing* (1988) is a study of rental housing in the United States. The authors discuss the structure of rental housing markets and factors that determine the availability of rental housing. Intended for policy makers, housing activists, and academics, this book makes clear how rental housing operates.

On an applied level, Robert Irwin's *Tips and Traps for Making Money in Real Estate* (1993) provides advice on how to successfully invest in a fluctuating market, how to accurately estimate operating expenses, how to identify maintenance minefields, and what home improvements to avoid. The author discusses what makes money and what doesn't and how to avoid nasty tax suprises. For a good source that elaborates on the tax considerations involved with rental property, Holmes. F. Couch's *Rental Real Estate* (1993) presents the basics, explains depreciation allowances, and income and expense calculations. It also provides tax related information when dealing with vacation home rentals, shared equity rentals, out-of-state rentals, and installment sales.

Periodicals

An applied periodical that focuses on the economics involved in the housing market is *Builder*. While this magazine has sections on the economy, business and building, and market updates, it also addresses other components of the real estate industry, such as speculative building, financing, marketing, and management. The information is appropriate for those actively engaged in the building industry.

Housing Economics addresses a number of current housing economic issues. The monthly publication has a regular "Outlook" essay and covers topics such as remodeling in the 1990s, mortgage market developments, housing activity, multifamily housing activity, remodeling activity, vacation homes, single-person households and housing demand, operating costs of new and existing homes, and home buyers' sources of down payment.

The scholarly *Journal of Housing Economics* is dedicated to "providing a focal point for the publication of economic research related to housing." The journal provides a forum for economists engaged in housing-related research. Topics include homeownership and housing demand, the homeownership decision of female-headed households, the accuracy of homeowners' estimates of house value, patterns of racial steering, and estimating house price appreciation.

Housing-related statistics are important in monitoring what is happening relative to supply and demand. *U.S. Housing Markets* surveys housing for a number of metropolitan areas, eight regions, and the United States as a whole. Data are provided on private housing permits for single- and multifamily units, along with information on multifamily housing units completed or under construction. Other information includes rental vacancy rates, households by age groups, and trends for existing home sales and mortgage markets. Mid-year and year-end issues include editorial analyses and forecasts.

Information relative to housing supply is provided by the Census Bureau's *Construction Reports*. These reports include *Housing Starts* (series C20), *New Residential Construction in Selected Standard Metropolitan Statistical Areas* (series C21), *Housing Completion* (series C22), *New One-Family Houses Sold and for Sale* (series C25), *Characteristics of New Housing* (series C25), *Price Index of New One-Family Houses Sold* (series C27), *Value of New Construction Put in Place* (series C30), *Housing Authorized by Building Permits and Public Contracts* (series C40), and *Residential Alterations and Repairs* (series C50). Some are published monthly and some quarterly. *Characteristics of New Housing* is published annually.

Construction Review presents statistical tables classified under the following headings: construction put in place; housing; building permits; contract awards; costs, prices, and interest rates; construction materials; and contract construction employment.

The Census Bureau issues a series of publications related to housing. One is the *Annual Housing Survey*, with data reported under six subject headings for the United States generally and for the Northeast, Midwest, South, and West in particular. The subject headings are: general housing characteristics, indicators of

housing and neighborhood quality by financial characteristics of the housing inventory, housing characteristics of recent movers, urban and rural housing characteristics, and energy-related housing characteristics.

Another series is the *Census of Housing*. Data collected every ten years is published in separate series volumes which include general housing characteristics, detailed housing characteristics and metropolitan housing characteristics, and components of inventory change and residential finance. These reports contain information about the physical and financial characteristics of housing units. One can determine the number of houses that are vacant or for sale and the number of condominium and renter-occupied units, among other things. Data are available for each state, for designated metropolitan areas, and for the United States as a whole.

Another series offered by the Census Bureau is the *Census of Population and Housing*. Housing data on a block-by-block basis is presented in the *Block Statistics* series, and by census tracts, cities, and counties in the *Census Tracts* series.

Other statistics are available from trade associations, private organizations, and commercial publishers. The National Association of Realtors's *Outlook for the Economy and Real Estate* presents current and projected economic conditions as they affect residential and other real estate markets. These are short reports containing an introduction and tables reporting such information as the gross national product, real estate markets, prices, and financial markets. The National Association of Realtors also publishes *Existing Home Sales*, which compiles data from over 275 boards of realtors and multiple listing systems. Data on the sales of existing one-family houses, the supply of such houses, and housing affordability are presented.

Information on construction and operating costs is provided by the *Dodge Cost Calculator and Valuation Guide*. This source provides average construction costs for residential and other types of buildings. Photographs of representative building types are shown, and specifications and cost factors are provided.

The Institute of Real Estate Management provides several annual reports that compile data contributed by its members. Two of the reports, *Income/Expense Analysis: Apartments* and *Expense Analysis: Condominiums, Cooperatives, and Planned Unit Developments*, provide information that can be used to compare national, regional, and local costs and incomes.

A source of information that reflects the interplay between supply and demand is the Consumer Price Index, which reflects the changing amounts that people pay for their housing, whether in amount of rent paid or in monthly mortgage payments. This information can be obtained from the *CPI Detailed Report*. The *Inter-City Cost of Living Index* compares apartment rents and other housing-related costs across 250 participating cities.

HOUSING MANAGEMENT

> Proper management creates a better living environment.
> —United Nations, *Basics of Housing Management*

Books and Articles

While it is essential to have in place those factors that generate a supply of housing for individuals and families, equally important for many is the proper management of that housing. The management of housing occurs primarily with rental property, which may be owned by the public sector (a government body) or by individuals or corporations in the private sector. One will also find housing management associated with certain forms of ownership, such as condominiums and cooperatives.

An early publication by the Department of Economic and Social Affairs of the United Nations, *The Basics of Housing Management* (1969), emphasizes that the building of housing alone does not bring about desired changes—effective management procedures are also needed. Good management practices promote social improvement, proper maintenance, and sound financial arrangements. The effective manager "deals not only with efficiency and economy, but equally with questions of ethics and humanism." This valuable resource addresses such topics as the role of the manager prior to occupancy and after occupancy; management when special groups such as aged persons, handicapped persons, large families, or students are involved; specialized management for cooperatives and condominiums; and the role of a supervisory government agency.

The technical aspects of how to successfully manage housing in the public sector is of primary interest to the U.S. Department of Housing and Urban Development (HUD). A series of publications commissioned by HUD cover a multitude of relevant topics, as indicated by their titles: *Communication Skills for Housing Managers* (1980a), *Energy Management for Housing Managers* (1980b), *Litigation Regulations and Guidelines in Housing Management* (1980c), *Maintenance Management and Service Contracts* (1980d), *Management of Housing for Handicapped and Disabled* (1980e), *Manager and Social Service Instructor's Guidebook* (1980f), *Marketing Procedures for Housing Managers* (1980g), *Personnel Administration in Housing Management* (1980h), *Pest Control and Grounds Maintenance in Housing Management* (1980i), *Professional Career Systems in Housing Management* (1980j), *Resident Participation in the Housing Management* (1980k), *Residential Security in Multi-family Housing* (1980l), and *Supervisory Skills for Housing Managers* (1980m). This series of publications covers a broad range of topics relevant to successfully managing rental housing. While this series was published in 1980, it continues to offer some of the best information available on how to determine and meet client needs.

In addition to managing public housing, another aspect of ensuring successful management is the role played by management reviews. Again, HUD has been instrumental by commissioning the McHenry Company's *Guide to Management Reviews of Public Housing Agencies* to help public housing authorities (PHAs) improve their operations by better understanding how well they are performing. The focus of the guide is on the low-income public housing program. The guide provides PHAs with information necessary to conduct a comprehensive manage-

ment review: review methodology, selection of a review team, and so on. An extensive list of performance measures are presented, and the process that should be followed in conducting a management review is described, including the executive director's role, the PHA staff's role, and the role of the review team. Techniques are presented for resident management assessment, facilities management assessment, financial management assessment, organization management assessment, and information management assessment. A methodology for developing a plan for carrying out the improvements cited in the management review is also included.

Resident management is an idea that many believe will result in public housing projects that better meet the needs of their residents. HUD's *Operations Guide for Resident Management Corporations* (1990) is intended to serve as a guidebook to help residents and resident groups who want to undertake resident management in their developments. This guide discusses the public housing resident management movement; its history, goals and objectives; and criteria for success. Information is presented on how to organize and establish a resident management corporation, with emphasis on organizing the community and obtaining a technical assistance grant. Information is presented on how to carry out property management tasks; how to develop supportive service programs, such as child care, job training and employment, mental health services, recreation, and elderly services; how to develop businesses; and how to increase homeownership opportunities. A short bibliography on resident management is included.

Another group interested in empowering residents of public housing and resident management is the National Center for Neighborhood Enterprise, 1367 Connecticut Avenue NW, Washington, D.C. 20036. This group publishes a number of bulletins on this subject.

For those interested in new questions, research strategies, and programs being formulated in Europe, Teepneer et al.'s *Rehumanizing Housing* (1988) is worthwhile reading. Tom Woolley asks, Do tenants want to manage the problems? He presents experiences from Glasgow. Marjorie Bulos and Stephen Walker discuss the need for intensive management from the United Kingdom experience. They address the critical issue of identifying management practices that meet the needs of residents, particularly those living in highrise housing. Marion Robers presents the problem of caretaking of municipal housing estates in Great Britain. What are the effects of a lack of caretaking? Who does take care of the environment? What role does gender play? What role do moral values play?

Because almost all assistance to disabled people is provided within an organizational context, housing management in relation to their needs is an area of concern. Keith Tully's *Improving Residential Life for Disabled People* (1986) has a section on managing residential services that considers a broad range of organizational and management issues. Tully offers a range of ideas from which all levels of workers can understand what is happening in residential contexts on an organizational level. Practical suggestions are provided to enable managers to improve the ways in which they deal with workers and organizational issues. Tully

notes that the improvement of services cannot succeed unless organizational and managerial dimensions are taken into account.

Housing management is of concern to those responsible for housing for the elderly. Lawton Powell's *Planning and Managing Housing for the Elderly* (1975) provides information for planners and administrators written from the viewpoint of a behavioral scientist. Powell's ecological approach focuses on the social and psychological aspects of management, following his belief that behavior occurs in a physical and social context. Stating that the most important but least known aspect of housing for the elderly is management, he discusses the role of attitudes in the management of housing, assisting with tenant problems, and the provision of on-site services, among other topics. He notes that little is known about commercially developed and managed housing for the elderly.

Related to improving the housing environment for elderly persons, Barbara M. Silverston's *Establishing Resident Councils* (1974) focuses on what both residents and administrators must do if a successful council is to come into being. The intent is to use resident councils to help elderly persons retain personal dignity and "freedom of action despite the ravages of time and limited resources." This guideline for residents presents the purpose of a council, who comprises the council, how business is conducted, how participation is stimulated, and how management can be influenced. The guidelines for administrators address topics such as the importance of having a resident council, the prerequisites to setting up a council, how to set up a council, and tasks and decisions appropriate for a council. The manual presents both a perception of human values and a knowledge of the principles of organization and administration.

Congregate housing management for the elderly is addressed in Donahue et al.'s *Congregate Housing for Older People* (1975). This resource contains sections on the role of management, tenant selection and placement, essential services, knowledge and use of community resources, and tenant relations. It is emphasized that congregate housing management calls for counseling, social intervention, and decisionmaking based on a knowledge of gerontology, social medicine, and the legal system in order to provide the kind of housing and services that contribute to the physical, psychological, and social well-being of the residents.

While the above sources have been written primarily with the public sector management as the focus, there is increasing interest in how to successfully manage rental property held by the private sector. A number of properties are owned by absentee landlords and organizations (i.e., limited partnerships and life insurance companies) that benefit from having property managers. The property manager negotiates leases, collects rents, supervises maintenance and repair, and provides accounting and financial services.

Kent Banning's *Residential Property Management Book* (1992) provides a guide for those engaged in property management. Topics include ownership and organizational structure, the role of the site manager, general rental housing policies and procedures, marketing residential properties, developing a comprehensive leasing program, effective resident–manager relations, managing people and re-

sources, personnel policies and procedures, building and ground maintenance, financial control and budgeting, contracts, landlord tenant law and the Fair Labor Standards Act, and discrimination and unemployment compensation issues.

Irene Melan and Mike Melan's *How to Buy and Manage Rental Properties* (1988) discusses managing people, buying right to manage right, rental interviews and agreements, keeping good tenants and getting rid of bad ones, bookkeeping taxes and property tracing, real estate agents and property sales, and equity sharing and partnerships. This book is particularly useful for the small investor in rental property.

The Property Manager Handbook (1991) by Stephen G. Pappas offers guidance on the business aspects of managing property, ethics and legal counseling, and administrative advice. Numerous charts, forms, and schedules are included.

Another aspect of property management is that performed by the homeowner associations of cooperatives and condominiums. David B. Wolfe's *Condominium and Homeowner Associations That Work* (1987) notes that community associations are unique contributions of the private sector to the long-term maintenance and stability of residential development: "A community association can be efficient, cost-effective and highly responsive to its constituency." A well-conceived community association with a sound legal basis, viable financial structure, and good management is important. With this in mind, Wolfe discusses "the process of designing a community association through the founding of legal documents, and the process of operating the governance structure thus designed." The book is intended for lay people, including volunteers "who seek to achieve practical social and institutional environments," as well as for professional management people.

Another resource on association management is *Financial Management of Condominium and Homeowners' Associations* (1985) by the Community Management Corporation. The intent of this resource is to provide up-to-date guidance on association management. It is a how-to book for those responsible for the financial management of an association. It contains sample forms, examples of budgets, and checklists. The book is intended for association staff and officers, management consultants, and others involved in association financial management.

The expertise of a number of housing professionals located in academic settings was used by the National Center for Housing Management to prepare *College Curriculum in Housing Management* (1974). This project, sponsored by HUD, consists of a "collection of working papers, centered around the problems, needed data base and necessary steps to making a new professionalized career out of a field of work which is evolving in importance and focus." The work defines housing management, discusses the various levels of responsibility, summarizes the characteristics of current resident managers, and assesses manpower needs at the national and local levels.

Periodicals

The primary periodical on housing management in the public sector is the *Journal of Housing*, a bimonthly publication that focuses on housing and com-

munity development issues. Each journal has several feature articles and then reports from various departments (Opinion and Comment, State Reports, City Reports, People Reports, Professional Profile). The journal contains a number of advertisements and job listings. In the area of housing management, one can expect to find articles ranging from grounds maintenance to housing for the elderly, from housing security management to how to automate property management operations, from insulation review to what managers can do about the language barrier. The feature articles are written by professionals from a wide variety of backgrounds, including property managers, community investment officers, housing group managers, consulting firms, professors, free-lance writers, and attorneys.

A journal more appropriate for those who manage residential property in the private sector is *Journal of Property Management*. The journal presents a legislative update, discusses tax issues, and contains feature articles and advertisements. The objective of the publication is to provide a medium for the "expression of individual opinion concerning management practice, procedures and topics allied thereto." Examples of topics of interest include enforcing condominium restrictions and covenants, management realities of giant multifamily communities, management of housing for the elderly, how to handle complaints, how to market apartment space, and offering consulting services to community associations.

REFERENCES

BOOKS AND ARTICLES

Housing Finance

Boroson, W., and K. Austin. (1993). *The home buyer's inspection guide.* New York: John Wiley and Sons.

Dorfman, J. R. and the Editors of Consumer Reports Books. (1992). *The mortgage book.* Yonkers, NY: Consumer Union.

Downs, A. (1985). *The revolution in real estate finance.* Washington, DC: Brookings Institution.

Estes, J. C., and D. R. Kelley. (1993). *Compound interest and annuity tables.* 2nd ed. New York: McGraw-Hill.

Federal Home Loan Bank of San Francisco. (1991). *Housing finance: The new environment.* San Francisco, CA: Author.

Florida, R. L. (ed.). (1986). *Housing and the new financial markets.* New Brunswick, NJ: Center for Urban Policy Research.

Irwin, R. (1990). *Tips and traps when buying a home.* New York: McGraw-Hill.

———. (1992). *Tips and traps when mortgage hunting.* New York: McGraw-Hill.

The Kiplinger/Changing Times guide to buying and selling a home. (1987). Washington, DC: The Kiplinger Washington Editors.

Miller, P. G. (1990). *Buy your first home now.* New York: Harper Collins.

———. (1994). *The common sense mortgage.* New York: Harper Collins.

Monthly interest amortization tables. (1984). Chicago, IL: Contemporary Books.

Porter, S. (1989). *A home of your own.* New York: Avon.

Rosen, K. T. (1984). *Affordable housing: New policies for the housing and mortgage markets.* Cambridge, MA: Ballinger.

Shenkman, M. M., and W. Boroson. (1989). *How to buy a house with no (or little) money down.* New York: John Wiley and Sons.

Suchman, D. R., with S. Middleton, and S. L. Giles. (1990). *Public/private housing partnerships.* Washington, DC: Urban Land Institute.

Texas Real Estate Research Center. (1985). *A guide to alternative mortgage instruments: Teacher instructional packet.* College Station, TX: Texas A&M University.

Thomsett, M. C., and the Editors of Consumer Report Books. (1990). *How to buy a house, condo, or co-op.* Yonkers, NY: Consumers Union.

Thorndike, D. (1980). *Thorndike encyclopedia of banking and financial tables.* Rev. ed. Boston: Warren, Gorham, and Lamont.

Vila, B., with C. Oglesby. (1990). *Bob Vila's guide to buying your dream house.* Boston: Little, Brown.

Wiedemer, J. P. (1990). *Real estate finance.* 6th ed. Englewood Cliffs, NJ: Prentice-Hall.

Your housing dollar. (1984). Prospect Heights, IL: Household International.

Marketing

Allen, R. D., and T. E. Wolfe. (1983). *The Allen and Wolfe illustrated dictionary of real estate.* New York: Wiley.

Bagby, J. R., and M. L. Bagby. (1981). *Real estate dictionary.* Englewood Cliffs, NJ: Institute for Business Planning.

Blankenship, F. J. (ed.). (1993). *Semenow's questions and answers on real estate.* 10th ed. Englewood Cliffs, NJ: Prentice-Hall.

Boyce, B. N. (1981). *Real estate appraisal terminology.* Rev. ed. Cambridge, MA: Ballinger.

Dasso, J. J. (1989). *Real estate: Principles and practices.* Englewood Cliffs, NJ: Prentice-Hall.

Edwards, K. W. (1993). *Your successful real estate career.* New York: American Management Association.

Gaddy, W. E., Jr., and R. E. Hart. (1993). *Real estate fundamentals.* 4th ed. Chicago, IL: Real Estate Education Company.

Gross, J. S. (1987). *Webster's new world illustrated encyclopedic dictionary of real estate.* 3rd ed. New York: Prentice-Hall.

Harris, J. C., and J. P. Friedman. (1993). *Barron's real estate handbook.* 3rd ed. Hauppauge, NY: Barron's Educational Series.

Irwin, R. (1993). *The for sale by owner kit.* Chicago, IL: Dearborn Financial.

Lyons, P. J., and M. J. Bowker. (1982). *Real estate investor's desk encyclopedia.* Reston, VA: Reston.

Seldin, M. (ed.). (1980). *The real estate handbook.* Homewood, IL: Dow Jones–Irwin.

Shenkel, W. M. (1985). *Marketing real estate.* Englewood Cliffs, NJ: Prentice-Hall.

Shenkman, M. M., and W. Bowson. (1990). *How to sell your house in a buyer's market.* New York: John Wiley and Sons.

Housing Economics

Burns, L. S. (1986). *The future of housing markets: A new appraisal.* New York: Plenum.

Crouch, H. F. (1993). *Rental real estate: Owner's and seller's tax guide.* Saratoga, CA: Allyear Tax Guide.

Feins, J. D., and T. S. Lane. (1981). *How much for housing?* Cambridge, MA: Abt.

Gilderbloom, J. I., and R. P. Applebaum. (1988). *Rethinking rental housing.* Philadelphia, PA: Temple University Press.

Irwin, R. (1993). *Tips and traps for making money in real estate.* New York: McGraw-Hill.

Muth, R. F., and A. C. Goodman. (1989). *The economics of housing markets.* New York: Harwood Academic.

Myers, D. (1990). *Housing demography: Linking demographic structure and housing markets.* Madison, WI: University of Wisconsin Press.

Pozdena, R. J. (1988). *The modern economics of housing: A guide to theory and policy for finance and real estate professionals.* New York: Quorum.

Sumichrast, M. (1977). *Housing markets: The complete guide to analyses and strategy for builders, lenders, and other investors.* Homewood, IL: Dow Jones–Irwin.

Housing Management

Banning, K. (1992). *Residential property management book.* New York: McGraw-Hill.

Community Management Corporation. (1985). *Financial management of condominium and homeowners' associations: A special report.* Washington, DC: Urban Land Institute.

Donahue, W. T., M. M. Thompson, and D. J. Curren. (1975). *Congregate housing for older people.* Washington DC: U.S. Department of Health, Education and Welfare.

McHenry Company. (1985). *A guide to management reviews of public housing agencies.* Washington, DC: Author.

Melan, I., and M. Melan. (1988). *How to buy and manage rental properties.* New York: Simon and Schuster.

National Center for Housing Management. (1974). *College curriculum in housing management.* Washington, DC: Author.

National Center for Neighborhood Enterprise. 1367 Connecticut Avenue NW, Washington, DC.

Pappas, S. G. (1991). *The property manager handbook.* Chicago, IL: Dearborn Financial.

Powell, L. M. (1975). *Planning and managing housing for the elderly.* New York: John Wiley and Sons.

Silverstone, B. (1974). *Establishing resident councils: Guide lines for residents and administrators.* New York: Federation of Protestant Welfare Agencies, Division on Aging.

Teepnur, N., T. Markus, and T. Woolley. (eds.). (1988). *Rehumanizing housing.* Boston, MA: Butterworths.

Tully, K. (1986). *Improving residential life for disabled people.* New York: Churchill Livingstone.

United Nations, Department of Economic and Social Affairs. (1969). *Basics of housing management.* New York: Author.

U.S. Department of Housing and Urban Development. (1980a). *Communication skills for housing managers.* Washington, DC: Government Printing Office.

———. (1980b). *Energy management for housing managers.* Washington, DC: Government Printing Office.

———. (1980c). *Litigation regulations and guidelines in housing management.* Washington, DC: Government Printing Office.

———. (1980d). *Maintenance management and service contracts.* Washington, DC: Government Printing Office.

———. (1980e). *Management of housing for handicapped and disabled.* Washington, DC: Government Printing Office.

————. (1980f). *Manager and Social Service Instructor's Guidebook.* Washington, DC: Government Printing Office.

————. (1980g). *Marketing procedures for housing managers.* Washington, DC: Government Printing Office.

————. (1980h). *Personnel administration in housing management.* Washington, DC: Government Printing Office.

————. (1980i). *Pest control and grounds maintenance in housing management.* Washington, DC: Government Printing Office.

————. (1980j). *Professional career systems in housing management.* Washington, DC: Government Printing Office.

————. (1980k). *Resident participation in the housing management.* Washington, DC: Government Printing Office.

————. (1980l). *Residential security in multi-family housing.* Washington, DC: Government Printing Office.

————. (1980m). *Supervisory skills for housing managers.* Washington, DC: Government Printing Office.

U.S. Department of Housing and Urban Development, Office of Public and Indian Housing. (1990). *An operations guide for resident management corporations: A guide for public housing residents.* Washington, DC: Government Printing Office.

Wolfe, D. B. (1987). *Condominium and homeowners associations that work: On paper and in action.* Washington, DC: Urban Land Institute.

GUIDE TO PERIODICALS

Finance

Black Enterprise. P.O. Box 3009, Harlan, IA.
Housing Finance Review. Federal Home Loan Mortgage Corporation.
Housing Policy Debates. Washington, DC: Office of Housing Research, FNMA.
Journal of Housing Research. Washington, DC: Office of Housing Policy Research, FNMA.
Kiplinger's Personal Finance Magazine. Editors Park, MD.
Mortgage Banking. Washington, DC: Mortgage Bankers Association of America.
Money. New York: Time.
Real Estate Review. Boston, MA.

Marketing

Real Estate Business for Brokerage Managers and Residential Sales Specialists. Chicago, IL: Real Estate Brokerage Managers Council and the Residential Sales Council of the Realtors National Marketing Institute of the National Association of Realtors.
Real Estate Issues. Chicago, IL: American Society of Real Estate Counselors of the National Association of Realtors.
Real Estate Review. Boston: Warren, Gorham, and Lamont.
Real Estate Today. 430 N. Michigan Ave., Chicago, IL: National Association of Realtors.

Housing Economics

Builder. Washington, DC: Hanley-Wood.
CPI Detailed Report. Washington, DC: U.S. Bureau of Labor Statistics.
Dodge Cost Calculator and Valuation Guide. New York: McGraw-Hill.
Existing Home Sales. Washington, DC: National Association of Realtors.
Expense Analysis: Condominiums, Cooperatives, and Planned Unit Developments. Chicago: Institute of Real Estate Management.
Housing Economics. Washington, DC: National Association of Home Builders of the United States.
Income/Expense Analysis: Apartments. Chicago: Institute of Real Estate Management.
Inter-City Cost of Living Index. Indianapolis, IN: American Chamber of Commerce Researchers Association.
Journal of Housing Economics. San Diego: Academic Press.
Outlook for the Economy and Real Estate. Washington, DC: National Association of Realtors.
U.S. Department of Commerce, Bureau of the Census. *Annual Housing Survey.* Washington, DC: Government Printing Office.
———. *Construction Reports.* Washington, DC: Government Printing Office.
———. *Census of Housing.* Washington, DC: Government Printing Office.
———. *Census of Population and Housing.* Washington, DC: Government Printing Office.
U.S. Department of Commerce, International Trade Administration. *Construction Review.* Washington, DC: Government Printing Office.
U.S. Housing Markets. Detroit, MI: Housing Markets.

Housing Management

Journal of Housing. Washington, DC: National Association of Housing and Development Officials.
Journal of Property Management. Chicago, IL: Institute of Real Estate Management of the National Association of Realtors.

RESOURCE GUIDES

ABI/Inform. Louisville, KY: UMI/Data Courier.
American statistical index, A comprehensive guide to the statistical publications of the U.S. government. Abstracts. Bethesda, MD: Congressional Information Services.
American statistical index, A comprehensive guide to the statistical publications of the U.S. government. Index. Bethesda, MD: Congressional Information Services.
Business periodicals index. New York: H. W. Wilson.
Economics working papers bibliography. Dobbs Ferry, NY: Trans-Media.
Haikalis, P. D., and J. K. Freeman. (1983). *Real estate: A bibliography of the monographic literature.* Westport, CT: Greenwood.
Harris, L. A. (1987). *The real estate industry: An information sourcebook.* Phoenix, AZ: Oryx.
HUD user online. Germantown, MD: HUD User.
Index to international statistics. Abstracts. A guide to the statistical publications of international intergovernmental organizations. Bethesda, MD: Congressional Information Service.

Index to international statistics. Index. A guide to the statistical publications of international intergovernmental organizations. Bethesda, MD: Congressional Information Service.

InfoTrac. Information Access Company.

New York Times index. New York: New York Times Company.

Public affairs information service bulletin. New York: PAIS.

Readers' guide to periodical literature. New York: H. W. Wilson.

Statistical reference index, A selective guide to American statistical publications from private organizations and state government sources. Abstract. Bethesda, MD: Congressional Information Service.

Statistical reference index, A selective guide to American statistical publications from private organizations and state government sources. Index. Bethesda, MD: Congressional Information Service.

Straus, D. W. (1988). *Handbook of business information: A guide for librarians, students and researchers.* Englewood, CO: Libraries Unlimited.

Ulrich's international periodicals directory. New York: Bowker.

U.S. Department of Commerce. Bureau of the Census (1986). *Construction statistics data finder.* Washington, DC: Government Printing Office.

U.S. Superintendent of Documents. (1987a). *Construction industry.* Washington, DC: Government Printing Office.

———. (1987b). *The home.* Washington, DC: Government Printing Office.

Wall Street Journal index. Ann Arbor, MI: U.M.I. Press.

Women studies abstracts. Rochester, NY: Abba.

7

Environmental Design, Construction Processes, and Technology

Barbara Flannery and Benyamin Schwarz

In the essence of building, little has changed since ancient times. We only think change has occurred in a new age; and a new frame of mind; with a dramatically different language; fueled by new, conceptual, energetic ideas.
 —Kerwin Kettler (1992)

This chapter contains titles of books, articles, and periodicals on environmental design, construction processes, and technology in the United States. Environmental design focuses on professional disciplines and their perspectives on housing, special populations, and accessibility issues. The section about construction processes includes descriptions of building trades, terms, materials, and construction processes, as well as past industrial housing experiments. The technology section includes books and articles about energy and associated new technology, computer technology, futuristic housing, and indoor air quality and household hazards.

Environmental design, construction processes, and technology of houses in the United States has shown elements of both stability and change throughout the past centuries. Historical house forms have emerged and transformed through the centuries. Political, economic, and social forces have shaped the housing stock and introduced new and indigenous house forms. The variety of geographic conditions has led to immense regional differences in housing that are probably

unmatched by any other country. Well organized building trades that have used sophisticated technology, advanced design disciplines, and a high level of industrialism have shaped housing in the United States in its current form.

Describing environmental design, construction processes, and technology topics in American housing involves discussion of products, techniques, perspectives of professional disciplines, and a sampling of past and present housing programs. All are influenced by, and in turn influence, trends in popular American housing. Nevertheless, the trends that endure and continue through time vary and often are based on changes in the demographics of the population and subsequent political, economic, and social forces.

ENVIRONMENTAL DESIGN

Books and Articles

While architects and interior designers plan only a small fraction of housing in the United States, their influence on types and forms of housing built by builders, contractors, and tradespeople is crucial. The body of architectural literature is vast in depth and breadth, and it spans a long period of time. Architecture as a profession can be examined through accounts of design philosophy, the work of architects, the critique of buildings, and standards and specifications used by architects.

There are many good dictionary and encyclopedia sources that provide insights into the discipline. *A Dictionary of Architecture and Building* (1920) by Sturgis and the *Encyclopedia of Architecture* (1988) by Wilkes provide through their entries both an overview of the discipline and details related to aspects of building, technology, and construction. Both are designed as a first source of information references. Using sources of common standards, such as the ones included in the materials section of this chapter, is another way to approach the topics. The *Macmillan Encyclopedia of Architects* (1982) edited by Placzek includes more than twenty-four hundred biographies of architects from around the world. This book is a good starting point for the study of architecture through its practitioners. The *History of Architecture* (1987) by Fletcher is arranged in chronological and geographical groupings and includes a detailed index. This classic book is illustrated with photographs, plans, and detail drawings. *Contemporary Architects* (1987) edited by Morgan and Naylor includes the work of more than four hundred prominent architects, theorists, landscape architects, and structural engineers.

For architects, *housing* is not only a verb but an architectural entity that reflects the human intellect. To develop an effective residential plan the designer must define and determine the needs and the wants of the occupants. One of the difficult roles of the designer is the distinction of basic requirements versus desirable or preferable features. Simply stated, an architectural need is a feature that the future occupant will not live without. A want, on the other hand, is a desired feature that can be omitted if space, circumstances, or budget restrictions demand.

Housing design issues may be found in the AIA Housing Committee's *American House* (1992), Devido's *Designing Your Client's House* (1990), Dickinson's *Small House* (1986), Metz's *Compact House Book* (1988), Sexton's *Cottage Book* (1989), Sherwood's *Modern Housing Prototypes* (1978), Sprague's *More Than Housing* (1991), Talcott et al.'s *Home Planners' Guide to Residential Design* (1986), Woods and Wells's *Designing Your Natural House* (1992), and Youssef's *Building Your Own Home* (1988).

The domestic architecture of the United States stems from a diverse European heritage that adapted to a range of climates and regions. It transformed as a result of a series of revival styles and developed due to the shifting and mixing of population during the period of migration settlement. This architecture reflects the changes in America from a handcraft society to a modern industrial nation. (Chapters 1 and 2 in this book explore the styles and types of the American house.) The following is a sampling list of books about the many faceted history of the American house: Foley's *American House* (1980), Ford and Ford's *Classic Modern Homes of the 30's* (1989), Jones's *Authentic Small Houses of the Twenties* (1987), the McAlesters' *Field Guide to American Houses* (1984), Polyzoides et al.'s *Courtyard Housing in Los Angeles* (1992), Radford's *Old House Measured and Scaled* (1983), Scully's *American Architecture and Urbanism* (1988), *The Architecture of the American Summer* (1989), and *The Shingle Style Today* (1974), Pomada and Larsen's *America's Painted Ladies* (1992), Walker's *American Shelter* (1981), Maass's *Victorian Home in America* (1972), Handlin's *American Home: Architecture and Society, 1815–1915* (1979), and Clark's *American Family Home, 1800–1960* (1986).

Several prominent architects devoted their professional practices to housing design. Gutman's *Design of American Housing* (1985) is a comprehensive monograph about the participation of professional architects in the housing industry. The following is a partial listing of books about individual architects that display the architects' role in the design of American housing. Most of the manuscripts mentioned in this section refer to architects of the twentieth century.

In *A Pattern Language* (1977), *The Timeless Way of Building* (1979), and *The Oregon Experiment* (1975) Christopher Alexander et al. deal with universal patterns of buildings to create individually compatible environments based upon naturally existing needs and sense of place. This important series on architectural design was preceded by *Community and Privacy* (1963) written by Chermayeff and Alexander. *The Architecture of Alden B. Dow* (1983) by Robinson includes photographs and plans of the architecture of the former apprentice of Frank Lloyd Wright. *Architecture Without Rules* (1993) by Masello presents twenty houses in chronological order that illustrate the design philosophy of the architects Marcel Brever and Herbert Beckhard. Some of the principals, such as interior and exterior spaces that blend into each other and utilization of natural materials, are displayed in the photographs. Peter Eisenman explores his unique approach to design through drawings schemes and text in *House X* (1982). Approximately sixty works of Frank Gehry's architecture are depicted in Stern's *GA Architect 10, Frank O. Gehry* (1993). *Bertram Grosvenor Goodhue* (1986) edited by Whitaker is a classic

book on the turn-of-the-century American architect. Goodhue used historical styles in churches and Spanish Colonial and neoclassical styles in homes and governmental buildings while refusing to be influenced by Beaux Arts or New European modernism.

Adam's *Eileen Gray, Architect/Designer* (1987) is about the turn-of-the-century self-taught architect whose innovations influenced European architects and won her international fame. *Gamble House 1907–1908, Greene and Greene* (1993) by Bosley is full of beautiful photos of the intricate details that have made the Gamble House a world-famous example of the California bungalow. Giedion's *Walter Gropius* (1992) is an analysis of the evolution of modern architecture with Gropius as one of the central figures. The architecture of the three architects' firm is explored by *Hardy Holzman Pfeiffer Associates: Concepts and Buildings* (1993) by Andreas. Schmertz and Sorkin's *Hardy Holzman Pfeiffer Associates Buildings and Projects 1967–1992* (1992) reviews the firm's work in the last twenty-five years. It includes a catalog of works and many interior details of residential and commercial buildings. Hejduk's *Lancaster/Hanover Masque* (1992) uses a rural farm community as a point of departure to create a visionary world of buildings and concepts in which the inhabitants work and live. *Franklin D. Israel* (1992) by Gehry is a book about an important young architect who practices architecture in the tradition of California modernism. Adams's *Jefferson's Monticello* (1988) is an excellent analysis of one of the most important historical houses in the United States. Ivy's *Fay Jones* (1992) is about residences and chapels, mostly in Arkansas, created by the former student of Frank Lloyd Wright. Whitney and Kipnis's *Philip Johnson* (1993) is about the architect's famous Glass House, which had inspired generations of architects around the world. A comprehensive study of one of America's greatest architects may be found in *Louis I. Kahn* (1991) by Brownlee and De Long. This book reviews Kahn's philosophy and architecture with photos, a biography, and a complete list of buildings and projects.

Although not an American architect, Le Corbusier influenced the architecture of housing all around the world. *The Villas of Le Corbusier, 1920–1930* (1991) by Benton is a concentrated study of his architectural philosophy and practice in single-family houses. *Richard Meier, Architect* (1984) and *Richard Meier, Architect: Volume 2* are two beautiful books about this gifted architect that include interior detail photos, documentation of plans and sites, biographical chronologies, and bibliographies of his architectural works. *Mellor Meigs and Howe* (1991) is a book about the early twentieth-century Philadelphia firm of architects who designed country houses from a blend of Flemish, English, Italian, and French influences. *Mies Reconsidered* (1986) edited by Zukowsky and *The Artless Word* (1991) by Neumeyer are two books reflecting the thinking, practice, and language of one of the greatest architects of this century. *Florida Architecture of Addison Mizner* (1992) by Mizner displays 30 of the great houses and estates built during the 1920s and 1930s in Florida, inspired by Mediterranean villas and palaces. Steele's *Moore, Ruble, Yudell* (1993) includes 34 residential projects of this architectural firm featuring their sensitivity to historical, architectural, and natural features through

interviews with and essays by the architects. *Charles Moore* (1986) edited by Johnson discusses 50 projects with chapters by the architect and his colleagues. *The Place of Houses* (1979) by Moore et al. is another book by three architects who suggest ways to build and inhabit houses. *Julia Morgan, Architect* (1988) by Boutelle tells the story of the first woman who earned an architectural degree from the Ecole and became famous for her Hearst Castle. *Eric Owen Moss* (1991) by Johnson is a collection of 27 projects by the Los Angeles architect, who experiments with spatial layering and intersecting programs. *The Architecture of Richard Neutra from International Style to California Modern* (1982) by Drexler and Hines includes the California houses and information about town planning projects that made the architect known. *Houses by Bart Prince* (1991) by Mead features American architecture by this new Mexican architect, who is influenced by Wright and Goff. *Architecture of H. H. Richardson and His Times* (1966) by Hitchcock illustrates the shingle style and the Romanesque in the social context of the nineteenth century. *Three American Architects* (1991) by O'Gorman reviews the continuous evolution of forms found within the sequential careers of the premier trinity of American architects, Richardson, Sullivan, and Wright. *Edward Ruscha* (1993) by Marshall is an overview of apartment architecture in Los Angeles. *Harry Seidler* (1992) by Frampton and Drew is a catalogue of the architectural works of the Australian architect who was influenced by Gropius, Niemeyer, and Nervi. *Rebuilding* (1992) by the San Francisco planner Solomon is the first book of a trilogy that displays philosophy and the built projects including Pacific Highest Townhouses. *Robert Stacy-Judd* (1983) by Gebhard is the story of the architect whose colorful, bold reworkings of Mayan and Aztec forms in the 1920s and 1930s defined a new style in American architecture. *The American Houses of Robert A. M. Stern* (1991) by Aslet and *Robert A. M. Stern* (1992) by Scully feature several houses, country homes, city apartments, unrealized designs, and projects under construction designed by one of the most prominent postmodern architects. *On Houses & Housing* (1992) by Venturi and Scott Brown is an analysis of ideology as reflected in residential projects designed by these gifted architects. *Harry Weese Houses* (1987) by Weese presents 39 of Weese's 80 houses in original sketches, floor plans, and photos. *Natural House* (1970) by Wright, *The Prairies School* (1976) by Brooks, the eight-volume *Selected Houses by F. L. Wright* (1990), and *Fallingwater* (1986) by Kaufmann are just examples of the plethora of publications about the architecture of Wright. Several more books may be found in Chicago's Prairie Avenue Bookshop catalog.

Interior design as a profession is relatively new compared to architecture. Four of the most instructive books in understanding the overall profession are cited here. The *American Society of Interior Designers Professional Practice Manual* (1992) edited by Asher Thompson includes sections on education, licensing, philosophy, practice, and specialty design areas, among others. The *Interior Design Reference Manual* (1992) by Ballast is designed to help candidates prepare for the National Council for Interior Design Qualification certification examination, but it is also useful in understanding the field and its components. A broader approach is taken

by Malnar and Vodvarka's *Interior Dimension* (1992), which explores issues such as theory, seminal viewpoints, the human dimension, and ethics. *Planning and Managing Interior Projects* (1988) by Farren is an excellent source for understanding the practice of interior design. It includes sections on the phases of a project, instructions and support for the client, a survey of client requirements, space planning and design, reuse of existing furniture, preparing a budget, specifications and coding for furniture, specifications and coding for finishes and furnishings, bidding and purchasing, plants, artwork, signage, project management and documentation, the actual move, and post-move administrative duties such as the punch list (a detailed list of everything near the end of the project that needs to be finished), maintenance specifications, final invoices, and the post-occupancy evaluation. A less detailed but still thorough account of project management is found in Danko's "Project Control Book" in *Asher Thompson's Interior Design Practice Manual.*

Books about residential design from an interior design viewpoint include *Time-Saver Standards for Interior Design and Space Planning* (1991) by DeChiara et al., *The Good House* (1990) by Jacobson, *Kitchens and Baths* (1993) by Jankowski, the *Family Housing Handbook* (1971), *Housing* (1978) by Keiser, *Designing Interiors* (1992) by Kilmer and Kilmer, *The Challenge of Interior Design* (1981) by Kleeman, *The Bathroom, the Kitchen, and the Aesthetic of Waste* (1992) by Lupton and Abbott, *Kitchens* (1993) by Madden, *Residential Interior Design* (1992) by Mount, *Inside Today's Home* (1994) by Nissen et al., *Household Equipment in Residential Design* (1986) by Pickett et al., *Homes Are for People* (1973) by St. Marie, *Architectural Detailing in Contract Interiors* (1988) and *Architectural Detailing in Residential Interiors* (1989) by Staebler, and *Interior Design in the 20th Century* (1986) by Tate and Smith.

Site design is the subject of many references in landscape architecture. Two recent books that are useful in providing a starting point to site design and orientation are *Simplified Site Design* (1992) by Ambrose and *Site Planning* (1988) by Brooks. Two other books that provide an introduction to landscape architecture are *Time-Saver Standards for Landscape Architecture* (1988) by Harris and Nicholas and *A Dictionary of Landscape Architecture* (1987) by Morrow. Harris and Nicholas include detailed descriptions of the profession and the standards, specifications, and issues of landscape architecture. Topics include processes such as construction documents and computer-aided design and drafting (CADD), standards and guidelines, techniques, structures, improvements, special conditions including roofs and decks, interiors and sound control, site utilities such as water and sewage, materials and details, and devices such as edges, curbs, and steps. Morrow includes photographs and line drawings as well as more detailed definitions of many entries.

Housing design for special needs is a vast topic with many implications for construction, technology, and environmental design. The number of disabled people is rising as life expectancies increase and medical advances continue to lengthen the life spans of people disabled by congenital diseases, illnesses, and

accidents. Hundreds of different disabilities and combinations of physical and mental conditions make the design of housing for people with disabilities complex even for specialists. People may experience a variety of problems depending upon the designs of the houses they live in and the types of disabilities they have. People with mobility impairments have problems with the greatest number of housing features, followed by people with visual impairment and those with hearing difficulties. Therefore, most of the books published about these issues are focused on guidelines and manuals that address topics of accessibility.

Students and researchers may refer first to primary source legislation, such as the Fair Housing Amendments Act of 1988 and the Americans with Disabilities Act (ADA) of 1991. It is important to recognize that individual characteristics of a person or household will guide preferences and needs as much as or more than the nature of any disability. Broadening the literature search to include psychological, social, economic, and political perspectives can help to focus on the "whole person" rather than the disability.

There is considerable diversity in the quality of publications related to accessibility and particularly to compliance with the ADA. Because the ADA is relatively recent, sources of published information are still emerging. The firm Moore Iacofano Goltsman has several publications on disability, including one of the best available accessibility compliance guides, *The Accessibility Checklist* (1992). Other publications of theirs include specialty design areas such as children's play spaces, universal design for education environments, and plants for play.

Three other organizations that publish are especially useful in providing high-quality resources related to disability. The Center for Accessible Housing (CAH) at North Carolina State University has a series of fact sheets defining terms and focusing on interpretations of the Fair Housing Amendments Act of 1988, among others. CAH also publishes two excellent resource lists—*Accessible and Universal Design Bibliography* (1992) and *Selected Readings List* (1992)—as well as Mace et al.'s *Accessible Environments* (1990).

Selected bulletins from National Center for Barrier Free Environments (BFE) include *Interior Furnishings and Space Planning*; *The Cost of Accessibility*; *Ramps, Stairs and Floor Treatments*; *Single Family Housing Retrofit*; *Adaptable Housing*; and *Doors and Entrances*. BFE also publishes housing-related sources such as *Accessible Housing Design File* (1991) and *Mobile Homes* (1976). *A Consumer's Guide to Home Adaptation* (1995) is available from Adaptive Environments Center (AEC).

Additional books on universal design and issues of disability focus on specific design perspectives. *Beautiful Barrier-Free* (1992) by Liebrock is an excellent reference for designers. *Housing Interiors for the Disabled and Elderly* (1991) by Raschko provides a good introduction to designing housing for those two populations. *Design for Aging* (1985) is published by the American Institute of Architects. Outdoor residential spaces are part of *Site Planning and Design for the Elderly* (1985) by Carstens. Useful compliance guides include the *Americans with Disabilities Act Handbook* (1990) by Perritt, the *UFAS Retrofit Guide* (1993) by Barrier-Free Environments, and the *ADA Compliance Guidebook* (1992) by BOMA

International. *Barrier-Free Residential Design* (1993) by Peloquin is a walk-through of imaginary homes showing techniques for ADA compliance that preserve the nature of existing designs.

Periodicals

The *Directory of International Periodicals and Newsletters on the Built Environment* (1986) by Gretes includes topics related to environmental design such as architecture, office practice, and interior design. Brief descriptions are included for most entries.

A partial list of periodicals of interest includes: *Architectural Design, Architectural Digest, Architectural Record, Architectural Review, Design Book Review, Designers West, Design Issues, Design Methods, Design Quarterly, Interior Design, the Journal of Housing for the Elderly, the Journal of Interior Design* (formerly the *Journal of Interior Design Education and Research*), *Kitchen and Bath Business, Metropolitan Home, Progressive Architecture,* and *Southern Accents.*

CONSTRUCTION PROCESS

Books and Articles

Elements of materials and construction processes include building materials and terms; building codes and cost estimations; site design and orientation; industrialized housing, including modular, pre-cut, mail-order, and mobile homes; and specifications and minimum space standards. The definition of building materials of construction is limited only by the imagination of the architect, designer, or builder. One general reference for building materials that is thorough in its discussion and is set up like an expanded dictionary is *Construction Materials* (1978) by Hornbostel. The format and detail in definitions makes the source appropriate as a starting point for its included topics. A second excellent dictionary is *Housing: A Multidisciplinary Dictionary* (1987) by Sayegh. Designed for both housing professionals and students, it includes more than 28,000 key terms entered alphabetically. It includes many interdisciplinary perspectives on housing, such as legal, social, economic, and philosophical aspects. It is also useful for construction and building terminology. *The Construction Glossary* (1993) by Stein is very detailed and is probably best suited for those with some background or significant interest in the building trades.

Most of the books about building construction are not focused on specific building types. The following books address the topics of construction of residential as well as commercial buildings: Allen's *Exercises in Building Construction* (1990a), *Fundamentals of Building Construction* (1990b), and *Professional Handbook of Building Construction* (1992); Ambrose's *Building Construction and Design*; Benson's *Timber-Frame Home* (1990); Berglund's *Stone, Log and Earth Houses* (1986); Breyer's *Design of Wood Structures* (1993); Ching's *Building Construction Illustrated*

(1991); Dietz's *Dwelling House Construction* (1991); Mann's *Illustrated Residential and Commercial Construction* (1989); Mitchell's *Short Log and Timber Building Book* (1992); Newman's *Standard Handbook of Structural Details for Building Construction* (1993) and *Design and Construction of Wood Frame Buildings* (1994); Parker and Ambrose's *Simplified Engineering for Architects and Builders* (1994); and Sherwood's *Wood Frame House Construction* (1991).

Interior construction and finishes are included in *Building Construction* (1991) by Ambrose, *Architectural Interior Systems* (1987) by Flynn et al., *Construction Materials for Interior Design* (1989) by Rupp and Friedmann, *A Manual of Construction Documentation* (1989) by Wiggins, *Interior Construction and Detailing for Designers and Architects* (1994) by Ballast, and *Materials and Components of Interior Design* (1989) by Riggs. Each of the sources provides a starting point for interior systems. A good reference source for acoustics is *Architectural Acoustics* (1988) by Egan. And for mechanical and electrical equipment, *Mechanical and Electrical Equipment for Buildings* (1986) by Stein et al. is recommended.

The *Guide to Popular U.S. Government Publications* (1990) by Bailey includes a section on housing with subsections on construction and building techniques, home improvement, maintenance and repair, home heating and cooling, and energy conservation. Each subsection lists free and low-cost references, many of which are designed for general consumers and homeowners. Other sections cover construction reports on housing starts, new residential construction in selected geographic areas, housing completions, price indexes of new homes sold, and expenditures for housing upkeep and improvement. This source provides statistical information to the building industry.

The specification of materials and products is often dictated by building and housing codes. Various national codes published by the Building Officials and Code Administrators (BOCA) International are regularly updated to reflect changes. Examples of national codes include *The BOCA National Building Code, The BOCA Basic/National Plumbing Code, The BOCA Basic/National Energy Conservation Code, The BOCA National Fire Prevention Code, The BOCA National Mechanical Code, The BOCA National Plumbing Code,* and *The BOCA Basic/National Code Interpretations.* State and local codes are also available as additional sources of information.

Construction cost estimators such as the R. S. Means cost data series are widely used in the building industry. Annual editions available in the R. S. Means cost data series include *Means Interior Cost Data, Means Site Work Cost Data, Means Mechanical Cost Data, Means Landscape Cost Data, Means Square Foot Cost Data,* and *Means Building Construction Cost Data.* Each book includes sections on how to use the book, unit prices of components, assemblies (i.e., the costs of construction systems made up by combining unit prices), references that explain the unit price data, and alternative pricing systems.

The Sweet's Group series is an industry source of construction and interior data that may be helpful to students both in understanding the complexity of building systems and in specifying products. Sweet's Group *Industrial Construction and*

Renovation is an annual three-volume product selection guide. *Contract Interiors* is an annual two-volume set that includes finishes, equipment, furnishings, mechanical systems, and electrical systems, among other topics.

Minimum space requirements and standards for activities are found in graphic standards books for architects, interior designers, and landscape architects. These books offer detailed space planning standards for a variety of settings, including residential housing. Examples of the most widely used standards books for architecture, landscape architecture, and interior design, respectively, are *Architectural Graphic Standards* (1988) by Ramsey, *Graphics Standards for Landscape Architecture* (1986) by Austin, and *Interior Graphic and Design Standards* (1986) by Reznikoff, and *Time-Saver Standards for Interior Design and Space Planning* (1991) by DeChiara et al. *Time-Saver Standards for Architectural Design Data* (1982) by Callender includes basic data on such topics as industrialized building systems; solar angles; structural design; building materials, components, and techniques such as flashing and roofing; and environmental controls such as acoustics and heating, ventilation and air conditioning, (HVAC) systems.

Levels of industrialization in housing—from custom built to pre-cut, panelized, and modular—represent a major market in housing production. To study levels of industrialization it is helpful to first look at the work of architects who have contributed to industrialized techniques. *The Dream of the Factory Built House* (1984) by Herbert provides a good example. Although industrialized housing dates to before the 1920s, modern industrialized techniques can be explored by looking at the 1960s federal program Operation Breakthrough, a $60 million project under the auspices of the new Department of Housing and Urban Development (HUD). It was designed to explore the possibilities of systems building to create new and better forms of housing production at less cost, and to alleviate consumer fears and misconceptions about "prefab" housing. *Housing Perspectives* (1976) edited by Wedin and Nygren provides historical reference on a variety of housing topics, including Operation Breakthrough. A good source for current industrialized housing resources is *Affordable Housing* (1989) by Burns.

In addition to Operation Breakthrough, there were two other classic visionary architectural projects in the 1960s: Paolo Soleri's Arcosanti and Moshe Safdie's Habitat. Both projects were designed to provide high-density yet supportive housing. Soleri's models of "arcologies" included mile-high structures designed to house up to a half-million people. *Visionary Cities* (1971) by Wall is a good reference for exploration of Soleri's work and philosophy. The 158-unit Habitat was built as part of Expo 1967 in Montreal, Canada, using 90-ton industrially produced living unit modules stacked and staggered vertically. Habitat provided much publicity for industrialized techniques. Although not American housing, Habitat was an important influence in the examination of the relationships among technology, housing, density, and supportive environments that emerged in the 1960s. *Beyond Habitat* (1970) by Habitat's architect, Safdie, describes the project and its philosophy in detail.

Housing Perspectives (1976, 1978) provides historical reference on a variety of

housing topics and is a useful source for housing topics of the 1960s and 1970s. The roles of builders and contractors can be better understood by referring to *Means Illustrated Construction Dictionary* (1985) by Smit and *Building Trades Dictionary* (1989) by Toenjes. Smit's book is illustrated and written in nontechnical terms for people in the construction trades and professions. It is also useful for the lay person. Toenjes's book is similar in its intended audience and is highly illustrated, with an emphasis on construction tools, materials, and processes used in the building industry. It also has separate sections for building trades terms and contractor terms (e.g., *estimating, bidding, labor relations, labor law, building codes, bonding* and *licensing*).

Periodicals

Periodicals related to the construction process are numerous. The titles give many clues to the intended audience. For example, *Custom Builder* is intended for builders, but its features include case studies of homes, descriptions of new products, HVAC, technology, and design, among other topics of interest to a more general audience. *Builder, Building Design*, and *Qualified Remodeller* are also useful periodicals for construction processes.

Gretes's *Directory of International Periodicals and Newsletters on the Built Environment* (1986) lists 1,199 titles. The reference includes a user's guide and sections on building types, building and construction, building services and systems, housing, and engineering. Many construction process, technology, and environmental design periodicals are cited in the Vance Bibliography series. The series includes 2,385 architecture subject bibliographies published between 1978 and 1990.

TECHNOLOGY

Books and Articles

In this chapter *technology* refers to a number of energy perspectives; low- and high-technology approaches to energy management; water as a resource; underground and earth-sheltered housing; heating, cooling and lighting systems; and smart house technology. Books and articles regarding futuristic housing, computer technology, air quality, and household hazards are included as well. General technical books that include discussions of these topics include Brawne's *From Idea to Building* (1992), Guise's *Design and Technology in Architecture* (1991), and Reid's *Understanding Buildings* (1989).

The oil embargo of 1974 forced millions of Americans to rethink their energy usage and represented a turning point in the relationship between housing design and energy. The large-scale and visionary programs of the 1960s were echoed to a certain extent through the energy-efficient house form experiments of the 1970s. Experimentation with solar and alternative energy forms in various climates throughout the country evolved from trial and error approaches to more sophis-

ticated computer-engineered prototypes by the end of the 1970s. Self-sufficiency was the goal of many of the experimental energy houses of the 1970s.

One example where a combination of low- and high-tech approaches can be found is a single-family house built near Minneapolis, Minnesota, in the 1970s. It included, among other features, several versions of solar heating panels, a biological toilet, a kitchen waste system, an efficient water heating system, and kitchen appliances. The interior was rustic, which was consistent with the early 1970s vision of energy efficiency as coupled with natural and low-tech environments.

A sample of books from the solar heyday of the mid-1980s includes *The Handbook of Conservation and Solar Energy* (1982) by Hunt, *The Complete Passive Solar Home Book* (1985) by Schepp and Hastie, and *The Passive Solar Construction Handbook* (1983) by Levy. *Passive and Low Energy Architecture* (1991) by Suzuki reflects a 1990s evolution in thinking in energy saving and is a good example of case studies of energy-saving architecture. Other books that cover interior and environment control include Anderson's *Solar Building Architecture* (1990), Balcomb's *Passive Solar Buildings* (1992), Bobenhausen's *Simplified Design for HVAC Systems* (1992), and Olgyag *Design with Climate* (1992).

In addition to experimental houses, the energy crisis led to at least three additional conceptual approaches to technology in housing: (1) an expanded view of natural resources, (2) interest in small-scale technological modifications to existing homes (as opposed to new construction), and (3) an expansion of energy conservation beyond the home to include community and regional issues. As part of the expanded view of natural resources, water emerged as an important conservation issue in the late 1970s. Regional droughts, the increased cost of water treatment, the decline of sewage infrastructure systems in Eastern cities, and an increased general awareness of conservation and resource issues led to an interest in water conservation. For the first time attention was given to the fact that the technology of American waste disposal systems is land-, money-, and resource-intensive. Nontraditional disposal systems such as biological air vacuums, incineration, and freezing toilets were developed experimentally. However, these systems were not practical alternatives due to consumer resistance and the restrictive nature of building codes. The positive outcome was an increasing awareness that small-scale modifications overall offer tremendous potential in energy savings. A classic study of bathrooms that incorporates historical outlook, design, energy conservation, and the technological aspects of bathrooms is *The Bathroom* (1976) by Kira. Other books about the bathroom that are humorous and informative include *Flushed With Pride* (1969) by Reyburn and *Goodbye to the Flush Toilet* (1977) edited by Stoner.

The notion of smaller-scale, lower-cost technological modifications for existing housing stock materials and products led to a shift away from the large experimental houses. Examples of developments include changes in construction basics in lighting, heating and cooling systems, insulation and building shell specifications, and appliances. Research on topics such as energy-saving strategies, passive

and active solar energy systems, underground earth-sheltered housing, and other forms of climate-responsive housing has been extensive. Reference sources from the 1970s and the early 1980s include several how-to guides for saving energy, descriptions of energy-efficient house forms, low-technology solutions, and the early high-technology approaches.

Numerous books have been published on energy saving strategies for homeowners. HUD's *Energy-Saving Home Improvements* (1977) is one of many publications available from the federal government. Knight's *Energy Resources Center Illustrated Guide to Home Retrofitting for Energy Savings* (1981) is another useful publication. Other good sources for insulation are Langdon's *Movable Insulation* (1980), Lenchek et al.'s *Superinsulated Design and Construction* (1987), and Brand's *Architectural Details for Insulated Buildings* (1989). Time-Life Books' series on home improvement and repair includes many construction titles, including a general energy efficiency book entitled *Weatherproofing* (1977). Although beyond the scope of this chapter, local energy and housing organizations are also a good source for reference materials. These sources often reflect the specific geographic, climatic, and housing stock issues of a particular area.

Smart house technology is the total integration and automation of energy, security, and other environmental systems in the home. A good source of information on smart house technology is Smart House, L.P., a company specializing in smart house design and applications. "The Start of the Smart Revolution" is one of their publications, reprinted from the January 1991 issue of *Professional Builder and Remodeler*.

Books on underground and earth-sheltered housing include sources on design, house plans, technology, and site design. The University of Minnesota Underground Space Center's *Earth Sheltered Housing Design* (1979) was used extensively during the development of earth-sheltered technology. An account of the more recent developments in the field can be found in Boyer's *Earth Shelter Technology* (1987). Broader perspectives may be found in Golany's *Earth-Sheltered Habitat* (1983).

Managing residential heating and cooling is a broad topic in building literature. Moore's *Environmental Control Systems* (1993) is one of the best reference books on this topic. Other sources on heating and cooling include Flynn et al.'s *Architectural Interior Systems* (1992), Lechner's *Heating, Cooling, Lighting* (1991), and Stein and McGuiness's *Mechanical and Electrical Equipment for Buildings* (1992).

Resources on residential lighting range from picture books of lighted interior and exterior spaces to technical data source books for lighting calculations and engineering. The Illuminating Engineering Society of North America, located in New York City, has many publications for lay people and those who are technically proficient in lighting. General Electric and other major manufacturers of lamps also offer publications on their products and on lighting applications. Useful books on lighting include the general sources *Designing with Light: Residential Interiors* (1991) by Jankowski, *Interior Lighting for Environmental Designers* (1976) by Nuckolls, *Bringing Interiors to Light* (1986) by Smith and Bertolone, *Lighting*

Design (1993) by Gardner and Hannaford, *Perception and Lighting as Formgivers for Architecture* (1992) by Lam, *Simplified Design of Building Lighting* (1992) by Schiler, and *Architectural Lighting Design* (1990) by Steffy. Although detailed, Nuckolls is one of the best sources for technical lamp, luminaire, and calculation information. Two lighting specialty sources are *Lighting in the Domestic Interior* (1991) by Bourne and *Lighting for Historic Buildings* (1988) by Moss.

Futuristic housing has captured the imagination of people throughout time. Recently, the potential for space colonization and projects such as Biosphere have been given attention in the literature. A bibliography by Lockerby entitled *Space Colonies* (1980) provides a useful starting point for study on that topic. Biosphere is the project in which eight people were sealed in a bubble from fall 1991 until fall 1993. The plan was for the "biospherians" to remain in the structure for the two years, surviving on food grown within and carrying out ecological experiments. The scientific validity of the project has been a subject of controversy. The Biosphere project can best be explored using newspaper and popular magazine accounts.

The effects of CADD and virtual reality on construction and environmental design have been tremendous. CADD is now part of most architecture, interior design, and landscape architecture curricula and professional practices. Computer technology changes rapidly and books are continually being published. Books that provide an overview of computer technology and CADD from a building perspective include *Architectronics* (1987) by Winn and *CAD: Design, Drawing, Data Management* (1986) by Kennedy. An historical look is given in *Pioneers of CAD in Architecture* (1985) edited by Kemper.

Virtual reality, the computer technology that provides an interactive and three-dimensional image to the computer user, is rapidly becoming of interest to design professions. The opportunity to put clients in the designed kitchen or to allow them to walk through the floor plan of a planned home captures the imagination and will dramatically alter design as it presently exists. A good overview of virtual reality applied to the design field is "Computers: Virtual Reality" (1992) by MacLeod. A more generic source is "A Primer on Virtual Reality" (1992) by McCluskey, which provides a good overview of what virtual reality is and a useful bibliography for those who want more detail on this technology.

Issues of indoor air quality (including the effects of asbestos and radon), household pests such as termites, and safety in the home have been the subject of considerable study. Indoor air quality in particular became a major housing issue during the 1980s in part due to the improvements in energy-efficiency through tighter building envelopes that evolved in the 1970s. Several bibliographies are available on the topic of indoor air quality in housing from the Vance Bibliography series. Since indoor air quality is often of great interest to both professionals and consumers, some good reference sources are provided by housing organizations such as the National Association of Home Builders (NAHB), state extension offices at land grant universities, and health and safety organizations such as the Envi-

ronmental Protection Agency (EPA) and the American Lung Association (ALA). In many cases, the more definitive sources of information are in technical journals in specialized fields and are therefore limited in their usefulness to housing consumers and generalist students of housing.

The ALA's brochure *Asbestos in Your Home* (1990) gives a basic overview of asbestos issues. More detailed sources related to buildings and interiors are the NAHB's *Asbestos Handbook for Remodeling* (1989) and Kominsky's *Evaluation of Two Cleaning Methods for Removal of Asbestos Fibers from Carpet* (1991). The EPA's *Citizen's Guide to Radon* (1986) gives an introduction to radon to homeowners and contains a listing of local EPA offices with addresses and telephone numbers.

Household Insect Pests (1974) by Hickin provides a detailed overview of a variety of household insect pests and includes bibliographic references. For less detailed sources on termites and other wood boring insects, cockroaches, ants, and other household pests, brochures are available from local exterminators and county and state extension offices. Home safety is the subject of *The Perfectly Safe Home* (1991) by Miller. Many other sources include sections on first aid or safety related to children or the elderly, such as *Parents Book of Child Safety* (1991) by Laskin, "Falls Among the Elderly" (1988) by Sorock, and "Older Adults Residing in Their Own Home" (1991) by Brent et al.

Periodicals

Gretes (1986) is a good starting point for the numerous periodicals in the diverse range of topics included in this section. Students may begin by searching through periodical titles, but sometimes titles are misleading in content and audience. For example, *Technology and Conservation* focuses on technological approaches to restoring, protecting, and documenting buildings, monuments, historic sites, and antiquities as well as art, books, and manuscripts.

Many of the periodicals related to energy are for a technical audience. *Solar Age*, the official magazine of the American Section of the International Solar Energy Society, was absorbed by *Progressive Builder* in November 1985. Back issues of this periodical are useful in providing historical perspective on the evolution of solar technology.

Computer technology is changing rapidly. Computer hardware and software sources such as *MacWorld* and *MacUser* for the Apple Macintosh system are good reference sources for state-of-the-art computer technology. Other periodicals dealing with databases, renderings, dialog boxes, and other aspects of CAD include *CADENCE*, *DesignNet*, and *Computer Graphics World*, which deals with modeling, animation, and multimedia.

Periodicals for specialty areas of technology can best be accessed using sources such as the *Avery Index to Architectural Periodicals*. For example, in lighting, *Architectural Lighting*, *Lighting Design and Application*, and *Lighting Dimensions* are all useful sources designed for general audiences.

REFERENCES

BOOKS AND ARTICLES

Environmental Design

Adam, P. (1987). *Eileen Gray, architect/designer: A biography*. Bergenfield, NJ: Abrams.

Adams, W. H. (1988). *Jefferson's Monticello*. New York: Abbeville.

Adaptive Environments Center. (1995). *A consumer's guide to home adaptation*. Boston: Author.

AIA Housing Committee. (1992). *The American house: Design for living*. Vol. 1. Washington, DC: AIA.

AIA Press. (1985). *Design for aging: An architect's guide*. Washington, DC: Author.

Alexander, C. (1979). *The timeless way of building*. New York: Oxford University Press.

Alexander, C., S. Ishikawa, and M. Silverstein. (1977). *A pattern language*. New York: Oxford University Press.

Alexander, C., M. Silverstein, S. Angel, S. Ishikawa, and D. Abrams. (1975). *The Oregon experiment*. New York: Oxford University Press.

Ambrose, J. E. (1992). *Simplified site design*. New York: Wiley.

Andreas, G. M. (1993). *Hardy Holzman Pfeiffer Associates: Concepts and buildings*. Middlebury, VT: Middlebury College Museum.

Asher Thompson, J. A. (1992). *American Society of Interior Designers professional practice manual*. New York: Whitney Library of Design.

Aslet, C. (1991). *The American houses of Robert A. M. Stern*. New York: Rizzoli.

Ballast, D. K. (1992). *Interior design reference manual*. Belmont, CA: Professional.

Barrier-Free Environments. (1993). *UFAS retrofit guide: Accessibility modifications for existing buildings*. New York: Van Nostrand Reinhold.

Benton, T. (1991). *The villas of Le Corbusier, 1920–1930*. New Haven, CT: Yale University Press.

BOMA International. (1992). *ADA compliance guidebook: A checklist for your building*. Washington, DC.

Boutelle, S. H. (1988). *Julia Morgan, architect*. New York: Abbeville.

Bosley, E. (1993). *Gamble House 1907–1908, Greene and Greene*. London: Phaidon.

Brooks, H. A. (1976). *The Prairies School, Frank Lloyd Wright and his Midwest contemporaries*. New York: Norton.

Brooks, R. G. (1988). *Site planning: Environment, process, and development*. Englewood Cliffs, NJ: Prentice-Hall.

Brownlee, D. B., and D. G. De Long. (1991). *Louis I. Kahn: In the realm of architecture*. New York: Rizzoli.

Carstens, D. Y. (1985). *Site planning and design for the elderly: Issues, guidelines, and alternatives*. New York: Van Nostrand Reinhold.

Center for Accessible Housing. (1992). *Accessible and universal design bibliography*. Raleigh, NC: Author.

———. (1992). *Selected readings list: An annotated bibliography of accessible housing literature*. Raleigh, NC: Author.

Chermayeff, S., and C. Alexander. (1963). *Community and privacy.* Garden City, NY: Doubleday.

Clark, C. E., Jr. (1986). *The American family home, 1800–1960.* Chapel Hill, NC: University of North Carolina Press.

DeChiara, J., J. Panero, and M. Zelnik. (1991). *Time-saver standards for interior design and space planning.* New York: McGraw-Hill.

Devido, A. (1990). *Designing your client's house: An architect's guide to meeting design goals and budgets.* New York: Watson Guptill.

Dickinson, D. (1986). *The small house: An artful guide to affordable residential design.* New York: McGraw-Hill.

Drexler, A., and T. Hines. (1982). *The architecture of Richard Neutra from International Style to California Modern.* New York: Museum of Modern Art.

Eisenman, P. (1982). *House X.* New York: Rizzoli.

Family housing handbook. (1971). Ames, IA: Iowa State University, Midwest Plan Services.

Farren, C. E. (1988). *Planning and managing interior projects.* Kingston, MA: R. S. Means.

Fletcher, B. (1987). *History of architecture.* Boston: Butterworths Heinemann.

Foley, M. M. (1980). *The American house.* New York: Harper and Row.

Ford, J., and K. Ford. (1989). *Classic model homes of the 30's.* New York: Dover.

Frampton, K., and P. Drew. (1992). *Harry Seidler: Four decades of architecture.* New York: Thames Hudson.

Gebhard, D. (1983). *Robert Stacy-Judd: Mayan architecture, the creation of a new style.* Santa Barbara, CA: Capra.

Gehry, F. (1992). *Franklin D. Israel: Buildings and projects.* New York: Rizzoli.

Giedion, S. (1992). *Walter Gropius.* New York: Dover.

Goltsman, S., T. Gilbert, and S. Wohlford. (1992). *The accessibility checklist: An evaluation system for buildings and outdoor settings.* Berkeley, CA: MIG Communication.

Gowans, A. (1989). *The comfortable house: North American suburban architecture 1890–1939.* Cambridge, MA: MIT Press.

Gretes, F. C. (1986). *Directory of international periodicals and newsletters on the built environment.* New York: Van Nostrand Reinhold.

Gutman, R. (1985). *The design of American housing: A reappraisal of the architect's role.* New York: Design Arts Program of the National Endowment for the Arts, Publishing Center for Cultural Resources.

Handlin, D. P. (1979). *The American home: Architecture and society, 1815–1915.* Boston: Little, Brown.

Harris, C. W., and T. D. Nicholas. (1988). *Time-saver standards for landscape architects.* New York: McGraw-Hill.

Hejduk, J. (1992). *The Lancaster/Hanover Masque.* New York: Princeton Architecture.

Hitchcock, H. R. (1966). *Architecture of H. H. Richardson and his times.* Cambridge, MA: MIT Press.

Hutton. (1993). *Kitchen and bath sourcebook 1993.* New York: McGraw-Hill.

Ivy, R. A., Jr. (1992). *Fay Jones.* Washington, DC: AIA.

Jacobson, M. (1990). *The good house: Contrast as a design tool.* Newtown, CT: Taunton.

Jankowski, W. (1993). *Kitchens and baths.* New York: PBC.

Johnson, E. J. (ed.). (1986). *Charles Moore: Buildings and projects 1949–1986.* New York: Rizzoli.

Johnson, P. (1991). *Eric Owen Moss: Buildings and projects.* New York: Rizzoli.

Jones, R. (ed.). (1987). *Authentic small houses of the twenties*. New York: Dover.

Kaufmann, E., Jr. (1986). *Fallingwater: A Frank Lloyd Wright country house*. New York: Abbeville.

Keiser, M. B. (1978). *Housing: An environment for living*. New York: Macmillan.

Kilmer, R., and W. O. Kilmer. (1992). *Designing interiors*. Fort Worth, TX: Harcourt Brace Jovanovich College.

Kleeman, W. (1981). *The challenge of interior design*. Boston: CBI.

Kostof, S. (1985). *A history of architecture: Settings and rituals*. New York: Oxford University Press.

Liebrock, C. (1992). *Beautiful barrier-free: A visual guide to accessibility*. Florence, KY: Van Nostrand Reinhold.

Linsley, L. (1992). *Key West houses*. New York: Rizzoli.

Lupton, E., and M. J. Abbott. (1992). *The bathroom, the kitchen, and the aesthetic of waste*. Cambridge, MA: MIT List Visual Arts.

Maass, J. (1972). *The Victorian home in America*. New York: Haworth.

McAlester, V. and L. McAlester. (1984). *A field guide to American houses*. New York: Knopf.

Mace, R., G. Hardie, and J. Place. (1990). *Accessible environments: Toward universal design*. Raleigh, NC: Center for Accessible Housing.

Madden, C. (1993). *Kitchens*. New York: Crown.

Malnar, J. M., and F. Vodvarka. (1992). *The interior dimension: A theoretical approach to enclosed space*. New York: Van Nostrand Reinhold.

Marshall, R. (1993). *Edward Ruscha: Los Angeles apartments*. Bergenfield, NJ: Abrams.

Masello, D. (1993). *Architecture without rules: The houses of Marcel Breuer and Herbert Beckhard*. New York: Norton.

Mead, C. (1991). *Houses by Bart Prince: An American architect for the continuous present*. Albuquerque: University of New Mexico Press.

Meeks, C. (1980). *Housing*. Englewood Cliffs, NJ: Prentice-Hall.

Meier, R. (1984). *Richard Meier, architect*. New York: Rizzoli.

———. (1991). *Richard Meier, architect: Volume 2*. New York: Rizzoli.

Mellor Meigs and Howe: Country estates, suburban homes, and other structures. (1991). Lanham, MD: Architectural.

Metz, D. (1988). *The compact house book: Thirty three prize winning designs over one thousand square feet or less*. 2nd ed. Pownal, VT: Storey Communications.

Mizner, A. (1992). *Florida architecture of Addison Mizner*. New York: Dover.

Moore, C., G. Allen, and D. Lyndon. (1979). *The place of houses*. New York: H. Holt.

Mount, C. M. (1992). *Residential interior design: Interior and architectural detailing*. New York: PBC.

Morgan, A. L., and C. Naylor (eds.). (1987). *Contemporary architects*. Chicago, IL: St. James.

Morrow, B. H. (1987). *A dictionary of landscape architecture*. Albuquerque: University of New Mexico Press.

National Center for Barrier Free Environments. (1976). *Mobile homes: Alternative housing for the handicapped*. Raleigh, NC: Author.

———. (1991). *Accessible housing design file*. Florence, KY: Van Nostrand Reinhold.

———. (1992). *Bulletins*. Washington, DC: Author.

Neumeyer, F. (1991). *The artless world: Mies van der Rohe on the building art*. Cambridge, MA: MIT Press.

Nissen, L., R. Faulkner, and S. Faulkner. (1994). *Inside today's home*. Fort Worth, TX: Harcourt Brace College.

O'Gorman, J. F. (1991). *Three American architects: Richardson, Sullivan & Wright, 1865–1915*. Chicago: University of Chicago Press.

Peloquin, A. (1993). *Barrier-free residential design*. New York: McGraw-Hill.

Perritt, H. H. (1990). *Americans with Disabilities Act handbook*. New York: John Wiley and Sons.

Pfeiffer, B. B. (1985). *Treasures of Taliesin: 76 unbuilt designs of Frank Lloyd Wright*. Fresno, CA: The Press at California State University.

Pickett, M. S., M. G. Arnold, and L. E. Ketterer. (1986). *Household equipment in residential design*. New York: John Wiley and Sons.

Placzek, A. K. (ed.). (1982). *Macmillan encyclopedia of architects*. New York: Free Press.

Polyzoides, S., R. Sherwood, and J. Tice. (1992). *Courtyard housing in Los Angeles: A typological analysis*. New York: Princeton Architecture.

Pomada, E., and M. Larsen. (1992). *America's painted ladies*. New York: Studio.

Radford, W. A. (1983). *Old house measured and scaled*. New York: Dover.

Raschko, B. B. (1991). *Housing interiors for the disabled and elderly*. New York: Van Nostrand Reinhold.

Robinson, S. K. (1983). *The architecture of Alden B. Dow*. Detroit, MI: Wayne State University Press.

St. Marie, S. S. (1973). *Homes are for people*. New York: Wiley.

Schmertz, M., and M. Sorkin. (1992). *Hardy Holzman Pfeiffer Associates buildings and projects 1967–1992*. New York: Rizzoli.

Scully, V. (1974). *The Shingle style today*. New York: Braziller.

———. (1988). *American architecture and urbanism*. New York: H. Holt.

———. (1989). *The architecture of the American summer*. New York: Rizzoli.

———. (1992). *Robert A. M. Stern: Buildings and projects, 1987–1992*. New York: Rizzoli.

Selected houses by F. L. Wright. (1990). 8 vols. Japan: GA.

Sexton, R. (1989). *The cottage book*. San Francisco, CA: Chronicle.

Sherwood, R. (1978). *Modern housing prototypes*. Cambridge, MA: Harvard University Press.

Siegel, G. (1993). *Gwathmey Siegel: Buildings and projects, 1984–1992*. New York: Rizzoli.

Solomon, D. (1992). *Rebuilding*. New York: Princeton Architecture.

Sprague, J. (1991). *More than housing: Lifeboats for women and children*. Stoneham, MA: Butterworth-Heineman.

Staebler, W. W. (1988). *Architectural detailing in contract interiors*. New York: Watson Guptill.

———. (1989). *Architectural detailing in residential interiors*. New York: Watson Guptill.

Steele, J. (1993). *Moore, Ruble, Yudell*. New York: St. Martin's, Academy Edition.

Stern, R. (1993). *GA architect 10, Frank O. Gehry*. Japan: GA.

Sturgis, R. (1902). *A dictionary of architecture and building: Biographical, historical and descriptive*. 3 vols. London: Macmillan.

Talcott, C., D. Helper, and P. Wallach. (1986). *Home planners' guide to residential design*. New York: McGraw-Hill.

Tate, A., and R. Smith. (1986). *Interior design in the 20th century*. New York: Harper and Row.

Venturi, R., and D. Scott Brown. (1992). *On houses and housing*. AD Monograph. London: St. Martin's Press.

Walker, L. (1981). *American shelter*. New York: Overlook.

Weese. K. B. (1987). *Harry Weese houses*. Chicago: Chicago Review.

Whitaker, C. H. (1976). *Bertram Grosvenor Goodhue: Architect and master of many arts.* New York: Da Capo.

Whitney, D., and J. Kipnis. (1993). *Philip Johnson: The Glass House.* New York: Random House.

Wilkes, J. A. (1988). *Encyclopedia of architecture: Design, engineering and construction.* 5 vols. New York: John Wiley and Sons.

Woods, C., and M. Wells. (1992). *Designing your natural house: Over 200 rules of good architecture you can apply to new or remodeled work.* New York: Van Nostrand Reinhold.

Wright, F. L. (1970). *Natural house.* New York: NAL–Dutton.

Youssef, W. (1988). *Building your own home: A step by step guide.* New York: John Wiley and Sons.

Yudell, M. R. (1993). *Moore Ruble Yudell.* New York: St. Martin's.

Zukowsky, J. (ed.). (1986). *Mies reconsidered: His career, legacy, and disciples.* New York: Rizzoli.

Construction Process

Allen, E. (1990a). *Exercises in building construction.* New York: Wiley

———. (1990b). *Fundamentals of building construction.* New York: Wiley.

———. (1992). *The professional handbook of building construction.* New York: Wiley.

Ambrose, J. (1991). *Building construction: Interior systems.* New York: Van Nostrand Reinhold.

———. (1992). *Building construction and design.* New York: Van Nostrand Reinhold.

Austin, R. L. (1986). *Graphic standards for landscape architecture.* New York: Van Nostrand Reinhold.

Bailey, W. G. (1990). *Guide to popular U.S. government publications.* Englewood, CO: Libraries Unlimited.

Ballast, D. K. (1994). *Interior construction and detailing for designers and architects.* Belmont, CA: Professional.

Benson, T. (1990). *The timber-frame home: Design, construction, finishing.* Newtown, CT: Taunton.

Berglund, M. (1986). *Stone, log and earth houses: Building with elemental materials.* Newtown, CT: Taunton.

Breyer, D. E. (1993). *Design of wood structures.* New York: McGraw-Hill.

Building Officials and Code Administrators International. (1983–). *The BOCA basic/national plumbing code.* Author.

———. (1984–). *The BOCA basic/national energy conservation code.* Author.

———. (1985–). *The BOCA basic/national code interpretations.* Country Club Hills, IL: Author.

———. (1986a–). *The BOCA national building code.* Author.

———. (1986b–). *The BOCA national fire prevention code.* Author.

———. (1986c). *The BOCA national mechanical code.* Author.

———. (1986d–). *The BOCA national plumbing code.* Author.

Burns, B. (1989). *Affordable housing: A resource guide to alternative and factory-built houses, new technologies, and the owner-builder option.* Jefferson, NC: McFarland.

Callender, J. H. (ed.). (1982). *Time-saver standards for architectural design data.* 6th ed. New York: McGraw-Hill.

Ching, F. (1991). *Building construction illustrated.* New York: Van Nostrand Reinhold.

Dietz, A. (1991). *Dwelling house construction.* Cambridge, MA: MIT Press.

Egan, M. D. (1988). *Architectural acoustics.* New York: McGraw-Hill.

Flynn, J. E., A. W. Segil, and G. R. Steffy. (1987). *Architectural interior systems.* New York: Van Nostrand Reinhold.

Gretes, F.C. (1986). *Directory of international periodicals and newsletters on the built environment.* New York: Van Nostrand Reinhold.

Herbert, G. (1984). *The dream of the factory built house: Walter Gropius and Konrad Wachsmann.* Cambridge, MA: MIT Press.

Hornbostel, C. (1978). *Construction materials: Types, uses and applications.* New York: John Wiley and Sons.

Lytle, R. J. (1971). *Industrialized builders handbook.* Farmington, MI: Structures.

Mann, P. (1989). *Illustrated residential and commercial construction.* Englewood Cliffs, NJ: Prentice-Hall.

Mitchell, J. (1992). *The short log and timber building book.* Vancouver, Canada: Hartley and Marks.

Newman, M. (1993). *Standard handbook of structural details for building construction.* New York: McGraw-Hill.

———. (1994). *Design and construction of wood framed buildings.* New York: McGraw-Hill.

Parker, H., and J. Ambrose. (1994). *Simplified engineering for architect and builders.* New York: Wiley.

Ramsey, C. G. (1988). *Architectural graphic standards.* New York: Wiley.

Reznikoff, S. C. (1986). *Interior graphic and design standards.* New York: Whitney Library of Design.

Riggs, J. R. (1989). *Materials and components of interior design.* Englewood Cliffs, NJ: Prentice-Hall.

R. S. Means Company. (annual). *Means building construction cost data.* Kingston, MA: Author.

———. (annual). *Means interior cost data.* Kingston, MA: Author.

———. (annual). *Means landscape cost data.* Kingston, MA: Author.

———. (annual). *Means mechanical cost data.* Kingston, MA: Author.

———. (annual). *Means site work cost data.* Kingston, MA: Author.

———. (annual). *Means square foot cost data.* Kingston, MA: Author.

Rupp, W., and A. Friedman. (1989). *Construction materials for interior design.* New York: Whitney Library of Design.

Safdie, M. (1970). *Beyond habitat.* Cambridge, MA: MIT Press.

Sayegh, K. S. (1987). *Housing: A multidisciplinary dictionary.* Ottawa, Ontario: ABCD–Academy.

Sherwood, R. (Ed.). (1991). *Wood frame house construction.* National Association of Home Builders Staff. New York: Delmar.

Smit, K. (ed.). *Means illustrated construction dictionary.* Kingston, MA.: R.S. Means.

Stein, J. S. (1993). *Construction glossary: An encyclopedic reference and manual.* New York: John Wiley and Sons.

Stein, B. M., F. H. Reynolds, and W. McGinness. (1986). *Mechanical and electrical equipment for buildings.* New York: John Wiley and Sons.

Sweet's Group. (annual). *Contract interiors.* 2 vols. New York: McGraw-Hill.

———. (annual). *Industrial construction and renovation.* 3 vols. New York: McGraw-Hill.

Toenjes, L.P. (1989). *Building trades dictionary.* Homewood. IL: American Technical.

Vance Bibliography series. A-1 to A2385. Monticello, IL: Vance Bibliographies.

Wall, D. (1971). *Visionary cities: The arcology of Paolo Soleri.* New York: Praeger.

Wedin, G. S., and Nygren, L. G. (1976; 1978). *Housing perspectives: Individuals and families.* Edina, MN: Burgess.

Wiggins, G. E. (1989). *A manual of construction documentation.* New York: Whitney Library of Design.

Technology

American Lung Association. (1990). *Asbestos in your home.* Washington, DC: Author.

Anderson, B. (1990). *Solar building architecture.* Ed. C. A. Bankston. Cambridge, MA: MIT Press.

Avery Library. (1975–). *Avery index to architectural periodicals.* Rev. ed. Boston: G. K. Hall.

Balcomb, D. (ed). (1992). *Passive solar buildings.* Cambridge, MA: MIT Press.

Bobenhausen, W. (1992). *Simplified design for HVAC systems.* New York: Wiley

Bourne, J. (1991). *Lighting in the domestic interior: Renaissance to Art Nouveau.* London: Sotheby's.

Boyer, L. L. (1987). *Earth shelter technology.* College Station, TX: Texas A&M University Press.

Brand, R. (1989). *Architectural details for insulated buildings.* New York: Van Nostrand Reinhold.

Brawne, M. (1992). *From idea to building: Issues in architecture.* Stoneham, MA: Butterworth-Heinemann.

Brent, R. S., R. G. Phillips, E. E. Brent, M. K. Gupta, and S. R. Degges. (1991). Older adults residing in their own home: Prioritizing housing inadequacies. *Housing and Society* 18 (1).

Environmental Protection Agency. (1986). *A citizen's guide to radon: What it is and what to do about it.* Washington, DC: GPO.

Flynn, J., A. Segill, J. Kremers, and G. Steffy. (1992). *Architectural interior systems: Lighting acoustics, air conditioning.* 3rd ed. New York: Van Nostrand Reinhold.

Gardner, C., and B. Hannaford. (1993). *Lighting design: An introductory guide for professionals.* New York: Halsted.

Golany, G. S. (1983). *Earth-sheltered habitat: History, architecture and urban design.* New York: Van Nostrand Reinhold.

Gretes, F. C. (1986). *Directory of international periodicals and newsletters on the built environment.* New York: Van Nostrand Reinhold.

Guise, D. (1991). *Design and technology in architecture.* New York: Van Nostrand Reinhold.

Hickin, N. E. (1974). *Household insect pests: An outline of the identification, biology and control of the common insect pests found in the home.* London: Associated Business Programmes.

Hunt, V. D. (1982). *Handbook of conservation and solar energy: Trends and perspectives.* New York: Van Nostrand Reinhold.

Jankowski, W. (1991). *Designing with light: Residential interiors.* New York: PBC.

Kemper, A. M. (ed.). (1985). *Pioneers of CAD in architecture.* Pacifica, CA: Hurland/Swenson.

Kennedy, E. L. (1986). *CAD: Design, drawing, data management: A basic book for architects, designers, and engineers.* New York: Whitney Library of Design.

Kira, A. (1976). *The bathroom: Criteria for design*. New York: Viking.

Knight, P. A. (1981). *The Energy Resources Center illustrated guide to home retrofitting for energy savings*. Washington, DC: Hemisphere.

Kominsky, J. R. (1991). *Evaluation of two cleaning methods for removal of asbestos fibers from carpet*. Cincinnati, OH: Environmental Protection Agency Risk Reduction Engineering Laboratory.

Lam, W. M. (1992). *Perception and lighting as formgivers for architecture*. New York: Van Nostrand Reinhold.

Langdon, W. K. (1980). *Movable insulation: A guide to reducing heating and cooling losses through the windows in your home*. Emmaus, PA: Rodale.

Laskin, D. (1991). *Parents book of child safety*. New York: Ballantine.

Lechner, H. (1991). *Heating, cooling, lighting: A guide of qualitative design methods for architects*. New York: Wiley.

Lenchek, T., C. Mattock, and J. Raabe. (1987). *Superinsulated design and construction: A guide for building energy-efficient homes*. New York: Van Nostrand Reinhold.

Levy, M. E. (1983). *The passive solar construction handbook*. Emmaus, PA: Rodale.

Lockerby, R. W. (1980). *Space colonies: The next frontier*. Monticello, IL: Vance Bibliographies.

McClusky, J. (1992, December). A primer on virtual reality. *Technological Horizons in Education*: 56–59.

MacLeod, D. (1992, April). Computers: Virtual reality. *Progressive Architecture*: 54–56.

Miller, J. E. (1991). *The perfectly safe home*. New York: Simon and Schuster.

Moore, F. (1993). *Environmental control systems: Heating, cooling, lighting*. New York: Mc-Graw-Hill.

Moss, R. W. (1988). *Lighting for historic buildings: A guide to selecting reproductions*. Washington, DC: Preservation.

National Association of Home Builders. (1989). *Asbestos handbook for remodeling: How to protect your business and your health*. Washington, DC: Author.

Nuckolls, J. L. (1976). *Interior lighting for environmental designers*. New York: Wiley.

Olgyag, V. (1992). *Design with climate: A bioclimatic approach to architectural regionalism*. New York: Van Nostrand Reinhold.

Reid, E. (1989). *Understanding buildings*. Cambridge, MA: MIT Press.

Reyburn, W. (1969). *Flushed with pride: The story of Thomas Crapper*. Englewood Cliffs, NJ: Prentice-Hall.

Schepp, B., and S. M. Hastie. (1985). *The complete passive solar home book*. Blue Ridge Summit, PA: Tab.

Schiler, M. (1992). *Simplified design of building lighting*. New York: Wiley.

Smith, F. K., and F. J. Bertolone. (1986). *Bringing interiors to light: The principles and practices of lighting design for interior designers*. New York: Whitney Library of Design.

Sorock, G. S. (1988). Falls among the elderly: Epidemiology and prevention. *American Journal of Preventive Medicine* 4(5): 282–88.

The star of the smart revolution. (1991, January). *Professional Builder and Remodeler*.

Steffy, G. (1990). *Architectural lighting design*. New York: Van Nostrand Reinhold.

Stein, B., and W. McGuiness. (1992). *Mechanical and electrical equipment for buildings*. New York: Wiley.

Stoner, C. H. (ed.). (1977). *Goodbye to the flush toilet: Water-saving alternatives to cesspools, septic tanks, and sewers*. Emmaus, PA: Rodale.

Suzuki, S. (1991). *Passive and low energy architecture*. Toyko: Process Architecture.

Time-Life Books: Home Repair and Improvement Service. (1977). *Weatherproofing.* Alexandria, VA: Time-Life.

University of Minnesota Underground Space Center. (1979). *Earth sheltered housing design: Guidelines, examples, and references.* New York: Van Nostrand Reinhold.

U.S. Department of Housing and Urban Development. (1977). *Energy-saving home improvements: A dollars and sense guide.* New York: Drake.

Winn, M. (1987). *Architectronics: Revolutionary technologies for masterful building through design.* New York: McGraw-Hill.

GUIDE TO PERIODICALS

Environmental Design

Architectural Design

Architectural Digest

Architectural Record

Architectural Review

Design Book Review

Designers West

Design Issues

Design Methods

Design Quarterly

Interior Design

Journal of Housing for the Elderly

Journal of Interior Design

Kitchen and Bath Business

Metropolitan Home

Progressive Architecture

Southern Accents

Construction

Builder

Building Design

Custom Builder

Professional Builder and Remodeler

Progressive Builder

Qualified Remodeller

Technology

Architectural Lighting

CADENCE

Computer Graphics World

DesignNet

Lighting Design and Application

Lighting Dimensions

MacUser

MacWorld

Solar Age

Technology and Conservation

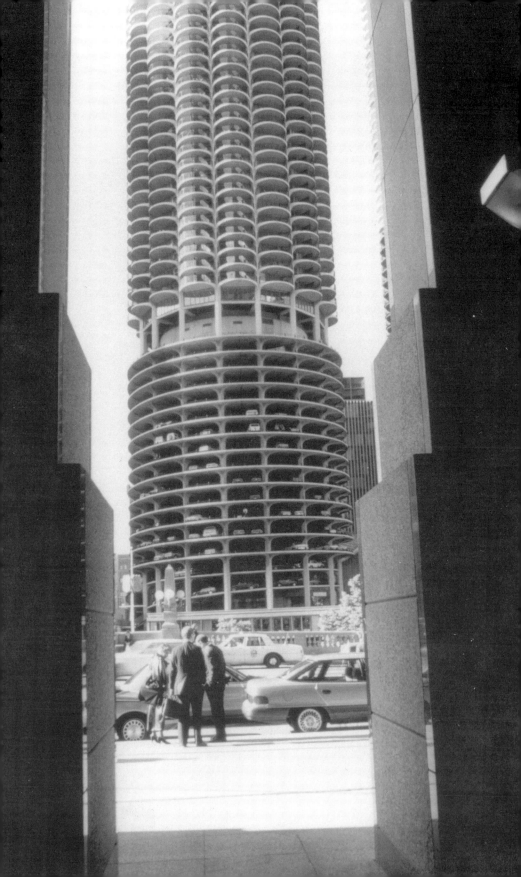

8

Electronic Resources
and Housing

*Edward Brent, Ruth Brent, and
Benyamin Schwarz*

> The Internet itself is only the beginning of an enormous upheaval in personal
> and global communications. . . . Changes are inevitable, particularly when the
> world is now only 600 milliseconds in diameter on the net. That makes for
> an awfully small but very accessible globe and a revolution in society the like
> of which we haven't seen since the Renaissance.
> —Geoff Huston, Internet Society

Major technological advances are transforming the way research is conducted.
The ways in which researchers search for citations have changed dramatically,
and they are destined to affect scholars more broadly and more quickly than ever
imagined before. Information technology is rapidly developing, creating a seem-
ingly endless potential of such developments as video for long-distance learning,
wireless communications that allow people to link computers without using tel-
ephone lines, multimedia databases that transcend the barriers of geography, and
multimedia software for classroom presentations. In fact, some would argue that
electronic resources will soon replace reference books such as this one. Therefore,
this reference guide would not be complete with review of only printed
publications and productions. The following sections serve as an introduction to
technology information that is currently available for researchers and practition-
ers.

Traditional copyrighted materials as well as electronic addresses may be ac-
cessed with computers at home, the library, and the workplace. The bimonthly
publication *Electronic House: Advanced Housing and Home Automation* is devoted

to contemporary issues of home automation. Some of the feature articles introduce existing automated homes and illustrate how technology helps bring independence to persons with disabilities. New advances in technology of interest to the researcher are also routinely reported in the column "Information Technology" in *The Chronicle of Higher Education.*

Today's popular magazines and newspapers are saturated with features about electronic resources that are changing the function of our homes. There are stories on how people log onto the Internet, an international network of computers, from any room in their home and interact live with other people anywhere on the globe. Adolescents play games with their peers a thousand miles away. Children look up encyclopedia articles and references for their school work. College students browse the Library of Congress for books, examine current research, or view satellite images from NASA. Executives send electronic mail and participate in online conferences from their home. Parents shop using cable television with 24-hour home shopping networks. Scholars participate in live interactive conferences combining satellite teleconferencing and Internet communications simultaneously in every place and no place.

In the article "Housing Technology in the United States" (1992), Laquatra and McCarty address housing technology considering the historical context, materials and processes, design and production, mechanical systems, and security and safety. They explain implications such as widespread adoption of improved materials and production processes. Interactive electronic communication is transforming physical space by linking physical space to electronic hyperspace. By one estimate, the United States is projected to have 2.2 computers per household by the year 2000, and no one really knows how many phones, modems, cellular phones, televisions, and electronic games. According to Martha Williams of the University of Illinois, over the seventeen-year time period from 1975 through 1992, database records have grown from 52 million to 4.5 billion (by a factor of 87), while the number of databases has grown from 301 to 7,907 (a factor of 26) (Marcaccio, 1993, p. xvii).

CONDUCTING HOUSING RESEARCH

While we are concerned here with references that can assist in the study of American housing, we recognize that with electronic resources there are now additional unlimited resources available for crosscultural comparisons. Locating these electronic resources may be difficult given the demands of communicating electronically. Compiling these sources requires "surfing the Internet," sampling commercial information services, and searching for useful resources.

Electronic resources can be organized into the following generic categories:

- Telecommuting (computer-based communication)
- The portable office (laptops, personal digital assistants, cellular phones)

- Electronic communication for business and finance
- Electronic communication for culture, interaction, entertainment, and community

This chapter focuses on electronic communication useful to the housing researcher. These information systems can be further subdivided as follows:

- Data tapes
- Online databases
- Other electronic databases
- Electronic mail
- Listserves, chat, and online communities
- Libraries
- Online electronic texts
- Software
- News and journals (including electronic journals)

Magnetic Data Tapes

Data tapes are available for examination of raw data. An excellent source of political and social research data is the Interuniversity Consortium for Political and Social Research (ICPSR). Located at the University of Michigan at Ann Arbor, it is a consortium of more than 370 other universities in the United States and around the globe. There is a membership dues structure for different types of institutions. (To determine the member institution in one's area, contact ICPSR.) Examples of data collections of particular interest to the housing researcher are:

- Annual American Housing Surveys (U.S. Bureau of the Census)
- Census of Population and Housing (U.S. Bureau of the Census)
- Cost of Living/Consumer Expenditure Surveys (U.S. Bureau of Labor Statistics)
- County and city data books (U.S. Bureau of the Census)
- Current Population Surveys (U.S. Bureau of the Census)
- National Jail Census (U.S. Bureau of Justice Statistics)
- National Nursing Home Surveys (National Center for Health Statistics)
- Retirement History Longitudinal Surveys (Social Security Administration)
- Surveys of Consumer Attitudes and Behavior (Economic Behavior Program, Survey Research Center, University of Michigan)

The American Housing Survey Series, for example, is comprised of a national survey of housing units throughout the country and surveys housing units in selected metropolitan areas. Information is collected on income, moves, and dem-

ographic data (e.g., age, sex, marital status, education, length of occupancy, travel to work). Computing assistance is also available for data analysis.

Online Databases

The *Gale Directory of Databases* provides annual comprehensive coverage of the electronic database industry. It contains contact and descriptive information on 8,400 databases, 3,260 producers, 825 online services, and 840 vendors/distributors of database products. The directory includes the databases and product descriptions, database producers, online services and vendors/distributors, a geographic index, a subject index, and a master index. The directory itself is also available electronically.

The first volume, *On-Line Databases,* profiles more than 5,200 online databases made publicly available by the producer or an online service via phone lines. An especially useful database is the Department of Housing and Urban Development News, which contains the press releases and fact sheets providing HUD initiatives, program allocations, and major policy decisions. HUD also publishes a directory of information resources in housing and urban development with information on organizations and online databases. Databases of particular interest include information on census, construction forecasts, building construction permits, and social trends.

The *DRI Housing Forecast* is a time series dataset that contains thirteen quarterly historical and forecast time series of U.S. housing sales and prices. It includes homes for sale; sales of uncompleted, new, and existing homes; median sales prices of new and existing homes; mortgage expenses; and effective after-tax costs of housing. Since 1970 it has been updated quarterly. The data are from the DRI's detailed housing model and the DRI's central U.S. data bank.

Other Electronic Databases

Other forms of electronic databases include CD-ROMs, diskettes, magnetic tape, and batch access database products. Examples of resources available on CD-ROM include:

- Census of Population and Housing
- Dissertation Abstracts Ondisc
- Econlit
- ERIC
- GPO Monthly Catalog
- Infotrac—Expanded Academic Index
- PAIS (Public Affairs Information Service)
- Psyclit

The second volume of the *Gale Directory of Databases* provides a comprehensive listing of available online databases. In addition, database catalogs from specific vendors, such as DIALOG Information Services, are available in most libraries. The DIALOG catalog lists more than 400 databases by disciplines such as architecture, psychology, and social science. For example, one database supplied by DIALOG is the Avery Architecture Index produced by Avery Architectural and Fine Arts Library, Columbia University, New York. It includes all aspects of architecture, interpreted in the widest sense. These databases are accessible online through commercial services such as COMPUSERVE or library computers. Databases commonly available for housing research include:

- Avery Architecture
- Architecture Database
- Arts and Humanities Search
- ERIC
- PsycINFO
- Dissertation Abstracts On-line
- Sociological Abstracts
- Ageline
- Family Resources
- Public Opinion On-line (POLL)

The Internet

The Internet is a collection of connected international computer networks. The advantage of using the Internet is its being free to most academics. Two useful books for beginners are: *The Internet Companion* (1993) by LaQuey and *The Whole Internet* (1992) by Krol.

Some of the resources available on the Internet include directories of network resources, regional and national catalogs, reference sources, secondary sources, primary sources, and computing and software resources. Directories of network resources include BITNET, Internet Resource Guide, and *Internet Accessible Library Catalogs and Databases* (1991) by St. George and Larsen.

One secondary source regarding online journals, articles, reports, and discussion forums (bulletin boards, electronic conferences) available on the Internet is PENpages. PENpages originates from Pennsylvania State Colleges of Agriculture and Health and Human Development, the Pennsylvania Department of Agriculture, and the U.S. Department of Agriculture. PENpages includes reports, newsletters, and fact sheets on agriculture and consumer issues.

Among primary sources is Project Hermes, which includes the texts of recent U.S. Supreme Court decisions. An example of computing and software resources is the Washington University Public Domain Archives, an archive of public do-

main and "shareware" software. The online electronic books mentioned above are also available primary sources.

Electronic Mail

Electronic mail (e-mail) is messages sent from one user to another via computer. They may be brief notes or long files. E-mail can be sent to another user on a local area network across the hall or around the world. Mail can include graphics, programs, spreadsheets, even audio or video attachments, as well as text. E-mail, like "snail mail" (traditional paper mail), does not require the other user to be online at the same time. Mail is sent to another machine where the receiver can read it the next time he or she logs on. E-mail can be very quick, reaching someone around the world in a matter of minutes, and is free to users when both users are on the Internet. E-mail is commonly used to correspond with other individuals or to send and receive messages from online discussion groups.

E-mail can be sent through the Internet, commercial services, or both. It can even be forwarded to someone who doesn't have a computer as a fax or a printout given to a local post office to be delivered by snail mail. Keep in mind that sending mail to someone on a commercial network is likely to cost them money. One of the current difficulties with using e-mail is finding out someone's electronic address. Since the information superhighway is a loose connection of many different computers in many different organizations, there is no system-wide "telephone book" with everyone's electronic address. There are, however, a number of "whois," "finger," and "netfind" servers dedicated to finding Internet addresses.

Listserves, Chat, and Online Communities

Listserves are like electronic bulletin boards where users can post messages. These messages are then forwarded to every electronic address on the list. The List-of-Lists for Internet and BITNET mailing lists are often updated and made available to usenet (electronic bulletin board) newsgroups, news.answers, and news.announce.newusers. Interested users can subscribe to these lists and receive text files sent to their Internet accounts. Kent State University maintains an annually updated list of these electronic conferences of interest to academics organized by academic subject areas, the *Directory of Electronic Journals, Newsletters and Academic Discussion Lists* by Strangelove and Kovacs. Broad areas of interest to housing researchers include ecology and environmental studies, urban planning, geography, and sociology. The directory includes lists of research funding opportunities and trends. Examples of listserves related to housing are provided in Table 1.

The electronic addresses of listserves are cryptic and often difficult to understand. Sometimes they include root words or acronyms that indicate their meaning. More often, one has to be told what they stand for or find information

Table 1
Example Listserves Related to Housing

Ecology & Environmental Studies	Urban Planning	Miscellaneous Academia
AR-TALK@THINK.COM	URBAN-L@TREARN	FUNDLIST@JHUVM
ECONET@IGC.ORG	URBAREG@UQUEBEC	GRANTS-L@JHUVM
ECONET@MIAMIU		RESEARCH@TEMPLEVM
ENVST-L@BROWNVM	*Sociology & Demography*	
	CENSUS-PULICATIONS@	*Anthropology*
ECIXFILES@IGC.ORG	MAILBASE.AC.UK	QUALRS-L@UGA
	CENSUS-NEWS@	INTERCUL@RPITSVM
ENV-LINE+@ANDREW.CMU.EDU	MAILBASE.AC.UK	
IRNES@MAILBASE.AC.UK	CENSUS-ANALYSIS@	*Art*
	MAILBASE.AC.UK	
ODP-L@TAMVM1	METHO@UQUEBEC	DESIGN-L@PSUVM
SAFETY@UVMVM	DISASTER RESEARCH	L-ARTECH@UQAM

Users can subscribe to a listserve by sending mail to the listserve at the site where a list is located with the message "subscribe listname" and your own name and electronic address.

summarizing them. This is why directories are so valuable. Otherwise, it is very difficult to find addresses on the Internet and understand what they mean.

Libraries

Over 250 academic and public libraries around the world have their online public access catalogs (OPACs) available over the Internet. Most are available twenty-four hours a day. A few of the more prominent libraries and their distinguishing features are shown in Table 2.

Online Electronic Texts

Several projects are working to place complete books in electronic form on the Internet for free access. These include the Gutenberg Project, wiretap, the Oxford Archive, and the Libellus Project. See electronic addresses for each of these at the end of this chapter. These online electronic texts include classic works of literature as well as other books. An Internet newsletter, *The B&R Samizdat Express,* provides monthly information about such projects. Send an e-mail message to samizdat@ world.std.com for a subscription.

Software

Freeware (free software) and shareware (software that can be freely copied and distributed) can often be downloaded over the Internet. These programs range

Table 2
Sample Libraries Available on the Internet

Library	Features
University of Saskatchewan	many free databases
Arizona State University	regional databases and directories
Carnegie Mellon University	good in-house bibliographies
CARL	periodical index database and article delivery service
Stanford University	access to only searchable bookstore on the Internet
Library of Congress	complete U.S. national library

from utilities to games to specialized programs for research. Note however that if one decides to use shareware one is obligated to send the author a specified fee. Popular sites to obtain software electronically are listed at the end of this chapter.

News and Journals (Including Electronic Journals)

Several journals are available in whole or in part electronically over the Internet. Springer-Verlag is working with the University of California at San Francisco to make as many as forty journals available online. Elsevier Science Publishers is working with the University of Michigan and nine other universities to provide science journals online. Cornell University and the American Chemical Society are working on a similar project for chemistry journals (DeLoughry, 1993).

CARL (Colorado Alliance of Research Libraries) UnCover is an electronic service offering a periodical database and index with an article delivery service for over fourteen-thousand English language titles. It is a regional and national catalog. Most articles cited in UnCover can be ordered online and delivered via fax within twenty-four hours. Articles from 1989 to the present are included. An example of a reference source is the Geographic name server, which gives name, state, county, population, elevation, and zip code of all U.S. cities.

RESOURCES FOR ELECTRONIC COMMUNICATION

Table 3 provides a list of important resources for taking maximum advantage of electronic communication through the Internet and commercial electronic services.

BITNET

BITNET (Because It's Time Network) began as a network open to all academic users when ARPAnet access was restricted. Today BITNET includes more than 1,400 organizations and 3,000 nodes in more than 50 countries around the world. BITNET and other networks are connected to the Internet by gateways, and many

Table 3
Resources for Taking Maximum Advantage of Electronic Communication

Directly through the Internet:
- BITNET
- Usenet, BBSs, and conferencing systems
- Remote login with telnet
- FTP
- User interface front ends for navigating the Internet
 - —Gopher
 - —Veronica servers
 - —Mosaic
 - —World Wide Web
 - —Archie servers
 - —WAIS

Through commercial electronic services:
- America Online
- CompuServe Information Service
- Dow-Jones News/Retrieval with MCI Mail
- Genie
- Prodigy Interactive Personal Service

of the public access archives of software, libraries, and databases are maintained at universities on BITNET.

Usenet, BBSs, and Conferencing Systems

Usenet, bulletin board systems (BBSs), and conferencing systems are the electronic equivalent of bulletin boards or classified ads. Usenet is the Internet version, consisting of a collection of bulletin boards around the world; each user can post messages to the local Usenet site, and that site distributes those postings to other sites. Usenet is organized into more than 3,500 "newsgroups" covering topics of interest ranging from Spam to *The Rocky Horror Picture Show*. The seven basic categories of Usenet groups are comp. (computers), misc. (miscellaneous), news. (announcements and news), rec. (recreation), sci. (science, research, and engineering), and soc. (social issues, politics, culture, and socializing), talk. (debates over controversial topics), and alt. (alternative news groups). Usenet and electronic mail account for the great majority of Internet activity, with 30 to 50MBytes of usenet information sent to each site daily, read by millions of people around the world. See Table 4 for a list of Usenet groups of potential interest to housing researchers.

Table 4
Usenet Groups of Potential Interest to Housing Researchers

alt.architecture.alternative

alt.architecture.int-design

bit.listserv.envbeh-1

de.housing

relcom.commerce.construction

relcom.commerce.energy

relcom.commerce.household

Remote Login with Telnet

Remote login with telnet permits one to log onto computers anywhere in the world through a remote connection whereby one's computer emulates a terminal of the computer it is connected to. This can be used to search electronic card catalogs of libraries around the world, including the Library of Congress. It can be used to run software available on remote computers but not available locally or to run more powerful computers such as the supercomputers at the various federal supercomputing facilities. The most common method for remote logon on the Internet is telnet, which is the name of the transmission control protocol/Internet working protocol (TCP/IP) supporting remote logon. For example, telnet can be used at a convention to log onto one's work computer in another state or country and check one's e-mail. It can also be used to log on anonymously to various libraries that permit one to use it to examine their electronic card catalogs. The Library of Congress's Internet address, for example, is locis.loc.gov, and on-line manuals are available by anonymous ftp from seq1.loc.gov in directory/pub/LC.Online. For a list of Internet addresses of libraries, look at gopher menus for the latest version of that list.

FTP

FTP (file transfer program or file transfer protocol) refers to transferring files from one computer to another. This can be used to send data or manuscript files from one site to another. Many Internet sites offer archives of computer programs, research data, and documents that can be transferred to one's own computer for use. Once a researcher has the necessary hardware and software to connect to the Internet, ftp can be as easy as issuing the command *ftp* followed by the Internet node or site identification. After a brief delay the researcher is connected to the remote site and asked to log on with a name and password. Typically one can log on with the name *anonymous* and is usually expected to give one's own Internet address as the password. Once logged on successfully, a researcher can issue common commands such as *dir* to view a directory, *cd/newdir* to change to another

directory with name *newdir,* and *get filename* to have a file at the remote site copied to one's own hard disk. If the file to be transferred is a graph or computer program, one should issue the command *binary* before downloading it to instruct the machine to send it in binary mode so it is not scrambled on the way to one's machine.

For example, ftp can be used to download a wide variety of software from sites such as Washington University and data sets from sites such as ICPSR and the Census Bureau. For a list of sites permitting anonymous ftp, a file called AN-ONFTP is updated monthly and posted on several Usenet news groups, including comp.misc, comp.sources.wanted, and news.answers. This list contains the electronic addresses of hundreds of sites permitting anonymous FTP with brief descriptions of the kinds of files they offer.

User Interface Front Ends for Navigating the Internet

User interface front ends for navigating the Internet are programs that help users find important resources and perform a variety of tasks on the Internet. These include gopher, WAIS, WorldWideWeb, and Mosaic.

Gopher

Gopher is an Internet navigational tool developed in 1991 at the University of Minnesota. A gopher server is a computer running a copy of gopher software making a variety of files, directories, and data available to others through that gopher. The gopher server provides a series of hierarchically arranged menus that one can read and select from using the client gopher program on one's computer. This client–server model is common to most Internet programs. Gopher menus can contain information available locally at that site or pointers to other gophers elsewhere on the Internet. For example, selecting the option "Popular FTP Sites via gopher" on the University of Minnesota gopher server, followed by the option "Merit Network, USA," takes one to another gopher server at the University of Michigan.

Gopher servers are available for a wide range of topics, including ACADEME This Week, the *Chronicle of Higher Education* news service; FEDIX, the experiential public-access system for several federal agencies; and Envirogopher, a gopher for environmental issues. Gopher menus include pointers to text-based remote logins, such as telnet or tn3270 connections; pointers to a software gateway such as ftp from publicly accessible archive sites; search facilities such as Veronica or Archie (see below) to find files or whois; and netfind to find Internet addresses. In many cases, the gopher program helps a researcher perform the first login steps and provides a front end to these other services, making it easier to use them without having to learn many new commands.

Veronica Servers

Veronica (Very Easy Rodent-Oriented Netwide Index to Computerized Archives) was developed at the University of Nevada at Reno. Veronica is searching

software that looks through gopher sites and directories to find matching key-words. It has a database of menu text lines from hundreds or even thousands of gophers on the Internet.

World Wide Web

World Wide Web (WWW or W3) began at CERN, the European Particle Physics Laboratory in Geneva, Switzerland. WWW uses hypertext and hypermedia to link one document on the web to any other document or file on the web at any other site in the world.

Mosaic

Mosaic is a program developed at NCSA at the University of Illionis at Urbana–Champaign. This program, available on Macintosh, MS-Windows, and X-Windows platforms, allows the user to view scrollable pages of information, including both text and graphics, from any WWW server on the Internet. Then, by selecting a hypertext term on that page, the user can pull up another page from any other WWW server throughout the world.

Archie Servers

Archie servers are one of the most common ways of searching for items on the Internet. Archie servers maintain lists of accessible sites on the Internet for anonymous ftp and a database of brief descriptions of over 3,500 public domain software packages, data sets, and documents. Each server polls those sites periodically and updates its database of available files. There are many different Archie sites on the Internet. Because they poll sources at different times, at any one time there may be files available on the Internet that some Archie servers know about and others do not. By the end of 1992 there were more than 1,500 archive sites around the world containing over 2.5 million files and over 230 GBytes of information.

WAIS

Wide-Area Information Server (WAIS) began at Thinking Machines Corporation in 1990. It is a client–server approach whereby one can run a client WAIS program on one computer to issue queries, and those queries are then used to search the information on WAIS servers throughout the Internet. The same query can even be searched simultaneously on different WAIS servers. WAIS can do indexed searches of the full text of a wide range of documents, including spreadsheets, text, formatted documents, pictures, graphics, and video.

Commercial Electronic Networks

Several commercial online information services are widely available for those who do not have direct access to the Internet. These include America Online, CompuServe Information Service, Dow-Jones News/Retrieval with MCI Mail, Genie, and Prodigy Interactive Personal Service. Most of these offer a wide range of services, including e-mail and communications, file downloads, news and finan-

cial information, hobbies and entertainment, and a wide range of information databases ranging from magazine archives to corporate financial information. Many have bulletin boards or forums where people with similar interests can find information on a topic, post questions for others, and participate in dialogues. Unfortunately, at the time of this writing we could find no bulletin boards or forums devoted specifically to housing issues.

DEFINITIONS

Archie	Searches indexes of ftp sites for specific files. Must know file name.
e-mail	Electronic mail system which allows one to send and receive mail from anyone connected to the Internet who has an active account.
FTP	Transfers files between computers. It's most useful for retrieving files from public archives scattered around the Internet. This is called anonymous FTP, because one doesn't need an account on the computer one is accessing (Krol, 1994).
gopher	A menu-based software program that leads to most information sites. A gopher logs onto other computers as the user selects items from a menu. In most cases, this can substitute for telnet.
Internet	An international network of computers. The three main uses for the Internet are e-mail, telnet, and file transfer (ftp).
Listserv	The program that supports discussion lists, but generally used to refer to the lists themselves. One can subscribe to professional or recreational discussion lists.
Server	A computer converted to a network and providing data to users at remote sites.
telnet	Used for logging onto other computers on the Internet. It's used to access public services, including library card catalogs and other kinds of databases (Krol, 1994).
Veronica	Searching software that looks through gopher sites and directories to find matching keywords.

References

BOOKS AND ARTICLES

DeLoughry, T. J. (April 7, 1993). Efforts to provide scholarly journals by computer tries to retail the look and feel of printed publications. *The Chronicle of Higher Education*: A19–A20.

Dern, D. P. (1994). *The internet guide for new users.* New York: McGraw-Hill.

DRI/McGraw-Hill. *DRI Housing Forecast.* (Updated quarterly.) Lexington, MA.

Garson, D. G. (1993). Exploring the Internet with Gopher. *Social Science Computer Review* 11(4): 515–19.

HUD User. (1993). *Information resources in housing and urban development.* 3rd ed. Washington, DC: Department of Housing and Urban Development.

Kehoe, B. P. (1993). *Zen and the art of the Internet—A beginner's guide to the Internet.* Chester, PA: Widener University.

Krol, E. (1994). *The whole Internet user's guide and catalog.* 2nd ed. Sebastapol, CA: O'Reilly and Assoc.

Laquatra, J., and J. A. McCarty. (1992). Housing technology in the United States. *Human Ecology Forum* 21.

LaQuey, T. L. (1993). *The Internet companion: A beginner's guide to global networking.* Reading, MA: Addison-Wesley.

Marcaccio, K. Y. (ed.). (Annual). *Gale directory of databases, vol. 1: Online databases.* Detroit, MI: Gale Research.

———. (Annual). *Gale directory of databases, vol. 2: CD-ROM, diskette, magnetic tape, handheld, and batch access database products.* Detroit, MI: Gale Research.

St. George, A., and R. Larsen. (1991). *Internet accessible library catalogs and databases.* Albuquerque, NM: University of New Mexico.

Strangelove, M., and D. Kovacs. (Annual). *Directory of electronic journals, newsletters and academic discussion lists.* Washington, DC: Association of Research Librarians, Office of Scientific and Academic Publications. (Also available through ftp from Ksuxa.Kent.edu.)

ELECTRONIC ADDRESSES

B&R Samizdat Express: Available at samizdat@ world.std.com

BITNET: Available by electronic mail to info@ bitnet.educom.edu

Carl (Colorado Alliance of Research Libraries): Available by telnet database.carl.org

Geographic name server: Available by telnet to martini.eecs.umicn.edu

Gutenberg Project: Available by ftp at mrcnext.cso.uiuc.edu/pub/etext/etext94

Internet Directory: Available by ftp to ksuvxa.kent.edu

Libellus Project: Available by ftp at ftp.u.washington.edu/pub/user-supported/libellus/texts

Library of Congress: Available at anonymous ftp locis.loc.gov

List-of-Lists: Available by e-mail and anonymous ftp from the Usenet FAQ archives at pit-manager.mit.edu

Mac programs: Available by anonymous ftp at ftp.apple.com, sumex-aim.stanford.edu, mac.archive.umich.edu

Oxford Archive: Available by ftp at ota.ox.ac.uk/ota/english/

PEN pages: Available by Telnet at psapen.psu.edu

Project Hermes: Available by gopher://marvel.loc.gov

Washington University software: Available by anonymous ftp at library.waste.edu

Windows programs: Available by anonymous ftp at oak.oakland.edu
wiretap: Available by ftp at 130.43.43.43/Library/Classic/

ADDITIONAL RESOURCES

Chronicle of Higher Education. 23rd St. NW, Washington, DC 20037.
Electronic house: Advanced housing and home automation. Mishawaka, IN: Electronic House.
Interuniversity Consortium for Political and Social Research (ICPSR). P.O. Box 1248, Ann Arbor, MI 48106–1248. Telephone: 313–764–2570. Fax: 313–764–8041.

Index

Contributors

EDWARD BRENT is Professor of Sociology at the University of Missouri, Columbia and president of Idea Works, Inc., a software company. He has coauthored or coedited *New Technology in Sociology; Computer Applications in the Social Sciences; Expert Systems; Policing: The Social Behavior Perspective*, and several computer software packages.

RUTH BRENT is Professor and Chair of Environmental Design, University of Missouri, Columbia, and software author of *Home Safe Home*. She has published over thirty papers in books, journals, and proceedings.

RAEDENE COMBS is Professor of Family Economics at University of Nebraska, Lincoln. She has served as associate editor for *Housing and Society* and the *Home Economics Research Journal*.

JACKIE DONATH is Assistant Professor of Humanities, California State University, Sacramento. She is also Northern California Vice President of the California American Studies Association.

BARBARA FLANNERY is Assistant Professor of Family and Consumer Studies, Miami University, Oxford, Ohio. She has coauthored many publications.

HOWARD WIGHT MARSHALL is Professor of Art History and Archaelogy at the University of Missouri, Columbia. He is the former editor of the journal *Material Culture* and author of *Folk Architecture in Little Dixie* and *American Folk Architecture*, among others.

ROBERTA MAUKSCH is Assistant Professor of Family Environmental Sciences

at California State University, Northridge. She serves as an ad hoc reviewer for the *Journal of Interior Design*.

JOSETTE H. RABUN is Associate Professor of Textiles, Retailing and Interior Design at the University of Tennessee, Knoxville. She is also a certified interior designer.

SANDRA RAWLS is Assistant Professor of Housing and Interior Design, University of North Carolina, Greensboro and chair of the Art and Design Division of the American Association of Family and Consumer Sciences.

BENYAMIN SCHWARZ is Assistant Professor of Environmental Design at the University of Missouri, Columbia, and a coauthor of *University-Linked Retirement Communities: Student Visions of Eldercare*.

ANDREW D. SEIDEL is Professor of Architecture at Texas A&M University, College Station, and editor of the *Journal of Architectural and Planning Research*. He has published over fifty articles and book chapters

BETTY MCKEE TREANOR is Associate Professor and Interior Design Program Coordinator at Southwest Texas State University, San Marcos.

ISBN 0-313-28032-0

EAN

9 780313 280320

90000>

HARDCOVER BAR CODE